THE
ETRUSCANS

Their Art and Civilization

By Emeline Richardson

The University of Chicago Press
Chicago and London

The University of Chicago Press, Chicago 60637

The University of Chicago Press, Ltd., London

ISBN: 0-226-71234-6 (clothbound); 0-226-71235-4 (paperbound)
Library of Congress Catalog Card Number: 64-15817

Designed by Adrian Wilson

THIS BOOK IS AFFECTIONATELY DEDICATED

TO MY NIECE

Margaret deBeers

Acknowledgments

M Y INDEBTEDNESS to those who are working in the field of Mediterranean archaeology and particularly the study of the Etruscans is too great for individual acknowledgment. I should like to express special thanks to three in Florence—Luisa Banti, Giacomo Caputo, Guglielmo Maetzke.

Contents

Introduction: The Tyrsenoi in the West I

I. Etruria: The Land and Its Settlement 10

II. Prehistory: The Villanovans 28

III. The Beginning of History: The Orientalizing Period 43

IV. A Summary of Etruscan History from Tarquin the First to Augustus 63

V. The Art of the Archaic Period (ca. 600–470 B.C.) 88

VI. The Art of the Classical Period (ca. 470–300 B.C.) 125

VII. The Art of the Hellenistic Period (ca. 300–30 B.C.) 154

VIII. Architecture 179

IX. Language and Literature, Music and Games 214

X. Religion 231

Bibliography 251

Indexes

 Index of Subjects 265

 Index of Proper Names 270

 Index of Places 273

 Index of Ancient Authors and Sources 278

Notes on the Plates 279

Plates 287

Illustrations

P L A T E S following page 286

Villanovans

I. *Hut urn. Tarquinia.*

II. *Biconical ossuary and helmet. Tarquinia.*

III. *Bronze Villanovan helmet. Tarquinia.*

IV a. *Italo-Geometric jug. Tarquinia.*

b. *Impasto jug. Yale University Art Gallery.*

V a. *Bronze figure of a nude woman from Tarquinia. In Florence.*

b. *Bronze woman with pot from Vetulonia. In Florence.*

VI. *Warrior's head from Vetulonia. In Florence.*

VII. *Beast-headed man and woman from Vetulonia. In Florence.*

Orientalizing

VIII. *Siren from the Bernardini Tomb, Palestrina. In Rome.*

IX a. *Ivory sphinx. Baltimore, Walters Art Gallery.*

b. *Bronze sphinx from the Bernardini Tomb, Palestrina. In Rome.*

X. *Ivory pyxis from Cerveteri. Baltimore, Walters Art Gallery.*

XI. *Ivory figurine of a nude woman from Marsiliana. Florence, Museo Archeologico.*

XII. *Head from a canopic jar from Castelluccio la Foce, Chiusi. In Siena.*

XIII. *Figured ash urn from Chiusi. University Museum, Philadelphia, Pennsylvania.*

xi

ILLUSTRATIONS

XIVa. Bucchero oenochoë with lion's head. Brussels, Musée du Cinquantenaire.

b. Bucchero kyathos with Etruscan inscription from Vetulonia. Florence, Museo Archeologico.

XVa. Bronze warrior. Arezzo 11495.

b. Bronze woman in cloak. Florence 225.

c. Bronze girl. Arezzo 11501.

Archaic—The Stone Tradition

XVIa. Tomb chamber, door, and windows. Cerveteri.

b. Tomb of the Capitals, central chamber. Cerveteri.

XVII. Winged stone lion. New York, Metropolitan Museum of Art.

XVIIIa. Grave with columnar marker. Marzabotto.

b. Stone slab from an early chamber tomb at Tarquinia. Florence, Museo Archeologico.

XIX. Stone cippus. Chiusi.

Archaic—The Terracotta Tradition

XXa. Antefix from Cerveteri. Berlin, Staatliche Museen.

b. Frieze from Cerveteri. Copenhagen, Ny Carlsberg Glyptotek.

XXI. Shell antefix, satyr's head. Boston Museum of Fine Arts.

XXII. Head of a kouros from a votive statue. London, British Museum.

XXIII. Head of a girl from Cerveteri. Copenhagen, Ny Carlsberg Glyptotek.

Archaic—The Bronze Tradition

XXIVa. Hercules. Fiesole 484.

b. Minerva found near Florence. Berlin Antiquarium.

XXVa. Warrior or Mars from central Italy. Paris, Louvre 125.

b. Togatus fom Pizzirimonte near Prato. London, British Museum 509.

XXVIa. Nude boy playing the double pipes. Naples Museum.

b. Woman in pointed cap. Paris, Bibliothèque Nationale 211.

XXVIIa. Umbrian warrior. Princeton University Art Museum 41-27.

b. Umbrian woman. Paris, Bibliothèque Nationale 212.

Illustrations

Archaic—Decorative Arts

XXVIII. Bronze group of lion and bull from a tripod. New York, Metropolitan Museum of Art.

XXIX. Bronze mirror with incised picture. London, British Museum 545.

XXX. Situla. Providence, Rhode Island School of Design, Museum of Art.

XXXI. Helmet found at Olympia. London, British Museum 250.

XXXIIa. Bucchero rhyton. Boston Museum of Fine Arts.
b. Etruscan black-figure amphora. Yale University Art Gallery.

XXXIIIa. Gem. Death of Capaneus. London, British Museum.
b. Gem. Perseus and Medusa. London, British Museum.

Archaic Painting

XXXIV. Tomb of the Lionesses, end wall. Tarquinia.

XXXV. Tomb of the Lionesses, detail of side wall. Tarquinia.

Classical Art

XXXVI. Cassuccini Tomb, interior. Chiusi.

XXXVII. Pediment group from Pyrgi. Rome, Villa Giulia.

XXXVIII. Head of a terracotta youth from Veii. Rome, Villa Giulia.

XXXIXa. Bronze figure of a woman. London, British Museum 613.
b. Bronze figure of a youth wearing a toga. Catania, Castello Ursino.

XLa. Gold bulla, relief of Daedalus flying. Baltimore, Walters Art Gallery.
b. Gold earring with filigree decoration. Paris, Louvre.
c. Pair of gold earrings. New York, Metropolitan Museum of Art.

XLI. Bronze mirror, Orpheus. Boston Museum of Fine Arts.

XLII. Etruscan red-figure skyphos. Boston Museum of Fine Arts.

XLIII. Sarcophagus from Vulci, front. Boston Museum of Fine Arts.

XLIV. Sarcophagus from Vulci, top and ends. Boston Museum of Fine Arts.

Hellenistic Art

XLV. Ash urn from Chiusi. Worcester Art Museum.

XLVI. Terracotta head of a youth wearing a Phrygian cap from Arezzo. In Florence.

ILLUSTRATIONS

XLVIIa. *Hercules. Florence, Museo Archeologico 146.*

 b. *Priestess. Florence, Museo Archeologico 554.*

 c. *Genius. Baltimore, Walters Art Gallery.*

XLVIIIa. *Model of a temple pediment from Nemi. Rome, Villa Giulia.*

 b. *Lid of an ash urn in the shape of a gabled roof. In Arezzo.*

 c. *Stone base, model of a temenos. Chiusi, Museo Civico.*

FIGURES

1. Map of Etruria. 21

2. Map of Italy. 22

3. Plans and elevations of the Hellenistic Capitolia of Cosa and Florence. 185

4. Reconstruction of the three temples on the Arx of Cosa. 186

Ancient Authors and Abbreviations

"Acta Triumphorum Capitolina." *Corpus Inscriptionum Latinarum,* I

App. — Appianus, historian. *Fl.* A.D. 140.
 Bell Civ. *Bellum Civile*

Arn. — Arnobius Afer, Christian writer. *Fl.* A.D. 295.
 Adv. Nat. *Adversus Nationes*

Ascon. — Q. Asconius Pedianus, grammarian. *Ob.* A.D. 88.
 In Scaurianam Ciceronis

Ath. — Athenaeus, author of symposia. *Fl.* A.D. 200(?).

Aug. — Aurelius Augustinus, Christian writer. *Ob.* A.D. 430.
 Civ. Dei *De Civitate Dei*

M. Porcius Cato, orator and historian. *Ob.* 149 B.C.

Censor. — Censorinus, grammarian. *Fl.* A.D. 238.

Cic. — M. Tullius Cicero, orator and philosopher. *Ob.* 43 B.C.
 Caecin. *Pro Caecina*
 Cat. *In Catilinam*
 Div. *De Divinatione*
 Mur. *Pro Murena*
 Rab. Post. *Pro Rabirio Postumo*

Critias, elegist and tragedian. *Ob.* 403 B.C.

Dio C. — Dio Cassius, historian. *Fl.* A.D. 194.

Diod. S. — Diodorus Siculus, historian. *Fl.* 59 B.C.

Dion. H. — Dionysius of Halicarnassus, historian and critic. *Fl.* 7 B.C.

Eusebius, historian. *Fl.* A.D. 300.

Fest. — S. Pompeius Festus, grammarian. *Fl.* A.D. 150(?).

Hellanicus of Lesbos, historian. *Fl.* 450 B.C.

Hdt. — Herodotus, historian. *Fl.* 432 B.C.

AUTHORS AND ABBREVIATIONS

Hesiod, epic poet. Eighth century B.C.
 Works and Days
 Theogony

Homer, epic poet. Ninth century B.C.(?).
 Il. Iliad
 Od. Odyssey

Isid. Isidore of Seville, grammarian. *Ob.* A.D. 640.

Just. Justinus, historian. *Fl. ca.* A.D. 150.

Juv. D. Junius Juvenalis (Juvenal) poet. *Ob.* A.D. 130.

Liv. Titus Livius (Livy), historian. *Ob.* A.D. 17.

Macr. Aurelius Theodosius Macrobius, critic. *Fl.* A.D. 400.

Mart. Cap. Martianus Minneius Felix Capella, satirist. *Fl.* A.D. 425(?).

Nep. Cornelius Nepos, biographer. *Fl.* 44 B.C.

Non. Nonius Marcellus, grammarian. *Ob.* A.D. 280(?).

Ov. P. Ovidius Naso (Ovid), poet. *Ob.* A.D. 17.
 Fast. Fasti

Paus. Pausanias, geographer. *Fl.* A.D. 160.

Plin. C. Plinius Secundus (major) (Pliny), encyclopedist. *Ob.* A.D. 79.

Plut. Plutarch, philosopher. *Fl.* A.D. 110.
 Tib. Gracch. *Tiberius Gracchus*
 Mar. *Caius Marius*

Polyb. Polybius, historian. Exiled 167 B.C.

Prop. Sex. Aurelius Propertius, poet. *Ob.* 16 B.C.

Sall. C. Sallustius Crispus (Sallust), historian. *Ob.* 35 B.C.
 Cat. Catilina

Scholia on *Iliad*

Scriptores Historiae Augustae

Sen. L. Annaeus Seneca, philosopher and tragedian. *Ob.* A.D. 65.
 Q.N. Quaestiones Naturales

Serv. Servius Honoratus, grammarian. *Fl.* A.D. 390.
 Aen. Commentaries on Virgil's *Aeneid.*

Sil. C. Silius Italicus, poet. *Ob.* A.D. 101.

Sol. C. Julius Solinus, grammarian. *Fl.* A.D. 260.

Stat. P. Papinius Statius, poet. *Ob.* A.D. 96.
 Theb. Thebais

Strabo, geographer. *Fl.* 30 B.C. (quoted by Casaubon's pagination).

Suet. C. Suetonius Tranquillus, biographer. *Ob.* A.D. 160.
 Aug. *Octavius Augustus Caesar*
 Claud. *Claudius*

Authors and Abbreviations

Tac. C. Cornelius Tacitus, historian. *Ob.* A.D. 119.
 Hist. *Historiae*

Tert. Q. Septimius Florens Tertullianus, Christian writer. *Ob.* A.D. 220.
 Apol. *Apologeticus*

Thuc. Thucydides, historian. Exiled 423 B.C.

Tim. Timaeus, grammarian. Date unknown.

Val. Max. Valerius Maximus, historian. *Fl.* A.D. 26.

Varr. M. Terentius Varro, writer on husbandry and antiquities. *Ob.* 27 B.C.
 L.L. *De Lingua Latina*
 R.R. *De Re Rustica*

Vell. P. Velleius Paterculus, historian. *Fl.* A.D. 30.

Verg. P. Vergilius Maro (Virgil), poet. *Ob.* 19 B.C.
 Aen. *Aeneid*

Vitr. Vitruvius Pollio, writer on architecture. *Fl.* 10 B.C.

Introduction:
The Tyrsenoi in the West

CIRCE then, daughter of Helios, Hyperion's son, bore in love to steadfast Odysseus, Agrios and Latinos, noble and strong; and these far away in the bays of the Isles of the Blest ruled over all the famous Tyrsenoi" (Hesiod *Theogony* 1011–16).

This, by one of the most ancient Greek poets, is the earliest literary reference to the Tyrsenoi, called Tyrrhenoi by later Greek authors, Tusci or Etrusci by the Romans, and by us Etruscans. In the *Theogony* the *nomen Latinum* is already associated with them and a tradition of visits by Greek voyagers in the person of the greatest of them all, Odysseus. They lived in a land of perpetual plenty, far to the west of the world Hesiod knew, "by the shores of deep-eddying Ocean, where the grain-giving plow-land brings forth honey-sweet fruit three times a year" (Hesiod *Works and Days* 170–73).

It is hard to say how precisely the Greeks ever identified the Isles of the Blest with Italy, but at least we know that Sicily and southern Italy seemed like the Promised Land to the Chalcidian and Corinthian colonists who settled the shores of Magna Graecia in the second half of the eighth century B.C. Very likely it was through these cities—most probably from the earliest and northernmost of the Greek colonies, Cumae, north of Naples on the coast of Campania, founded, according to ar-

chaeological evidence, about 750 B.C.—that the mainland Greeks first learned the name Latinos and heard of the Tyrsenoi in the west.

Who were these Tyrsenoi? We have three extended references by fifth-century historians to people of this name. Herodotus (1.94) says that the Tyrsenoi were Lydians who, in the reign of Atys, son of Manes (that is to say, shortly after the Trojan War or, in archaeological time, at the end of the Bronze Age), were afflicted by a disastrous and extended famine. For some time they endured it patiently, and when it showed no sign of abating, they distracted their minds from their hunger by inventing various games—dice, knucklebones, handball, and others. Their plan was to alternate days of eating with days of gaming, when they would play with such concentration as to still their craving for food. "In this way," says Herodotus, "they passed eighteen years." But the famine continued, so at last the king was forced to divide the nation in half and draw lots, one half to stay, the other to leave the country. He would continue to rule over those who stayed; those who must depart would be under the leadership of his son Tyrsenos. These, then, went down to Smyrna, built themselves ships, and sailed away to find new livelihoods and a new country. Having voyaged past many peoples, they came to the land of the Umbrians, where they built cities and lived thereafter. And instead of Lydians they called themselves Tyrsenoi after the name of their leader.

Herodotus speaks of the Tyrsenoi, though only in passing, in one other passage (1.57). He is discussing the elusive Pelasgians and their language, or languages, and he says, "If we may judge from the language they speak nowadays—that is, the Pelasgians who inhabit the city of Creston above the Tyrsenoi and who came originally from Thessaliotis and those who founded Placia and Scylacé on the Hellespont and who came from Attica—the Pelasgians of the past spoke a barbarous tongue."

The whereabouts of the city of Creston "above the Tyrsenoi" is a well-known puzzle. The reasonable assumption is that it was the city of the Crestonians who, according to Thucydides (4.109), lived on Acte, the promontory of Chalcidice that ends in Mount Athos, since Thucydides also locates on Acte, among other peoples, Pelasgians "of those

Introduction

Tyrsenoi who once lived in Attica and on Lemnos." But Dionysius of Halicarnassus, an antiquarian of the time of Augustus, took Herodotus' "Kreston" (the word given in all our manuscripts of Herodotus) for a city in Italy named "Kroton." This city was, according to Hellanicus of Lesbos, an older contemporary of Herodotus (Dion. H. 1.28), the first in Italy captured by the Pelasgians who changed their name to Tyrsenoi after they had settled in Italy. Hellanicus' "Kroton" is the "Cortona" of central Italy (Dion. H. 1.26), a city which, according to Latin tradition, was Umbrian before it became Etruscan.

Herodotus is the only fifth-century author who insists on a distinction between Tyrsenoi and Pelasgians; he knows of barbarous-tongued Pelasgians who once lived in Thessaly and others who had once lived in Attica and later on Lemnos (6.137), but his Tyrsenoi are Lydians and nothing else. Thucydides' term "Tyrsenoi" seems to be general, as though he did not think of them as a single nation or tribe, the Pelasgians of Acte and Lemnos being one branch of them. Hellanicus held that the Tyrsenoi were merely Pelasgians who had changed their name to Tyrsenoi after they had moved to Italy.

Thucydides says nothing specific about a westward movement of Tyrsenoi or Pelasgians, though he knows and speaks of the Tyrsenoi of Italy in connection with the disastrous Sicilian expedition of the Athenians in 413 B.C. (7.53–54, 57). Both Hellanicus and Herodotus, however, were aware of a tradition that central Italy was conquered, or settled, by some people from the east who took the name of Tyrsenoi after they reached Italy. This is the classical Greek tradition reduced to its essentials.

The later, apparently Italian, tradition is more complicated. Pliny the Elder puts it most neatly (3.5.50): the Umbrians were expelled from Etruria in ancient times by the Pelasgians and these, in turn, by the Lydians who took the name of Tyrrheni from their king. The earlier Greek tradition of a single invasion from the east has now to contend with a tradition of two invasions. This version is recorded somewhat differently by Dionysius of Halicarnassus (1.20): the Pelasgians, having first attacked the Aborigines of central Italy, finally settled among them and with their help founded a number of new cities,

among them Caere, Pisa, Saturnia, and Alsium; all of which, in later times, were taken by the Tyrrhenoi.

The Pelasgians of this Italian tradition, incidentally, would seem to have spoken Greek. This is implicit in Strabo's story of the founding of Caere (5.C220): it was settled by Pelasgians (see Dion. H. 1.20) who called it Agylla; the name was later changed to Caere by the Lydians, when they captured the city, because they had mistaken the Pelasgians' salutation "χαῖρε" ("welcome") for the name of their city itself. This is doubtless simply a good story, invented late, perhaps based on the fact that there was still a Greek-speaking community at Caere as late as the third century B.C. But the earlier name, Agylla, does seem to be Greek and is the only name for the city in Herodotus (1.167), which suggests that its Greek colony still called it Agylla in the second half of the fifth century B.C.

In Italy, in fact, the traditions of Pelasgians and Greeks are interwoven: Caere was founded by Pelasgians from Thessaly or by Thessalians and Pelasgians (Strabo 5.C220; Plin. 3.5.51); Pisa was reputed a Greek city (Plin. 3.5.50; Serv. Aen. 10.179); Falerii was said to have been founded by the Argive Halesus, son of Neptune (Ov. *Fast.* 4.73–74; Plin. 3.5.51; Sol. 2.7; Dion. H. 1.21), who was also the ancestor of the kings of Veii (Serv. *Aen.* 8.285); even Tarquinii, that most Etruscan of cities, was said to have been founded by Thessalians (Just. 20.1). Whether this tradition of Greek settlers in central Italy echoes a real situation there at the beginning of the Iron Age we cannot determine, but it is true that even the earliest Villanovan cemeteries in Etruria contain some Greek material or material influenced by the late Bronze Age civilization of Greece.

Although Dionysius of Halicarnassus recorded at least three traditions of the coming of the Tyrsenoi—that of Hellanicus (1.28), that of Herodotus (1.27), and that which corresponds with Pliny's tradition of two invasions (1.20)—he did not himself subscribe to any one of them. He accepted Herodotus' statement that Pelasgians and Tyrrhenians were different peoples (1.30) but did not believe that the Tyrrhenians were Lydians; "Because," he argued, "they have in common with those neither language nor laws, nor do they worship the same

gods. Therefore, those who say that the Tyrrhenians are not a people who came from elsewhere, but indigenous, seem to be nearest the truth, for they are a very ancient people and unlike any other in language or customs." These are shrewd observations and must be taken seriously.

Ancient writers have thus given us three possible stories about the settlement of central Italy: (1) a single invasion by the Tyrsenoi at the end of the Bronze Age (Hdt. 1.94; Hellanicus *ap.* Dion. H. 1.28); (2) two invasions of unspecified date, the first of Pelasgians perhaps helped by Greeks, the second of Tyrrhenians (Dion. H. 1.20; Strabo 5.C220; Plin. 3.5.50); (3) no invasion at all, at least so far as the Tyrrhenians are concerned (Dion. H. 1.30). The attempt to make one or another of these traditions square with the available archaeological evidence is constantly and maddeningly frustrated. Too many pieces of evidence are missing; too many can be used to bolster the arguments of more than one opinion. I myself, having been brought up as a Herodotean and then having tried conscientiously for several years to convert to a belief in Dionysius and the autochthonists, now find that I prefer Pliny's tradition of two migrations of foreigners from the east to central Italy, with an understratum of original inhabitants.

Prehistorians have recently determined that the first settlers of the Iron Age, the so-called Villanovans, a cremating people with many cultural connections with northern Europe, actually came to Italy by sea from the eastern Mediterranean some time between 1000 and 900 B.C. Before their arrival, Etruria was already settled, though not densely, by Bronze Age tribes related to, or identical with, the pastoral Apenninic peoples of the mountainous spine of Italy, who were probably the first Indo-European-speaking peoples in the peninsula.

Suppose that these Bronze Age tribesmen are equated with Pliny's Umbrians, among whom his Pelasgians settled, and these Pelasgians— the term seems to mean "Peoples of the Sea"—with the so-called Villanovan cremating people, whose arrival by sea is attested by the fact that their earliest settlements in Italy are all on or near the coast. Then his Lydian-Tyrrhenians would correspond to a second migration of peoples from the east to Etruria. The archaeological evidence for a second migration is controversial, and many scholars refuse to admit any

change in the inhabitants of Etruria after the beginning of the Iron Age; to these archaeologists, the Etruscans of historic times were merely the Villanovans civilized. Other archaeologists, of whom I am one, believe that the sudden, profound change in the culture of Etruria at the beginning of the Orientalizing period, in the first decades of the seventh century, can best be explained by a new migration of peoples from the east.

Herodotus gives the only date for any of these movements, "in the reign of Atys the son of Manes," and this date, shortly after the end of the Trojan War, in the period of great disruption before and during the Dorian invasion of Greece, precedes by some two hundred and fifty years the first appearance of Villanovan settlements on the coast of Etruria. One must suppose that the Villanovans moved westward by easy stages as Herodotus' word, which I have translated too simply as "having voyaged past," implies. Perhaps it was during this voyage, while they were settled briefly among the Greeks, even at Athens (Hdt. 1.57; 6.137; Thuc. 4.109), that the Villanovans got the name of "Peoples of the Sea" from their Greek neighbors. To the Greeks, they were barbarians; to the Italians, they were Greeks, to judge by the story of Caere. Perhaps some Greeks actually sailed to Italy with the Villanovans, driven west from their homeland by the invading Dorians, as we know others were driven east to the shores of Asia Minor.

We are still in some difficulty. Pliny's neat sequence of events can, it is true, be squared up with archaeological evidence to a certain extent: the Bronze Age Apenninic people may correspond to the Umbrians and the Villanovans to his Pelasgians; the Orientalizing migration could have been the movement of his Lydian-Etruscans. But the people who lived in Etruria in historic times, the "Etrusci" of Roman writers, were called Tyrsenoi by Herodotus and Thucydides, and that name, if we can trust Hesiod, was in the West considerably before the beginning of the seventh century and the Orientalizing migration. The Villanovans, then, should be Herodotus' Tyrsenoi as well as Pliny's Pelasgians, in spite of the distinction that Herodotus draws between the two peoples. Thucydides, we must remember, did know of Pelasgians who were also Tyrsenoi, and Dionysius of Halicarnassus comments on the

interchangeability of the two names (1.25). In that case, Pliny's Lydians would have taken the name Tyrsenoi because they found it in Italy already, and this may account for the persistent detail in all the traditions that the invaders changed their name to Tyrsenoi or Tyr-rhenoi *after* they reached Italy as, again, Dionysius suggests (1.25), "All the western part of Italy was called by that name (Tyrrhenia), the several peoples who lived there having lost their own names." This would settle everything neatly, or almost everything.

The word "Tyrsenoi" is a Greek form of a non-Greek word, apparently related to such words as *"turannos,"* the Lydian word for prince, "Tursa," a place-name in Lydia, and "Turan," the Etruscan name for the Greek Aphrodite and the Roman Venus. The language spoken and written in Etruria in historic times was, according to Dionysius of Hali-carnassus, unlike that of any other people. Though it is still imperfectly deciphered, modern scholars have recognized that the Etruscan lan-guage is non-Indo-European and connected with other eastern Medi-terranean languages of a non-Indo-European, pre-Hellenic character. Conceivably, this language could have been the original tongue of the primitive peoples of Italy, one of a family of pre-Indo-European Medi-terranean languages. It could also have been introduced to Etruria by the Villanovans, when they came from the eastern Mediterranean some time after 1000 B.C. (Would this be the "barbarous tongue" that the Pelasgians spoke, according to Herodotus?)

Indo-European languages appeared in Asia Minor (with the Hit-tites) and in Greece during the Bronze Age, and probably a first wave of Indo-European languages came to Italy then, too, with the Bronze Age Apenninic tribes. But there is evidence that some of the Iron Age cremating peoples of the urnfield culture (in which culture the Villano-vans are included) spoke Indo-European tongues; Celtic, for example, seems to have been introduced into Spain by an urnfield people, as was Venetic to northeastern Italy. In view, however, of the enormous num-ber of urnfields in the late Bronze and early Iron Ages, and the wide range of countries they cover, it cannot be that their peoples were all of one race or that they all spoke one language or even a single family of languages.

THE ETRUSCANS

If we cannot be sure what people first spoke Etruscan in Italy, we do know that it was first written there about the middle of the seventh century B.C.; the earliest Etruscan inscriptions are found in the princely tombs of the late Orientalizing period. Like the earliest Phrygian inscriptions from Gordium, which predate the Etruscan by three generations and are scarcely a decade younger than the earliest Greek, they are written in an archaic alphabet which makes use of the Phoenician consonants plus the five vowels of Greek and later European alphabets. Whether, like the Greek and Phrygian alphabets, the Etruscan was also developed in the Near East some time in the eighth century, or whether the Etruscans learned it from the Greeks of southern Italy during the seventh, is still a point of argument.

A grave stele with the profile of a warrior carved on one side and two long inscriptions in a language and alphabet apparently related to Etruscan was found in 1885 on the remote Thracian island of Lemnos, where, according to Thucydides, the Tyrsenoi once lived (Thuc. 4.109). In style and type the stele is not unlike one from Etruria of the late seventh century, and it suggests that the Etruscans of Italy still had relations on Lemnos as late as the end of that century, or even later. Other fragmentary inscriptions on potsherds, apparently in the same language, have since been found in a sixth-century house at Hephaestia on Lemnos. (The island also produced a late Iron Age urnfield of the eighth and seventh centuries, whose culture is not at all Villanovan and which is apparently not connected with any of the inscriptions, a singularly unhelpful fact.) If the Lemnos inscriptions are really related to the Etruscan language of Italy in historic times, we might suggest that both the Tyrsenoi of Italy and their kinsmen of Lemnos were fugitives from some none-too-advanced region of Asia Minor, whose economy and existence were disrupted toward the end of the eighth century by, or perhaps rather in consequence of, the exploits and empire-building of that aggressive Assyrian, Sargon II, or by the contemporary invasion of Cimmerians from the northeast, who destroyed so many cities, among them Phrygian Gordium.

On this view, the Etruscan language was brought to Italy by the last migration, that of the Orientalizing period, in the early seventh century

B.C. But the name "Tyrsenoi" was already established in Italy in the eighth, since it was known to Hesiod; and it should belong to the earlier migration, that of the Villanovans in the early Iron Age. Could the Villanovans and the later emigrants have brought the same language from the east, though one had a cremating culture and the other inhuming? It is not impossible; the Achaean Greeks of the Bronze Age spoke Greek and buried their dead; the Dorian Greeks of the early Iron Age spoke Greek and cremated theirs.

In any case, whichever tradition of the origin of the Etruscans and whichever explanation of their language the reader may prefer, he must remember that the linguistic and archaeological evidence is conflicting and inconclusive. Some day we may know more. It is, however, the history of the Tyrsenoi in Etruria and the development of their civilization there during historic times that concern us in this volume. The Etruscans of Italy are of much greater importance to history and to the history of art than are these speculations on the enigma of their ultimate origin. And it is to Italy and the land of Etruria to which we must now turn.

Etruria:
The Land and Its Settlement

ETRURIA, that part of Italy to which the Tyr-
senoi came, lies between the Arno and the Tiber on the western, or
southwestern, watershed of the Apennines, facing the Tyrrhenian Sea.
In the Augustan reorganization of Italy into administrative provinces,
the northern boundary of Etruria, the seventh region, was pushed
northward to include the territory of Luna on the coast south of La
Spezia, near modern Carrara, which is also the northern coastal limit
of modern Tuscany, whose southern boundary lies between the rivers
Fiora and Albegna, near modern Orbetello. Almost all of southern
Etruria, which includes the three crater lakes—Bolsena, Vico, and
Bracciano—now belongs to Lazio (Latium), while Perugia, Lake
Trasimene, and Orvieto on the east have been given to Umbria. The
traveler who wishes to visit ancient Etruria today should, therefore,
provide himself with the C.I.T. guidebooks to Lazio and Umbria as
well as to Toscana.

He should carry in the other hand George Dennis' *Cities and Ceme-
teries of Etruria.* First published in 1848 and revised and enlarged in
the third edition of 1878, this delightful book was written by a young
Englishman while he was British consul at Civitavecchia, and is "the
fruit of several tours made in Etruria between the years 1842 and

1847." It was intended as a traveler's handbook and includes information on routes, inns, trustworthy guides, and hospitable country folk; but its body is an invaluable record of antiquities, many of which have since disappeared, while others have been far more battered by time than his book has been. This is the most vivid and charming, as well as the most accurate, general description of the various ancient sites of Etruria ever written. Dennis saw them as we no longer can, usually alone or with a Tuscan guide, on horseback or on foot, and the feeling he gives of the wild and picturesque desolation of central Italy some one hundred and twenty-five years ago is immensely affecting.

An illuminating companion to Dennis, for the student of ecology and economic history, is part of von Vacano's *Die Etrusker: Werden und geistige Welt* (Stuttgart, 1955), for he describes brilliantly, in the course of this unwieldy volume, the present appearance of a number of Etruscan sites. In particular, his picture of the site of Vulci torn open by the deep plowshares of the agrarian reform of the last decade makes a fascinating contrast wtih Dennis' description, "The wide, wide moor, a drear, melancholy waste, stretches around you, no human being seen on its expanse. . . ." And one may fill in the recent history of this region with D. H. Lawrence's *Etruscan Places* (London, 1932), which gives charming sketches of the modern towns of Tarquinia (Corneto), Cerveteri, and Volterra, and again the site of Vulci. But the reader will believe anything Lawrence says about ancient Etruria and the Etruscans only at his own risk.

No part of Italy is without its beauty, but perhaps ancient Etruria has a greater variety of landscape than any other region. The reason for this is geological—though Etruria is geographically coherent, circled as it is on the north, east, and south by the courses of the Arno and the Tiber, the most considerable rivers of central Italy—geologically it is made up of three very different regions.

To the north and west, more or less parallel to the coast, runs a chain of ancient mountains, the so-called Catena Metallifera (the ore-bearing chain); these begin with the rugged Apuan Alps above Pisa and stretch to the low hills of Capalbio, overlooking the valley of the Fiora.

THE ETRUSCANS

Eastward, this chain broadens at one point to take in the highlands around Volterra and Siena; to the west, it includes the Tuscan Archipelago with the islands of Elba and Montecristo. Within this region are found the metals that made Etruria wealthy: copper in many places, particularly in the region of the Val di Cecina south of Volterra and around Massa Marittima; iron on Elba and at Gavorrano north of Vetulonia; iron and lead at Campiglia Marittima northeast of Populonia; iron and tin—the only tin found in Italy—at Mount Valerio near Campiglia Marittima. Many of these lodes are so rich that they are still productive, though they were worked extensively in antiquity and during the Middle Ages.

This is true mountain country, though the mountains are not particularly high, and along the coast the dense, gray Triassic limestone of Mount Argentario and Cosa and the compact schists and sandstones of the hills of Talamone, Vetulonia, and Piombino thrust into the sea as rocky promontories whose steep, rugged headlands remind one of the coast of Greece.

South of this region, from the Fiora to the Tiber, reaching eastward to the valley of the Paglia and northward to Acquapendente on the Cassian Way, stretches the great tufa plateau of southern Etruria. The rock of this plateau, very variable in quality and color but usually soft and easily worked—often it can be carved with a penknife—is the compacted volcanic ash spewed from the vents of three great craters which are now lakes surrounded by steep mountains—Lake Bolsena, Lake Vico, and Lake Bracciano. In addition to these three, there are hundreds of smaller, shallow craters in this region; the Cassian Way crosses a great tract of these near Lake Vico, lying like so many giant piepans scattered over the high brown plain.

The undulating highland of this volcanic plateau is cut into a network of gorges by the creeks that are all this region can support; only two of these can really be counted as rivers—the Fiora, which marks the northwest boundary of the tufa country from Sovana to Vulci; and the Marta, which flows out of Lake Bolsena. The smaller streams worm their way through narrow gorges choked with vegetation; the reddish-brown tufa weathers on either side to perpendicular cliffs, often

many meters high, hung with loops of vine, and crumbled here and there by an occasional bush, which can be of considerable help to one who tries to climb one of these cliffs. In the spring, there are blue flags in the stream beds; in August, you can gorge yourself on blackberries; in December, wild cyclamen blossoms in rosy patches under the higher scrub at the edge of the plateaus.

This tufa country of southern Etruria is interrupted on the east by the isolated spine of Mount Soracte, 40 kilometers (25 miles) north of Rome, the one outcrop of the Apennines west of the Tiber in this southern region. Look north from Rome on a winter day when the Tramontana is blowing from the northwest, and you will see the five peaks of Soracte in strange, sharp focus, glittering with snow. Beyond Soracte, the broad valley of the Tiber narrows to a winding gorge as it cuts through the hard limestone.

On the coast, the low mountains of La Tolfa, a little north and east of Civitavecchia, also interrupt the tufa plateau. These are an eroded mass of trachyte, remains of earlier volcanic activity in central Italy, and here, too, copper was mined in antiquity.

North of the tufa country, the land rises, and plateau and gorge are exchanged for mountain and valley. The ancient volcanic cones of Mount Amiata and Radicofani mark the gateway to the most beautiful and fertile regions of Etruria, the great valleys of the northeast—the Val di Chiana and Lake Trasimene, the upper Tiber Valley, and the Val d'Arno—cut off from one another by rugged limestone or sandstone ridges that are fingers stretching south from the great chain of the Apennines. Here there is no lack of water, even in summer; winters are colder; trees are taller; cattle are handsomer; and the wine is lighter and more delicious, though indeed the wine of Orvieto, at the northeastern margin of the tufa country, can hold its own against any from Chianti and so can that of Pitigliano, though it is not so well known. None of them travels, of course, which is another excellent reason for studying Etruria at first hand.

In geologically recent times the coast of Etruria has been rising. The tufa plateau, formed during the Pliocene, is bordered by low hills of later marine sediments, and the present coastline shows a chain of

beaches backed by low dunes, frequently enclosing long lagoons or marshes. From the mouth of the Tiber to just south of Civitavecchia there is a long, curving beach, behind which grow stands of sea pines and on which blossoms a long parade of beach umbrellas in July and August; northward, from just beyond Civitavecchia, another beach sweeps to the promontory of Ansedonia (the Roman colony of Cosa). The rugged coastal hills of the Catena Metallifera, from Mount Argentario north to La Spezia, that plunge so picturesquely into the sea, are now linked by chains of barrier beaches and tombolos (sand bars that the wind sweeps across the mouth of a bay, joining headland to headland), and the lands behind these barriers are low-lying plains, formed by the sediment washed down by the rivers that drain into the Tyrrhenian Sea.

The wide plain surrounding the modern city of Grosseto is the fill of two rivers, the Ombrone and the Bruna; it was a broad, shallow bay opening south to the sea when the cities of Vetulonia and Rusellae were founded, the former in the hills on its western shore, the other on the east. By Cicero's time the mouth of the bay had been closed by a sand bar, forming a lagoon, like the lagoons of Orbetello, once the port of Vulci, now—and even in Roman times—shut off from the sea by the two pine-covered tombolos that swing from the shore to Mount Argentario. North of Leghorn, Pisa was a seaport at the mouth of the Arno, though now it lies 10 kilometers (6.5 miles) from the coast. Strabo, the Greek geographer of the Augustan age, reports that even in his day Pisa's importance as a port was waning.

The promontories of this coast and the hills behind it are covered with the famous (or infamous) *macchia,* a dense growth of evergreen scrub, "leathery, prickly and aromatic . . . able to endure the sun's oppression and the ravages of goats . . ." to quote John L. Myres (*Geographical History in Greek Lands* [Oxford, 1953]). Scrub pine, laurel (bay), thorn, and scraggly evergreen oak grow in the *macchia,* as well as the taller cork oak, whose trunk is periodically stripped of its thick bark and painted red with creosote and whose bark was used to seal bronze vessels in the early Etruscan tombs of Vetulonia. Where the brush is densest, there are paths and clearings made by charcoal-

burners, and the circles of burnt earth where they reduce the small wood to charcoal are still a common sight. The *macchia* flourishes on thin, stony or sandy soil, and evidently it intends to take over the Mediterranean, for wherever the forest has been cut down, or the land is not conscientiously cultivated in grain or olives, the *macchia* spreads. Around Rusellae, it is a cheval-de-frise of fiendish thorns, just as Dennis found it in 1844; on the promontory of Cosa, it flowers in great clumps of rosemary, whose tiny pale-blue blossoms color the hill in late summer. Fish stuffed with rosemary, roast pork flavored with rosemary, pork livers cooked with bay leaves—these must have been the feast-day dishes of the Lucumones of Vulci and Tarquinia, as they are today in the Maremma. Fifteen years ago, you could eat your pasta garnished with tortoise eggs, and fresh sardines could be bought in Orbetello, instead of their having been whisked by refrigerator car to Florence. Today the diet has lost all such local character; on the other hand, Orbetello has good drinking water now, for the first time in two thousand years, thanks to some sort of progress.

That the life of the sea was at least as charming to the Etruscans of Tarquinii as it is to us, we know from the wall paintings of the Tomb of Hunting and Fishing, a chamber tomb of the last quarter of the sixth century B.C. It has two rooms; the walls of the outer one are covered with dancers in a grove hung with garlands, and a procession of hunters returning with a very mixed bag fills the gable above the door. The inner room shows the sea along the coast of the Maremma, with a few steep, rocky islets. Two boatloads of boys are out fishing, one with a trident, one with a line; the boat is steered by a great paddle maneuvered by the boy in the stern; its bows are painted with huge eyes to ward off ill luck, as they still are occasionally in Greece. A third boat stands off from one of the islands to watch a boy diving from its top, while another boy scrambles up behind him. On another island, a man with a sling is taking aim at a flock of improbably colored birds, perhaps pigeons, but their breed is uncertain, though several unmistakable ducks are bouncing on the crinkled surface of the water, through which a school of dolphins plays. This is the "life of the sea" as the Etruscans loved it, but there was another "life of the sea" on the

coast of Etruria as well, and we know of this not only from literary references but from the position of the earliest cities along the Tuscan shore.

Unlike the Greek colonies in Sicily and southern Italy, the cities along the Etruscan coast—with the exception of Populonia, on its beautiful rocky promontory overlooking the little bay of Porto Baratti —were never actually on the water. Instead, the city is always drawn back from the shore, on a rise of land, naturally rather well protected, that overlooks the coastal plain, upstream along some watercourse that empties into the Tyrrhenian Sea. Cerveteri (the Etruscan Caere) and Tarquinia are so situated, only a few kilometers from the shore; Vulci lies farther inland, up the Fiora, but the view from the tableland on which the ancient city stood stretches northwest to Mount Argentario and the promontory of Cosa. Marsiliana, an early Etruscan site whose ancient name we do not know, commands a view westward down the broad, shallow valley of the Albegna to the coast between Talamone, the ancient Telamon, and Mount Argentario. Vetulonia and Roselle (Rusellae) were built high on the hills that circled their bay (the present plain of Grosseto); Volterra, (Volaterrae), though its main highway ran down the valley of the Cecina to the coast, is far inland, almost out of sight of the sea on the forbidding, treacherous heights north of the mining district of the Catena Metallifera. These are the oldest cities in Etruria, Villanovan before they were Etruscan; indeed, Tarquinia and Cerveteri have good claim to be the earliest Villanovan settlements in Etruria.

The first settlements were by the sea but not on it, dependent on the sea but not too near it. The sites recall those of many of the great Mycenaean cities of Greece—Athens, Corinth, Argos, Mycenae—within sight of the water, but on a defensible height at some distance from it. Seafarers are wary of the sea when they anticipate pirates, and piracy, in remote antiquity, was a recognized way of making a living and carried no social stigma. The question, "Are you a merchant or a pirate?" seems not to have offended Odysseus or to have been meant at all unkindly; in fact, Odysseus repeatedly prides himself on the success of his pirate raids. But piracy, though recognized, was scarcely

endearing; and sites were to be preferred which, like Cerveteri and Tarquinia, were near enough to the coast to see an unknown ship beaching and yet far enough away that the citizens could get ready to defend themselves, if necessary, before the strangers approached.

By the time Greece sent colonies west to Magna Graecia and Sicily, in the second half of the eighth century, most coastal cities were too big to be in fear of a pirate raid, and piracy had dwindled, so most of these new Greek cities took advantage of the splendid harbors of Sicily and southern Italy—Syracuse, Messina, Taranto, etc. But the coastal towns of Etruria had been settled long before (see Introduction) by the Villanovans, who came by sea from the eastern Mediterranean and who prudently made their settlements inland, out of reach of a sudden raid. But it must have been each other they especially feared, since the earlier Bronze Age inhabitants of Etruria had apparently all been landsmen, related to the Apenninic tribes of the mountains of Italy. Certainly the Etruscans of the Classical period still had the reputation of being pirates; Strabo (5. C220) says the people of Caere were the only Etruscans who were *not* pirates; and Dionysius, tyrant of Syracuse, gave the excuse that he was going to suppress Etruscan piracy when, in 384 B.C., he set out to sack the great and famous temple at Pyrgi in the territory of Caere (Diod. S. 15.14).

Whether fear of pirates was the dominant reason for it or not, the settlement of Etruria in the Iron Age proceeded from the coast to the interior. Though Etruria's sea power was always stressed in antiquity—particularly by the Greeks, but perhaps this was because they were seafarers themselves and found the marauding Etruscans irksome—Etruria was never like Greece, which had to look to the sea and the foreign sale of her manufactured goods for existence. Etruria, like Rome, could live on the land and generally preferred to do so. "Corn from Etruria" is mentioned again and again by Livy. Even the coastal cities were basically agricultural; when Strabo speaks of the decline of Pisa as a port (5. C223), he adds that the city is yet not without repute by reason of its stone quarries (in the hills of the Catena Metallifera between Pisa and Lucca), its timber for shipbuilding, and the fertility of its fields. And in Livy's account of the supplies furnished

THE ETRUSCANS

by certain Etruscan cities to outfit Scipio's African fleet in 205 B.C. (28.45), Caere contributed grain and provisions of all kinds for the crews; Tarquinii provided cloth for the sails (it is not known if Tarquinii grew flax or if this is evidence of cloth manufacture there); Rusellae and Volaterrae, the great cities of the northwest, grain and timber for the ships. The timber has long since gone from the hills of Rusellae and Volaterrae, though just north of Pisa, on the road to Viareggio, the magnificent pine woods called the Macchia di Migliarino, a royal hunting preserve till World War II, shows what the coastal woodlands of ancient Etruria must have been like. But in July the grainfields of Etruria still lie in great rectangles of gold spangled with scarlet poppies over Tuscany and northern Latium.

As Rome gradually became mistress of Italy, she linked the new extensions of her empire to the capital by paved highways whose ancient lines can still be followed on the map of Italy and frequently are followed by modern roads. Four of these highways crossed Etruria. The Claudian Way, built perhaps before 300 B.C., which skirts Lake Bracciano and the Sabatinian Mountains on the west and reaches the Ciminian Mountains above Lake Vico; the Flaminian way, between Rome and Rimini, built in 220 B.C.; the Cassian Way, which leads through Siena to Florence, perhaps dating from the end of the third century; and the Aurelian Way along the coast, built, or finished, at the time of the Ligurian Wars and the foundation of the Roman colony of Luna in 177 B.C.

Nowadays, as in all the centuries since the founding of Luna, one takes the Aurelian Way northward along the coast to reach the most ancient Etruscan cities, the first Cerveteri (Caere), then Tarquinia, Vulci, Marsiliana, Roselle (Rusellae), Vetulonia, Populonia, and finally Pisa, the city on the borderland between the Etruscan and Ligurian territory (Serv. *Aen.* 10.179), whose founders were traditionally Greeks, though Cato's researches left this in doubt. None of these cities is actually on the line of the Aurelian Way, but it crosses the territory of each, and from it each is easily reached.

The Cassian Way, branching off from the Claudian Way near the site of Veii, the southernmost city of Etruria and Rome's greatest rival

in the early days, runs north through the middle of Etruria, over the tufa plateau of the south, skirting Lake Bracciano on the east, Vico on the west, and Bolsena on the east again, till it comes to the northern edge of the tufa at Acquapendente, and from there runs north over the ancient volcanic plug of Radicofani, over the easternmost hills of the Catena Metallifera, north to Siena, and at length to Florence. Few Etruscan cities of any importance are on the Cassian—Sutri, Vetralla, Viterbo, and Montefiascone seem to have been minor Etruscan towns —but Bolsena, near the site of ancient Volsinii, if the French excavators are right, is on the shore of its lake only a little way from the main road.

One turns to the right a little beyond Bolsena to reach the great flat mesa of Orvieto, overhanging the valley of the Paglia, and from Orvieto one takes a difficult mountain road, on which one always seems to meet an ambulant cattle fair—herds of goats being driven to market, sheep, and great white oxen, their heads hung with scarlet tassels against the flies. This road takes one past the secretive hills of Chiusi (Clusium) and on to the splendid mountain-bordered plain stretching north from Lake Trasimene. On the eastern hills halfway along the plain is Cortona, at the north is Arezzo (Arretium). If you drive this road from Rome, you can stop at Orvieto for lunch and dine at Arezzo, both of which meals will be splendid, but you will be traveling fast and will have to miss Chiusi and Cortona. From Arezzo the road leads up the Val d'Arno to Florence. These long, beautiful valleys that link Chiusi with Florence were the "most fertile and richest in livestock and every kind of produce" in Etruria in 217 B.C., when Hannibal marched south into the country and plundered the lands between Faesulae (Fiesole), the Etruscan outpost in the hills above Florence, and Arretium, and laid waste the fields between Arretium and Trasimene (Liv. 22.3).

If you keep to the Cassian Way through Siena—an Etruscan city, but late and unimportant—to Poggibonsi, a road off to the left will take you to Volterra. It crosses great reaches of high, stony land, and from one of these I had my first view of the most isolated and forbidding of the Etruscan cities, high on its pale, steep, spiny hill,

crouched under the dazzling lightning flashes of an October cloudburst. There is always something unreal about Volterra's weather; it is windy and somber for the most part, but given to strange brilliant spells of sunshine and wild clouds and sudden unexpected storms. It is one of the few cities in Etruria where snow is not unfamiliar. And, as Macaulay knew, it is always, somehow, vastly impressive.

There are two roads leading down from Volterra to the coast, both of which must have been used in antiquity; one follows the valley of the Cecina westward; the other goes south, crossing the Cecina at Le Saline, passing through the town of Pomarance, down to Massa Marittima and from there to Follonica on the coast. This was the road Dennis took in the 1840's, and it goes through the heart of the mining district of ancient Etruria, the Colline Metallifere (the ore-bearing hills), between the Cecina and Massa Marittima. Volterra, though it lies a little north of the mining country, was the great city of that region in antiquity; Populonia, on the coast between Cecina and Follonica, was her port—her colony, according to some (Serv. *Aen.* 10.172). In the course of time, Populonia became a major city in her own right, the port to which the iron ore of Elba was shipped and a smelting center. When certain Etruscan cities supplied material for Scipio's fleet in 205 B.C., it was iron that Populonia contributed, and the ancient slag heaps that are spread like dunes along the shores of its bay are now being reworked by modern methods, they are so extensive and rich in metal ancient methods could not extract.

The easternmost Roman road through Etruria, the Flaminian Way, runs due north at first, passing between Soracte and the towns of the Faliscan region on the tufa plateau—Città Castellana (Falerii Veteres), Santa Maria dei Falleri (Falerii Novi, so late that it must count itself Roman), Narce, Nepi—towns which considered themselves Etruscan, though they spoke an Italic dialect closely akin to Latin. North of these cities, the Flaminian Way crosses the Tiber and swings into Umbria, while the Tiber veers northeast and then northwest, winding through a narrow gorge till it reaches its broad upper valley at the Umbrian city of Todi, on the east bank of the river. Northward, this broad valley stretches to the high spurs of the Apennines,

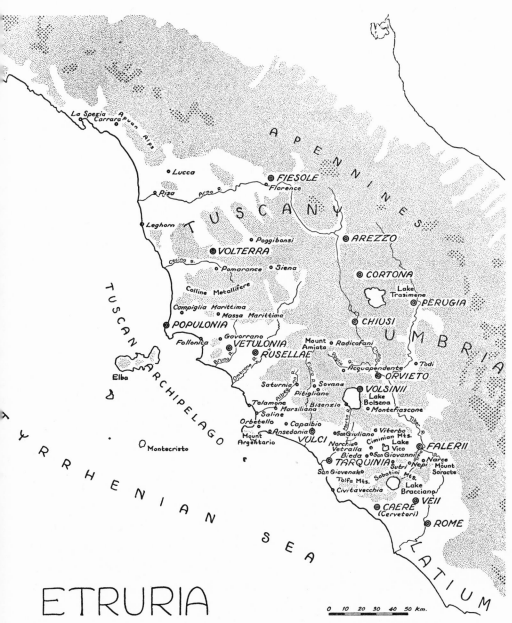

ETRURIA

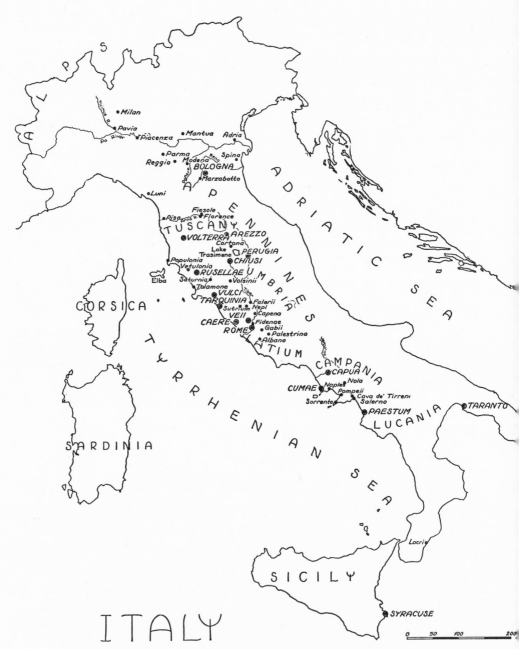

ITALY

2. Map of Italy. Drawn by Edward Hansen, Department of Geology, Yale University.

east of Lake Trasimene, where Perugia is situated. This is the eastern-most city of Etruria and the least Etruscan in appearance, a proper hill town high among limestone mountains. And no wonder, for it was founded by mountaineer Umbrians and did not become Etruscan till the end of the fifth century. Yet, a hundred years later, it was, Livy says (9.37), one of the chief cities of Etruria.

All the chief cities of Etruria, according to the lists of the ancient historians, have now been named in our itineraries: Caere, Tarquinii, Vulci, Rusellae, Vetulonia, and Populonia, on the coast; Volaterrae, inland, dominating the northwest; up the center, Veii, Volsinii, Or-vieto, Clusium, Cortona, Arretium, and perhaps Faesulae, though its importance is not clear; and Falerii and Perugia, on the eastern borders. Of all these cities, there is only one whose ancient name we do not know—Orvieto. This was evidently a most important Etruscan city, soaring above the broad valley where its estimable wine is grown, on an isolated mesa, an outpost of the tufa country. It has been con-jectured that this was ancient Volsinii, rather than the somewhat meager site in the hills above modern Bolsena; the name Salpinum has also been suggested—the Salpinates and Volsinians together in-vaded Roman territory in 392 B.C. (Liv. 5.31–32), but this is the only mention of them in antiquity.

Other names of Etruscan cities float loosely without firm association with a site. About Statonia, for example, we know various odd facts: it had a very large game preserve in the last century B.C. (Varr. *R.R.* 3.12.1); a fine white building stone was found in its territory, as at Tarquinii and around Lake Bolsena (Vitr. 2.7.3; Plin. 36.49.168); and its lake was remarkable for floating islands (Plin. 2.96; Sen. *Q.N.* 3.25.8). It also produced excellent wine (Plin. 14.8.5). The little hill of Poggio Buco, high up the Fiora, south of Pitigliano, has been sug-gested to be the cemetery of this ancient city, since a lead sheet in-scribed *Statnes* in Etruscan letters was found in the excavations there, but the town site is too small for an important center.

Pitigliano itself has no ancient name, though Statonia has also been suggested for it, and the wine of Pitigliano is indeed excellent; nor has Marsiliana d'Albegna, a very wealthy site of the early Etruscan

period, unless we can perhaps identify it with the ancient Clusium Vetus, mentioned by Pliny (3.5.52). In Polybius' story of the defeat of the Gauls at Telamon in 225 B.C. (2.25), a Clusium lay near the sea, and Virgil links it with Cosa as a sea power in his list of the ships that sailed with Aeneas against the Latins (*Aen.* 10.167–68). A number of scholars have recognized that the combined evidence of Polybius and Virgil is too strong to be ignored; somewhere on or near the coast of Etruria, south of Talamone and presumably north of Tarquinia, there must have been another powerful Etruscan city, the city of Lars Porsenna, the city that asked Rome for help against the Gauls in 390 B.C. Orbetello has been suggested, but that site is more probably the Etruscan Cusi which was later replaced by the Roman Cosa on the hill of Ansedonia.

Though many of the inland cities have produced evidence of Villanovan occupation, the material is later and less wealthy than in the cities of the coast; Falerii and the other Faliscan towns had large Villanovan cemeteries; a few Villanovan tombs have been found at Orvieto and Chiusi (Pliny's Clusium Novum?); Arezzo and Fiesole seem to have had Villanovan sanctuaries, if not settlements. By the end of the eighth century, it would appear, the urnfield people had penetrated to all the big river valleys of Etruria.

These valleys were the natural and original highroads to the interior. However difficult to negotiate they may have been—and they must have been virtually impassable in some parts of the year—no other passage would have been practical, since the Villanovans and the later settlers of the Orientalizing period were looking for arable land, and that was to be found inevitably along the courses of the rivers. Livy's story (9.35 ff.) of the Consul Quintus Fabius' march through the dreaded Ciminian Forest with his army in 310 B.C., which took the Etruscans besieging Sutrium completely by surprise and led to their disastrous defeat in the Second Samnite War, is indirect evidence of this. The once heavily wooded Ciminian Mountains north of Lake Vico are still an impressive barrier and must have been forbidding enough when the oak and beech that still crown them covered their whole slopes, but the Etruscans had thought them impassable when,

in fact, they were merely unprofitable. "Not even merchants had passed through the forest before that day," says Livy.

But along the rivers that drain into the Tyrrhenian Sea or into the southern reaches of the Tiber, in the tufa country, there were innumerable settlements in antiquity. The earliest of these inland cities are apparently the Villanovan settlements of Capodimonte and Olmo Bello, near Bisenzio, ancient Visentium, at the head of the Marta where it flows out of Lake Bolsena, and the Faliscan towns of Falerii and Narce on the Treia, a tributary of the Tiber. And the "cliff-bound tablelands" of the tufa country, to borrow from Dennis again, were the sites preferred by the later Etruscans. Wherever a sizable plateau is defended on three sides by the steep, almost vertical, cliffs characteristic of the tufa and wherever the water that runs in at least one of the gorges below is a stream that will maintain its flow even through the heat of the almost rainless southern Etruscan summer, you may look for Etruscan potsherds on the tableland and for traces of Etruscan tombs in the walls of the cliffs that face it or on the highlands opposite, across the river gorge. Like many primitive peoples, but unlike the Greeks, the Etruscans seem to have preferred to put running water between themselves and the houses of their dead. Pitigliano, high up the Fiora, is such a cliff-bound tableland, of considerable size, with cliffs almost as high as Orvieto's, and it was settled by the late seventh century. The cliff-tomb cities—where the soft rock of the cliffs facing the city is carved into great tomb façades with false doorways, the symbolic gates to the underworld, while the real entrances to the tombs lie below, hidden now by tangles of brush and vines—were mostly founded later, in the sixth century; these are Bieda, San Giuliano, San Giovenale, Norchia, and Castel d'Asso, on the Marta and its tributaries; and Sovana, near Pitigliano, on the Fiora.

North of the tufa country, the broad valley of the Albegna runs northeast past Marsiliana and up to Saturnia on the edge of the hills of the Catena Metallifera. This city was also founded in Villanovan times; Dionysius of Halicarnassus (1.20) records a tradition that it was settled by Pelasgians and Aborigines; according to Pliny (3.5.52), its inhabitants were originally called Aurini. Here there are sulphur

baths and a river of hot water—startling but very pleasant when you feel impelled to cross it by wading—that coats the long grasses that overhang it with a crumbly carapace, travertine in the making. The city rises abruptly on a steep hill of travertine, below which broad fields slope gently to the Albegna; the eye is carried for great distances across this fertile valley, beyond which spreads another great tableland of travertine (the Pian di Palma) where the tombs of the city lie, safely across running water, not carved out of soft tufa but half-dug, half-constructed of rude travertine slabs. Some of these tombs are now put to use for storing cheeses; they keep a more even temperature than the surface of the plateau, and it can be very hot there at midday in August.

Northeast Etruria was never so thickly settled as the south, and Chiusi is the only really venerable site, though even it is not so ancient as the coastal cities. Though there is some Villanovan material at Orvieto, it was apparently not a city till the beginning of the sixth century; Cortona seems to have been no older, while the Etruscan city of Arezzo was founded in the second half of that century, though there must have been an important and much older pre-Etruscan sanctuary somewhere in the neighborhood, to judge from the quantity of early votive bronzes found there.

This northeast quarter was the region of Etruria that, in the last three centuries of the Roman Republic, was wealthiest and most vigorous. Livy tells us (9.37) that when the Romans marched through the Ciminian Forest in 310 B.C. and saw the lovely valleys of northeast Etruria for the first time, Cortona, Perusia, and Arretium were already the principal cities of Etruria. Theirs was the territory that Hannibal devastated in 217 B.C. (Liv. 22.3), yet Arretium was able to supply more material and equipment than any other Etruscan city to Scipio's fleet in 205 B.C. (Liv. 28.45), and all during the later years of the Hannibalic and the Macedonian Wars, Arretium was the station of Rome's "legions in Etruria." And when, after the Social and the Civil Wars, Italy settled down thankfully to a quiet middle age under the eye of Augustus, Arretium was the only city in Etruria to develop a distinguished new manufacture—the beautiful coral-colored

Etruria

Arretine ware, light and delicate pottery, beautifully glazed and decorated with reliefs and stamped proudly with its factory's trade-mark.

The three geological divisions of Etruria—the southern tufa plateau, the northwestern Catena Metallifera, and the Apennine valleys of the northeast—account for the strongly regional quality of Etruscan art and civilization. Each region has its own pattern of city and cemetery; each has its own specialties in bronzework, terracotta, stone carving, and painting. We can see from the earlier books of Livy that the regions were for a long time quite cut off from each other and from Rome; the inland cities were not forever bustling out to the coast, and the coast became sophisticated earlier, for it had connections by trade (and piracy?) with the Greek cities of Magna Graecia and even with Delphi. It was fortunate for Rome's development that her nearest neighbors were, in fact, the highly civilized Caere and Veii to the north and that she lay between these and the Greek cities on the Bay of Naples.

Prehistory:
The Villanovans

PERIODS

In this chapter and the next I follow the divisions and dates supplied by Dr.
Hugh Hencken (*AJA*, 62 [1958], p. 265), which are based on those of Mon-
telius, as revised by Professor Massimo Pallottino in his definitive publication
of the finds at Tarquinia (*MonAnt*, 36 [1937]).

Archaic I. Early Geometric. The period of disc fibulae, beginning in the
tenth or ninth century B.C. and continuing to about the middle of the eighth.
The material, including the fibulae, is like that of the pre-Hellenic cemetery
at Cumae (E. Gabrici, *MonAnt*, 22 [1913]). Cumae, the oldest Greek colony
in the West, was founded *ca.* 750 B.C. Dunbabin (*The Western Greeks*, p. 446),
gives the accepted date, 756 B.C.

Archaic II. Later Geometric, *ca.* 750–675 B.C. Characterized by the presence
in the graves of late Geometric vases and local imitations. Contemporary with
the founding of Cumae and the earliest Greek colonies in Sicily—Naxos, 735;
Syracuse, 734; Leontini, 729; Katane (Catania), 729; Megara, 728; Gela, 688—
and the colonies in Apulia and Calabria in southern Italy—Rhegium, accepted
date 730–720; Sybaris and Croton, *ca.* 708; Tarentum, 706; Metapontum,
accepted date 690–680.

The dates of the Sicilian colonies are based on Thucydides (6.3–5), those
of the Italian colonies on the less trustworthy tradition of Eusebius. Thucydides'
Sicilian dates are the basis for dating the fine Corinthian pottery found in the
tombs of the Greek colonists, particularly the small perfume flasks (aryballoi)
that were a specialty of Corinth and whose shape changed with fashion. These

vases of Corinthian manufacture are then used to date all Archaic Greek and Italian sites where they—or any material like that found with them in the Greek graves of southern Italy and Sicily—appear.

Archaic III. Orientalizing, *ca.* 675–600 B.C. Best characterized and dated by the presence of so-called Protocorinthian vases, pottery manufactured at Corinth from the late eighth till sometime in the second half of the seventh century B.C. This ware is found in the Greek cities of the West from the time of their foundation, but north of Cumae, in the non-Greek settlements of central Italy, it is not found till the Orientalizing period. This anomaly has not yet been properly explained, though the tradition of Demaratus of Corinth and his trade with the Tyrrhenian cities in the early seventh century (Dion. H. 3.46) hints at a possible solution.

The earliest tomb in Etruria of the Orientalizing period, the Bocchoris Tomb at Tarquinia (G. Karo, *AM,* 1920, pp. 108–12), is dated by Dunbabin, on the strength of the imitations of Protocorinthian vases found in it, shortly after 700 B.C. (*Western Greeks,* p. 462) and by Mrs. Dohan (*Italic Tomb Groups,* p. 108), about 670 B.C. A convenient date for the beginning of Archaic III is, I think, 675 B.C.; its end is marked by the disappearance of Protocorinthian ware and its imitations and the sudden popularity of pottery in the later, Corinthian style. This style appeared in Greece in the last quarter of the seventh century; in central Italy its popularity seems to date from about 600 B.C.

IT WAS likely the presence of copper, tin, and iron in the Catena Metallifera (see chap. i) that brought the first Iron Age settlers to central Italy, as later the presence of gold on Ischia and copper in Campania (Plin. 34.2.2) brought the Greeks to Pithecusa and Cumae in the eighth century. To be sure, some of the earliest Iron Age settlements on the Tyrrhenian coast—those in Latium around the Alban Lake and on the Palatine Hill and in the Forum at Rome—do not provide evidence of any considerable amount of any metal. But at Tolfa and Allumiere, the earliest known Iron Age settlements in Etruria, in the mountains of La Tolfa between Cerveteri and Tar-

quinia, a wealth of bronze objects has been found, many of which resemble the types found in the rich Bronze Age settlements of Umbria. Bronze from Etruria must already have been known to the peoples of Italy before the Iron Age.

URNFIELDS

In the Bronze Age, the universal burial rite in peninsular Italy had been inhumation. But the first Iron Age settlements of the Alban Hills and Etruria, instead, follow a pattern developed in central Europe during the Bronze Age; its earliest known sites are in Hungary. The salient characteristic of this culture is cremation, the ashes of the dead being placed in urns which are buried close together in cemeteries near to, but beyond, the boundaries of the settlement. During the late Bronze and the early Iron Ages, urnfield peoples spread through Europe from Rumania to Spain and from Poland to Italy, down the valleys of the Iskar and the Struma (the Strymon of Greek writers) to the head of the Aegean and the coasts of Asia Minor. They seem always to have brought with them considerable agricultural competence based on settled communities and a determination to defend their fields. Wherever their villages have been found they are large and sometimes fortified, with substantial buildings; the wealth of handsome and efficient weapons and armor buried in their cemeteries speaks for the prosperity and warlike character of these peoples. The horse came with them, and with the horse came the war chariot.

The oldest urnfields in Italy are in Emilia, south of the Po, and date from the late Bronze Age. This people may have reached Italy by land, over the Alps, or around the head of the Adriatic; but most of the other urnfields of Italy are near the coast, and their people evidently came by sea. There are a few sporadic late Bronze Age urnfields east of the Apennines at Pianello in Picenum, at Timmari near Taranto in Apulia, on the Lipari Islands, and at Milazzo in northeastern Sicily; but even the earliest urnfields on the west coast of Italy, in Latium and in the mountains of La Tolfa in Etruria, belong to the beginning of the Iron Age. The great urnfields of Etruria and their close rela-

tions at Bologna in the Po Valley and at Fermo and Verrucchio in Picenum begin somewhat later. The people who settled the coast of Etruria and Bologna apparently came in greater numbers than the earlier urnfielders, and certainly they established themselves more firmly and with far more lasting effect.

It is the urnfield people of Etruria and Bologna who are called, for convenience, Villanovans. The name is taken from a site near Bologna where one of their characteristic cemeteries was first discovered in 1853. Since they, like all other Europeans of the early Iron Age, were illiterate and since they burned their dead, we have no direct evidence of their language or physical type (see Introduction). Some urnfield peoples seem to have spoken Indo-European languages; possibly the Villanovans of Italy did so, too; it is equally possible that they brought the non-Indo-European language of the historical Etruscans to Italy.

Whatever their language, they did introduce a wholly new civilization to Italy. Not only a new burial rite, but a new agriculture requiring fields annually refertilized by flooding rivers, a year-round supply of water, and settled communities on defensible sites came in with the urnfielders. Italy was already inhabited, of course, by people who knew agriculture and warfare, but the civilization of the Bronze Age peoples of most of Italy, the so-called Apenninic peoples, was seminomadic; they were shepherds who followed their flocks up and down the slopes of the Apennines as the seasons changed and the pastures grew green over the next hill. Even now much of the Abruzzi belongs to such people; you can still see their sheepwalks stretching like ghostly six-lane highways over the hills. But the agriculture of those Apenninic shepherds was rudimentary, though their handmade burnished pottery, decorated with incised patterns filled with white paint, and their elaborate bronze ornaments are far from contemptible works of art. They were inhumers, like most of the peoples along the Mediterranean in the Bronze Age, and their ultimate connection seems to have been with the Aegean and Anatolia; very probably they were the *first* Indo-European-speaking peoples in Italy, the ancestors of the Umbrians, Sabines, Samnites, etc., of historic times.

THE ETRUSCANS

If the reader is nonplussed by the suggestion that cremating peoples possibly speaking Indo-European dialects followed earlier immigrants who also spoke Indo-European dialects but had a very different civilization, one must remember that this was exactly the pattern in Greece. (In Latium, that "possibly" should read "probably," since the urnfield settlers of the Alban Hills and Rome were not Villanovans and seem to have been the direct ancestors of the Romans of historic times.) The Greek language seems to have come to Greece from Asia Minor with the makers of Minyan ware at the beginning of the middle Helladic period, about 1900 b.c.; the language of the late Bronze Age in Greece was Greek, as we now know; cremation came to Greece with the invading Dorians about 1100 b.c., and the Dorians spoke not merely an Indo-European language but another dialect of Greek.

We have now built a pattern for Italy in the early Iron Age in which the central mountainous spine of the country is held by the descendants of the Apenninic Bronze Age peoples, while their winter pastures along the shores of the Adriatic and Tyrrhenian Seas are being pre-empted by small bands of aggressive seafarers looking for permanent homes. But the earlier, inhuming population did not retreat immediately and permanently to the hills on the arrival of the seafaring urnfielders; the two burial rites appear amicably side by side in a number of places, at Rome and Cerveteri, for example; and the Villanovans borrowed various elements and objects, in particular the disc fibula, from their earlier, established neighbors.

The urnfield peoples came to Italy by sea and those of the Iron Age apparently not just by a short ferry trip across the Adriatic but from the eastern Mediterranean. Intimate cultural connections between the Latin urnfields and the late Bronze and early Iron Age civilizations of Crete have been convincingly demonstrated; and some connections, particularly the shape and fabric of certain pots, reach even further east to Troy itself, where the people of Troy VI, contemporaries of Late Mycenaean I and II in Greece, in fact, buried the ashes of their dead in a characteristic urnfield cemetery.

The Villanovans of Etruria and the Po Valley brought to Italy the Mycenaean T-hilted sword and flasks in the shape of animals (askoi)

which recall flasks from Cyprus, as well as bridle bits of Anatolian design. Wherever they had once been settled in the eastern Mediterranean (perhaps on the coast of Asia Minor, like the people of Troy VI?), their voyage westward must have been made by slow stages, since most of the urnfields of the Aegean date from the late Bronze Age (though one has been found on Lemnos which is dated by its excavator in the eighth or seventh century) while the Villanovans of Italy belong to the full Iron Age. In any case, it appears that the characteristic Villanovan culture developed in Italy itself.

Archaic I

When the Villanovans chose a site for a new town, they intended it to be a permanent settlement, and, indeed, many of their earliest sites are still inhabited today though, like Gilbert and Sullivan's Titipu, in many instances "the city has been reduced to the rank of a village." Continuously inhabited sites have a way of sitting on top of, grinding up, sweeping out, and generally obliterating the evidence of their earlier stages. So what we know about the Villanovans, we know from their tombs. Their cremation graves are usually small circular shafts (well tombs), without lining, each covered with a stone slab; less commonly the grave is squarish, lined and roofed with stone slabs. The inhuming graves of the coexistent older population are trenches in which the body is laid on its back, extended at full length.

In the cremation burials, the ashes were enclosed in an urn, most commonly of the biconical shape shown in Plate II. There is generally a single, horizontal handle at the widest part of the body. In some cases, where the urn originally had two handles, one has been deliberately broken off. The pots are handmade of coarse clay given a highly polished brown or blackish surface; this fabric is generally known as impasto. The surface is decorated with incised geometric designs usually picked out with white paint. Two-storied urns of somewhat similar shape are found in the Bronze Age urnfields of Hungary and Rumania and are sometimes decorated with meander patterns like the Villanovan urns, but the meander is also a favorite pattern of the Apenninic

peoples of Bronze Age Italy, and the practice of filling the design with white paint is characteristically Apenninic.

The urn was usually covered with a shallow, one-handled, inverted bowl, but occasionally the cover took the shape of a terracotta helmet, either pointed and with a high ogival crest (Pl. II) or hemispherical with a knob at the crown. Bronze helmets of both shapes have been found in Villanovan tombs in Etruria and on the Adriatic; one urn in Tarquinia had a crested helmet of bronze for a cover.

The bell helmet is a shape familiar in eastern central Europe; the crested helmet is also European in origin but appears farther west, chiefly in Germany and France. The Italian examples (Pl. III) are made of hammered bronze, with two sheets joined along the top of the crest and on the cap below. Three spikes project fore and aft from the cap under the crest; both cap and crest are decorated with repoussé patterns of bosses and beading; such decoration is characteristic of the bronzework of the first Villanovan period, Archaic I.

The effect of setting a helmet on top of an urn containing the ashes of a dead man is, of course, to make an image of the urn, not a likeness but a representation—the transformed embodiment of the man himself. Such an image must have had great magical power; this particular concept of the dead recurs more than once in the course of Etruscan history.

Another form of ash urn found in certain Villanovan cemeteries in Etruria is the hut urn (Pl. I). This the Villanovans borrowed from the urnfield people of Rome and the Alban Hills, who had, apparently, brought the idea from Crete. The hut urns of Latium are round and show a building of wattle-and-daub with a steep thatched roof of two slopes with deep eaves. The roof sometimes has a sort of pediment over the door with an open smoke hole; and the ridgepole is decorated with horned elements or birds' heads, either of which, in Crete, would have indicated a sanctuary. It has been suggested that the Latin hut urn represents not a house but the oldest temple of Vesta which, we know from Ovid (*Fast.* 6.261–62), was round and built of wattle-and-daub. Vesta, so far as we know, was not worshipped in Etruria; but the Villa-

novan hut urns from Tarquinia, Bisenzio, and Vetulonia—where they are commonest—are also decorated with horns, though infrequently, and with bird protomes. The protomes that decorate the ridgepole of our example from Tarquinia (Pl. I) look rather like snakes' heads, but in intention they are birds. These rooftree ornaments are evidently meaningful; they may mark a shrine, or they may have been purely apotropaic. Their position along the spine of the roof certainly seems to anticipate the decoration of Etruscan temple roofs in the late Archaic and early Classical periods, when the rooftree often carried a row of terracotta statues.

The concept of the tomb as the *house* and *shrine* of the dead has a long history in Etruria. Many chamber tombs, from the seventh to the first centuries B.C., particularly at Cerveteri and Chiusi (Pls. XVI and XXXVI), are divided into rooms embellished with architectural detail and furniture carved from the soft rock of the region, and the die tombs and cliff tombs of the inland cities of the tufa region—Bieda, Norchia, San Giovenale, etc.—frequently have architectural elements carved on the façades. In some cases, the façades certainly imitate temples; others probably represent house fronts, though their doorways are generally the archaic, Doric T-shaped doors (Pl. XVI*a*) used in Greece and later at Rome only for temples.

The Villanovans of Archaic I show themselves to have been skilled bronzeworkers and alert to the fashions and specialties of the peoples with whom they traded. From the Apenninic peoples they borrowed the style of decoration of their pottery and the disc fibula (perhaps even the idea of a safety pin rather than a straight pin, since straight pins are characteristic of most other urnfield peoples). From the urnfields of Latium they borrowed the hut urn; from northern Europe, their characteristic helmets and the splendid antennae swords found in some of their tombs. Their Greek connections are indicated by the T-hilted swords and the animal-bodied askoi, and their continued trade with the Aegean and the Near East is proved by the discovery of two bronze tripods in graves at Tarquinia, little gold bullae in other graves, and an occasional scarab or figurine of glass paste from Egypt or Phoenicia.

THE ETRUSCANS

ARCHAIC II

The period of Archaic II in Etruria was marked by greatly increased wealth and intensified foreign trade and intercourse. Inhumation becomes much more common: at Tarquinia, of the eighty-six known burials of this period, fifty-eight were inhumations. This change, along with the sudden increase in wealth and in foreign goods found in the tombs, led a generation of archaeologists to suppose that the first wave of Etruscans had just then settled in Italy, among the Villanovans. But the change in burial rite seems, this time, to be a change in fashion rather than evidence of the arrival of a new people. In the same manner, at Athens, early Geometric burials are almost exclusively cremations, while late Geometric ones are almost exclusively inhumations; yet there seems to have been no change in the population of Athens nor any break in the development of her characteristic pottery during the whole Geometric period.

The well tombs of Archaic II are less closely set than those of Archaic I and slightly larger; several have a large jar as a lining, to protect the ash urn and other material in the grave. The trench tombs are roofed with stone slabs, sometimes arranged in a gable, as if the grave itself were the house of the dead, like the earlier hut urns. One or two graves of this period at Tarquinia are approached by a narrow corridor cut in the soft rock that opens into the end of the trench, which now becomes a rock-cut chamber.

The bell helmet and the antennae sword disappear; a new shape, the cap helmet, is introduced, but the splendid, crested Villanovan helmet has by no means gone out of fashion. There are round bronze shields in the tombs of warriors and bronze leaf-shaped girdles in the women's graves. Bronze vessels of several shapes are common, including two-storied urns similar to the biconical ossuaries of Archaic I. These bronze urns are occasionally used to hold the ashes of cremation burials, but the majority of ash urns are still of black impasto, though they tend to be less elaborately decorated than those of Archaic I. Shapes introduced during Archaic II include a tall pail, swelling to its greatest diameter near its mouth; cups of various shapes; and the so-

called pilgrim's flask, a bottle with a lenticular body and a long, narrow neck, evidently designed to carry water like a modern canteen.

These bronzes are decorated with repoussé bosses and beading like the helmets of Archaic I; the repertory of patterns is wider—a new favorite is the wheel flanked by birds' heads—and the embossed designs are elaborated with incised details. The iron blades of the T-hilted swords of Archaic II, themselves a legacy of Archaic I, have bronze sheaths ornamented purely with incised geometric designs. The bronze vesesls are made of two sheets of bronze, as the helmets of Archaic I had been; these are fastened together by rows of large conical-headed rivets used for decorative as well as for practical purposes.

The leaf-shaped girdles are evidence for continued trade with Europe beyond the Alps, since they are of eastern and central European design; the bird-wheel ornaments also come from eastern Europe. Another European fashion is the wheeled cart, a playful vessel apparently used on the banquet table; the most delightful of these comes from Tarquinia, and its body is in the shape of a double-headed bull-bird.

The shapes of the bronzes are of eastern Mediterranean origin; the T-hilted sword is Greek in origin; the round shield and the pilgrim's flask are Eastern. The fibulae of Archaic II, which take the place of the outmoded disc fibulae of Archaic I, are Greek or designed under Greek influence. Serpentine fibulae with knobs along the sides were worn by men; their shapes are like some found in the earliest tombs on Ischia; the women wore fibulae with swollen crescent bodies, also like Greek fibulae of the mid-eighth century. Most of the Etruscan examples of Archaic II have short catchplates; Greek examples have longer catchplates, a fashion that spread to Etruria in Archaic III.

Indeed, Etruria's closest connections during Archaic II were with the Greek world. Pithecusa on modern Ischia and Cumae on the coast of Campania were founded shortly before the middle of the eighth century by Greeks looking for metals, and the rumors of mines found in Etruria no doubt brought Greeks still farther up the coast, to Cerveteri and Tarquinia. They founded no colonies north of Cumae, perhaps because the climate of Tuscany was too cold and rainy to suit their notion of the good life, perhaps also because the Villanovans already con-

trolled the coast, or at least the mines and harbors. But the Villanovans seem to have been quite willing to allow Greeks to settle among them, and the strong Greek colony that continued at Cerveteri during the Classical and early Hellenistic periods may date from this time. At Tarquinia Greek craftsmen set up a pottery manufacture where they trained Villanovan apprentices, and the graves of Archaic II at Cerveteri, Tarquinia, and Veii, inland in the Faliscan territory, at Bisenzio, and even as far as Chiusi, contained imported Greek pots or local imitations of these. This Italo-Geometric pottery (Pl. IV*a*) is wheel-made, of finely levigated potter's clay, light buff in color, decorated with designs in a linear geometric style, painted in thinned glaze, and fired in a proper kiln with regulated heat. The shapes as well as the technique and decoration of these vases are borrowed from the late Geometric repertory of Greece; the trefoil wine jug (oenochoë) in Plate IV*a*, the mixing bowl (krater), and the deep drinking cup (skyphos) are the favorite new shapes. One wonders a little whether the Greeks had introduced wine to the Villanovans along with their wheel-made pottery. Perhaps what they really introduced was an elaborate drinking ritual.

The Warrior's Grave at Tarquinia, a rich inhumation burial of the last years of Archaic II, contained a great number of these painted Italo-Geometric vases, as well as bronzes characteristic of Archaic II: a round shield, a pilgrim's flask, a two-storied urn, and a round-bodied urn on a high, conical foot. The bronze ash urn has become merely part of the grave furniture, as in other inhumation burials of this period. In addition to the bronzes, there were two silver cups in this grave, one, hemispherical with a single, high ring handle; the other, two-handled with an offset rim above a deep bowl, like the Greek drinking cup called a kantharos. A pectoral of gold decorated with repoussé geometric designs over a bronze lining was further evidence of the warrior's wealth. This tomb illustrates nearly the whole repertory of objects characteristic of Archaic II.

But there is one refinement the Greeks taught the Villanovans during Archaic II that does not appear in the Warrior's Grave—the use of cast bronze figurines for decoration. To a people who could see an image of the dead in a two-storied urn capped with a helmet, the

abstract, geometric forms of eighth-century Greek sculpture must have appealed naturally. At all events, the Villanovans late in Archaic II created a wiry geometric sculpture style that strongly resembles the late Geometric bronzes of Greece. The legs of a number of small tripods that support a bronze basin are set with figures of helmeted horsemen; the horses' bodies are tubular; the arched necks, hogged manes, prick ears, and long, snouty noses look at once lively and precise. The riders have spindly bodies and large round heads, on which perch Villanovan helmets. The legs of the riders are suppressed, as in some Greek terracotta horsemen of the same period; sometimes the arms are suppressed as well; other examples have long, wiry arms that reach forward to grasp the horse's ears.

One late Archaic II grave at Tarquinia contained an amulet in the form of a nude woman wearing earrings, standing with straddled legs, her left hand on her hip (Pl. V*a*). An almost identical figure, though less elegant in proportions and finish, was found on the Greek island of Rhodes. The proportions of the Tarquinia figure are interesting: large round head, flattened face with great oblong nose and gashed mouth, cup-handle ears; long, tubular torso, wiry arms, rounded hips and buttocks, and short, well-shaped legs. This is the Villanovan canon of beauty, and it will reappear under peculiar circumstances.

This bronze lady is a pendant, meant to be suspended from the ring at the top of the head. The heavy chain around the neck apparently had a different purpose; it can hardly have been a mere necklace.

Archaic III

The proportions of this pendant (Pl. V*a*) set a standard for a number of wiry geometric bronzes, most of which must be dated later than Archaic II, though before the generation of the great tombs of the Orientalizing period. The wiry geometric style, which first appeared at Tarquinia, is developed most fully at Vetulonia, in tombs which have furnishings that resemble those of Tarquinia's Archaic II (though lacking the Greek pottery) but which must nevertheless be dated in the early years of Archaic III because of the Orientalizing character of some of their contents. The years between *ca.* 675 and 650 B.C. must

have been crucial for Vetulonia. Her great wealth came at that time—fifty or more years after Tarquinia's—and with the wealth came the flowering of her artistic ethos.

The characteristic tombs of Archaic III at Vetulonia and nearby at Marsiliana d'Albegna, which shared Vetulonia's civilization and stage of development at this time, are the so-called circle tombs, great rings of roughly squared stones enclosing a number of rectangular trenches, once covered by a mound of earth like the tumuli that cover the Orientalizing chamber tombs of Cerveteri and Tarquinia (see chap. iii). Only one of the trenches in any circle was used for a burial; the others held the wealth buried with the dead. The earlier circle tombs and some of the later contained cremation burials; the ashes of the dead were apparently buried in wooden chests; but the majority of the burials in circle tombs were inhumations.

The earliest Geometric bronzes from Vetulonia reflect the wiry canon of Tarquinia (Pl. V*a*), but the school soon develops new tendencies. The nude female (Pl. V*b*), the crowning figure of a pot stand from the Second Circle of the Pelliccie, has the long, tubular torso and short, straddled legs of the earlier style, but the head is a lumpy oval, rather like an Idaho potato, with narrow eyes slanting downward, jutting nose, and gashed mouth; the ears are suppressed. The arms are very long and posed in a bold scheme of repeated triangles; the heavy bracelets on the upper arms as well as the modeling of the breasts are evidence of a greater taste for realism in detail, though the design of the whole is purely, and brilliantly, geometric. The two-storied urn balanced on the lady's head indicates her Villanovan ancestry; the pose—right hand raised to steady the vessel on the head, left hand spread open across the belly—occurs among Greek Geometric figures; but down the back of this bronze hangs a long braid, which connects the figure unequivocally with the East.

The long braid hanging down the back, which first appears in Etruria on this bronze of the early Orientalizing period, had been worn by women in the Near East for centuries. Recently, at Hacilar in Anatolia, Neolithic statuettes of 5000 B.C. have been found wearing it. To my knowledge, it was never worn in Greece. Its appearance at this

moment in Etruria, at the beginning of the Orientalizing period, shows a new *direct* contact between Etruria and the Near East, without the intermediacy of Greece.

A second example of the geometric sculpture of Vetulonia in the early Orientalizing period is a head of a warrior from the Circle of the Acquastrini (Pl. VI). A cluster of four such heads crowned one of Vetulonia's characteristic pot stands; twelve others were found loose in the grave. Planned on a relatively large scale, these heads are carefully modeled and beautifully finished; the narrow head is the refinement of the oval head of the lady who carried the two-storied urn (Pl. V*b*); the deeply bored eyes are shadowed by downward slanting brows like hers; the jutting nose and gashed mouth are taken from the same repertory. The depth of profile is new, and so are the bulging cheeks and neat, doughnut-shaped ears. The helmet, whose cap is decorated with curving ribs, has a crest like the old Villanovan helmet. The rod that supports the head is rendered with a bead-and-reel ornament, which is more Greek than Oriental.

The culmination of the Vetulonian geometric style is a group found loose in the earth above one of the tombs of the Costiaccia Bambagini (Pl. VII). Two tall, slender figures, one male, the other female, are joined together by a triple chain, one end of which is fastened to the end of the short braid worn by the female; the other ends are attached to the elbows of the male figure, whose forearms are suppressed. The bodies are broad-shouldered, with long torsos, shallow in profile; the buttocks are prominent and well modeled, the legs long but rather shapeless. The female's breasts are small but very prominent; the male's phallus is erect. Though the anatomy of the bodies leaves no doubt that they were intended to be human, the heads are monstrous; the faces in profile are long and jut forward like axeheads, with slanting foreheads and projecting jaws; the flat, rounded ears are set close to the head like an animal's. Apes were a popular subject in both Greek and Villanovan sculpture just at this period, but these figures are not apes; they are beast-headed divinities, gods of fertility, obviously, and since they were tomb figures, presumably also gods of the underworld. A Villanovan Pluto and Persephone? Wealth and Springtime as well as Death and

the Grave? Later, in Etruria, the commonest monument set up over a man's grave was a stylized phallus (Pls. XVIII*a* and XIX); occasionally a stylized female member was used to mark a woman's grave. The Villanovan ancestors of this imagery of rebirth seem to be this pair of bronzes from Vetulonia.

The chain that binds the two figures looks very like the chain around the neck of the earlier geometric amulet from Tarquinia (Pl. V*a*). Was she also one of a pair? That she represents a divinity is quite probable; the goddess in the tomb is a recurring image in Etruria.

The Beginning of History: The Orientalizing Period

I

T IS hard to say precisely what made the whole of the Mediterranean suddenly conscious of the spell of the East or exactly when it happened. Greece had, of course, traded with Egypt and the Near East since the Bronze Age, and if the traffic slacked off during the first centuries of the Iron Age, still it was never wholly given up. Even in Italy, in the period of Archaic I, the Villanovans had an occasional faïence scarab or necklace of glass beads that had come from Egypt or Phoenicia or Cyprus.

Greek history is vague about dates before the middle of the eighth century, though archaeology has proved it surprisingly accurate about events in the remote past; but when the Greeks began to date by Olympiads the framework of history became more precise, and we have a reasonable hope of knowing more or less exactly when things happened. The Olympic Games were founded, or reorganized, in 776 B.C. Probably it is not accident that the traditional dates for the founding of Rome are not far from this; Timaeus' date, 814 B.C., corresponds to the traditional date for the founding of Carthage in North Africa; Varro's, the most popular date, 754 B.C., puts the foundation of Rome about a generation after the first Olympiad. Neither of these Roman dates has any connection with archaeological evidence; recent dis-

coveries have proved that the first village on the Palatine dates from as early as the tenth century B.C.

THE SITUATION IN THE EAST

In the course of the eighth century, the Greek cities along the coast of Asia Minor came to know the great states of Anatolia; through them, we hear of the Phrygian empire and the gold of Pactolus, and recent excavations at Gordium in central Turkey have revealed the wealth and splendor of the Phrygian capital. The last king of Phrygia, one Midas, a perfectly historical monarch, ruled from 738 to 696 B.C.; he was the first barbarian king to send gifts to Delphi (Hdt. 1.14); he married a Greek princess from Kyme; he first fought against, and then became a vassal of, Sargon II of Assyria (722–705 B.C.) and died in the first Cimmerian invasion of Anatolia, which destroyed the kingdom of Phrygia and its capital.

Assyria, the great power that had begun under Tiglath-Pileser III (744–727 B.C.) to annex the kingdoms of the East, was not well known at first hand to the Greeks; but Syria, which they did know well, became an Assyrian province between 725 and 711 B.C. The kingdom of Van (Urartu, the biblical Ararat), whose great wealth derived from the mines of the Taurus Mountains, fell under the control of Assyria in 720 B.C. Bokhenranf, the pharaoh of Egypt whom the Greeks called Bocchoris (718–712 B.C.), sent tribute to Sargon II in 715 B.C. It was in his time that Greek trade with Egypt became so important that the Milesians founded an emporium there, the city later known as Naukratis, close to Sais.

Esarhaddon II of Assyria (681–668 B.C.) made Phoenicia an Assyrian province and annexed Egypt, Bocchoris having been captured and burnt alive by the Nubians, against whom he fought most of his life. From the Black Sea to the Red the ancient East was Assyrian or paid tribute to Assyria. Even Gyges of Lydia (ca. 685–652 B.C.) paid tribute to Assyria for help against the Cimmerians. However, when Psamtik of Egypt (663–610 B.C.?), whom the Greeks called Psammetichos, decided to revolt against the Assyrians, who had made him governor of the country, Gyges sent Lydian troops to help the Egyptians; and with

them went Ionian and Carian mercenaries, "the brazen men from the sea" (Hdt. 2.152). The Assyrian chronicle records with satisfaction that after this breach of faith Gyges was defeated and killed by a fresh wave of Cimmerian tribesmen (652 B.C.) and Lydia was overcome and devastated.

The last quarter of the eighth and the first half of the seventh centuries were evidently lively times in the Near East. The Greeks, who traded and fought on the fringes of the Assyrian world, learned much from the East in those years—coinage from Lydia, the use of stone for architecture and monumental sculpture from Egypt, the splendor and luxury of Eastern bronzes and Eastern fabrics from every port they reached.

THE ORIENTALIZING PERIOD IN CENTRAL ITALY

Farther west, in central Italy, the Oriental style broke like a tidal wave over the simple, if competent, civilization of the Villanovans. Here, it was not a question of occasional Villanovan traders or mercenaries coming home with new goods in a new style, not even a question of Greek traders sailing west to Cumae and north along the Tyrrhenian coast (though this trade route was always of considerable importance), but there must have been an actual shift of population from the old world of the East to the relatively uncluttered new world of the West. Almost any of the events we have chronicled above or something we have yet to discover might have caused such a shift during those turbulent seventy-five years.

THE BOCCHORIS TOMB

It is impossible to date the beginning of the Orientalizing period in Italy exactly, but one early Orientalizing tomb at Tarquinia does, at least, provide a *terminus post quem*. This, the so-called Bocchoris Tomb, was discovered by accident in 1895 and excavated by amateurs; the material recovered is in the museum at Tarquinia, but the tomb had already been robbed in antiquity. On the evidence of what remains, the lady buried there must have belonged to an important family. She was certainly wealthy, and the amount and quality of the Oriental material

in the tomb suggest that she was not just a wealthy Villanovan. This tomb marks the beginning of Archaic III, the Orientalizing period in Etruria.

It was a true chamber tomb, rectangular with a gable roof, carved out of the soft stone of the hillside. Its most spectacular treasure was a large blue faïence vase bearing the cartouche of the pharaoh Bocchoris, the friend of the Greeks. Since the relief decorations on the vase show him successful in battle against the Nubians who eventually killed him, one presumes that it was made before his death in 712 B.C. or would have been were it a genuine Egyptian vase. Instead, it is a Phoenician imitation, made no one knows how many years after the original. For any closer date for the tomb than after 718, one must turn, as usual, to the painted pottery that imitates Greek shapes and designs. Two pieces were found in the tomb, a skyphos and the lower part of an oenochoë; the shape of the skyphos is Protocorinthian; the decoration of both pieces seems to date them after 700 B.C.

In addition to the Phoenician vase, the lady of the Bocchoris Tomb had a necklace of ninety-one faïence figurines of Egyptian gods and two blue-and-white faïence figures of Bes, wrapped in silver, which she may have used as earrings. Her dress was sewn with gold plaques decorated with designs in repoussé. Among them are circles and zigzags from the old Villanovan repertory but also the new, Orientalizing patterns: the guilloche, rosettes, lions with reversed heads, and the so-called Phoenician palmette, a group of vertical petals springing from one or more horizontal bands enclosed in a calyx with tips that curl in on either side. The ivory sphinx from Cerveteri (Pl. IX*a*) is crowned with such a palmette. One of the gold plaques shows a woman in a long skirt, with a long lock of hair curling down and out on either side of her head, standing between two crowned sphinxes, a heraldic arrangement found in Greece from Mycenean times and derived from the Near East. The lady's pose is exactly that of similar figures on Syrian ivories from Nimrud; one of these figures holds flowers in her hands; two others grasp the tails of long, sinuous lions, lifting their hindquarters from the ground. This is the Oriental "Mistress of animals," whom the Greeks identified with Artemis; the lady dominating the sphinxes

must represent the same great goddess, perhaps already called by the Greek name "Aritimi" or "Artumes" in Etruria (see chap. x). Her curling locks are the Egyptian "Hathor locks," which are also worn, like her long skirt, by two of the Nimrud ladies.

The same heraldic group in a livelier, less hieratic style appears in the lower band of an ivory box (pyxis) from Cerveteri (Pl. X). Here the sphinxes wear the Hathor locks; the woman turns her head to the sphinx on the right and grasps a forepaw of each sphinx in either hand.

The faïences of the Bocchoris Tomb were imported; the goldwork was probably made at Tarquinia, with new, foreign designs added to a native craft; its technique is exactly the same as that of the gold pectoral from the Warrior's Grave, Archaic II (see chap. ii). Two splendid pottery stands, certainly of local manufacture, copy Eastern bronze originals. These hourglass stands have conical bases, narrow waists ornamented with two rounded swellings, and low, broad cones above, which served to hold the cauldrons. Similar stands are pictured on Assyrian reliefs of the late eighth and early seventh centuries; actual bronze stands of this shape were found in later Orientalizing tombs in Etruria and Latium; some of them undoubtedly were imported from the East; others are Etruscan imitations.

Evidence for a continuing Greek element in the Bocchoris Tomb is furnished by the two painted vases, local imitations of Protocorinthian pottery. The Villanovan tradition, already noticed in the technique of the goldwork for this tomb, can also be seen in five bronze fibulae in the shape of Geometric horses, for all the world like the horses of the tripods of Archaic II, though here two have riders who lift their arms skyward, and three are mounted by crouching apes—a sure sign of the new interest in the East. The superb impasto cauldrons and beaked jugs are also in the Villanovan tradition; the sharp fluting which decorates their bodies is characteristic of this period, a bold and handsome ornamentation that we have already seen on the helmet of the contemporary bronze head from Vetulonia (Pl. VI) and can admire again on a beaked jug in New Haven (Pl. IV*b*). Such jugs, with rounded bodies, tall necks, and sky-pointing spouts, seem to be a specialty of Tarquinia; their ancestors may have been designed in Hittite Anatolia, but their

great popularity in Etruria coincides with the early Orientalizing period, when the finest impasto vases were made, just before the invention of true bucchero.

BUCCHERO

Bucchero (Pl. XIV) is a fine wheel-made pottery fired so that the oxygen that reaches the clay is insufficient to turn the iron in it to red ferric oxide but instead turns it to black ferrous oxide. The technique is ancient in Anatolia but may perfectly well have been discovered independently in Etruria, just as it was rediscovered in the Santa Clara pueblo in Arizona within the present generation. Many of the shapes of early bucchero vessels are the same as those of impasto vases of Archaic II. One (Pl. XIV*b*), a cup with a high-swung ribbon handle on a conical foot, is a variant of a Greek drinking cup, the kyathos; another (Pl. XIV*a*), which appears in bronze as well as in bucchero, is of Phoenician origin. The body is hemispherical; the long neck, a tapering cone diminishing to a very small mouth; generally the lip is trefoil; here it is modeled in the shape of a snarling lion's head; the vertical handle runs from the lip to the widest part of the body.

The Bocchoris Tomb contained no true bucchero, and though its gold ornaments were decorated with little rows of lions, these had neither the breadth of design of the pair of winged lions in low relief that pace round the inside of the bucchero kyathos (Pl. XIV*b*); nor the sinister humor of the lions incised on the body of the jug, a human leg dangled negligently from their jaws (Pl. XIV*a*); nor yet the elegant, formal ferocity of the charming lion's head that crowns this oenochoë.

The lion as a subject in art took possession of the imagination of the West in the Orientalizing period—he stalks, crouches, and snarls through the art of Greece and Etruria as he never did there in real life.

WRITING

Another characteristic element of the Orientalizing period which the Bocchoris Tomb does not illustrate is the knowledge of writing. The conical foot of the kyathos with the refined and innocent winged lions (Pl. XIV*b*) carries an inscription in an archaic Greek alphabet, incised

from right to left in a spiral beginning at the bottom, *"naceme uru ithal thilen ithal igeme mesnamertancina mulu."* This is the non-Indo-European language of the historic Etruscans, first written down in the period of the princely Orientalizing tombs of Archaic III, very few of which are without some inscribed object. This cup comes from the Tomb of the General in Vetulonia, one of the late circle tombs whose material is contemporary with that of the wealthiest tombs of Archaic III—the Regolini-Galassi at Cerveteri and the Barberini and Bernardini at Palestrina in Latium.

The problem of the origin of the Etruscan language and the problem of the alphabet in which it was first written are not the same, though they are often confused. Whether the language which appears in writing for the first time in the era of the great Orientalizing tombs was already the language of the earlier Villanovan inhabitants of Etruria or whether it had only recently been introduced with a new wave of settlers from the East cannot be determined by the inscriptions alone. There are no inscriptions in Villanovan graves nor in the earliest graves of the Orientalizing period, such as the Bocchoris Tomb at Tarquinia and the earlier circle tombs at Vetulonia and Marsiliana. The fact that the Tomb of the General at Vetulonia, from which the inscribed bucchero kyathos comes (Pl. XIV*b*), contained a cremation burial and the related fact that Chiusi, a site which provides us with a very large number of Etruscan inscriptions, always maintained the old Villanovan practice of cremation argue for the theory that the Villanovans spoke Etruscan. On the other hand, the inscriptions on the Lemnian stele of the late seventh century suggest that the Etruscans of Italy still had close relations on Lemnos at that time (see Introduction).

In any case, the people of Etruria learned to read and write about the middle of the seventh century B.C. The Faliscans and Latins seem to have learned at about the same time, and the Etruscans were apparently their teachers, since they borrowed the Etruscan alphabet. The Etruscans themselves seem to have learned their letters from Cumae, with a few additions (see chap. ix). If they came from the East at the beginning of the seventh century B.C., they were still illiterate when they arrived.

THE ETRUSCANS

TUMULI

One reason for suspecting that the Etruscans of the seventh century were not the same people as the Villanovans of the ninth and eighth is the change in the style of burial. This does not refer to the change from cremation to inhumation which, one must remember, also happened in Athens during the eighth century, evidently without any change in the population, nor even to the change from the well tombs of Archaic I to the trench tombs of Archaic II and from them to the little chamber tombs of late Archaic II and early Archaic III. One can argue, as many archaeologists do, that one form developed out of another and that it was largely a question of the amount of wealth to be buried with the dead that determined the size of the grave. Certainly some late cremation burials at Tarquinia are found in trench tombs, as they are at Vetulonia; and one, at least, was found in a corridor tomb (a primitive chamber tomb). In this tomb the ashes of a man were placed on the floor, while the body of a woman lay on a bench running along the side wall of the chamber, evidence for the use of both burial rites in a single family but unfortunately no proof that the lady was an Etruscan and the man a Villanovan.

But in the middle of the seventh century something new was added to the chamber tomb—a monumental tumulus. The tombs were now covered with a great mound of earth, on the top of which stood the funerary monuments of the family buried there. Often, especially at Cerveteri, the tumulus covers more than one tomb. The base of the mound is a drum built of masonry or carved out of the soft tufa and often ornamented with moldings. There are steps leading to the slope of the tumulus, which apparently held an altar as well as the monuments on top. At Tarquinia about one hundred tumuli are still visible (in 1830 there were more than six hundred); the largest of these also had, at one time, a stone kerb. There are two famous tumuli at Vulci, the Cucumella and the Cucumelletta; and at Vetulonia, in addition to the circle tombs, there is a handsome example, the Pietrera tumulus, with a single grave chamber whose roof was a corbeled dome. Another tomb of this type has recently been excavated at Quinto Fiorentino,

near Fiesole. There are many tumuli at Populonia on the coast, some small, others of considerable size. Here, too, there is a stone kerb of carefully shaped blocks, and each tumulus covers a single tomb.

The shape and number of the tomb chambers, the size and construction of the tombs, vary from city to city; but the tumuli present a constant image, repeated everywhere. Whoever has seen the great tumulus fields of Anatolia—at Gordium, or Sardis, or Pergamum—cannot fail to be struck by the resemblance between these and the tumulus fields of Etruria, and such tumuli do not appear elsewhere in the Mediterranean during the Orientalizing period—there are none in Greece, or in Italy outside Etruria itself. Their presence in Etruria ought to mean more than the fashionable imitation of Eastern styles in the far West.

THE REGOLINI-GALASSI TOMB

One of the earliest and richest of these tumulus burials is the Regolini-Galassi Tomb at Cerveteri; its material is in the Museo Gregoriano of the Vatican. The tumulus was intended for a single burial chamber, but at a later period five other chamber tombs were added on the periphery. The central tomb originally consisted of a long narrow chamber half-carved out of the living tufa, the upper part of the walls and the roof built of huge stone blocks. The roof is a corbeled vault. The chamber was originally reached by a sloping corridor (dromos), with a large, shapeless niche hollowed out of the tufa on either side, just in front of the door of the tomb proper. This is the normal plan of a chamber tomb at Cerveteri and elsewhere—dromos, niches, tomb chamber—though the chambers became more elaborate and more numerous with time, and the niches were enlarged and given architectural form (see chap. viii).

The dromos of the Regolini-Galassi Tomb was roofed over shortly after the tomb was built, and then it too was used as a burial chamber. There were three people buried in this tomb: a woman with the Etruscan name Larthia in the inner chamber, presumably the lady for whom the tomb was made originally; a man, cremated and buried in an ash urn in the right-hand niche; and another man, an inhumation burial like the lady's, in the converted dromos.

THE ETRUSCANS

To judge from her treasure of golden jewelry, Larthia was a woman of importance, a princess or a priestess. Her most spectacular ornament was a gigantic gold fibula, a monstrous version of the old-fashioned disc fibulae of Archaic I. The great disc, shaped like the moon in the third quarter, is bordered by two chains of palmettes; its center carries five slender lions pacing in an empty field. These figures are worked in repoussé with details picked out in granulation, a technique that, like filigree, first appears in Etruria during Archaic III. The bow of the fibula is also covered with rows of repoussé lions, and seven files of little ducks ride between the rows. Equally hideous and equally a masterpiece of the goldsmith's art is a great pectoral of gold, ornamented with designs in repoussé and lined with bronze, like the pectorals from the Bocchoris Tomb and the Warrior's Grave at Tarquinia. Here, Orientalizing and Geometric motifs are associated again—the old Villanovan zigzags and beading; the new Orientalizing palmettes, sphinxes, lions, winged lions, winged horses, winged goddesses, and an heraldic group, very common in the Orient, of a man stabbing two rampant lions. A pair of bracelets, also in the combined repoussé and granulation technique, show the Mistress of Animals, this time between two rampant lions, and a group of three women seen from the front, wearing long dresses and Hathor locks, clasping hands in front of a row of palm trees. In addition to many other gold and silver pins, bracelets, necklaces, earrings, and ribbons, there were a large number of small gold plaques, once sewn to the lady's dress, as in the Bocchoris Tomb.

Besides her jewelry, Larthia had a silver table service inscribed with her name, including an oenochoë of the Phoenician shape illustrated here on Plate XIV*a*. Some of the cups imitate Greek shapes; one amphora is purely Villanovan. There was also an ivory pyxis with a single carved band showing a sphinx with a palmette on her head, very like the sphinx of Plate IX*a;* a man in a chariot, very like the figure on the pyxis in Plate X; and a man between rampant lions. And Larthia also had her dice, not just a pair, but five. It is quite common to find dice in the tombs of wealthy ladies in Etruria, and one remembers Herodotus' story (1.94) that the Lydians invented dice and other

games to distract themselves from the famine that finally drove them west to Italy. A bronze cauldron with six griffin's heads and parts of the sheathing of a throne, as well as many other smaller bronze vessels, were also found in the inner tomb chamber.

The cremation burial in the right-hand niche had far less tomb furniture; the impasto ash urn is a great ribbed jar with a round body and domed lid surmounted by the figurine of a horse; since remains of a chariot were also found in this niche, one may presume that the latter-day Villanovan buried here had been a lover of horses. He also loved Greek pottery, for more than a dozen Greek cups were buried with him, ten of them Protocorinthian skyphoi. There were also thirty-five little bucchero figures of mourning women, very like the mourners on contemporary ash urns from Chiusi (Pl. XIII).

The niche with the cremation burial had been walled off before the last burial was made, in the dromos of the tomb. This burial was that of a warrior, whose body lay in state on a bronze bed with a four-wheeled car beside it, presumably the funeral car itself. Four handsome bucchero figures of women, evidently the caryatids which supported a stemmed cup, were found near the bed. Eight parade shields were nailed to the walls of the dromos; they are in the old Villanovan repoussé technique, like the shield from the Warrior's Grave at Tarquinia, and some are decorated entirely in the old Villanovan patterns, though the central bosses of four other (wooden or leather?) shields are ornamented with rosettes, palmettes, and rampant lions. The warrior's weapons are buried with him too—an iron sword and ten bronze javelins, as well as two great cauldrons with lion protomes and a wheeled perfume brazier whose purpose, if not its shape, is the same as the wheeled bull-bird of Archaic II from Tarquinia (see chap. ii).

The warrior's table service was put in the left-hand niche—three silver-gilt Phoenician bowls and the lining of a fourth, a cup in the same style, a purely Villanovan amphora decorated with repoussé bosses and beading, six other bronze bowls, a huge terracotta cauldron decorated with a frieze of painted animals, and a small bucchero flask with an inscribed syllabary.

This group of burials presents us with a bewildering jumble of old

THE ETRUSCANS

Villanovan tastes and practices, contemporary Greek refinements, superb importations from the Near East, and more or less happy local adaptations of the new Eastern style and motifs. It cannot be much later than the Bocchoris Tomb or even the Warrior's Grave of the end of Archaic II. Whatever the relationship of the three people buried here (I should like to suppose an Etruscan princess with a Villanovan consort and their son, the warrior, buried in the dromos), their juxtaposition in this tomb indicates a certain and rapid merging of two contrasting cultures.

SCULPTURE

Another reason to suppose that Villanovans and Etruscans were not, at first, a single people suddenly influenced by a new wave of fashions from the East is that for at least a generation after the beginning of the Orientalizing period there were two very different sculpture styles current in Etruria. We have seen at Tarquinia, at the end of Archaic II, the beginning of a geometric figure style under Greek influence (Pl. V*a*); and its development at Vetulonia, in the early years of Archaic III (Pls. V*b*, VI, VII).

The new figure style was completely different. Like writing and bucchero, it appears first in the great tombs of the Regolini-Galassi period, not at the beginning of Archaic III, and its origins are unmistakably the treasures imported from the East—bronzes from northern Syria or Anatolia, Syrian and Phoenician ivories, silver-gilt Phoenician bowls, Phoenician or Egyptian faïence. These first supplied the motifs that characterize the Orientalizing style—the rosettes, guilloche, palmettes, lions, winged monsters, and the like—found on the goldwork of the Bocchoris and Regolini-Galassi tombs. They also supply the models for the first sculpture style in central Italy that is monumental.

The magnificent head of a bronze siren (a bird with a human head and arms) from the rim of a cauldron found in the Bernardini Tomb at Palestrina (Pl. VIII) may be taken as an example. The aesthetic of the head is far removed from that of the wiry geometric bronzes of Archaic II and III (Pls. V, VI, VII). Here the forms are heavy and rounded and inclosed by a single flowing line that makes a compact

54

mass of the whole and gives it an effect of aloof dignity surprising in so small an object (it is only 7 centimeters high). The broad, shield-shaped face is dominated by enormous eyes, emphasized by the continuous broad rim of the lids. The pronounced ridges of the eyebrows sweep from the root of the nose to the temples. The large nose, which continues the sloping line of the low forehead, is boldly curved and delicately modeled; the cheekbones are high and pronounced; the neat little mouth has sharp lips with the suggestion of a smile, and the chin is small and rounded. The whole is framed by the smooth, heavy hair which clings to the round skull and bells out in a soft roll that touches the top of the shoulders.

Two other cauldrons, one with sirens very like this, the other with bearded Janiform heads, were found in the Circle of the Cauldrons at Vetulonia. Bronze cauldrons with siren heads have also been found in the Near East and in Greece—one, whose sirens are very like the Bernardini head, in a royal tomb of the late eighth century at Gordium. There is a current theory, not definitely proved, that siren cauldrons were of Urartian make; the heads of the Bernardini and Vetulonia cauldrons were certainly imported from somewhere in the Near East. But the cauldrons from Italy have, in addition to the small, compact, hieratic human heads that ornament their rims, great lion or griffin protomes springing from the shoulders, completely dwarfing the sirens and apparently products of an entirely different aesthetic. These lion and griffin protomes are common in Greece and rare in the Orient; indeed, the cauldron griffin is a Greek monster, though his remote ancestors may have been Oriental. Whether the cauldrons in Italy were assembled from Anatolian and Greek elements after they had been imported or whether, as Professor Rodney Young believes, they are Oriental, of a type that has simply by chance not yet been found in the East, remains to be seen.

The head from the Bernardini cauldron (Pl. VIII) is of cast bronze, in a style completely foreign to the competent Villanovan bronzeworkers who produced the Geometric figurines of Archaic II and III. A bronze sphinx from the same tomb as the cauldron (Pl. IX*b*) illustrates some of the difficulties the native craftsmen had when they tried to

work in the new style. The head begins well: low, rounded skull; shield-shaped face; great, bulging eyes, set off by the ridge of super-cilious eyebrows which spring from the root of the nose; big, jutting nose; sharp mouth; narrow chin. The enormous ears are a happy thought, partly decorative and, perhaps, partly characteristic of a mon-ster, as shown in the figures from the Circle of the Bambagini (Pl. VII). The long neck is thick and massive, but now the geometric tradi-tion becomes too much for the sculptor; the body, legs, and tail are reduced pretty much to geometric abstractions, and the whole figure is an open design in the old Villanovan manner. Not that this amiable, wingless sphinx with his great curling tail is not a delightful figure. He is also a very uncommon monster, though the wingless sphinx is known in Syria and one bronze example has been found at Olympia in Greece. The Egyptian wingless sphinx is the lion with head of a king; such royal sphinxes do not appear in Greece or Etruria, where the common sphinx, as in Syria and Palestine, had the body of a dog or lion, the wings of an eagle, and the head of a woman.

The ivory sphinx from Cerveteri (Pl. IX*a*) is of this Syrian type. It was probably the handle of the lid of a cylindrical ivory pyxis found in the debris of the Sorbo Cemetery at Cerveteri, near the entrance to the Regolini-Galassi Tomb (Pl. X). The forms of the head and the body are part of the new repertory of Orientalizing sculpture; the heavy, round head with its prominent nose and Hathor locks that curl down behind the ears looks more like a Syrian than a Phoenician head, in spite of the Phoenician palmette balanced on top. But the figure and the pyxis were made in Etruria, and their details are eclectic, though they all come from the East and most of them from northern Syria.

Ivory pyxides were a northern Syrian specialty; their walls are deco-rated with bands of low relief which show fantastic or real animals, processions, hunts, or battles. The Phoenician palmette in the upper frieze (Pl. X, *left*) appears in Syria as a true palm tree, flanked by ladies or sphinxes. The procession of chariots in the middle frieze (Pl. X) derives from a Syrian lion hunt, where the long, trailing robes of the charioteers can also be seen. The beautiful stag on the upper frieze seems out of place among the stocky little figures of the other two; it is

more realistic and more graceful. The half-crouching attitude with head turned back is old in Egypt, and something like it appears on ivories of Assyrian style from Nimrud. The stag was worshipped in Anatolia from a very early period; he appears on one of the Syrian pyxides from Nimrud and comes to Etruscan art only with the other animals of the Orientalizing repertory.

The use of ivory in Etruria was in itself a new fashion from the East. Almost all the wealthy tombs of the mid-seventh century contain ivories, some imported, like the Phoenician ivories in the Bernardini Tomb at Palestrina; the majority, like this pyxis, were made in Etruria by Eastern craftsmen or their native apprentices. A figurine from the Circle of the Fibula at Marsiliana d'Albegna (Pl. XI) is another Etruscan ivory of this generation. It represents a nude female holding a cup under the right breast and clasping the left breast with the left hand, one of the gestures of the Oriental fertility goddess. The hair is worn down the back in the long, heavy braid characteristic of northern Syria and Anatolia (see chap. ii). The small eyes are outlined by a continuous ridge, like the huge eyes of the bronze siren from the Bernardini Tomb (Pl. VIII); and the big ears are not unlike those of the wingless sphinx from the same tomb (Pl. IX*b*). The modeling, particularly of the lower torso and legs, is extremely subtle and delicate. But the proportions of the figure—the big, round head on its massive neck, the exaggeratedly long torso and spindly arms, the rounded hips and short legs—go back to the canon of the Villanovan bronzes of Archaic II (Pl. V*a*). Although the new Orientalizing closed outline is at least approximated in this ivory, it is not really achieved; there is too much space between the legs and between the arms and the torso. Even the sharply pointed elbows have a distinct Villanovan flavor and recall the bronze water carrier from Vetulonia. (Pl. V*b*).

The figurine was loosely wrapped in a sheet of gold foil, some of which still clings to the back of the head and shoulders; the excavation report makes clear that this was not originally a golden dress or shawl, as it is often described. This figurine was not part of some larger object, as so many of the ivory figures from Etruscan tombs are, but an isolated figure and therefore of ritual significance. Here again is the Oriental

fertility goddess, buried in the tomb as a protection for the dead and perhaps as a symbol of rebirth (see chap. ii and Pls. V*a* and VII).

The new Orientalizing figure style was employed with marked success in terracotta. The lion's head that crowns the bucchero oenochoë (Pl. XIV*a*) has the closed outline, the formal elegance, and even the enormous eyes of the Oriental bronze siren (Pl. VIII). The bucchero figures of women from the Regolini-Galassi Tomb show the whole figure in a solemn, hieratic pose whose closed outline is completely Eastern; the best of these—the four caryatids from the dromos—have full, rounded forms and shield-shaped faces whose modeling is very like that of the bronze siren.

The finest Etruscan terracottas of this period are three seated figures from a tomb at Cerveteri. Each of these heads has the low, rounded skull and convex profile of the bronze siren; and the shape of the face, broad at the temples and narrowing to a rather delicate, rounded chin, is very similar. The eyebrows sweep boldly from the root of the strong nose to the temples, but the eyes, though almond-shaped, are not over-large nor emphasized with heavy lids, and the mouth is larger, fuller, and more naturally modeled, with a rather narrow, slightly cleft upper lip and a full, soft underlip. In these terracottas, again, the closed outline of the body and the immobility of the pose are Eastern. Though the wide-set, stubby feet and open right hand might seem to be legacies from the Italic tradition, even these can be compared with the feet and hands of the gigantic seated figure from Tell Halaf, herself a funerary statue.

A head of black impasto from a canopic jar from the neighborhood of Chiusi (Pl. XII) belongs to the same Orientalizing tradition as the Caeretan terracottas. The low, rounded skull, the sweeping curve from forehead to nose tip, the pronounced ridge of the eyebrows, arching over the long, almond eyes, the full cheeks, and rounded chin are very similar; the long ears are handsomely modeled and frame the face more gracefully than the big ears of the sphinx from the Bernardini Tomb (Pl. IX*b*) or those of the ivory figure from Marsiliana (Pl. XI). The hair is brushed straight back and cut short at the nape of the neck, where it flares like the hair of the male figure from Cerveteri. Nose,

lips, and chin are sharper, and the jaw is more powerful; the slight parting of the lips gives the head an alert and lively expression, emphasized by the tilt of the head to the right and the lifted chin. This is the Orientalizing canon of beauty, as peculiar and unmistakable as the Villanovan had been before it (see chap. ii and Pl. V*a*). The wingless sphinx from Palestrina (Pl. IX*b*) reproduces the canon in a more primitive manner.

The impasto head must be counted a portrait, though probably not a likeness; it is the cover of an ash urn from the Chiusi district, where the practice of cremation continued uninterrupted from the earliest Villanovan settlement and where, in the Orientalizing period, the ash urns were often transformed into images of the dead by the addition of a head and sometimes arms, clearly a development from the earlier practice of covering an ash urn with a helmet (Pl. II). These heads are to be counted among the ancestors of the Roman portrait bust.

There is nothing inept or provincial about the modeling of this head; it is as assured and sophisticated a work in the Orientalizing style as any piece from the coastal cities of Etruria, though it was manufactured far inland. Most of the other terracottas from the same region are considerably more provincial.

A few ash urns of this period are crowned with complete figures, presumably representing the dead, while the shoulders of the urns are decorated with double rings of mourning men and women and protomes of griffins (Pl. XIII), terracotta imitations of the bronze griffins on some of the cauldrons from the great Orientalizing tombs. The mourners are little bell-shaped figures, fired separately and slipped over pegs. The women beat their breasts or clasp their arms at the waist; the men wear long plaid garments which reach from neck to feet and completely cover the arms or occasionally show one forearm emerging, as if through a slit, to lie across the breast. The women's usual dress is more elaborate (Pl. XIII*a*); short-sleeved and reaching only to the ankles, it is generally belted at the waist; and a short rectangular cloak of the plaid material hangs from the shoulders to the hem of the skirt (Pl. XIII*b*). This is the costume of the bucchero caryatids from the Regolini-Galassi Tomb; the plaid material is like that worn by the

THE ETRUSCANS

seated terracotta figures from Cerveteri; it is an Oriental stuff worn by many figures on the Syrian ivory pyxides from Nimrud as well as on other Oriental monuments. And though the plaid material appeared in Greece, too, in the seventh century, it was never so popular as in Etruria.

The lady from Chiusi wears the long Syrian braid (Pl. XIII*b*), here obviously padded and covered with some elaborate binding; her ears are pierced for earrings, and she wears a heavy bracelet on her left upper arm. Her long, flat face has the shield-shaped outline of the Bernardini siren (Pl. VIII), but only the outline. The eyes are carefully drawn blank circles; the nose, a jutting pyramid; the mouth, a tiny slit—features reduced to a childish shorthand. The big ears framing the face echo, to some extent, the handsome ears of the impasto head (Pl. XII*b*); otherwise, there is almost no relationship between the two terracottas. Yet they must be contemporary and were made in the same region. Here, as in the bronzes of this period, the simultaneous presence of two sculptural traditions is apparent; the head (Pl. XII) was made by someone trained in the new Orientalizing school; the standing figure (Pl. XIII) by a tyro gallantly trying to imitate it. At least the new costume has been faithfully reproduced, and except for the stiffly outthrust right arm, the closed outline has been mastered.

THE ETRUSCAN FIGURE STYLE

In the generation after that of the great tombs—roughly, the last quarter of the seventh century—the old Villanovan and the new Orientalizing styles fused to produce a new figure style, the first that can honestly be called Etruscan. One of the first of these Etruscan figures is a small votive bronze from Arezzo (Pl. XV*c*). Actually, it must still belong to the Regolini-Galassi period, since it represents a girl wearing the costume of that time, the short-sleeved, ankle-length dress belted at the waist and the short, rectangular cloak hanging from the shoulders. The hair is very elaborately dressed; the back part is drawn into a heavy braid that forms a hump on the shoulders and hangs to the hem of the skirt; the front is brushed forward in a bang from a transverse parting that runs from ear to ear over the crown, while a cork-

screw curl on either side of the face in front of the ear hangs to the shoulder. This arrangement of the hair is, again, Syrian. The seated statue from Tell Halaf has similar corkscrew curls, and they appear on a number of Syrian ivory heads from Nimrud, in one case, at least, worn with the long pigtail. Such an arrangement is never found in Greece; its appearance on this little bronze and others from Etruria looks like more than a simple copy of an Oriental object. It is too carefully reproduced with too much understanding to be anything but a contemporary Etruscan fashion. And if Etruscan ladies of the mid-seventh century were wearing their hair as Syrian ladies did somewhat earlier—the Syrian ivories from Nimrud are dated between the end of the ninth and the end of the eighth centuries—it looks as though they must have learned the fashion in the East and brought it with them as part of their heritage.

The modeling of this little figure is still primitive; the big head with its long face above the strangely flattened body recalls the Vetulonian bronzes of early Archaic III (Pls. V*b* and VII), though the convex profile and bulging almond eyes belong to the Orientalizing repertory (Pls. VIII and IX*b*). The modest bend of the head is new; so is the pose of the arms, the upper arms parallel to the body, the forearms lifted to the horizontal and thrust forward. This is the so-called Hittite pose frequently seen on Hittite and Syrian bronzes, and it is character-istic of all the small Etruscan bronzes of the late seventh century. This figure must have carried something in her hands; they are half-closed, the right turned palm down, the left palm up.

The two other bronzes shown on Plate XV are slightly later than the girl with the corkscrew curls and were probably, like her, made in Arezzo, since the male figure (Pl. XV*a*) was found there and both are evidently from a single workshop. These figures are solider; the depth of the head is no longer disproportionate to that of the body; the rounded contours and closed outline of the pair are highly successful. The woman (Pl. XV*b*) wears an all-enveloping cloak pulled in a hood over her head; her forearms are thrust through it as if it were slit. Her heavy braid makes a ridge through the cloak in back; her arms are in the Hittite pose; the right hand grasps a kyathos like that from the

THE ETRUSCANS

Tomb of the General (Pl. XIV*b*); the left is open, palm up, in a gesture of prayer. The modeling of the face is surprisingly like that of the impasto head from the Clusine region (Pl. XII).

The male figure's proportions reflect the Villanovan canon (Pl. V*a*) —big head, long torso, rounded hips, and short, straddled, muscular legs—filled out under the influence of the Orientalizing sense of weight and solidity. His hair is worn in the Orientalizing fashion of the mid-seventh century, longer than that of the impasto head (Pl. XII) but rather like that of the Bernardini siren (Pl. VIII), except that the ears are exposed; and these have the neat doughnut shape of the ears of the earlier warrior from Vetulonia (Pl. VI). The arms are again in the Hittite pose; the right hand still holds the stub of a weapon, and the left originally held another (perhaps a sword and dagger?). The little loincloth which is his only garment seems to be of metal lined with leather. For all that he looks underdressed, this is the Etruscan warrior of the late seventh century, and one must remember that Syrian bronze warriors, who stand in the same Hittite pose, also are bare-headed and wear only loincloths and carry no shields.

The appearance of this figure style may be said to introduce the Etruscans of Italy to history. Whatever their origins may have been and however complicated their ancestry and earlier history, they are henceforth a people with their own traditions of culture and their own aesthetic. What we know of their history as a Western nation begins in the second half of the seventh century, and the distinctive character of their style was first crystallized at the same period.

A Summary of Etruscan History
from Tarquin the First to Augustus

ALTHOUGH Varro, the great Roman anti-
quary of the first century B.C., spoke of Etruscan historical writings
(Censor. 17.6), and the emperor Claudius must be presumed to have
had access to extensive Etruscan chronicles for the composition of his
twenty volumes on the subject (Suet. *Claud.* 42), what little we know
of the political history of the Etruscans in Italy has to be pieced to-
gether from scrappy references in Greek and Roman writings. Greek
historians, beginning with Herodotus, mention isolated episodes in
which Greek states were involved with Etruria; Roman historians pro-
vide a reasonably comprehensive outline of Etruria's relations with
Rome, but there is woefully little information about the internal affairs
and organization and the histories of the individual Etruscan cities and
states. Perhaps the most illuminating picture of Etruria's internal poli-
tics and the way we learn about them is Livy's story of the council of
the Etruscans at Fanum Voltumnae in 403 B.C. (4.61; 5.1) when the
other Etruscan states refused to help Veii against Rome because the
Veientines had not only chosen a king, a form of government at that
time odious to the rest, but an arrogant king, detested throughout
Etruria because he had impiously interrupted the sacred games by with-
drawing the performers, most of whom were his slaves, in anger be-

cause the Twelve Peoples had elected someone else to be priest. Here Livy provides us with the information that by the end of the fifth century the Etruscan states normally had, like Rome, republican governments, that they were separate city-states like the Greek poleis, that these states were organized into a league of twelve cities, which seems to have been primarily a religious organization, one of whose duties was to elect a priest to preside at the sacred games that were held periodically at the sacred grove of Voltumna. Livy emphasizes the fact that the quarrel between the Twelve States and Veii was essentially religious; the Etruscans were, he says, a people above all others devoted to religious rites, and therefore the council refused to help the impious king of Veii against the very real threat of Rome.

Livy's sketch of this petulant and dangerous monarch seems also to emphasize the lamentable scarcity of personalities in Etruscan history. Livy clearly realized that history needs actors as well as actions, and he made every effort to charm living characters out of the dusty annals that were his main sources. His "noble Romans" do quite often come to life, and occasionally his researches turned up something that made it possible to introduce a living Etruscan—the haruspex of Veii (5.15), the villainous schoolmaster of Falerii (5.27), the ingenious magistrates of Arretium (27.24). But in general, what he could report of Etruscan history was no more than a scattering of episodes whose connections with Roman history had preserved their memory in Roman annals; he apparently could not read Etruscan (9.36) and makes no reference to Etruscan sources.

Roman Tradition

Some Etruscans were, of course, an essential part of Roman tradition, and these appear in the pages of Roman history with definite, if not always credible, personalities and stories. The first of these is Mezentius, king of Caere. According to Cato, when Aeneas and the Trojans first came to Latium they had to fight the combined forces of Latinus and Turnus. Latinus was killed in the first battle, and Turnus and his Rutulians then took refuge with Mezentius at Caere and with his help renewed the war. In the course of this, both Turnus and Aeneas were

killed, and the war was finally decided by a single combat between Mezentius and Aeneas' son Ascanius, in which Mezentius was either killed or forced to make a treaty of peace and alliance with the Trojans. Livy (1.2–3) gives a slightly different version of this story. The splendidly sinister Mezentius of Virgil's *Aeneid, contemptor divum,* seems to have been an invention of the poet, though his atheism was suggested by the tradition that he demanded from the Rutulians the first fruits due to Jupiter for himself (Ov., *Fast.* 4.876–900; Macr. 3.5.9–10).

The Roman traditions of the royal family of the Tarquins are considerably fuller and more elaborate, and archaeological evidence shows that they were based, however obscurely, on fact.

The founder of the family was Demaratus of Corinth, a member of the ruling family of the Bacchiadae, who had become a sea trader between Corinth and the cities of the Tyrrhenian coast and who settled at Tarquinia when the revolution of 657 B.C. at Corinth expelled the Bacchiadae and made Cypselus tyrant of the city (Dion. H. 3.46; Liv. 1.34; Plin. 35.43.152; Hdt. 5.92). Demaratus, in the stories of Livy and Dionysius, married an Etruscan woman of noble birth and had two sons, Lucumo and Arruns, both of whom also married high-born Etruscan ladies. Arruns died young, and Lucumo found that his mixed blood interfered with the political career he wanted, in spite of his having inherited his father's enormous wealth. His wife, the seer Tanaquil, persuaded him to move to Rome with all his wealth and household and a great number of his friends, since at Rome all men were welcomed and any stranger could become a citizen (Dion. H. 3.47). At Rome, Lucumo took the name of Lucius Tarquinius; and his wealth, liberality, and tact made him popular with all Rome, not least with the king, Ancus Marcius, at whose death Tarquinius persuaded the Roman people to make him king. He ruled for thirty-eight years (616–578 B.C.).

The story of the Corinthian Demaratus and his Etruscan sons may be no more than legend, but it is a fact that Corinthian pottery—especially the beautiful Protocorinthian skyphoi and oenochoae—became popular in Etruria during the second quarter of the seventh century (see chap. iii), that is, in the generation before the Cypselid coup d'état.

THE ETRUSCANS

Some enterprising Corinthian in the days of the Bacchiadae really did open up a new market for his city's pottery in the Etruscan coastal cities. And just such mixed marriages as that of Demaratus and his Etruscan wife did take place at Tarquinia in the mid-seventh century, to judge from an inscription painted on a late Italo-Geometric oenochoë; the inscription reads "*axapri rutile hipucrates.*" The first word is unexplained; "*rutile*" is an Etruscan proper name; "*hipucrates*" is the Etruscanization of the Greek name Hippocrates. Must this not be "*rutile* (Rutilius), son of Hippocrates"?

The Etruscan name given by Livy and Dionysius to Lucius Tarquinius—Lucumo—was actually a royal title. "*Lucumones reges sunt lingua Tuscorum*" (Serv. *Aen.* 11.178). So, apparently, his supposed name meant literally "a prince from Tarquinia," though the title "*Lucumo*" (*Lauchumni, Lauchumsnei*) was actually used as a family name later in the region of Perugia and Chiusi. The name "Tarquinius," the Latin equivalent of the Etruscan "*Tarchu*" or "*Tarchunies*," does mean "the man from Tarquinia," but in historic times it was the name of a wealthy family of Caere, whose tomb has been found there, and it was to Caere that the last Roman Tarquin and his two younger sons fled when they were driven out of Rome in 509 B.C. (Liv. 1.60).

The reign of Lucius Tarquinius Priscus is described by Dionysius and Livy. His wars were primarily with the Latins and the Sabines who came to their help and, according to Dionysius (3.51), also with certain Etruscan cities, five of which promised to help the Latins—Clusium, Arretium, Volaterrae, Rusellae, and Vetulonia. This is the first appearance in Roman tradition of any of the northern or inland cities of Etruria, puzzling in that it seems unlikely that Arretium or, indeed, any of these cities should have been concerned with the fate of the Latins in the late seventh century B.C.

At all events, Tarquinius Priscus, according to Dionysius, defeated the Etruscan allies of the Latins and Sabines and devastated the territories of Veii and Caere. The Etruscans, forced to sue for peace, sent him, as tokens of submission, "the insignia of their own kings: a crown of gold, an ivory throne, a sceptre surmounted by an eagle, a purple tunic embroidered with gold, and a gold-embroidered purple cloak like

that worn by the kings of Lydia and Persia, except that it was not rectangular, but semicircular—what the Romans called a toga. . . ." Some authorities say that they also brought to Tarquin twelve axes, taking one from each city, for it seems to have been an Etruscan custom for the king of each city to be preceded by an attendant carrying an ax in a bundle of rods (fascis) (Dion. H. 3.61).

These insignia of Etruscan royalty, however they may have first come to Rome, remained throughout Roman history the symbols of Roman dignity: the ivory throne (the sella curulis) was the prerogative of men of magisterial rank; the twelve lictors with their fasces were the attendants of the consuls; the gold crown, the sceptre, and the embroidered purple tunic and toga were the dress of the triumphing general, as they were the dress of Jupiter Optimus Maximus himself. The semicircular toga was, in fact, the most important badge of a Roman citizen; foreigners were not allowed to wear it nor could Romans in exile, while Roman citizens were expected to wear it on all public and official occasions, even in the heat of summer. And these insignia really were taken from Etruria by the Romans; an ax encased in a bundle of iron rods was found in an early tomb at Vetulonia, and a number of sarcophagi and ash urns of the Hellenistic period from Tarquinia and Volterra show the dead man accompanied by lictors carrying bundles of rods. To name only a few examples, the semicircular toga is worn by a late Archaic bronze figure found near Florence (Pl. XXV*b*), by a Classical bronze (Pl. XXXIX*b*), and by a figure on a Faliscan red-figure vase of the fourth century (Pl. XLII), as well as by the attendants on a fourth-century sarcophagus from Vulci (Pl. XLIII), one of whom also carries the curule chair (see chap. vi).

Both Dionysius and Livy describe the transformation of the Latin town of Rome into an Etruscan city under the first Tarquin. He is said to have laid out the Circus Maximus and instituted the annual celebration of the great games (Ludi Magni or Ludi Romani) with boxers and race horses brought from Etruria; these games must have been like those disrupted by the king of Veii two centuries later at Fanum Voltumnae. Etruscan horse races, chariot races, and wrestling matches are painted on the walls of tombs at Tarquinia and Chiusi, and on the late

Archaic bronze situla in Providence (Pl. XXX*a*) a pair of boxers are contending for prizes—a cauldron on a high stand and a curious duck-headed object, perhaps a firedog.

According to Livy, the first Tarquin also started to build walls around the city, drained the marshy lowlands between the hills of the city where he laid out the Forum Romanum, and laid the foundations for the Temple of Jupiter on the Capitoline Hill.

However, some of these public works are also credited to Tarquin's grandson, Lucius Tarquinius Superbus, the last king of Rome. Livy (1.55) tells how Tarquinius Superbus had the site for the temple deconsecrated and rededicated to Jupiter and how on his projects he employed not only laborers from Etruria but the Roman plebs themselves, who objected, without effect, to this conscript labor—not that they minded building temples so much, they said, but when it came to making seats for the Circus Maximus or digging ditches . . . !

Both Livy and Dionysius credit the younger Tarquin with building, or at least completing, the Temple of Jupiter. According to Varro, however (Plin. 35.45.157), the temple was completed by Tarquinius Priscus, who also set up in it the first cult statue of a god at Rome, a terracotta statue of Jupiter made by an Etruscan artist, Vulca of Veii. Before its consecration, the Romans had worshipped their gods without images (Aug. *Civ. Dei* 4.31).

Varro apparently believed that the temple and its cult statue were Etruscan innovations, brought to Rome by an Etruscan king. But the foundations of the temple on the Capitoline are actually older than any known temple remains in Etruria, and there are no statue types in Etruria that are recognizable divinities from the end of the Orientalizing period, in the third quarter of the seventh century, till the height of the Archaic period, in the third quarter of the sixth. About 530 B.C., representations of the gods began to appear in Etruria: Mars, Minerva, and Hercules came first (Pls. XXIV and XXV*a*), and by the end of the century the great Latin gods, Jupiter, Juno, and Diana, can also be recognized in small bronzes. In every case, the type is borrowed from Greece; in two of them, Hercules and Jupiter, by way of Cyprus. Archaeologically, therefore, the traditional reign of Tarquinius Super-

bus (534–510 B.C.) is a more likely time for the first cult statues to have been set up at Rome than that of Tarquinius Priscus (616–578 B.C.).

Tarquin the Proud is also said to have fought a series of wars with Rome's Latin neighbors and to have made Rome the head of a Latin League. The text of a treaty between Rome and Gabii, concluded under him, was preserved till imperial times in the Temple of Semo Sancus at Rome (Dion. H. 4.58.4), and the first treaty between Rome and Carthage, which Polybius (3.22) dates in the first year of the Roman Republic, 509 B.C., did in fact recognize Rome as the head of a league of Latin cities.

It may be, of course, as some historians believe, that the traditions of the two Tarquins are mere reduplication and should all be assigned to the reign of a single king, late in the sixth century. But Rome was really too thoroughly Etruscanized for this to have been the work of a single generation. According to Roman tradition, there were three Etruscan kings—Lucius Tarquinius Priscus, Servius Tullius, and Lucius Tarquinius Superbus—and they ruled Rome for more than one hundred years. Etruscan dynasties in other cities outside the borders of Etruria lasted as long or longer.

Servius Tullius, in Livy's story (1.39–40), was the son of a slave woman, reared as a prince and married to a Tarquin princess, but, according to a speech of the emperor Claudius, preserved in an inscription at Lyons, he was originally an Etruscan hero named Mastarna, a friend of the warrior Caeles Vibenna, for whom the Caelian Hill was named. A famous wall painting of the fourth century B.C. from the François Tomb at Vulci shows Mastarna (Macstrna here) releasing Caile Vipinas (Caeles Vibenna) from bonds, while four armed men, among them an Avle Vipinas (Aulus Vibenna), presumably the brother of Caile, attack and overcome four men who have just been roused from sleep—one of them is Cneve Tarchunies Rumach, Gnaeus Tarquinius of Rome. This Etruscan record of an episode of Roman history passed over in silence elsewhere has been made startlingly vivid by the discovery of a fragment of bucchero pottery of the second half of the sixth century among the dedications at a sanctuary in Veii, inscribed with the name

THE ETRUSCANS

"Avile Vipiiennas," possibly the hero himself, certainly one of his family, in spite of the spelling.

Livy's story of the rape of Lucretia, the downfall of the Tarquins, and the founding of the Roman Republic is well known: the Latin nobles of Rome, the patricians, rose against the Etruscan dynasty and set up an oligarchical government insured against becoming a dynastic tyranny again by a duality of leadership and yearly elections. The Tarquins fled to Cerveteri and appealed to Veii and Tarquinia for help; Veii, as the nearest Etruscan neighbor of Rome, was delighted to attack her, and Tarquinia felt a family pride in the Tarquins, but the new Roman state succeeded in driving both armies off. At this point, Tarquinius Superbus asked Lars Porsenna, prince of Clusium, for help, and he succeeded in defeating the Romans and forcing them to come to terms, though the Tarquins were not restored to power and the Roman Republic retained its independence.

There are many stories about Lars Porsenna; he appears in Roman tradition as a model of chivalry and generosity; it is reported that he gave the contents of his camp on the Janiculum to feed the starving people of Rome. His tomb at Clusium was described in detail by Varro, though his report seems to have been based on hearsay, and Pliny (36.19.91) was very doubtful that Varro's description could be believed: a rectangular stone base, 300 feet on a side, 50 feet high and enclosing a labyrinth, surmounted by three stories of pyramids reaching to a height of some 550 feet and hung with bells. No wonder Pliny had his doubts, though tombs with pyramidal and conical elements rising from stone bases are actually found in central Italy. A late republican tomb on the Appian Way near Albano, the so-called Tomb of the Horatii, has four such towers on a rectangular base, and the huge tumulus of the Cucumella at Vulci had at least two.

Lars Porsenna's Clusium is generally supposed to have been the modern town of Chiusi, in the hills at the southern end of the Val di Chiana, and it is true that that ancient and rather provincial city suddenly underwent a great wave of Hellenism at the end of the sixth century. A flourishing bronze industry that produced vessels and statuettes of great charm, closely resembling Greek works from southern Italy

and Campania, appeared at the end of that century and continued through the first half of the fifth; the finest reliefs on the limestone cippi from the chamber tombs of Chiusi date from the late sixth century; several handsome painted tombs date from the first half of the fifth. Some great increase in Chiusi's wealth and power must have fostered this Hellenizing process, which coincides in general with the traditional dates of Porsenna. But it would be more convenient in many ways if Porsenna's Clusium were Polybius' and Virgil's Clusium-by-the-Sea, since all the other Etruscan cities whose involvement with Rome and the Tarquins is recorded seem to have been on or near the coast.

THE ETRUSCAN EMPIRE: LATIUM

Rome was not the only Etruscan principality beyond the borders of Etruria. To be sure, the rich Orientalizing tombs at Palestrina may have been the burials of Etruscanized Latins rather than Etruscans, since they have no tumuli, unlike their contemporary, the Regolini-Galassi Tomb at the Etruscan town of Cerveteri. But the very name of Tusculum in the Alban Hills suggests that it had an Etruscan foundation, and though the Tusculans themselves claimed descent from Telegonus, a son of Ulysses and Circe, Tusculan princes intermarried with, and were supporters of, the Tarquins.

THE LAND EMPIRE TO THE NORTH

Northward, Etruscan settlers moved into the Po Valley (Polybius 2.17); according to Livy (5.33–35), they once held the whole valley from the Apennines to the Alps, except for the territory of the Veneti in the northeast, and were settled there by the time of Tarquinius Priscus. They founded twelve cities north of the Apennines to match the twelve great cities of Etruria, and their control of the Po Valley extended at least as far west as the region of Milan and Pavia, since their first great battle with the Gauls from beyond the Alps was fought on the banks of the Ticinus.

There is no archaeological evidence, however, that the Etruscans reached the Po Valley as early as the seventh century B.C. At Bologna, which the Etruscans called Felsina, the earliest Etruscan object—a little

bronze woman with a forbidding expression—cannot be dated earlier than the middle of the sixth century, and the earliest imported Greek vases are dated about 530 B.C. Felsina was established on the site of an ancient and flourishing Villanovan settlement whose cemeteries were the first of these Iron Age urnfield peoples to be discovered in Italy, but the Etruscan cemeteries are carefully separated from the Villanovan. Did the Etruscan invaders drive out the earlier inhabitants, or consign them to serfdom? The local, late Villanovan art of Bologna does seem to have had considerable influence in the formation of the local Etruscan art of Felsina, but it looks as if the two peoples amalgamated no better than they did at Rome.

Felsina, whose traditional founder was Ocnus, a brother or son of Aulestes, the traditional founder of Perugia (Serv. *Aen.* 10.198), was certainly one of the twelve Etruscan cities of the Po Valley. Probably Adria (Atria, Hatria), on the coast just north of the Po in Venetic territory, was another; Livy (5.33) calls this city the Etruscan colony from which the Adriatic Sea took its name. Spina, another port near the ancient Panaro mouth of the Po, may have been a third. Both Adria and Spina had large Greek populations as well and were apparently centers for Greek trade with the Po Valley and northern Europe. The Greeks of Spina had a treasury at Delphi. Masses of fine Attic pottery of the fifth and fourth centuries B.C. were shipped to these two ports and bought by the Etruscans of Felsina, as well as by the Adrians and Spinates themselves.

The coastal cities seem to have been somewhat younger than Felsina, to judge by the Greek pottery found on the three sites; the earliest vases from Adria are some ten or fifteen years younger than the earliest of Felsina, and Spina seems to have begun to import Greek pottery later still. Evidently the route the Etruscans first took from Etruria to the Po Valley was not by sea but over land. An ancient Villanovan road seems to have crossed the Apennines from the neighborhood of Florence and followed the valley of the Reno northeast to the plain of the Po. Some kilometers up the Reno, an Etruscan city was established during the second half of the sixth century at a place now called Marzabotto. Its ancient name is not known, nor whether it counted as one of the twelve

northern cities. Its site is beautiful, on a bluff overlooking the river (which has, in course of time, washed away a regrettable amount of the ancient city), framed by the steep slopes of the Apennines. What is left of the city itself is laid out on an unwalled, rectangular grid and speaks for a high degree of urban development among the Etruscan settlers. In one of the deep gutters that run along the sides of the broad main streets was found the head of a late Archaic marble kouros, Attic work, the only known piece of Greek marble sculpture from an Etruscan site. There are remains of temples and altars on a slightly higher hill behind the city, and two cemeteries have been uncovered. The tombs are made of stone slabs arranged to form a box, surmounted by a stele, conical or egg-shaped, a shorthand equivalent of the Tomb of Lars Porsenna (Pl. XVIII*a*). Marzabotto still shows us more of the appearance of an ancient Etruscan city than any other site.

Mantua was traditionally another of the Etruscan cities of the Po Valley; some said it, like Felsina, was founded by Ocnus or was a castle fortified by his soldiers; some said the city was named for Ocnus' mother, Mantus, daughter of Tiresias of Thebes, or for Manto, daughter of Hercules; some said that Mantus was the Etruscan Dis Pater, the king of Hades. According to Pliny (3.19.130) Mantua was the only city across the Po which remained Etruscan after the Gaulish invasions of the fourth century B.C.

No Etruscan remains have yet been found at Mantua, but south of the Po, on the line of the Aemilian Way eastward from Bologna, Modena, Reggio, and Parma have produced Etruscan material; while the most significant of all Etruscan religious monuments, a bronze model of a sheep's liver inscribed with the names of Etruscan gods (see chap. x), was found near Piacenza.

THE LAND EMPIRE TO THE SOUTH

To the south, the Etruscans also made settlements in Campania (Polyb. 2.17), which Strabo (5.C242) says is "the most blessed of all plains, and round about it lie fruitful hills. . . ." Nowadays, around Vesuvius, the fields may yield as many as five crops a year, and the wines of

THE ETRUSCANS

Campania are famous and delicious; it is well worth going to Naples just to drink the Gragnano of the Sorrentine Peninsula.

In this lovely plain, according to Strabo, the Etruscans founded twelve cities, a third dodecapolis to match those of Etruria and the Po Valley. The most important of the twelve was Capua, whose Etruscan name, Livy says (4.37), was Volturnus—the name has been transferred to the river on which the city is founded. Cato gave a date for its founding corresponding to *ca.* 600 B.C. (Vell. 1.7), which seems to suit the earliest archaeological evidence very well. Farther south, Nola, at the back of Vesuvius, was also an Etruscan city; it was somewhat younger than Capua, according to Cato. Strabo claims that Herculaneum and Pompeii were once Etruscan cities, too, but the archaeological evidence here is equivocal. Nola, however, is on a highway leading south from Capua, behind Vesuvius and the mountains of the Sorrentine Peninsula, down to Salerno and the Greek city of Paestum in Lucania. A little town called Cava de' Tirreni, at the head of the pass that leads to Salerno, commemorates in its name the builders of this road. Strabo (5.4.13) reports that between the Sorrentine Peninsula and Paestum there was another Etruscan town, Marcina (perhaps Fratte di Salerno), evidently a further stage on this Etruscan trade route. It now looks as though the Etruscans controlled the interior of Campania and a land route to the south, while the Greek city of Cumae and her colony Neapolis dominated the coast and the Bay of Naples.

Capua was the first Etruscan city of all to produce terracotta temple decorations, antefixes with the heads of women or bearded sileni; they look like provincial Greek work, and the earliest cannot be dated much after 600 B.C., Cato's date for the founding of the city. Capua was also the mother of a fine school of bronzework (Pl. XXVI*a*), dating from the mid-sixth century to the mid-fifth century. Capuan bronzework, like the temple terracottas, was much influenced by the Greek arts of southern Italy, and exported examples have been found in the Greek cities of Cumae and Locri, as well as to the north in Latium, Umbria, and Picenum. In fact, much of the Greek style of the Latin and southern Etruscan sculpture of the late sixth and early fifth centuries seems to have percolated north through Campania.

Summary of Etruscan History

Both the Campanian and the Po Valley empires were essentially land-
ward extensions of the Etruscans and dependent on roads, but Etruria
has always had the reputation of having been a sea power. The name of
the Tyrrhenian Sea itself is evidence for their power; Diodorus Siculus
(5.40) says that they were masters of the sea for many years, and
Herodotus (1.165–67) tells of their annexation of Corsica in the mid-
sixth century. Twenty years before the Persian satrap Harpagus sub-
dued the Greek cities of Asia Minor, the Phocaeans had founded the
colony of Alalia on Corsica, which they called Cyrnus (*ca.* 564 B.C.),
and when the Phocaeans of Ionia determined to leave their homes and
abandon their city to Harpagus, they sailed west and joined these earlier
colonists, with whom they lived for some five years. But their means of
livelihood seems to have been piracy, which provoked the Etruscans
and Carthaginians to send out a combined fleet of sixty ships to suppress
the Phocaeans. In the resulting seafight, the Phocaeans were the victors,
but they lost forty of their ships, and the others were so damaged that
they could no longer defend Alalia, so they sailed south with their
women and children to Rhegium and eventually founded Elea (Velia)
on the Lucanian coast, south of Paestum.

The Carthaginians and Etruscans drew lots for the crews of the cap-
tured Phocaean ships, and most of the prisoners fell to the share of the
Caeretans, who led them out and stoned them to death. Although this
was not so uncommon in antiquity as one might like to think, the gods,
in this case, disapproved, for all the creatures of Caere—men or animals
—who passed the place where the stoned Phocaeans lay became crip-
pled and palsied. The citizens sent an embassy to Delphi, and the priest-
ess told them to institute an annual festival with religious ceremonies,
games, and horse racing in honor of the dead Phocaeans; and these
they performed, says Herodotus, to his day.

Still, the Etruscans had won control of Corsica by this battle and
founded a city there with the surprising Greek name of Nicaea (Diod.
S. 5.13). In the meantime the Carthaginians turned their attention to
Sardinia, which they colonized but never entirely subdued. Evidently

THE ETRUSCANS

Etruria and Carthage had come to a gentleman's agreement about their spheres of influence and were united in their opposition to the sea power of the Greek colonies of southern Italy.

The possession of Corsica and the colonization of the Po Valley and Campania mark the farthest extent of the so-called Etruscan empire. It was never an empire in the modern sense, or even in the Athenian sense —ruled, that is, by a single city—for the cities of Etruria were independent and presumably those of Campania and the Po Valley were, too, and the leagues of twelve cities that are said to have been established there, as in Etruria, were probably more religious than political in character. Whether the cities outside Etruria were actual colonies, in the Greek sense, sent out by an Etruscan city or by the joint venture of two or three, or whether they were rather the results of the enterprise of individuals disgruntled by life at home, like Tarquinius Priscus, we cannot tell.

But the eventual loss of her empire certainly did seriously affect the whole of Etruria. Whatever their political connections may have been, the cities of Etruria must have counted heavily on the commerce with the Etruscan cities in Campania and the Po Valley, because when they were lost the public wealth in Etruria all but disappeared.

The Loss of the Etruscan Empire

The first loss we know of was Rome. The Tarquin dynasty had transformed a Latin town into a wealthy, handsome Etruscan city, the head of a Latin League. The Tarquins had ruled like the Greek tyrants, maintaining themselves in power by the help of the city populace and curtailing as far as possible the power of the country nobility. It was evidently a revolt of this Latin aristocracy that overthrew the Tarquins, and perhaps Brutus and Collatinus could not have succeeded if Tarquinius Superbus had not already exasperated the plebs by forcing them to labor on his public works projects (Liv. 1.56). At any rate, Rome and Latium were lost to Etruria in 509 B.C., and though Veii, Tarquinii, and Clusium recognized the seriousness of this loss and sent help to the Tarquins, Rome was never again an Etruscan city politically.

Summary of Etruscan History

It may have been the loss of Latium and the cutting of the land route to Campania that determined the Etruscan attempt to capture Cumae, the ancient and powerful Greek city on the coast above Naples. They had, in fact, tried unsuccessfully to annex this city even earlier, in 524 B.C. (Dion. H. 7.3), and now they desperately needed a port in Campania. Apparently the Etruscans enlisted Carthaginian help for this new assault, but the Cumaeans, shrewder or more fortunate than the Phocaeans of Alalia, asked for help from Hieron of Syracuse (Diod. S. 11.51), and in 474 B.C. his fleet inflicted an overwhelming defeat on the attackers. Pindar celebrates this victory in the First Pythian Ode, and an Etruscan helmet captured in the battle was sent by Hieron as an offering to Olympia with the inscription: "Hieron, son of Deinomenes and the Syracusans, to Zeus [for the victory] over the Tyrrhenians at Cumae" (Pl. XXXI). It was found at Olympia in 1817 and is now in the British Museum.

The battle of Cumae marks the decline of Etruscan sea power, though not, it would appear, its total destruction. Syracuse, having once been called into Etruscan affairs by Cumae, apparently took it as a permanent obligation, or privilege, to police Etruscan waters; in 453 B.C., the city sent an admiral with a fleet to put down Etruscan piracy. He sailed first to Elba and ravaged the island but was bribed to withdraw and return to Sicily. Shortly thereafter, a second Syracusan expedition under a less venal commander sacked the Etruscan cities on Corsica and along the coast of Etruria and captured Elba. The slaves and plunder this expedition brought home encouraged the Syracusans to think of raids on Etruria as a convenient way of raising money in an emergency. Thus, in 384 B.C., the tyrant Dionysius, facing bankruptcy at home, led a fleet northward, again on the pretext of suppressing Etruscan piracy, and sacked and laid waste the immensely wealthy sanctuary of Leucothea at Pyrgi, in the territory of Cerveteri (Diod. S. 15.14).

The enmity between Etruria and Syracuse persuaded several Etruscan cities to promise Alcibiades help in 415 B.C. for his Sicilian expedition, but the help was limited, in fact, to three ships of fifty oars which took part in the maneuvers against Syracuse in 413 B.C. (Thuc. 6.88,

THE ETRUSCANS

103; 7.57). Whether this pathetically small force represents all the ships Etruria could supply or whether it is merely evidence of indifference to Greek affairs, we cannot tell. At any rate, by the end of the next century, in 307 B.C., the Etruscans had so far forgotten their old enmity for Syracuse and their old friendship for Carthage as to send a fleet of eighteen ships to help Agathocles raise the Carthaginian blockade of Syracuse (Diod. S. 20.61). This is the last recorded expedition of an Etruscan fleet.

Meanwhile, the land empire of the Etruscans had also been lost. About the middle of the fifth century, the Samnites swept down from the mountains into Campania (Strabo 5.C249) and took possession of its fields and cities. In 438 B.C. the new nation of the Campani was formed (Diod. S. 12.31); neither Etruscans nor Greeks could stand against them; Capua fell in 423 and Cumae in 420 (Liv. 4.37, 44).

In the early fourth century, Celtic tribes from beyond the Alps moved into the Po Valley and took possession of it, driving out the Etruscan colonists (Polyb. 2.17; Liv. 5.33; Diod. S. 14.113). Diodorus gives 387 B.C. as the date of the Gaulish invasion, and his description of their conquest of the land between the Alps and the Apennines suggests that it was sudden and overwhelming. But Livy believed that the Gauls had come to the Po Valley two hundred years earlier, in the reign of the first Tarquin, and that the Etruscans had fought them many times, and in support of him the grave stelae of Felsina, of the fifth century B.C., show many scenes of combat between Etruscans and Gauls—the earliest representations of these Celtic warriors in the Mediterranean world.

Whenever the Gauls may first have appeared in the Po Valley, they secured their hold on the whole of it before the middle of the fourth century, and it is probable that their final conquest of the region was as swift and complete as Diodorus' description makes it. According to Cornelius Nepos (Plin. 3.17.125), the wealthy Etruscan city of Melpum (whose whereabouts is unknown) fell to the Gauls on the very day that Camillus took Veii in 396 B.C. There is no fourth-century material, either Etruscan or Greek, at Bologna or Marzabotto, where a Gaulish cemetery lies beside the earlier Etruscan graves. Our sources tell us that only Mantua remained Etruscan, though Spina and Adria,

whatever their political connections may have been, continued to flourish throughout the fourth century and to import vases from Attica as they had throughout the fifth. Perhaps their large Greek population and their position on the sea protected them from inundation by the Gauls; more likely, the Gauls, who had already acquired a taste for Greek goods, found them useful to foster overseas trade.

The Beginning of Rome's Encroachment

Through Livy's books describing the early history of the Roman Republic runs like a *Leitmotif* a constant, nagging fear of Veii, the powerful Etruscan city which was Rome's nearest neighbor across the Tiber and disputed all too strenuously Rome's control of the lower Tiber Valley. Fidenae, an Etruscan town allied to Veii but situated on the side of the Tiber that the Romans considered theirs, had fought the Romans more than once and had been forced to accept them as overlords when, in 437 B.C., it revolted to Veii and her king Lars Tolumnius and added outrage to injury by murdering the Roman ambassadors sent to inquire into this—some say at the suggestion of Lars Tolumnius himself (Liv. 4.17). Evidently the responsibility for starting the great Veientine War was to be given squarely to Rome's enemies.

Between 437 and 406 B.C. there were almost yearly campaigns between Rome and Veii, with Fidenae always the bone of contention, and the Faliscans, who considered themselves Etruscans, though they spoke an Italic language closely related to Latin, came periodically to the help of Veii. Finally, in 406 B.C., the Romans undertook a continuous blockade of Veii, and though their wars with the Volscians to the south made this a slow and rather desultory procedure at first, they maintained their siege for ten years, winter as well as summer, and finally took the city by storm.

This sustained campaign was an extraordinary innovation in a world where wars had always been seasonal affairs: the war season opened in March, the month of Mars, and closed in October with the sacrifice of the October Horse on the fifteenth and the Armilustrium on the nineteenth. The sustained military service weighed hard on the Romans (Liv. 5.11); it even alarmed a few of the Etruscan states into making

common cause with Veii against Rome. At the beginning of the siege, in 405 B.C., the council of the Twelve Cities, meeting at Fanum Voltumnae, had debated whether the whole nation should go to Veii's help against Rome and had decided against it. In 402, Falerii and Capena joined Veii, realizing that Rome's policy was more than an appetite for booty, and geographers enough to see that if Veii fell Rome's next move would be against them. The Tarquinians, in 397, made a raid on Roman territory, not so much in concern over the fate of Veii and Etruria as because it seemed a good opportunity (Liv. 5.16). In the same year, at Fanum Voltumnae, Falerii and Capena tried to rouse the nation of Etruria to come to Veii's help, but again without success (Liv. 5.17).

So Veii was taken "and the day was spent in the slaughter of enemies and the sack of that most wealthy city" (Liv. 5.21). The freeborn inhabitants were sold into slavery; the city was razed; the gods were transported to Rome, and the site became part of Rome's public land. Rome had learned how to play for keeps, but Etruria had not—and never did.

The other cities of Etruria evidently felt no resentment against Rome for the destruction of Veii. Volsinii and Salpinum (an otherwise unknown Etruscan city) raided Roman territory in 391, in the same spirit as Tarquinia a few years earlier (Liv. 5.31–32), but when the Gauls crossed the Apennines and attacked Clusium in 390 B.C., it was to Rome that Clusium appealed for help (Liv. 5.33–35). The incredible defeat of the Roman army on the banks of the Allia and the capture and sack of Rome by the Gauls was a tale of horror at Rome for centuries thereafter. The flamen of Quirinus and the Vestal Virgins, with as many of Rome's sacred objects as they could carry, fled to Caere by the road over the Janiculum, and the asylum offered them by the Caeretans had an abiding effect on Rome's relations with Caere.

THE ANNEXATION OF ETRURIA

Other Etruscan cities saw Rome's disaster as a golden opportunity to attack her and get a bit of their own back. Tarquinii and Falerii were the chief movers against Rome in the years between 389 and 351 B.C.,

but they underestimated Rome's powers of recovery, just as Etruria had earlier underestimated her staying power. In 383, Rome sent a Latin colony to Sutrium and in 381 another to Nepete, the cities which Livy calls the gateways to Etruria (6.9), and no Etruscan efforts were ever able to recapture them and hold them against Rome. Between 358 and 351 B.C., war between Tarquinii and Rome was constant and savage; Falerii and even, for a time, Caere joined in with Tarquinii. But in 351 Tarquinii and Falerii were forced to ask for peace and were granted a forty years' truce, which was scrupulously kept. Falerii, in fact, became an ally of Rome in 343. Caere, because of her friendship to Rome in the time of the Gauls, was granted a truce of one hundred years.

This truce with her most truculent Etruscan neighbors allowed Rome to attend to the Volscians, old enemies to the south, and to the Samnites of Campania, beyond. Rome's involvement with Campania proved the beginning of still greater changes—the gradual development of the Roman state as a power in the Greek world and the progressive Hellenizing of Rome itself.

In 311 B.C., in the middle of the Second Samnite War, the forty years' truce came to an end and "all Etruria except Arretium" suddenly appeared before the Latin colony of Sutrium (Liv. 9.32). According to Livy's story, the Romans had to defend Sutrium again in 310 B.C., and it was during this second campaign that the consul Quintus Fabius marched his legions through the great Ciminian Forest to carry the offensive to the northern and inland cities of Etruria.

The country north and east of the Ciminian Forest, covering the slopes of the volcanic mountains and Lake Vico, had been *terra incognita* to the Romans till then (Liv. 9.32; 35–37). The forest itself was considered impassable, since "not even a trader had visited it up to that time." But the consul's brother, Caeso Fabius, and a single slave, disguised as shepherds, made their way through the forest to the land of the Umbrian Camertes, where they found men ready to welcome an alliance with Rome. This exploit of Caeso Fabius was possible because he and his slave had been educated at Caere in the house of family friends and could not only read, but speak, Etruscan; but nevertheless,

indeed, Livy says, he must have been an exceptional man to undertake so daring an adventure in enemy territory.

By his march through the Ciminian Forest, the consul Fabius was able to inflict a decisive defeat on the Etruscans—some say near Sutrium, some say inland near Perugia. Wherever it was, Cortona, Perusia, and Arretium, "at that time the leading cities of Etruria," made treaties with Rome, and the treaty with Tarquinii was renewed in 308 B.C. (Liv. 9.37).

Rome was now involved with the cities of northern Etruria. Her treaty with Arretium had introduced her to the leading families of the city, and one of these, the Cilnii, was responsible for the next war between Rome and the Etruscans. In 302 B.C., shortly after the beginning of the Third Samnite War, a democratic revolution at Arretium drove out the noble families, and the Cilnii appealed to Rome for help (Liv. 10.3). In this war Rome evidently moved north up the coast, attacking and defeating the Etruscans at Rusellae in 302 (Liv. 10.4) and at Volaterrae in 298 (Liv. 10.12; "Acta Triumphorum Capitolina," CIL, I, p. 456). Inland, Volsinii was attacked and her fields devastated in 294 (Liv. 10.37), and in the same year Rusellae was captured. This put a temporary stop to the war; Volsinii, Perusia, and Arretium were granted truces of forty years.

The years between 294 and 200 B.C. were the last years of Etruscan independence. In 287 Volsinii again fought Rome and was defeated. Allied with the Samnites and the Gauls, the Etruscans made a last tremendous effort against Rome in 282 B.C.—tragically, the first truly concerted effort of the separate Etruscan cities—but the coalition was overwhelmingly defeated at Lake Vadimo (Polyb. 2.20). In 280 a Roman consul triumphed over Vulci and Volsinii ("Acta Triumphorum Capitolina," CIL, I, p. 457) and presumably from then on the cities of Etruria were all subject-allies of Rome.

The Etruscan Allies of Rome

The Etruscan allies were not overjoyed by their condition. As early as 293, Falerii had revolted but was reduced and eventually readmitted to her alliance with Rome; in 273, Rome's old friend Caere rose against

her and after being defeated was forced to cede half her territory (Dio C. 10. frag. 33); in 264, at the beginning of the First Punic War, a slave war at Volsinii was put down by Rome, and in 241, at the end of the First Punic War, Falerii revolted a second time. Both these latter cities were then settled with colonies to keep a watch on them.

It may have been these drastic measures that quieted the Etruscan states; at any rate, there was no trouble from Etruria during the first years of the Second Punic War, even when Hannibal, in the spring of 217, marched over the Apennines into Etruria, plundering the land between Faesulae and Arretium where the Roman army was stationed, "one of the most fertile districts of Italy," and then pursued the Romans to Lake Trasimene, laying waste the land between Cortona and the lake (Liv. 22.3–4). Hannibal had hoped that the Etruscans would rise and join him against Rome, but perhaps his army was too thorough in its plundering. They did not revolt, but it seems to have been touch and go. Etruria was Rome's chief granary during the long years that Hannibal remained in southern Italy, but the constant presence of Roman legions on Etruscan territory during these years was evidently exasperating; in 208, reports that the city of Arretium was the center of a planned revolt of the Etruscan cities led Rome to send troops to occupy the city and seize one hundred and twenty children of the leading families, who were sent to Rome as hostages (Liv. 27.24).

However, in 205 B.C., when Scipio was recruiting an army for his invasion of Africa, Arretium contributed an enormous amount of equipment for his fleet—three thousand shields and helmets; fifty thousand javelins, short spears, and lances; enough axes, shovels, sickles, baskets, and hand-mills for forty warships; one hundred and twenty thousand pecks of wheat; and allowances for the petty officers and oarsmen (Liv. 28.45). Evidently the city had not really suffered from the Roman occupation. Seven other Etruscan cities helped to outfit Scipio's fleet— Populonia contributed iron; Tarquinii, linen for sails; Volaterrae, fittings for ships as well as grain; Perusia, Clusium, and Rusellae supplied grain and fir for ships' timbers. It would seem that Etruria was by no means impoverished by the war with Hannibal and moreover had no intransigent dislike of Rome, or, more probably, the political situa-

tion in Etruria was like that somewhat later in Greece, the In's, as it were, being pro-Roman and the Out's pro anybody who was anti-Roman. When the In's, or Rome, were powerful enough, there was no revolt. In 205 B.C., Rome, or the persuasive charm of Scipio, was strong enough to fire even Etruria with enthusiasm for the invasion of Carthage, but in the next year, 204 B.C., when Hannibal's brother Mago landed in northern Italy, the Etruscans were said to have sympathized and entered into intrigues with him, and a general revolt was prevented only by the severity of the Roman consul's legal proceedings against the conspirators, thanks to which many Etruscan nobles lost their lives and others, who escaped death, were stripped of their property (Liv. 29.36).

The history of Etruria during the second century is almost a blank; the focus of history had shifted elsewhere. We know that Roman legions were stationed every year at Arretium, as a defense for Italy against the Gauls in the Po Valley and the Ligurians, and that in 196 the legions put down a slave rising in Etruria (Liv. 33.36). In 187 B.C. the younger Flaminius built a road across the Apennines from Arretium to Bononia, the Roman colony founded in 189 B.C. in Gaulish territory, on the site of the old Etruscan city of Felsina. A Roman citizen colony was founded in 183 B.C. on the site of the ancient Etruscan city of Saturnia far up the valley of the Albegna; a maritime colony on the coast north of Rome at Graviscae was founded in 187 on land that had once belonged to Tarquinii. North of the Arno, the Romans founded two more colonies in territory that was thereafter counted as Etruscan, though it is doubtful that Etruscans had ever really held it—one at Luca in 180 B.C. on land offered by the city of Pisa and one on the coast at Luni in 177 B.C. Both were outposts against the Ligurians (considerably more convenient than Arretium for this purpose), with whom the Romans fought more or less constantly during this century. Other than these small facts there is nothing to record.

There was a tradition that it was the sight of Etruria empty of free-born farmers and tilled by barbarian slaves that first turned Tiberius Gracchus' mind to land reforms (Plut. *Tib. Gracch.* 8). The spread of latifundia through Italy was a tragic result of the Hannibalic War;

these vast estates, manned by slave labor, were all too efficient; the small farmer could not possibly compete with their productivity, and Rome had learned this method of farming from Carthage. The first half of the second century must have been the period when the economy of Etruria changed, since in 205 B.C. the several cities of Etruria had still been economically independent and indeed wealthy, though by the second half of the second century the countryside was virtually uninhabited.

The sadly depleted Etruscan cities seem to have taken no prominent part in the Social War at the beginning of the first century B.C. In the last months of 90 B.C., some cities joined the rebellious allies but were defeated, and in 89 all received Roman citizenship under the Lex Julia. In the wars between Marius and Sulla, the Etruscan cities seem generally to have sided with Marius; he landed in Etruria in 87 B.C., at Telamon, according to Plutarch (*Mar.* 41), and raised a force of six thousand men among the slaves and freeborn countrymen of the region. Clusium and Arretium sided with him, and the survivors of the Marian party made their last desperate stand at Volaterrae, which withstood for two years a siege by Sulla's army (82–80 B.C.).

Sulla took a firm hand with his enemies; the cities that had sided with Marius were punished by confiscation of land and loss, or diminution, of citizenship. He planted colonies of his veterans at Faesulae and Florence and apparently also at Arretium, Clusium, and Volaterrae. The people of Arretium and Volaterrae, at least, lost some of their rights of citizenship, and one of Cicero's first successful lawsuits was the defense of the rights of a woman of Arretium (*Caecin.* 33.97); he later defended his friend, Aulus Caecina of Volaterrae, in a similar case (*Caecin.* 7.18; 33.95; 35.102).

Sulla's veteran colonies seem to have had their own troubles, for it was from among them that Catiline's revolutionary army was largely recruited in 63 B.C. "Those colonies," says Cicero, "are full of the best of citizens and the bravest of men, but nevertheless there are some among them . . ." and he goes on to list the extravagances of many of the veterans which had so loaded them with debt that only revolution could

save them (*Cat.* 2.20). And not a few of the Etruscans who had been dispossessed by Sulla in 80 B.C. joined the debt-ridden colonists of Faesulae and Arretium in Catiline's armed mob (Cic. *Mur.* 24.49; Sall. *Cat.* 28).

The last stand of an Etruscan city against the power of Rome came 'in 41 B.C., when Perusia sheltered Lucius Antonius against the armies of Octavian; the city was starved into capitulation and burned by one of the citizens before it could be plundered by the victorious troops; only the Temple of Vulcan was left standing (Appian *Bell. Civ.* 5.5.49). It is also reported that Octavian sacrificed 300 of the leading men of Perusia on the altar of the Divine Julius (the deified Julius Caesar) on the Ides of March, following the surrender of the city (Suet. *Aug.* 15; Dio C. 48.14), a piece of savagery that Appian does not mention and whose only historical precedent at Rome was the slaughter of 358 Tarquinian prisoners of war in 353 B.C., in retaliation for the sacrifice of 307 Roman prisoners at Tarquinii five years earlier (Liv. 7.15, 19). Even without this, the end of Perusia was grim enough.

Octavian later restored Perusia, when he was emperor and Augustus, and his action in the Civil Wars was tactfully forgotten. The new name for the city, Augusta Perusia, can still be seen inscribed over the city gate now called the Arco di Augusto. The city seems to have flourished under the empire and was raised to the rank of a colony by the emperor Trebonianus Gallus.

Another Etruscan city to get a new lease of life under Augustus was Arretium, which became rich and famous again from the manufacture of a particularly handsome and delicate pottery, the coral-colored Arretine ware, whose walls are decorated with scenes of hunting, banqueting, and love-making, or with masks and garlands and all the pretty, Hellenizing paraphernalia of the new Imperial style.

We know of several distinguished Romans under the early empire who were proud of their connection with Etruscan noble families; Augustus' friend and Horace's patron, the millionaire Gaius Maecenas, was connected through his mother with a noble Etruscan family— according to a late tradition, the Cilnii of Arretium. Volaterrae produced

one imperial poet, the satirist Aulus Persius Flaccus; his praenomen Aulus and his mother's name Sisinnia are both Etruscan and indicate that he was no descendant of Sulla's colonists but a native Volterran of old Etruscan stock.

To have Etruscan blood in one's veins was a point of pride to many Romans till late in the empire, as it is in the United States to be able to say you are descended from the Barons of Runnymede. The vanity shown by such a claim was innocent enough, and not less innocent because such claims are usually false.

The Art of the Archaic Period
(ca. 600–470 B.C.)

FROM the last decades of the seventh century B.C., when the Etruscans developed a new figure style peculiarly their own, down to the beginning of the second century B.C., the Etruscan style was the dominant element in the art of central Italy. Even after 200 B.C. it still had local vigor that lasted down to the beginning of the Roman empire in the old cities of Etruria. But throughout the six hundred years of its existence, Etruscan art always took its chief inspiration from Greece.

This is not to say that the Etruscans were mere copyists. To be sure, they never had that inventive genius with which Greece transformed the ancient patterns and motifs of Egypt and the Near East into something brilliantly different that the world had never conceived of. Still, the Etruscans, like the Greeks, were highly selective in their borrowing and stamped every borrowed type and motif with a new and distinctive character. Derivative, often downright bad, Etruscan art was always triumphantly Etruscan and never simply uninspired imitation.

SCULPTURE: MATERIALS

Etruria's great debt to Greek art was known and acknowledged in antiquity. Pliny the Elder, in his chapters on the uses of clay, discusses

the terracotta sculpture of the ancient world and says about its history in Italy: "Modeling portraits in clay was first invented at Corinth by Butades, a tile maker of Sicyon . . . though some authorities attribute the art of clay modeling to Rhoecus and Theodorus of Samos. . . . Butades was the first to ornament the ends of roof tiles with clay masks, and it was from these that the ornaments on the pediments of temples originated. Demaratus, who in Etruria became the father of Tarquin, the king of Rome, when he was banished from Corinth took with him to Etruria three craftsmen—Eucheir, Diopus, and Eugrammon—and they introduced modeling to Italy. . . . The art was elaborated there and particularly in Etruria, so that Tarquin invited an Etruscan artist, Vulca of Veii, to come to Rome and make the cult statue of Jupiter for the new temple on the Capitoline; this was the first cult statue in Rome. . . . The four-horse chariot on the ridgepole of the temple was also of clay and the work of Veientine artists. Vulca also made a terracotta Hercules for Rome. These were the most splendid gods of that time . . . and statues of this kind are still to be found in various places, while at Rome and in the municipal towns there are many temples whose roofs are still adorned with terracotta figures, remarkable for their modeling and artistic quality as well as their durability . . . more deserving of respect than gold, certainly more innocent" (35.43.151–53; 45.157–58).

Pliny records, too, the fame and excellence of Etruscan bronze statuary (34.16.34): "There is no doubt that the so-called Tuscan statues which are scattered all over the world were actually made in Etruria . . . in fact, Metrodorus of Scepsis claims that we Romans took Volsinii and destroyed the city for the sake of its two thousand bronzes."

Archaeology has supplied abundant evidence of Etruscan proficiency in terracotta and bronze sculpture in almost every period of Etruscan history. In fact, the small bronzes made in Etruria are so numerous, and the best of them are so handsome that they could furnish, in themselves, a whole history of style in Etruria, to say nothing of a history of Etruscan costume and fashion. Most of these are votive, that is, temple dedications (Pls. XV, XXIV, XXV, XXVI*b*, XXVII, XXXIX, XLVII), though bronze statuettes were also used to decorate candelabra, tripods,

and other furniture, as they had been in the Villanovan period (Pls. XXVI*a* and XXVIII); very occasionally a funerary statue, a "portrait" of the dead, was made of bronze.

Terracotta statues are less common, but their uses were more diverse. Pliny mentions only cult statues of the gods and temple decorations, but as we have already seen (see chap. iii and Pls. XII and XIII) terracotta was also used for funerary sculpture and continued to be throughout Etruscan history (Pls. XLIII and XLV). Decorative figures of terracotta were also made from the mid-seventh century; the bucchero caryatids that so elegantly embody the new Orientalizing style of the Regolini-Galassi period are the first of these (see chap. iii). And, particularly in southern Etruria, terracotta was used for votive figures (Pls. XXII, XXIII, and XXXVIII).

It may seem, at first, mere pedantry to dwell on the particular purposes for which sculptures in different materials were made; but in central Italy, not least at Rome, the purpose of the statue determined the material. This comes out clearly in Pliny's encyclopedia. Terracotta was used for cult statues of the gods and the adornments of their temples (35.46.157–58); bronze could be used for ornament (34.7.13–15), but its chief use was for the votive figures of gods (34.9.15) or men (34.11.23; 34.13.29) dedicated in sanctuaries or temples. Bronze was also used for honorary statues, erected by the state to distinguished citizens—the first of these at Rome being the statue of Horatius Cocles, who held the bridge against the army of Lars Porsenna (34.13.29). It is clear from Pliny's account that in Rome, as in Greece (for which Pausanias supplies abundant evidence), the idea of the honorary statue developed from the votive, and that the statue types were the same for both.

Marble sculpture, one of the glories of Greece from the end of the seventh century, was late in coming to Rome and simply decorative there—a sinister development, according to Pliny, of the first century B.C. (36.8.49–50). And as for sculpture in other stones, Pliny ignores it completely, though there were statues of local stone at Rome earlier than the first century, the so-called bust of Ennius from the Tomb of

the Scipios, for example. But this stone sculpture was purely funerary and did not interest Pliny.

STONE

This curious restriction on stone prevailed in Etruria as well; in fact, Rome undoubtedly took her lead from the Etruscans, as she took Etruria's other dicta on material; that is, terracotta was used for temple decorations; bronze, for votive figures. The Etruscan restriction of the use of stone, not only applying to sculpture but to architecture as well, is in sharp contrast to the Greek practice. Greece seems to have discovered the beauty of stone architecture and sculpture in Egypt some time in the seventh century. Her first stone temples, or temples with at least some architectural elements in stone, date from the end of that century; her first great sculpture style, the so-called Daedalic, was created during the same century, and the limestone and marble Daedalic figures of the end of the century are the earliest examples of monumental sculpture in mainland Greece. Greece felt no limitation in her use of limestone and marble; not only were her temples embellished with cut stone, but marble statues were dedicated at the sanctuaries of the gods at least as often as they marked graves.

But in Etruria, except for altars and foundations, stone was used only for the architecture and sculpture of the tomb. It is often said that a lack of good limestone or marble explains the Etruscans' reluctance to carve in stone, but tufa is handsome and lends itself to carving, as the tombs of Vulci and Cerveteri (Pl. XXXV) and the beautiful Samnite houses of the second century B.C. at Pompeii demonstrate. And central and northern Etruria had sandstone and travertine, which the Roman colonists of the Hellenistic period found to be excellent building material. It was not poverty of material or incompetent stonecutters that restricted the use of stone in Etruria to the honor of the dead, but some scruple based on the power and meaning of stone itself.

The great stone traditions of Asia Minor and northern Syria and of Assyria itself apparently had no direct influence on Etruria; whatever else the Orientalizing period may have brought to central Italy from the eastern Mediterranean, the arts of building in stone and of stone

sculpture were not. Before the end of the seventh century, stone was used to build tombs, but these were without architectural refinement or monumental form. Villanovan well graves were sometimes lined with stone slabs, and occasionally, particularly at Vetulonia, roofed with a heavy stone slab carved in the shape of a shield; later trench graves were cut out of the soft tufa in southern Etruria, and the first chamber tombs were simply enlarged trenches, cut more deeply, roofed with stone, and entered from one end rather than from above. Even the Regolini-Galassi Tomb, for all its great wealth, did not have a monumental form for the chamber, only for the enclosing tumulus.

But toward the end of the seventh century, tomb chambers began to take on a monumental character; shape and proportion became important, and the rooms were often embellished with architectural details.

One of the earliest tombs to have a handsome chamber was the Pietrera tumulus at Vetulonia. Here, a chamber five meters square was roofed by a lofty false dome supported on a central pillar. Evidently the first attempt at building the dome was a failure; the roof fell, and a second chamber of the same size and shape as the first was built on its ruins. This time, the builders used a better stone and managed to produce a very handsome structure. Fragments of columns and other architectural members carved with fantastic Orientalizing animals in low relief show that the chamber and the approach were elaborately decorated as well, and the whole was covered by a large tumulus.

It was in this tomb that the oldest stone statues from Etruria were found, fragments of some eight or ten life-size figures, including parts of six heads (only two of which are at all well preserved), five or six upper torsos, four lower torsos, and five pairs of feet. These are now in the Museo Archeologico at Florence. The well-preserved heads and upper torsos apparently came from female, the lower torsos from male, figures. The statues were carved in soft sandstone; the bodies were very flat and simplified, with details in low relief on the front, the heads completely in the round. Such suppression of the body and emphasis on the head we have seen already in the slightly earlier bronze statuette of a young girl from Arezzo (Pl. XVc); it probably descends from late Villanovan figures like the beast-headed divinities from Vetulonia (Pl.

VII), and it appears sporadically through the history of Etruscan sculpture, a recurrent non-Greek element.

The costume and hairdress of the female figures from the Pietrera Tomb are still Oriental. The hair is dressed in spiral locks which fall forward over the shoulders; the upper part of the body is nude except for a heavy necklace; a long straight skirt hangs from a broad belt carved with fantastic animals. Such a costume, though not entirely unknown in Greece during the seventh century, is common in the Near East; in Etruria, apart from these stone figures, the costume appears on a bronze half-figure from the so-called Isis Tomb at Vulci, a votive statuette of a winged goddess from Cortona, and a number of gold reliefs. The hands of the Pietrera ladies are raised and pressed to the body, between the small breasts; in one case, they are open, one over the other; in another, the forefingers point upward while the rest of the hand is closed. Both gestures are Oriental. In contrast, the lower torsos of the male figures are quite Greek in appearance. The figures stand in the kouros pose, though the left foot is not advanced; the hands are dropped to the sides and loosely closed, thumbs pointing downward. The male figures wear neat, triangular loincloths with incised borders, much like the perizoma of the bronze male figure from Arezzo (Pl. XV*a*), though apparently of cloth rather than metal. No Greek marble kouros wears such a garment, but occasionally their small bronze forerunners of the seventh century do wear loincloths. At all events, the Greek elements in these figures are matters of detail rather than of style.

A half-life-size alabaster figure from the Isis Tomb at Vulci, now in the British Museum, is much closer in style to her Greek prototypes. The seventh-century figure style of Greece, the Daedalic, reduced the human figure to a formal design which recalls the Doric column. Draped figures were preferred to nudes; the long, straight lines of the dress hid the articulations of the body so that it resembled the shaft of the column, while the head had something of the character of the Doric capital, with its sharp horizontal emphasis. The top of the head was much flattened; the low forehead's breadth emphasized by a straight fringe of hair that barely cleared the eyebrows; the broad face was

square or trapezoidal in outline, with a straight chin forming yet another horizontal line. The heavy, shoulder-length hair was dressed in triangles, framing the face; the ears were hidden or projecting at right angles to the head and seen in relief against the triangular masses of hair. Thus Greek art transformed the flowing contour of the Oriental closed outline to a geometric figure of remarkable elasticity and charm.

The strict geometry of the early Daedalic style was considerably softened by the beginning of the sixth century, and it is the Greek figures of this post-Daedalic stage that the Isis Tomb's lady really imitates. The long, slender body is still a column, its vertical importance emphasized by the straight lines of the drapery; the broad trapezoidal face is defined by the horizontals of forehead and chin, but the profile is deep, and the small, flat ears are visible, set high and well back. A row of spiral curls softens the line of the forehead, and at the back of the head the hair bulges naturally over its confining fillet. The costume is Greek, a belted dress that falls to the ground but whose hem is pulled up in front to show the sandaled feet; over the dress is a heavy shawl, reaching to the calves of the legs in back and falling in long, symmetrical panels nearly to the hem of the dress in front. For all that, the figure does not look really Greek; the huge eyes outglare any Greek Daedalic figure and recall the eyes of the Bernardini siren (Pl. VIII); though the hair is arranged in two beaded locks over each shoulder, the rest of the long tresses are gathered in a long, loose mass, tied near the end by a ribbon wound many times around it, a late version of the Syrian braid worn by Etruscan women during the seventh century (Pls. XIII and XVc). The hands are held in the Hittite pose, the right open, palm up, the left closed and pierced to hold some ritual object, like the hands of the cloaked bronze woman in Florence (Pl. XVb); the firmly planted, straddled feet recall not only that figure but the much earlier Villanovan figure from Tarquinia (Pl. Va).

Another stone statue from Vulci, carved in the local tufa, is a somewhat later example of the Daedalic style as it appears in Etruria. It is a centaur whose torso and forelegs are human, so that it appears to be, when viewed from the front, a statue of a kouros. Here again, the big head is low-crowned and broad in the Daedalic manner. The hair

makes a shallowly curved bang across the forehead; a single spiral lock falls on each shoulder, while the mass of hair behind is arranged in the layered wig which the Greeks imitated from Egyptian statues. The face is longer and fuller than that of the alabaster lady; the huge eyes bulge from their sharp lids; the cheeks swell; the nose and mouth are broad. He wears a beard, but in pursuance of the kouros effect this was simply incised on the cheeks, not given the exuberant plasticity of the hair. The figure has no neck; the torso is too short and too narrow for the head; the arms are much too short; the hands, which are open and pressed to the thighs, are enormous.

This centaur was a guardian figure that stood originally at the doorway of a tomb or on the summit of a tumulus. Many such guardians are found in Etruscan cemeteries—horses, sphinxes, and especially lions. The splendid winged lion of Plate XVII is one of a group made at Vulci in the early years of the sixth century. He sits erect (the hind legs of this example are broken, but complete specimens show that the legs were bent and the figure seated), his forelegs stiff, head up, mouth open, eyes fixed. The anatomy is perfunctory; for details the sculptor is content with grooves and ridges—rounded close-set ridges for the snarling muzzle, long vertical grooves for the ribs and haunches, a fanned whorl of shallow planes for the eye of the sickle wings. A similar scheme of surface decoration has appeared in Etruria before, on the helmet of the late Villanovan bronze head from Vetulonia (Pl. VI) and on the impasto beaked jug in New Haven (Pl. IV*b*); here, for the first time, it is applied to the anatomy of a three-dimensional figure, and the effect is most impressive. The winged lion itself probably had a Greek prototype, though perhaps not in stone; the sickle wings, at any rate, are Greek, not Oriental.

In the Archaic period Tarquinia also had a school of stone carving, but instead of statues in the round, it specialized in reliefs. Large slabs of tufa were decorated on one face with bands of continuous relief bordering a steplike element, which was divided down the center and framed at the sides by vertical bands of relief divided into rectangular scenes. Though these slabs were all found in the ancient cemeteries of Tarquinia, none was *in situ,* and their exact use has not been de-

termined; a plausible suggestion is that they were used to roof early chamber tombs that were still cut with an opening at the top, like the trench tombs of the late Villanovan period. Certainly the reliefs seem to imitate wood carving, and they may well have been intended to represent carved ceiling beams.

These curious reliefs are datable in the first half of the sixth century. Their repertory of figures is Greek, and one may suppose that it was taken from the Corinthian vases that flooded Etruria in those years—panther, goat, stag, centaur, sphinx and griffin, winged male figures, men on horseback, combats of various kinds. The panels and friezes are generally framed by a guilloche pattern; the carving is in low relief with a sharp vertical edge setting it off from the face of the background; interior details are marked by harsh grooves, like the muscles of the winged lion from Vulci.

The relief illustrated on Plate XVIII*b* is one of the largest and best preserved: the lower frieze, from left to right, shows a centaur attacking a man who seems to be cowering behind a large churn but who is actually Hercules drawing his bow behind the dining table; in the center, a small boy on horseback is being accidentally prodded by the splendid horns of a stag about to be attacked by a lion, while at the far right, a man kneeling on one knee is drawing his sword. Achilles lying in wait for the young horseman Troilus? The frieze may be continuous, but the plot is not. The right panel of the upper frieze shows a winged lion or panther (the head is gone) seated and lifting one paw; the central panel is filled by the figure of a winged boy in the bent-knee position that was the Greek convention for running figures in the Archaic period. His sickle wings spring from the waist in front; like similar figures on Corinthian vases, he is probably one of the winds or one of the sons of Boreas. The left panel shows one of the rare indecent pictures from Etruria. Under each panel, a file of three ducks marches to the left.

The third great center for stone sculpture was Chiusi, and its school lasted longest and produced the finest pieces. Its earliest manifestations are a number of curious figures of mourning women, their open hands pressed to their breasts in the same gesture as the Pietrera figure's. Their

hair is dressed in long, thin plaits that fall over their shoulders and wrists; in a few cases, the head seems to have been designed like a Daedalic head—large and almost flat-crowned—a trapezoidal face cut off by a sharp horizontal line under the chin. But in general their appearance is far less Greek than that of the figures from Vulci; the crown of the head is deep; the nose, narrow; the chin, pointed; the eyes are enormous, as usual. The figures are carved only to the waist; below, the body is a column made of separate drums. These apparently stood in pairs at the entrances to tombs of the early sixth century.

About the middle of this century, the first of a long series of finely carved reliefs introduced a prolific new school of sculpture at Chiusi. The material used was a fine local limestone; the reliefs ornamented grave monuments, ash urns, and sarcophagi; the latest examples date from the second quarter of the fifth century. The soft, friable character of the stone forced the sculptors to develop a particular style of carving; the relief is very low with rounded edges and surfaces left as simple as possible; the drawing is delicate and confident—this is almost the only sculpture from Etruria to create a satisfactory drapery style—the placing of the pretty figures on a plain background forms a rhythmical composition without much dramatic impact.

The scenes are all related to the funeral and the honors due to the dead and thus form a valuable supplement to the paintings in the contemporary tombs at Tarquinia and Chiusi. The prothesis, the lying-in-state of the dead, surrounded by mourning women, is very common; it evidently owed much to Attic black-figure vases or pinakes. Funeral games, dances, and the funeral banquet are popular. A pretty scene, not found in tomb paintings, is a conversation between two ladies who are seated and facing one another with their attendants or friends standing behind them; this scene appears in a number of variants. The spectators at the funeral games are shown, too, sitting on folding stools or on benches on a raised platform. The favorite games are foot, horse, and chariot races, probably because the artists liked repeated figures; tumbling and wrestling are shown occasionally, and there is one dancing girl with castanets whirling to the music of the double pipe.

A few of these reliefs show scenes of departure to the other world.

THE ETRUSCANS

The cippus illustrated here on Plate XIX, a grave stone with a quad-rangular base ornamented with reliefs and surmounted by an onion dome, shows two such scenes: in one, a boy on horseback takes leave of some friend or kinsman; in the other, a man mounts a chariot drawn by two winged horses. Such scenes of the journey to the underworld are rare in the Archaic period but become very common later (Pls. XLIV*a* and XLIV*b*).

The shape of this particular cippus is characteristic of the group; there are variations, but the great majority is of this type. The rounded or onion-shaped finial may be a stylized phallus or a development from the phallus, the symbol of rebirth, though some scholars see in the square base crowned by a rounded element an abstract image of the goddess of the tomb, whose half-figures flanked the entrances to the Chiusi tombs at an earlier period. The combination of cube and dome or cube and column is not uncommon in Etruscan funerary art. The late Archaic graves at Marzabotto, for example, are boxes made of five stone slabs surmounted by an egg-shaped or columnar element (Pl. XVIII*a*).

TERRACOTTA

Architectural terracottas have been found at nearly every important site in Etruria and Latium, and antefixes for the eaves, decorated with human heads or masks—a Corinthian invention of the second half of the seventh century—were particularly admired and elaborated in Etruria.

The earliest, which cannot be dated before the first years of the sixth century, come from Capua in Campania rather than from Etruria proper. These heads are still in the Daedalic style—low-crowned, the undulating line of hair still almost horizontal across the low foreheads, the broad, wedge-shaped faces with prominent chins, the batwing ears set high and outlined against the heavy locks of hair that frame the face, very like the earliest Greek antefixes of this type from Thermum in Aetolia, the work of Corinthian artists.

The earliest head antefixes from Etruria are slightly later in style; they have been found at Veii and Cerveteri and date from the first half

of the sixth century. Though they still have a Daedalic flavor, it is softened: the hair curves smoothly down from the low, rounded skull, framing the face and setting off the batwing ears; the triangular face is rounder and fleshier; the eyes are generally almond-shaped; the tip of the nose, broad; the small mouth has full, smiling lips (Pl. XX*a*). Heads like these have also been found at Thermum, and there are contemporary examples from Capua in a similar style.

Associated with these first Etruscan head antefixes were fragments of continuous friezes in low relief, representing processions of two-horse chariots, with armed warriors mounting or standing behind the charioteers (Pl. XX*b*) or pairs of galloping horsemen armed with spears and round shields. Such friezes are not found in Campania nor on the Greek mainland. In the Aegean they are characteristic of Ionia and particularly Lydia, and they must have been borrowed directly from the Ionian Greeks by the Etruscans. Antiquarian details on these reliefs, such as the short tunic of the charioteer and the coal-scuttle chariot with five-spoked wheels, are also Ionian.

Other Etruscan and Latin cities have provided us with early terracotta friezes of the same sort: Tarquinia and Tuscania, with foot soldiers, horsemen, and chariots; Poggio Buco, a unique design of alternating griffins and grazing stags; Vignanello in the Faliscan territory, armed riders; Orvieto and Rome, horses and riders.

These architectural terracottas, both antefixes and friezes, were normally pressed in molds and retouched before firing, and the same molds were not infrequently used to make revetments for different cities; the frieze illustrated on Plate XX*b* has turned up at Veii and Tarquinia, as well as at Cerveteri.

A new series of head antefixes and friezes dates from the second half of the sixth century and is strongly influenced by the contemporary figure style of Ionia, a style which, in the third quarter of the century, took the fancy of the whole Mediterranean world. The head is egg-shaped, the profile, pointed; the sloping forehead forms a continuous line with the nose, and the chin recedes; the face is oval with slanting almond eyes under elegantly arched brows; the lips smile, frankly, agreeably, subtly, secretively, sinisterly. This was the ideal of beauty

THE ETRUSCANS

from Ephesus to Etruria; the Attic korai of *ca.* 540–520 B.C. are the best known of these charming ladies.

The Etruscan antefixes of this period wear stephanes and disc earrings like many of the Attic korai; and like the Athenian figures, their hair is dressed on the forehead in deep scallops. Not that this fashion is strictly Attic; such jewels and such looped and curling locks were worn on Rhodes and Cyprus as well as at Ephesus—in fact, wherever the Ionian koine spread.

A slightly later group of antefixes in the Ionian style (*ca.* 525–500 B.C.) are framed by a great shell of concave tongues, apparently a Capuan invention; it never appears in Greece. This is the preferred form from the late Archaic period to the late Hellenistic, when the simple head antefix reappears. It is, among other things, evidence that temples of the late sixth century were considerably bigger than any built earlier; the effect of the fine showy shell would carry from the roof far better than a simple head.

Some of the finest Archaic shell antefixes come from Veii, where the female heads alternated with gorgoneia, as had the early Capuan and Corinthian series, and with satyrs' heads—the first satyrs in Etruscan art. The example shown on Plate XXI, of unknown provenience but perhaps Caeretan, is one of the finest of these. He had a shell, but he has lost all but the molding at its base; the molding arches over his bald forehead and swings down behind his ears. He looks surprised and pleased—horse ears pricked, eyebrows raised, eyeballs bulging, full lips pursed for a wolf whistle. Drooping moustache and full beard are neatly trimmed; for a satyr he is very civilized.

Late Archaic shell antefixes have been found in Etruria not only at Veii but at Cerveteri (where the types are maenad, gorgon, seated satyr, and a negro's head, unique in this series), Falerii, Orvieto, Chiusi, and Bettona in Umbria, near Perugia; the Latin examples come from Palestrina, Velletri, Lanuvium, and Satricum. And with the shell antefixes appears a new repertory of terracotta revetments; the figured frieze disappears, and its place is taken by a frieze decorated with chains of hanging palmettes and lotuses.

Art of the Archaic Period

The same years that produced the first shell antefixes also produced the first examples of freestanding terracotta statuary in Etruria. The head of a kouros in the British Museum (Pl. XXII) has been attributed, like the antefix of Plate XXI, to the school of Veii; his face is broader and shorter than the antefix's; the eyes and mouth are straight and more sharply outlined; the arch of the eyebrows, more arrogant. The large ears are set low and frame the face; the forehead is sloping. The hair is cut rather short on the nape of the neck and bound with a double fillet; short, loose locks fall over the forehead. There are still traces of paint on the eyeballs and ears of this figure; all terracotta sculpture was painted in antiquity. This head was apparently broken from a votive statuette; it is modeled freehand, the surface carefully retouched with tools before firing.

The most famous, as well as the finest, of all Etruscan terracottas are the heroic figures of divinities that once stood along the rooftree of the Portonaccio Temple at Veii. A group of Apollo and Hercules fighting for the sacred hind in the presence of Hermes and of a woman with a child in her arms are the work of one artist; other statues found with these are by different hands. The muscular Apollo, with his long, snaky, black curls sliding over his shoulders, strides forward with glaring eyes and a sinister, fighting smile on his lips. Hercules (his head has not been found) is waiting truculently, one foot on the body of the poor hind, which has been trussed and thrown to the ground. Hermes is allowing himself a sardonic grin in the background. Whether the woman and child are part of this same drama we do not know; there is a sort of frenzied *sauve qui peut* look about her wide-open eyes, but she smiles too. The artist has succeeded, in fact, in diversifying the Archaic smile so that each one of these heads has a different expression.

These magnificent figures are perhaps ten years younger than the antefix and the votive kouros (Pls. XXI and XXII). As in the kouros, the eyes and lips are very sharply outlined; and the arrogant eyebrows and rough, plastic locks of hair are treated like his. But the faces are longer, with heavier and more formidable jaws, and the ears are not so big. Apollo's proportions are those of a Greek kouros of about 490 B.C.

Apollo's costume is interesting; he wears a tunic with short sleeves

and colored borders and over it a semicircular cloak, the Etruscan toga. The style of the drapery resembles nothing in Greece; it clings tight to the body as if it were wet, and it is fretted into numerous sharp, fussy ridges. The dress of the female figure is treated in the same way; the muscles of Apollo's legs and the tendons of the woman's hands stand out as narrow parallel ridges, so that virtually the whole surface of their bodies is covered with a pattern of sharp ridges and broad shallow grooves, a scheme of decoration that was first seen in the early Orientalizing period (Pls. IV*b* and VI).

Cerveteri and Veii were the two great Etruscan centers of terracotta sculpture in the Archaic period. Two superb ash urns from Cerveteri—one in the Villa Giulia Museum at Rome, the other in the Louvre—represent a husband and wife reclining together on a banqueting couch, the man's right arm thrown across the woman's shoulders; both faces are full of life and its pleasures, the hands gesturing in animated conversation. The figures are life-size. Their surface is smoother than that of the Veientine figures; the egg-shaped heads, the slanting foreheads which make a single sweeping line with the short, uptilted noses, the narrow jaws, and the fall of the cheeks toward mouth and chin are very close to Ionian sculpture of the third quarter of the sixth century; the smooth, somewhat fleshy bodies, with no indication of muscle and precious little of bone, are also Ionian. The drapery is indicated by a series of rounded ridges alternating with broad, smooth surfaces, quite unlike the drapery style of Veii.

A pretty head of a girl in Copenhagen (Pl. XXIII), which has been broken from a statue, comes from Cerveteri and will serve to illustrate the Caeretan style of *ca.* 510 B.C. The full, oval face and heavy chin are not unlike the Veientine heads in proportion; the modeling of the features, particularly the nose and lips, is much softer; and the hair is laid in flat, smooth scallops over the forehead. The girl wears a soft conical cap kept in place by a stephane; at the crown, a tuft of hair sticks out through a small opening, while the heavy mass of her hair hangs down her back. This headdress is one of several kinds of conical cap very fashionable in Ionia and Etruria during the second half of the sixth century, though it never became part of the women's costume in

Greece proper. The popularity of the pointed cap in Etruria is, indeed, good evidence that the "Ionian" period there was directly affected by the cities of Ionia and not merely, as in Greece, the result of the spread of Ionian fashions through the Mediterranean.

It is clear by now that the Greek influences on Etruria were varied and conflicting. The earliest stone sculpture seems to have been affected by the Daedalic style of mainland Greece; Tarquinia's archaic reliefs owed their designs and, to some extent, their style to Corinthian vase painting, while the later reliefs of Chiusi borrowed much from Attic black-figure vases. The terracotta tradition was at the beginning influenced by Corinth through Capua and also directly by the Ionian cities of Asia Minor. The Corinthian influence faded in the course of the sixth century, while the Ionian was intensified. Probably the presence of Ionian craftsmen in Etruria was responsible for this phenomenon; Persia's conquest of the kingdom of Lydia in 548 B.C. was a bitter blow to the Ionian Greeks, whose sympathies lay with Croesus and who saw they must inevitably follow him under the Persian yoke. In the wake of this conquest, the Phocaeans sailed west to found their ill-fated colony on Corsica (see chap. iv), and no doubt many other Ionians moved west as well, preferring to take their chances with the Etruscans, whom they already knew, as the terracotta friezes of the first half of the century show, rather than with Persia. Moreover, Etruria's fondness for Ionian luxuries is recorded by Athenaeus (12.519), and at least one Ionian vase painter had set up a workshop in Cerveteri by 530 B.C.

BRONZE

The bronze sculpture of the first half of the sixth century was a curious mixture of rigid repetition of the male and female Etruscan votive figures of the late seventh century (Pl. XV) and very small-scale imitations of Greek types of the first half of the sixth. Not till the third quarter of the century did Etruscan bronzeworkers regain the assurance and sense of style that they had had in the last quarter of the seventh.

All the bronzes of the third quarter of the sixth century are votive, and most are relatively small, about 15 centimeters high; the tallest is 41 centimeters. Except for a few Latin bronzes, they all come from

northern Etruria. The figures are cast solid, sometimes with small square or round bases; more often there are long tangs under the feet which were originally fixed with lead in a base of wood or soft sandstone. After casting, the surface was carefully polished and finished with much delicately incised detail; the almost finicky reworking of the surface is one way of recognizing an Etruscan bronze.

The Etruscans never had the Greek artists' interest in anatomy for its own sake; generally they were content to model a passably human lay figure and focus their attention on the modeling of face, hands, and feet—those parts of the body that most easily betray personality. This is the reason for the often exaggerated size of the hands and feet of Etruscan bronze figures and for the enormous eyes that demand our attention like those of the Ancient Mariner. During the second half of the sixth century, however, these expressionist elements were more subdued; and the bronze figures, like the terracottas of these decades, nearly reproduce the proportions and anatomy of contemporary Greek statues.

Votive bronzes before the mid-sixth century had reproduced anonymous types, male and female worshippers and kouroi. But all at once, about 530 B.C., the figures take on individuality; worshippers wear elaborate and significant costumes (Pl. XXV*b*), and the gods—at least Hercules, Minerva, and probably Mars—arrive (Pls. XXIV and XXV*a*).

Minerva, whose worship at Veii in the third quarter of the sixth century is attested by bucchero sherds inscribed with her name and a fine terracotta head broken from a votive figure, always appears in the costume and attitude of the Greek Athena Promachos, helmeted, right arm raised to brandish a spear, left stretched forward to support a shield. The earliest, found near Florence and now in Berlin (Pl. XXIV*b*), stands stiffly in a hieratic pose, evidently the miniature copy of a large local terracotta cult statue and not a direct imitation of the lively Greek bronzes. Her plump face, with its big eyes and tiny nose and chin, stares out comically under a heavy helmet with fixed cheekpieces and a lofty support for the crest, now lost. Her enormous shoulders and the bulging muscles of her arms show that she is, indeed, the

warrior goddess. And her curiously stiff dress with its braid ornaments is the only example of the Doric peplos from Archaic Etruria; obviously it was a costume that the Etruscans neither used nor understood. Even in the Classical period the Greek peplos was worn in Etruria only by the goddess Athena (see chap. vi and Pl. XXXVII).

The early Hercules figures are better modeled and more sophisticated in style. The example on Plate XXIV*a* was found near Fiesole in 1898 and is now in the museum there. The god wears a short tunic and over it a lion's skin, like a hooded coat; the lion's mask is pulled over his head like a cap; the forepaws are knotted on his breast; the skin is pulled tight around his body at the waist and pinned neatly in front, while the hind paws hang down his legs rather like a tail coat. This costume was worn by the Greek Herakles on innumerable black-figure vases during the course of the sixth century, but as a statue type this Hercules is Cypriot, not Greek.

Though the surface of this bronze is badly damaged, particularly about the face, the powerful and graceful modeling of the body is still evident. The broad curve of the lion's skin sweeps from the crown of the head to the waist; the deep chest, protruding buttocks, and heavy thighs are like those of Greek kouroi of *ca.* 540–520 B.C. The lower legs, much too short from knee to ankle, and the very long, narrow feet are purely Etruscan.

To this same period belong the first bronze warriors in Etruria, if one excludes the Villanovan figures and those of the late seventh century that wear the perizoma (Pls. VI and XV*a*). These imitate the pose and frequently the armor of the striding Greek warriors of the sixth century. The beautifully preserved example in the Louvre (Pl. XXV*a*) wears a heavy helmet with fixed cheekpieces, like the Minerva from Florence, and a crest ornamented with an animal's head. He wears greaves, as most Greek warriors did at that time, but his close-fitting tunic, perhaps of well-tanned leather, is again Cypriot rather than Greek. The pose is like that of the Minerva, with considerably more life given it by the determined stance of the legs and the flourish of the left arm. The modeling of the face and the fleshy curves of the body are characteristic of the Ionian phase of Etruscan art, and this figure too

THE ETRUSCANS

must be dated 540–520 B.C. Whether he is only a mortal warrior or the god Mars himself we cannot tell.

A purely Etruscan type is the male figure wearing a toga. An example in the British Museum (Pl. XXV*b*) from Pizzirimonte, near Prato in the territory of Florence, is one of the handsomest and best preserved of these. The young man wears the semicircular toga, one corner thrown forward over the left shoulder, the straight edge pulled tight under the right armpit, the other corner thrown back over the left shoulder, while the curved border hangs to mid-calf; with this he wears high-laced, soft leather boots with pointed toes. The borders of the cloak are elaborately ornamented with delicately incised patterns; this must be the toga praetexta, the bordered toga, one of the symbols of royalty taken by Rome from the Etruscans, and this beautiful boy must be an Etruscan prince.

He stands with his feet together, the left hand on the hip, the right stretched forward, as if about to shake your hand. The attitude never appears in Greece during the Archaic or Classical periods, though it had been known in the Geometric period; but it is common among Etruscan votive figures of the last three dtcades of the sixth century; presumably it has a ritual meaning.

This bronze must be dated in the late Archaic period, a contemporary of the Apollo and Hermes of Veii. His head is, like the Apollo's, broadly egg-shaped with a rounded skull and an oval face. The almond eyes are set horizontally; the cheekbones are prominent, and the heavy chin is cleft. The long hair is brushed forward in a soft roll over the forehead, looped up at the nape of the neck, and tied with a double fillet, like the hair of Greek kouroi of *ca.* 515–480 B.C. The shoulders are broad; the collarbones, strongly indicated; the arms and chest, muscular; the waist, slender. These proportions can be paralleled in Greek kouroi, though the Etruscan's head is rather too big. Like the toga of the Apollo of Veii, the surface of this one is gathered into shallow ridges— fewer and less fussy, but giving something of the same relief pattern.

PROVINCIAL BRONZES

The four figures just discussed may be said to illustrate the aristocratic tradition in Etruscan bronzework and the Ionian International Style.

But a great many contemporary small bronzes have a strong local or provincial flavor, sometimes the consequence of incompetence but more often the result of the Etruscan love of expressionism and a preference for geometric abstraction that must be a recurrence of the old Villanovan predeliction for wiry geometric figures. A female figure of a type found in the Po Valley (Pl. XXVI*b*), now in the Bibliothèque Nationale in Paris, is a delightful example of this provincialism at its best. The big, round head is set on a tall, narrow, flattened body, only the swell of the breasts and the buttocks breaking its solemn line. The ankle-length dress is unbelted and unornamented; the tall, smooth pointed cap is greatly elongated, adding to the height of the whole figure; the turned-up toes of the pointed shoes repeat the point of the headdress. All expression is concentrated in the bulging eyes, rabbit nose, tiny, pursed mouth, and the enormous hands, which are stretched forward in the Hittite pose, the left open, palm up, the right daintily holding an egg between thumb and forefinger.

On the other hand, the bronzes of Campania are impregnated with the Greek tradition. The finest Capuan bronzes are difficult to distinguish from Greek figures, and even the less aristocratic figures are more likely to copy Greek types than are bronzes from Etruria proper. In Capua, types which are not common in Etruria are found: horsemen, athletes, boxers, and discoboli; the kriophoros (a man carrying a sheep across his shoulders), which is found in Etruria in only two examples, one of which was obviously bought at Capua; dancers, satyrs, and maenads, and, at least once, a player on the double pipes (Pl. XXVI*a*).

Here the provincialism is not so much in the structure of the body—though the short-waisted torso is far from Greek—as in the head and hands. The sturdy legs and long, muscular arms recall the Greek anatomical studies of the decades 540–520 B.C. The head is egg-shaped; the face is simplified to a triangle, framed above by a stiff frill of hair that is brushed forward over the forehead and dominated by the enormous almond-shaped eyes. The narrow ridge of the little, pointed nose seems to divide at the root into two sweeping ridges for the eyebrows; below the tight mouth is a long, triangular chin. The boy's pose is strictly frontal; the legs are close together but the left foot is slightly advanced;

the long, muscular arms, held at shoulder height, are bent sharply at the elbows; the enormous hands hold the double pipes with delightful delicacy.

There was at least one region beyond the political empire of Etruria that came strongly under the influence of Etruscan art. This was Umbria, whose territory once extended considerably west of the Tiber. Perugia was an independent Umbrian city as late as the fifth century, and Chiusi, too, according to tradition, may have once been an Umbrian town called Camers (Liv. 9.36; 10.25). From the mid-sixth century onward, Etruscan bronzework of very high quality was exported to Perugia; the magnificent chariot from Monteleone in the Metropolitan Museum of Art, the Loeb tripods in Munich, and the superb reliefs from Castel San Mariano in the Perugia Museum were all found in the neighborhood of the city but were almost certainly made elsewhere—to judge from their style at Cerveteri, though not such bronzes have actually been found there.

When, at the end of the sixth century, Umbrian workshops began to produce their own votive bronzes, the types were all borrowed from Etruria: the kouros, the woman wearing a pointed cap, and eventually the armed warrior. But the style is not in the least Etruscan. These Umbrian figures are geometric; as though the instinct toward elongation and abstraction that the Villanovans manifested had lurked for over a century in the Umbrian sense of design and had finally come to light when the Umbrians learned to cast bronzes for themselves. And, like the Villanovan figures rather than the Etruscan provincial works (Pl. XXVI*b*), the Umbrian bronzes are full of lively motion, light on their feet, and free in their gestures.

The warrior (Pl. XXVII*a*) in Princeton wears the arms of a Greek hoplite of the early fifth century: Attic helmet with hinged cheekpieces and a great low-set horsehair crest, leather cuirass with a belt, a short skirt of lappets over a short tunic, and greaves. He stands like a Greek warrior; and, like the Ionian Etruscan (Pl. XXV*a*), his right arm is raised to brandish his weapon—from the position of the hand, this must have been a sword—his left is stretched forward, covering his body with his round shield; the armpiece and bar for the hand to

grasp are still in place. But the proportions—the wiry arms, long, tubular torso; lean, limber legs—and the rhythm of the whole figure are supplied by Umbria. It used to be thought that bronzes of this type were extremely old, of the eighth or seventh century B.C., but the costume cannot be earlier than the beginning of the fifth, and all the bronzes of this type—and there are hundreds—must be dated within that century.

The face of this warrior is cut on Archaic lines: long, almond eyes; broad, short nose; smiling mouth. The Umbrian lady illustrated on Plate XXVI*b*, now in Bibliothèque Nationale at Paris, has a face whose modeling and expression come from art of the Classical period —a long, thin face, with a narrow nose which makes a continuous line with the high forehead, sober mouth, square chin, and small eyes. To be sure, the features are reduced to shorthand, but ladies on Attic vases of the mid-fifth century show the inspiration for this face. The Umbrian figure wears a heavy diadem fastened at the back with a narrow ribbon, an Etruscan fashion of the Classical period (Pl. XLII); her short, unbelted dress, which clings to her flat torso and wiry legs, is the characteristic Etruscan dress of the Archaic period (Pl. XXVI*b*). The dress is embroidered with wavy dotted lines and a pattern of triangles at the neck; she wears soft shoes and holds a fruit or large egg in the right hand. Though her pose looks like a first, nervous attempt at ice-skating, she is really stepping forward, an offering in one hand, the other stretched out, palm down, in an attitude of prayer.

Decorative Bronzes

The beauty of Etruscan metalwork is twice mentioned by Athenaeus. Once (1.28), he quotes a poem of Critias, Socrates' pupil and one of the hated thirty Tyrants at Athens: "The Etruscan cup of beaten gold is king, and any bronze whatever that adorns the house for any purpose;" and again (15.700), quoting from a comedy of Pherecrates to illustrate an archaic word form, he says, "The lampstand was Tyrrhenian . . . for manifold were the crafts among the Etruscans, since they were skilled and loving workmen." The bronzes Athenaeus and his fifth-century authorities had in mind were not freestanding statues and

certainly not votive figures, but furniture and utensils for household use, and the Etruscans did indeed produce these in quantity and with great style.

The art of decorating sheets of bronze in repoussé had been an old Villanovan specialty (Pl. III), and during the Orientalizing period it continued unabated. The first half of the sixth century, that curious period of decline among the bronzeworkers of Etruria, produced very few bronze reliefs, but from the middle of the century to the end of the Archaic period they are numerous and of high quality. Among the earliest and finest is the splendid parade chariot, now in New York, from a grave at Monteleone near Perugia. The bronze plates originally covered a wooden frame. The body is made in three panels: the front, high and bowed; the two sides, low and flat; all three have rounded tops. Each is filled with a group of figures in low relief; the designs are monumental, the figures completely filling the available space and admirably adapted to its shape. In the bowed central panel, a woman and a warrior stand on the either side of a magnificent helmet and figure-eight shield, which they both grasp. The great curved sweep of the helmet's crest echoes the curve of the top of the panel; the sturdy male and female figures stand erect, repeating the strong verticals of the sides; but their round heads are slightly bent toward one another, to fit under the spring of the arch at the top, while their long, narrow feet emphasize the horizontal line of the lower border. The man is a warrior, wearing a close-fitting tunic and greaves; the woman is giving him his armor. Is she Thetis, bringing the arms of Hephaistus to Achilles? Near their heads, two birds of prey are diving at a hind, which is shown upside down under the shield; this must be a portent of some sort, but it is not one mentioned in the *Iliad*. One side panel shows a combat of two armed warriors over the fallen body of a third; the other, a hero in a chariot drawn by a pair of winged horses that spring up above a woman crouching on the ground. It has been suggested that this scene shows the apotheosis of Achilles, for which there is no Homeric authority either, though there may have been later authority for it. In any case, the plot is less clear than the artist's sense of design. The tomb in which this chariot was found also contained

two Attic black-figure vases, dating from the middle of the sixth century.

A number of bronze buckets (situlae) ornamented with bands of figures in repoussé have been found in the Po Valley; the finest is from the Certosa Cemetery at Bologna, where it was used as an ash urn. The top frieze shows a file of marching soldiers; the second, a funeral procession; the third, scenes of country life; the lowest, a row of fantastic animals and filling ornaments. A similar situla is now in the Rhode Island School of Design (Pl. XXX). In shape, the vessel is a broad bucket with a narrow shoulder and vertical lip; the upper part is somewhat broken, but the rolled rim, the looped handle attachments, and the single swinging handle are still in place. Here, there are only three friezes: the lowest shows a file of long-horned goats, with hanging lotuses as filling ornaments; the central frieze, a procession of soldiers; the upper, a series of contests, perhaps part of the funeral games, if this situla, too, was meant to be used as an ash urn. The figures are designed with short, fleshy bodies; bulging shoulders, upper arms, and thighs; and very slender wrists, ankles, and feet. The big heads are round and bald, with round, bulging cheeks; little, round eyes; big, pointed noses; protruding lips; and clean-shaven chins. The style of these figures is evidently derived from the Ionian style popular in Etruria in the third quarter of the sixth century B.C., but many details of costume and action are local. To be sure, the great pot helmets with outturned brims worn by some of the warriors in the second file are exaggerations of a favorite Etruscan shape; the Etruscan helmet dedicated at Olympia by Hieron of Syracuse after his victory over the Etruscans off Cumae in 476 B.C. (Pl. XXXI) is a more classical version of the type. And their oval shields are of the shape characteristic of most of Italy in the early Iron Age, though the Etruscans of Etruria preferred the round Greek shield. But the short, smooth cloaks and flat berets of the men watching the boxers and the braided straw(?) turbans worn by the musicians and piled on top of the boxers' clothes on the ground behind them (Pls. XXX*a* and XXX*b*) never appear in Etruria. Nor do those peculiar dumbbells the boxers are flourishing

at each other ever appear, and the Panpipes played by the musicians are played in Etruria only by satyrs.

Boxers and musicians are both contending for prizes; between the seated pipers, a great cauldron on a tall stand decorated with three rounded swellings recalls the fine Orientalizing cauldron stands of Etruria. The huge bird perched on its rim must be an omen; probably the man he faces is going to win. The boxers are to win a hemispherical basin on a similar stand and a pair of firedogs(?) with duck's head finials, very like Villanovan bronzes. A small bird that startlingly resembles a fish is perched on the basin's rim; I take him for an omen, too.

The reliefs of this situla are, as usual, retouched with fine, incised details; Etruscan artists were equally competent at engraving on a flat bronze surface. Plate XXIX shows the back of a hand mirror in the British Museum engraved with a nude youth running lightly over a sea full of small fish. The boy runs in the conventional bent-knee position of the Archaic period; his head is turned backward; and he has a somewhat worried expression, as if he were being pursued. Since he has no name and no attributes except the ability to run across water, we cannot tell who he is, but these mirrors were the prized possessions of Etruscan beauties of both sexes, and one suspects that this is half of a love scene—Cephalus fleeing from Eos? or, since the scene is wreathed with ivy, Dionysus fleeing from the pirates? The figure is beautifully drawn, with an economy of line and detail that recalls the best Greek vase painters, and the circular design must owe not a little to Greek cups of the last quarter of the sixth century. The boy's face has the fine, pointed profile of Ionian art—a sloping forehead, long nose, and receding double chin—his long hair is looped up under a fillet at the nape of the neck. Such engraved mirrors seem to have been an invention of the Etruscans, and they remained an Etruscan specialty from the last quarter of the sixth century till well into the third.

During the last two or three decades of the sixth century, the city of Vulci developed a manufacture of bronze utensils decorated with human and animal figures in the round or in high relief—tripods, incense burners, candlesticks, vase handles, ornaments for helmets, and

other objects. A large number of these have been found in the tombs
at Vulci, but they were exported to other parts of Etruria and else-
where; one of the tripods was found at Spina, on the Adriatic, and
an exceptionally handsome fragment of another among the Persian
debris on the Acropolis at Athens.

The incense burners generally have the form of a three-legged
stand, which sometimes represents a dining table; on this stand is a
figure from whose head rises a shaft ornamented with discs or leaves,
crowned with a shallow basin in which the incense was burned. The
human figures that support these basins are generally connected with
banquets and the joy of life—dancers, sileni, and Hercules, a frequent
associate of the sileni in Italy and always a famous eater and drinker.
The finest figure of all, in the Vatican Museum, is the young Dionysus,
naked except for soft slippers with pointed toes and a necklace with a
pendant in the shape of a fawn's head; he holds an egg in one hand
and a drinking cup in the other, and there are little fawns couched at
his feet on the corners of the stand. He has the plump body and pointed
profile of the running boy on the mirror (Pl. XXIX), but his legs are
longer, and there is greater distance between his shoulders and his hip-
bones; he probably dates from the very end of the sixth century.

The tripods have feet shaped like lions' paws, which sometimes rest
on crouching frogs; from each foot rise three rods; the one in the
center is straight; the outer two are arched to link one foot with the
others. On top of each straight rod and on the crown of each arch
stands a figure or a group, while the arch itself is filled with an orna-
mental design of conventionalized tendrils and leaves. Plate XXVIII
illustrates one of the arch ornaments from a tripod in the Metropolitan
Museum in New York; the curve is filled with looped tendrils ending
in leaves and acorns, below which hangs a chain of alternate acorns
and palmettes. Such acorns are the hallmark of the school of Vulci.
The curve of the arch itself is decorated with a tongue pattern, and
the whole is topped by a group in which a lion attacks a bullock. The
little bull collapses forward; the splendid lion, whose lean flanks and
muscular legs contrast oddly with his highly stylized mane, is twice
the bull's size and can easily set one hind paw on its forehead while

he rakes its flanks with his forepaws and bites its spine near the tail. Handsome though they are, these figures are moldmade, not individually modeled like the votive bronzes. But the groups are never exactly the same; the mold was retouched after each casting, and the surface was always carefully reworked and finished.

At the beginning of the fifth century another school of decorative bronzework developed at Chiusi; it specialized in braziers and candlesticks. At least one other school existed in the first half of the fifth century, somewhere in the north, possibly at Bologna, where a great many pretty candlesticks crowned with mythological figures or groups have been found. This northern school also sold its wares to Spina, on the Adriatic.

In addition to the Vulci tripod from Athens, Etruscan decorative bronzes have been found at Locri in southern Italy, at Olympia and Dodona in Greece, and at Lindos on the island of Rhodes. Evidently the traffic was a flourishing one, and it bears out the opinions of Critias and Athenaeus on the popularity of Etruscan bronzes in the Greek world.

Painting

In antiquity, the art of painting was quite as widespread and as much admired as sculpture, but the perishable nature of paint and painted surfaces has left us very few ancient paintings (apart from vase paintings) earlier than the Roman period, and even then we have not much but third- or fourth-rate Pompeian wall decorations. A few paintings from Rome seem to show that the Romans could do better than that, and the rare surviving painted stelae from Greece prove that the Greeks could do very much better. But the Greek stelae are painted on marble; so to see what ancient frescos looked like, one must visit the painted tombs of Etruria.

Tomb Paintings

A few tombs of the late seventh century and the beginning of the sixth were decorated with paintings in an Orientalizing style; the least damaged of these—and it is wretchedly faded and battered—is the

Campana Tomb at Veii, a tomb with two chambers approached by a long dromos with a niche on either side of the door of the outer chamber. The door in the back wall of this outer room is bordered with a band of triangles and flanked on either side by a pair of painted panels; the lower panel on the left is filled with a lioness and her cubs; that on the right, by a walking sphinx, a running horse(?), and a seated lion pawing at the sphinx's hindquarters. These creatures are parti-colored; the hindquarters or shoulders are spotted; the rest of the body, in solid colors. The backgrounds of the panels are filled with looping floral designs. The upper panels show boys on horseback; the boy on the right is accompanied by men and dogs, and a hunting cheetah crouches on his horse's crupper. The animals have very long, thin legs, the horses' manes are flamelike, and the boys that ride them are tiny, like the riders on an early seventh-century frieze from Praisos on Crete. The color of these frescos is entirely arbitrary and in a limited but rather bright palette: gray, yellow, and red on a blue ground.

The *floruit* of Etruscan tomb painting came in the second half of the sixth century, the same years that saw the great development of terracotta sculpture and bronzework. All the painted tombs of this half-century that survive are at Tarquinia. The technique varies somewhat: occasionally the colors are laid directly on the smoothed stone walls of the tomb; sometimes there is a priming coat of grayish paint; most often, the paint was applied to a thin coat of plaster which, owing to the dampness of the rock-cut tomb chambers, took the pigment in a true fresco technique. The figures were usually first traced with a sharp point on the wet plaster, then drawn over in light red; the colors were laid on flat, like the colors on Attic white-ground lecythi; and finally the outlines and interior details were added in black. Often the final outline does not follow the original red sketch or its incised predecessor as one can see in the drawing of the profile of the dancing girl on the left and the legs of the dancing girl on the right in Plate XXXIV; these second thoughts usually improve the composition.

The tomb generally has a single, small chamber with a gable

roof; and the whole interior, roof and all, is painted. In the commonest arrangement, the rooftree is a heavy beam, either carved from the soft stone or simply painted; it is carried on painted king posts in the gables, which have an elaborate form with concave sides that end in volutes at the top and bottom. The ceiling is painted in lively colors; the rooftree is often wreathed with vines, and in the Tomb of the Lionesses (Pls. XXXIV and XXXV) six painted Doric columns, at the four corners and in the center of each long side, hold up the roof. The slenderness and height of these columns, as well as their color, show them to be wood rather than stone; the spreading echinus and deep hawk's-beak necking below resemble those of the capitals of the Basilica at Paestum. Shaft and abacus are dark reddish brown; the echinus, a lighter brown; the necking, bright apple-green; the torus beneath this, black. The ceiling is painted in a big checkerboard pattern of red and white, and quite obviously this tomb (and others of the same type) does not represent a house or a temple but a pavilion with a canvas roof and no walls, which sheltered the banqueters as they feasted in honor of the dead, presumably at an annual feast in the vicinity of the tomb, like the Roman Parentalia.

Though the earliest of these tombs at Tarquinia, the Tomb of the Bulls, *ca.* 540 B.C., has a mythological scene painted on the main wall —Achilles lying in wait for Troilus at the fountain—and another, the Tomb of Hunting and Fishing, *ca.* 520 B.C., is decorated with scenes of life in the Tuscan Maremma, the other Archaic tombs here, like the contemporary stone cippi of Chiusi, illustrate the funeral banquet or games in honor of the dead.

In the Tomb of the Lionesses, named for the she-panthers that flank the king post in the gable of the end wall (Pl. XXXIV), the banquet takes place on the side walls. Above a continuous frieze of flying ducks and blue and green dolphins plunging into a gray, ruffled sea, young men lie stretched out between the painted columns (Pl. XXXV); their flesh is dark reddish brown, according to the convention for male coloring as old as Egypt; their long hair is wreathed with green leaves. One young man has yellow hair that curls on the forehead and hangs in long, coiling locks over the shoulders. His dress is a short,

green toga whose lower, curved border is embroidered with a running wave pattern in black, while the upper border, pulled tight around his ribs to leave arms and shoulders free, is white with black embroidery. He leans on an orange cushion spotted with black dots arranged in stars, and behind this is another cushion of bright blue. In his right hand he holds an egg, while his left clutches the stem of a shallow drinking cup.

The end wall shows dancers at the banquet; in the center is a huge mixing bowl, a bronze volute krater whose incredible size has recently been confirmed as fact by the discovery of the even larger bronze krater at Vix in France. The krater is wreathed with vine leaves, and on either side stand the musicians—on the left, a citharist wearing a blue-bordered white toga and pointed shoes; on the right, a piper in a blue toga dotted with black. A long-handled dipper hangs from a ring behind the piper, and a handsome jug stands on the floor near the right-hand column.

To the left, a young woman dances behind the citharist; her unbelted orange dress is spotted with black, like the banqueter's cushion, and has a plain red band at neck and hem; the sleeves come to a point at the elbow. Over the dress she wears a heavy blue cloak with a dark-red lining; her hair is covered by a soft cap of the same material as the dress; she wears big disc earrings and shoes with pointed toes. She has a pretty, Ionian pointed profile; her hands turn back at the wrists like those of a Balinese dancer, and as she moves her cloak swings out to frame her graceful body. To the right of the musicians, a boy and girl dance opposite each other; the black-haired girl is barefoot and wears only a clinging white dress which has a narrow red border at the hem and neck and down the top of the sleeves. The bronzed boy is nude and has long, curly yellow hair. They leap toward one another, each with one knee sharply bent; the girl makes the gesture of the horns (to ward off the evil eye?) with her left hand; the boy swings a jug in his left hand, while his right is lifted toward the girl. There is nothing mournful about this dance; Etruria's slogan would seem to have been like Lorenzo de Medici's, "*Le temps revient.*"

Other tombs—and they are all fascinating—show the funeral games:

the Tomb of the Augurs has wrestlers, boxers, and a gladiatorial combat; the Tomb of the Baron, boys on horseback. Still others show chariot races, runners, mourners, dancers, and the whole dramatis personae of the Etruscan last rites.

OTHER PAINTINGS

Funerary painting must have been, like funerary sculpture, a minor art in antiquity. Pliny knows nothing of it, though he devotes a number of chapters to the history of painting (35.15–150). Painting also was ancient, he says, in Italy; there were very old paintings in temples in the Latin towns of Ardea and Lanuvium and still older ones at Caere (35.6.18), and he quotes Cornelius Nepos as saying that a Corinthian painter, Ecphantus, came to Etruria with Demaratus of Corinth, the father of Tarquinius Priscus (35.5.16).

There are, in fact, a number of ancient paintings from Cerveteri— several groups of painted terracotta plaques that fitted together to form continuous friezes. Some were found in tombs; others, in the excavations of the city itself, where they decorated temples and perhaps other public buildings. Such terracotta plaques (pinakes) are common in archaic Greece, particularly at Corinth, and it may be that Corinthian artists (Demaratus' follower Ecphantus?) brought this art to Etruria. The fact that the Greek artists Damophilos and Gorgasos (their native city is unknown), who decorated the archaic Temple of Ceres on the Aventine at Rome, according to Pliny (35.154), were famous workers in terracotta as well as painters suggests that all the paintings in temples may originally have been such pinakes. As in vase painting, the color was laid on the terracotta before firing, and the palette is a beautiful, subdued one of earth colors—black, red, brown, ochre, buff, and white. The earliest Caeretan plaques date from the mid-sixth century; others are as late as the beginning of the fifth.

VASE PAINTING

Besides the more or less monumental paintings we have been examining, there are Archaic painted vases from Etruria which imitate,

sometimes with ebullient success, the black-figure styles of Attica and the rest of Greece.

Central Italy had begun to import and imitate Greek vases in the second half of the eighth century B.C. (Pl. IV*a*); by the late seventh century, Corinthian wares had become overwhelmingly popular, and during the first half of the sixth they continued to be imported in quantity and imitated in even greater quantity. About the middle of the century, however, the old Corinthian monopoly was destroyed; Etruria developed a taste for Attic, Ionian, even Laconian pottery, and the beautiful black-figure ware called Chalcidian, which may have been made at Cumae in Campania.

Attic black-figure vases were evidently counted among the treasures of an Etruscan family; they are buried in the tombs of the second half of the century, not in whole table services, as the Corinthian pots had been, but singly or in pairs, like the two kylikes found with the Monteleone chariot. They must also have been objects of daily use, since several Athenian workshops took pains to turn out pots imitating Etruscan bucchero shapes, evidently deliberately fostering the Etruscan trade. The workshop of Nicosthenes, for example, imitated a partic-ular form of amphora with wide ribbon handles and a molded band around the belly—a shape whose ancestry in Etruria goes back to the Regolini-Galassi Tomb—and a form of drinking cup, a deep, straight-sided kyathos with a high-swung vertical handle decorated at the top with a knob or acorn, also apparently imitates a bucchero shape.

Ionian vase painters actually settled in Etruria and taught their trade to native craftsmen. The finest Ionian vases made in Etruria are the so-called Caeretan hydriae of the last third of the sixth century, the work of one, or possibly two, Ionian artists settled at Cerveteri; the shape of these water jars is most satisfactory; the broad, egg-shaped body with almost horizontal shoulders rising above a flaring foot, a high, broad neck, and a wide, disc-shaped rim. The foot is painted with a tongue pattern; the lower body, with ivy sprays or chains of palmette and lotus; the shoulder, with ivy sprays or a tongue pattern; the broad band running around the widest part of the jar is decorated with a figured scene. Generally this illustrates a myth—Europa and

the bull, Hercules and Busiris, Apollo expostulating with the infant Hermes for having stolen his cattle. The jars are brilliantly gay, with clear, red backgrounds and much white and red paint added; the figures are large and lively, widely spaced to give full play to gesture and situation; the best of these rank among the finest Greek comic drawings.

The so-called Pontic vases, which were also made in Italy—this time by Etruscan artists—come nearest to the Caeretan hydriae in vigor and liveliness. Like them, these are bright-colored black-figure vases; red shoes, figured cloaks, and gaudy ornaments enliven the scenes. The details of this fabric are highly eclectic; its favorite shape is the Attic neck amphora of the mid-sixth century; other shapes imitate Etruscan bucchero. The decorative details are a fine mixture of Attic, Corinthian, Laconian, and Ionic; the figures are Ionian.

Usually there are two bands of figures, one on the shoulder, one on the lower body, separated by a floral chain or a starred meander band, itself an Ionian pattern. The lower frieze almost invariably consists of animals mixed with the fantastic creatures of Orientalizing art—sphinx, griffin, panther, lion, centaur—a scheme of decoration that would have seemed hopelessly old-fashioned in Greece by the second half of the century. The upper frieze is also likely to be designed as a procession, a file of dancers or revelers, horsemen, racing chariots, or a mythological scene. The most famous and amusing, in Munich, is the "Judgment of Paris": on one side a white-bearded Priam leads the way, followed by Hermes in a cloak embroidered with white crosses; he turns to give some last-minute instructions to Hera, who comes next, enveloped in a great veil which covers her head but accents the outlines of her body; with her right hand she holds the veil away from her face in the classic gesture of the Greek bride. Next comes Athena with shield and helmet (it looks like a low-crowned beaver hat) her hair is arranged in long curls; her dress is tight and revealing, and she has knotted a gaudy scarf around her hips. Aphrodite, smiling, walks last, lifting her skirts so that not only her feet in their red slippers, but her white ankles, too, are well in view. On the other side of the vase, young Paris, also wearing a gaudy cloak—red crosses on a

white ground—turns to welcome them, while behind are three of his cattle and his dog. The figures are slim and lively, with pointed Ionian profiles.

Other groups of Etruscan black-figure vases have the more sober coloring of late sixth- and early fifth-century Attic black-figure. An amphora at Yale (Pl. XXXII*b*), like the Pontic vases, imitates the shape of Attic neck amphorae. The proportions, however, are like those of the Attic vases of the early fifth century, and the hanging palmette that decorates the neck is also found on the necks of early fifth-century Attic vases, though hardly ever so badly drawn. The main scene is confined to a panel across the top of which runs a key pattern; the rest of the vase is covered with black glaze. On the panel, a young boy with wings on his ankles and a long narrow scarf slung around his shoulders is running away from a large severe-looking siren. The boy's attitude is the usual archaic running pose, like that of the runner on the mirror in Plate XXIX; there is still something of the Ionian fondness for juicy curves in the drawing of his buttocks and thighs, but the figure as a whole is slenderer, and the profile of the face is more Attic than Ionian. The Orientalizing siren had long since disappeared from the Athenian repertory; finding her here, part of the main decoration of the vase, emphasizes the curious lag noticeable, particularly in vase painting, between the Greek forerunners of a detail and the Etruscan reproductions of it.

But the most characteristic ware produced in Etruria in the sixth century was still bucchero, though no longer the extremely fine, lustrous fabric of the seventh century (Pl. XIV). The shapes are clumsier; the walls, thicker; and the decoration, almost always in relief, is enhanced in the better examples with incision. The favorite shapes are still the chalice on a high foot, though now without caryatid figures, and the oenochoë, oval-bodied, with discs where the handle joins the lip. These are ornamented with a relief frieze around the middle of the body or on the shoulder; fantastic animals or dancers are popular, and so are spectators sitting on folding stools to watch boxers and other sports, a reminiscence of tomb paintings which makes one wonder just how exclusively funerary this bucchero may have been.

THE ETRUSCANS

There are bucchero vases of fantastic shapes as well. Rhyta (drinking horns), for example, were given a human head and foot (Pl. XXXIIa)—the head that of a smiling Ionian with a spade beard; the foot neatly shod in a high boot of soft leather with a pointed toe. In another instance, a milk jug was topped with a cow's head from whose mouth the liquid poured, like the seventh-century lion jug in Brussels (Pl. XIVa). On the whole, however, the shapes and their decorations are clumsy and repetitious. Chiusi was the center of manufacture of this late bucchero.

JEWELRY

The jewels of the Archaic period are happily less preposterously opulent than those of the Orientalizing. In general, the Etruscans seem now to have followed Greek fashions; we have seen that disc earrings and the low stephane (Pls. XXI and XXXIV) were part of Ionian fashion and were worn everywhere this fashion was found appealing. Earrings shaped like little barrels are more characteristically Etruscan (Pl. XLb); they are made of thin gold and ornamented with delicate loops and spirals of filigree applied to the smooth ground, while the ends are filled with openwork patterns. This shape seems to be confined to the second half of the sixth century. Necklaces are hung with pendants; sometimes a large single pendant is strung on a stout chain, like the bulla in the shape of a fawn's head worn by the young Dionysus from Vulci. More often, there are many small pendants of glass or carnelian strung on necklaces of gold beads or looped to them by delicate chains.

The important change, as far as art and style goes, is that engraved seals become fashionable in Etruria during the sixth century. The earliest were Greek importations from Ionia; the first Etruscan gems date from late in the century. They are generally cut in carnelian, usually scarab-shaped like the ancient Egyptian faïence seals, and were used as jewels as well as seals. In Etruria there was a greater fondness for scenes with a number of figures than in Greece, and where names are inscribed, they are not the names of the artist or the owner, as on Greek gems, but of the subjects, as in Greek vase paintings.

Art of the Archaic Period

The best of the Etruscan gems are marvels of miniature technique. Two in the British Museum, a sardonyx and a carnelian, show Etruscan versions of admired Greek myths—the deaths of Capaneus and of Medusa (Pl. XXXIII). The story of the Seven against Thebes was a particular favorite in Etruria; the attack on her seven gates by the seven champions is the culmination of the tale. The Argive Capaneus attacked the Electran Gate and managed to scale the wall. As he mounted the ramparts, he shouted that now not even Zeus could keep him out of the city. The thunderbolt of Zeus struck him to the ground. Hellenistic ash urns show the hero with his scaling ladder, either mounting the wall or falling headlong from the top. Here he collapses into the curve of the gem, one knee touching the ground, head and shoulders sagging toward the hollow of his great hoplite shield, whose rim still half supports him; his sword has fallen from his hand and is sliding down the beaded border of the seal. The god's thunderbolt has caught him between the shoulder blades. The figure is nude except for his Attic helmet; head and legs are drawn in profile, shoulders frontally; the torso twists from front to profile in the formula inherited by the early red-figure vase painters of Attica from black-figure technique. The lean, muscular body, modeled with loving skill, has the delicate precision of early red-figure painting.

The second gem shows Perseus cutting off the head of the gorgon Medusa. She does not look like the conventional gorgon of the Greeks (for example, Minerva's gorgoneion on Pl. XXXVII), but instead like an ugly young woman with swollen features and thick, panting lips; she is elegantly dressed in a thin, delicate chiton and the diagonal Ionian himation. She sinks to her knees and turns her head away from her attacker, while with the right hand she tries to catch and control his sword hand. Perseus, in an extraordinary twisted pose, like a dancer in some savage ballet, bends fiercely over her, pressing down her left shoulder with his left hand, while he seems to be sawing at the back of her neck with his sword. This may be the most ruthless Perseus in ancient art; surely he is the most reckless, for his head is turned toward the gorgon, bent down over hers, so that, if she had not turned

her face away, her fatal glance would have glared into his. If it were not for his winged hat, one would say that this scene represents, not Perseus and Medusa, but the slaughter of some hapless barbarian captive by her brutal conqueror.

The later Archaic period in Etruria was her Golden Age; her wealth and her political power and prestige were at their height, and her artistic energy rose eagerly to the opportunities offered it. Temples, sanctuaries, tombs, and houses were splendidly ornamented and furnished in a style which owed a great deal to Ionia but quite as much to Etruria herself. She imposed her art on Latium and much of Campania; she revitalized the old Villanovan art of the Po Valley and inspired the first school of Umbrian sculpture. In Rome, her cultural influence lasted two hundred years longer than her political dominion, and even Greece was pleased to buy Etruscan bronzes in the last years of the sixth century and the first decades of the fifth.

The Art of the Classical Period
(ca. 470–300 B.C.)

ONE might say that Etruscan political power began to decline even before the end of the Archaic period, with the loss of Rome in the last years of the sixth century. But Rome was only one city among many, and the southern Etruscan cities seem to have profited, rather than lost, by her defection. The defeat of the Etruscan fleet off Cumae by Hieron of Syracuse in 476 B.C. was a catastrophe of a very different sort, for after that Etruscan sea power was no longer preeminent in the Tyrrhenian Sea. Still more disastrous was the loss of Capua and the rich lands of Campania to the Samnites in the late fifth century and the loss of the Po Valley to the Gauls in the fourth. Most damaging of all was Rome's sustained and successful siege of Veii at the beginning of that century and the total destruction of that city, for it marked the beginning of the ebb of Etruscan power in Etruria itself. Thereafter, Etruscan princes could no longer carve out new city-states for themselves; the Etruscan navies, far from being able to brighten their trade with a little piracy, could not even repulse the piratical raids of Greek neighbors; the Etruscan empire's richest fields had passed to barbarians, and Etruria's oldest cities could no longer defend themselves against the steady, determined encroachment of the Romans, who had once been proud of their Etruscan kings.

THE ETRUSCANS

It is a melancholy history, and its mood is reflected in the art of the Classical period. There is less material evidence—fewer bronzes, fewer painted tombs, fewer temple terracottas—and there is less variety in these, though there is no lessening of technical ability.

The Etruscan Classical style is based, as the Archaic had been, on the art of Greece. But it is the severe Greek style of 480–460 B.C., the years between the Persian Wars and the completion of the pediments at Olympia, that the Etruscans imitate; the new attitudes created for the figures of the Parthenon frieze, flowing in an S-curve from the bent head to the slightly lifted heel of one foot, are seldom attempted and then without much success; the glorious drapery styles of the later fifth and fourth centuries in Greece had almost no effect at all on Etruria.

In general, Etruscan figures of the Classical period, in whatever medium they are presented, are rather stiff and severe, short-bodied, with big, square heads and large features; the torsos tend to be too narrow for the heavy arms and legs; the eyes and hands, as in the Archaic period, may be excessively large. In the second half of the fourth century, however, the figures are taller; the heads, proportionately smaller; the attitudes are easier and more graceful; the composition more nearly approaches the Greek. Even so, it is not always easy to date the Classical sculpture and paintings of Etruria at all closely; the types are too repetitious, and a melancholy, slightly frowning severity stares out of face after face, in stone, bronze, terracotta, and painted fresco. This Classical Etruscan figure style begins late in the second quarter of the fifth century and persists into the first decades of the third.

TERRACOTTA

To judge from the finds of temple terracottas, the first half of the fifth century, particularly the second quarter, was a period of wealth and activity in southern Etruria and Latium. Superb terracottas, whose style corresponds to that of Greece in the half-century between the Persian and the Peloponnesian wars, have been found at Falerii, Cerveteri, and Pyrgi in Etruria and at Segni, Satricum, Lanuvium, and Rome in Latium. In addition to shell antefixes ornamented with the heads of satyrs

and maenads, there are many antefixes in the form of complete human figures or groups—satyrs with maenads are the most popular—and the Villa Giulia Museum in Rome has two delightful series from Satricum and Falerii. An antefix from Cerveteri, now in Paris, shows Athena pouring wine for a weary Herakles; one from Rome shows a harpy who has seized and is carrying off two little male figures.

These lively little groups arranged along the eaves of the temples were balanced by larger groups that stood as acroteria at the three corners of the gable; a group from Cerveteri shows a winged goddess carrying off a child—Eos and Cephalus, or perhaps Turan and Tinia (see chap. ix). A pair of fighting warriors from Falerii makes an acroterion. Other pairs or groups of figures modeled in high relief with the heads standing free decorated plaques that covered the ends of the principal beams of the wooden roof which projected on the façade. Examples have been found at Segni and Satricum in Latium.

The normal furnishing of terracotta for these early Classical temples consisted of these figured antefixes, acroteria, relief plaques, and a number of revetment plaques with purely formal decoration. The raking cornice was furnished with a high sima above which rose the acroteria, or occasionally (at Satricum and Falerii, for example) an openwork cresting of loops surmounted by palmettes, which must have stood out like lace against the sky and made a happy transition from the heavy sweep of the temple's roof to the blue blank of the Tuscan sky. A third revetment, nailed across the rafters at the base of the pediment, was a hanging curtain of alternating palmettes and lotuses; its lower border was cut in scallops, following the pattern.

At Satricum, in addition to all these, the temple's rooftree carried a line of life-size figures of divinities, like the late Archaic Portonaccio Temple at Veii. The figures from Satricum are broken and incomplete; the head of a bearded god, probably Jupiter, is the best-preserved fragment. It lacks the life and vigor of the heads from Veii but is still a handsome face, framed with heavy, snail-shell curls.

The Temple of Pyrgi, in the territory of Caere, was dedicated to a goddess whose character we can guess at from the names given her by Greek writers—Eileithyia, protector of women in childbrth; Leuco-

thea, goddess of the sea. Her Etruscan name seems to have been Uni; at any rate, dedications to that goddess have been found in the recent excavations of the temple at Santa Severa, the site of ancient Pyrgi. This temple was decorated with the first sculptured pediment in Etruria, the only one known earlier than the second century B.C. The usual Archaic or Classical Etruscan temple (see chap. viii) had an open pediment, and its floor was covered with roof tiles that ended in a row of antefixes like those along the eaves (Pl. XLVIIIa), but the temple at Pyrgi had a closed pediment like a Greek temple, filled with terracotta figures arranged in a pyramidal composition showing the battle of the gods and the giants (Pl. XXXVII). Fragments of four figures have been recovered which formed a single, closely knit group, evidently the center of the composition, since one figure is Athena and another almost certainly Zeus himself. The goddess wears the Doric peplos with a long overfold, the aegis, and an Attic helmet with raised cheekpieces. Her dress hangs in flat, overlapping folds, whose lower edges fall in a series of rounded loops. The aegis is broad and smooth, covering her shoulders and upper arms; it has a scalloped border and is painted with a scale pattern. Medusa, in the center, is framed by six writhing snakes in relief; her face, in spite of the tusks and protruding tongue, is fat and benign, the low forehead framed by flat waves of crimped hair. Athena's face is broad with a low, square forehead framed by a row of snail-shell curls above which her hair is waved like Medusa's. In front of the exposed ears, the hair is looped in a crinkled roll before it falls back over the ears, a fashion seen in several of the later Acropolis korai; since this is a warrior goddess, her hair is cut off at the shoulders instead of hanging to the waist like that of the korai. Her eyes are large with sharp lids, the tear duct pronounced; she has high cheekbones, a broad jaw, softly modeled cheeks, and a small mouth with sharply defined, half-parted lips. Though the face is pretty and well executed, the expression is one of blank and wooden surprise, and her attitude is equally ineffectual. She stands behind the other figures, to their right; her right hand originally held some weapon, her left shakes the aegis while she stares vacantly across the fighters.

To her left, just in front of her, a great, bearded god strides forward.

His right leg, which crosses diagonally in front of Athena, is in profile; his torso is twisted in three-quarter view. His muscular right arm is lifted to brandish a weapon; the head is turned sharply in profile. The pose is well thought out and the twist of the torso highly successful. Unlike a Greek Zeus, this divinity wears a thin, crinkled tunic and over it a heavier cloak, recalling the costume of the Apollo of Veii, though here the contrasting textures of the two garments are insisted on. It is characteristic of the Etruscan, as of the Roman, Jupiter that he wears a tunic and toga, and for this reason, as well as because of his dominant position in the group, this figure must be the Zeus of the Gigantomachy.

At his feet, stretched across the foreground of the group, are the two most interesting figures on the pediment—an almost nude, bearded god and the giant with whom he wrestles. The god, the better-preserved figure, is shown from the front; his right thigh is stretched across the feet of Zeus and Athena; the bent knee does not quite touch the ground, and the lower leg is canted back and inward, to show the back of the calf. He wears greaves, and one flap of his short cloak can be seen on his right shoulder and another on his right hip. What god he is one cannot say. His right arm is raised and bent; the hand is missing, but he probably held a weapon. The arm and elbow cross the hip of the striding god above him. The wrestling god's head is thrust forward so that his chin rests against the crown of his opponent's head; the broad face is framed by delicate, pointed curls; the ridged eyebrows arch widely above the big eyes; folds of flesh fan out from the wings of the big nostrils across the cheekbones; and the lower face is hidden by a neat, fan-shaped beard and long moustaches. The features are powerful; the face is expressionless, intentionally so, for the giant's face below it is twisted into a grimace of ferocity and strain; his forehead and nose are grotesquely wrinkled and distorted. Like the god's, the giant's hair frames his forehead in narrow curls and is bound by a fillet, but the locks of his beard are pointed and flamelike.

Only part of the giant's head is preserved; his body must have stretched to the right, opposite his adversary's, across the floor of the pediment. The four figures—Athena, Zeus, the wrestling god, and the

giant—are so arranged that each successive figure overlaps the next, putting Athena in the background and the giant in the immediate foreground. Evidently the sculptor was striving for an effect of depth in his composition, as well as violent activity and contrasting emotion. Though the figures are actually pressed close to one another, the torsos, in fact, somewhat flattened to save space, the illusion is remarkably successful, not least because of the way the lower part of the wrestler's right leg projects back into the plane of Athena, while her left forearm reaches forward into the plane of Zeus.

The Pyrgi pediment owes a great deal to the west pediment at Olympia; there, too, strenuous figures overlap one another to produce an illusion of depth, and draped and nude figures are mingled. The head of the snarling giant with his flamelike beard is surprisingly like that of the centaur biting the young Lapith's forearm. The calm face of the wrestling god is not like anything at Olympia, but the anxiety of the bitten Lapith, especially his half-parted lips and the modeling of mouth and jaw, is surprisingly like that of the Pyrgi Athena. Considering the composition and the attempt at psychological expression in this pediment, the folds of Athena's dress and the arrangement of her hair are anachronistically old-fashioned.

After the middle of the fifth century, there are fewer temple terracottas. The figured antefixes disappear; only the satyr and maenad heads continue to be produced, the shell usually ornamented with a chain of palmettes. A beautiful bearded head from Falerii in the style of the late fifth century is evidence that a few cities maintained the great tradition of temple terracottas, but the next large group comes from Orvieto and must date from the very end of the Classical period, perhaps as late as the beginning of the third century.

These terracottas were found in three different parts of the city, but they are all modeled on a half-life scale and in the same style. Evidently Orvieto was rich enough at the end of the fourth century to build and decorate at least three temples in a single spurt of activity. As a matter of fact, this was not uncommon in Etruria; Marzabotto, in the late sixth and early fifth centuries, built a row of sacred structures on the terrace above the city (see chap. viii); Falerii redecorated three temples

during the second century; and the Latin colonies of Cosa, in the second century, and Luni, in the first, each built three important temples in less than a generation.

The most complete series of terracottas at Orvieto was found in the excavation of the so-called Belvedere Temple, a large building 16.30 meters wide (see chap. viii). The figures, which were found at the rear of the temple as well as in front, include warriors; a nude youth; a seated woman; a bearded old man whose wrinkled forehead and worried expression recall the figure of the seer from the east pediment at Olympia; and an ugly, middle-aged bearded man whose open mouth shows big, prominent teeth and whose round eyes roll ferociously. The proportions of these figures conform to the Etruscan Classical canon; the attitude of the nude ephebus is a relatively successful imitation of figures in the style of the Parthenon frieze; the bearded villain, however, looks like a later creation—such a theatrical pose is unlikely before the second half of the fourth century—and the general eclecticism of all the figures indicates an even later date for them.

Though these figures are frequently said to have been part of pedimental groups, the evidence of their scale and of the terracotta plaques on which they are modeled in high relief with freestanding heads, like the earlier relief plaques from Satricum and Segni, points to these figures' having been arranged in groups of two or three to mask the ends of the roof beams that projected from the front and back.

VOTIVE TERRACOTTAS

The sanctuaries of southern Etruria and Latium have provided us with a great number of terracotta ex-votos of the fifth and fourth centuries. The majority are large female heads, often life-size, moldmade but carefully retouched, apparently representing a goddess. The heads are youthful with regular features and a sort of expressionless serenity; the lady wears a diadem and, generally, elaborate earrings of the type shown on Plate XL*c*, and a necklace as well. What goddess or goddesses these heads represent is hard to say; a number of such heads come from Cerveteri; others, from the Portonaccio stips at Veii, whose temple was dedicated to Minerva and possibly to Artemis and Turan (Aphrodite)

as well (see chap. viii). There are also many figurines of a seated goddess holding a child or children on her lap. This kourotrophic type was used as a votive offering at all sorts of sanctuaries, and with these goddess and child groups were found great numbers of assorted anatomical ex-votos. It looks as if all the gods of central Italy, whatever their specific attributes may have been, took on the job of caring for every human prayer and human ill in the Classical period.

A few terracotta ex-votos are of finer style and greater interest than the majority. A series of nude male figures from Veii, of the late fifth or early fourth century, were evidently made by followers of that city's great Archaic school (Pl. XXXVIII); modeled by hand, they owe much to the athlete statues of Polyclitus—the long, narrow skull; the heavy, oval face; the broad planes of the muscular body and its chiastic pose all indicate that the Veientine sculptors were well aware of Polyclitus' new theories of proportion and rhythm. Such details as the rather small, wide-open eye with its long, sharply keeled eyebrow and the deep cleft in the soft lower lip are also distinctly Polyclitan, but the very shallow lower eyelid and the treatment of the hair are Etruscan rather than Greek. The rough, short hair is combed forward in a shallow bang on the forehead and is bunched in heavy curls above the ears and on the nape of the neck, an arrangement to which Etruscan sculptors remained faithful throughout the fourth and early third centuries.

Bronze

The votive bronzes of the Classical period are fewer than those of the Archaic period and more limited in type. There are almost no recognizable figures of divinities. Two small bronzes of the beginning of the fifth century represent the Etruscan or Roman Jupiter, a bearded figure who stands like the Greek Zeus Keraunios, with his right arm lifted, brandishing the thunderbolt, and his left thrown stiffly forward; but unlike the nude Greek figures, the Etruscan Jupiter wears a long tunic with short sleeves and over it a heavy cloak, in one case unmistakably a semicircular toga. These must be the tunica palmata and the toga picta that were part of the treasure and, presumably, of the costume, of Jupiter Optimus Maximus at Rome (*Scriptores Historiae Augustae: Vita*

Alexandri Severi 40.8; *Gordiani* 4.4); but the image of a *clothed* Zeus brandishing a weapon is Cypriot, like the archaic Etruscan Hercules (see chap. v and Pl. XXIV*a*). It is from these undistinguished little bronzes (one in Berlin, the other in Cleveland) and from the fragmentary Zeus of the Pyrgi pediment (Pl. XXXVII) that we must build our picture of the great terracotta cult statue that Vulca of Veii made for the Capitolium at Rome.

Only two Classical figures of Hercules have been found in Etruria, one, of the late fifth century, from the northern Etruscan sanctuary at Lake Falterona; the other, of the late fourth, from Massa Marittima. Luckily, both are extremely handsome bronzes, and the types they imitate are purely Greek.

The vast majority of Classical votive bronzes represent worshippers, as indeed did most Archaic bronzes. The warrior, the togatus, and the lady reappear again and again; the lady, however, oftenest.

A pretty example in London (Pl. XXXIX*a*), from the end of the fifth century, will serve to illustrate this type. The lady stands in an attitude of prayer, with arms bent at the elbows and hands expressively open. The pose is easy—the weight on the right leg, the left knee bent, the head turned very slightly to the left. Her face is rather short and broad, with neat, classical features, eyes of normal size, and a cleft upper lip; the hair is arranged in severe crimps that frame the forehead. She wears a low stephane, which is fastened behind by a narrow ribbon and a tight necklace of large round beads. Her dress is loose and clinging, with wide sleeves to the elbows; it is fastened with buttons along the top of the arm like the classical Greek linen chiton, but unlike the Greek dress, this is apparently short enough to be worn without a belt. Over this, the lady wears a heavy rectangular cloak, covering the left shoulder and arm but leaving the right arm free. The contrast between the thin stuff of the dress, with its close, shallow folds, and the heavy cloak, which falls in wider and smoother ridges, is well worked out. Though there is about one hundred years' difference in date between this bronze and the late Archaic prince (Pl. XXV*b*), the sharp ridges and smooth stretches of their cloaks follow the same tradition.

THE ETRUSCANS

An odd detail of the woman's costume is the ribbon with a tasseled end that hangs from her right shoulder—a counterpart hangs down behind. They appear to be made of long, loose strands of wool bound together at regular intervals by narrow transverse bands, as though they were some sort of woolen fillet. What they signify and what they were made of, nobody knows, but such tassels were evidently an essential part of an Etruscan lady's dress in the Classical period, perhaps a sign of rank, since they are worn by the lady on the front of a sarcophagus from the Vulci (Pl. XLIII) but not by her servants. They never appear in Greek art.

Plate XXXIX*b* shows an Etruscan bronze youth made perhaps a decade later than the lady. His attitude is very like hers—the weight on the right leg, the left knee bent, the right hand lifted higher than the left. The head is turned more sharply, however, and toward the right. The big, square head and muscular body were modeled, like the contemporary terracottas from Veii (Pl. XXXVIII), by an artist who had studied Polyclitus; but the rather sullen, full mouth with its very short, sharply M-shaped upper lip, is an Etruscan version of the "Parthenon pout," much affected in Etruria in the late fifth and fourth centuries.

The anatomy of this figure is interesting and expert; the feet and ankles are beautifully modeled; the muscles over the ribs and the tendons of the powerful neck, well observed. The torso is a trifle short and the arms thin, while the hands, like those of many Archaic figures, are exaggeratedly large.

The youth wears a heavy toga thrown loosely over the left shoulder and arm, so long that its curved hem nearly reaches the right ankle. Like the Archaic prince (Pl. XXV*b*), he wears no other garment; this is still the toga sine tunica which, according to Pliny (34.11.23; 34.13.29), was the fashion at Rome in the days of the kings and was imitated in hot weather, in the last years of the republic, by that rabid antiquarian, the younger Cato (Ascon. *in Scaurianam*).

Of all the votive warriors of the Classical period, the largest and most impressive is the so-called Mars of Todi, a nearly life-size figure wearing a leather cuirass with movable shoulder guards and two rows

of lappets at the lower hem; under this is a tunic long enough to cover the hips. The helmet shown in some illustrations is a modern restoration. He stands with his weight on the right leg, the left foot advanced, and the knee bent; his left hand grasped a lance on which he evidently leaned, since without it his pose is oddly unsteady, and his right is held out, palm up, probably to balance a patera for libation. The heavy, solemnly handsome head is turned sharply to the right and lifted, a theatrical pose that belongs to the mid-fourth century or later. The downy beard of youth curls in snail shells on his cheeks, and similar short curls fringe the nape of his neck.

Anatomically this is not so successful a figure as the smaller togatus (Pl. XXXIX*b*); the legs are rubbery; the neck, as characterless as the face; the regular tubular folds of the tunic are extremely dull, as far as possible from Greek drapery of the fourth century; but the muscles and veins of the arms are handsomely rendered.

This figure is completely Etruscan in style, though it was found near the Umbrian city of Todi and is inscribed with an Umbrian dedication: "*Ahal Trutiois dunum dede*" ("Trutius Ahala gave this gift").

One of the most famous Etruscan bronzes, the Chimaera found at Arezzo in 1553 and repaired by no less a master than Benvenuto Cellini, is also an ex-voto of the Classical period, probably of the mid-fourth century. As with the much earlier lion from Vulci (Pl. XXVIII), the modeling of this figure shows a strong contrast between the savage realism of the lean body and powerful legs and the formalism of mane and muzzle. The beast crouches, stretching its forelegs stiffly and snarling grimly at the hero who has, one imagines, just wounded him. The hindquarters arch upward; the flanks are drawn in; every rib shows; each stiff lock of the mane that surrounds the face and extends down the spine bristles individually. This pose is characteristic of the fourth century in Etruria; monumental stone lions, tomb guardians, and lions carved in relief on sarcophagi or painted on the walls of tombs crouch in this menacing attitude, often with the head of an animal or even of a man between their huge forepaws.

The Chimaera, like the Mars of Todi, has an inscribed dedication,

this time a single Etruscan word *"tinscvil,"* which appears often on ex-votos and means, one may conjecture, something like "devoted to the gods," or "sacred property."

DECORATIVE BRONZES

The candlestick industry which had developed during the last decades of the sixth century flourished to the end of the fourth. The use of candles was ancient in Italy, where oil lamps became fashionable only gradually under the influence of Greece. There are Etruscan candle-holders of various shapes dating from the seventh century; a handsome example was found in the tomb with the Monteleone chariot. In the Classical Etruscan form, the base is composed of three feet ending in lions' paws or horses' hoofs, often with pendant palmettes or ivy leaves where they join; from this rises a tall shaft, usually fluted, that finishes at the top in a shallow, inverted bowl ornamented with a repoussé pattern, leaf or tongue. Above this, a short stem enlivened with a series of moldings supports the candleholder itself, which is made of three or four radiating arms, each ending in a prong or fork on which the candle was stuck, and in the midst of these a little statuette or group. Two tall candelabra of this pattern, though without crowning statues, are painted on one wall of the Golini Tomb at Orvieto; they hold the candles that light the banquet of the dead. The ancestors of these handsome utensils were Oriental lampstands; some dating from the sixth century, from Cyprus, have bases and shafts very like the Etruscan candlesticks. But the Etruscans adapted their form so that it could be used for candles and added the elaborate palmettes at the base and the shallow bowl at the head of the shaft, to say nothing of the crowning figures. Roman lampstands from Pompeii still have bases and shafts like the more elaborate Etruscan examples.

The game of kottabos, which the Etruscans borrowed from the Greeks, also called for a tall shaft on a steady base and a little disc-shaped saucer balanced on top. The game was played at banquets; the banqueter tried to flip the last drops of wine from his cup so that they would hit the saucer (plastinx) balanced on top and make it fall off and clang against a second disc (manes) fastened halfway down the

shaft. Obviously, the banqueter with the steadiest hand won—the game was not generally played when one was sober. An Etruscan red-figure kylix in Florence shows a maenad balancing the saucer on top of the stand for an already unsteady Dionysus, who is being supported by a helpful satyr. The game is being played in the underworld on a relief on a fourth-century sarcophagus from Tarquinia, now in Florence. The kottabos stands between two reclining banqueters, a man and a woman; each raises a cup in the right hand; the woman turns her head in an easy gesture, to see the stand and her opponent. They are flanked by two huge winged and bearded serpents, creatures of the underworld, and the head of a third pops out of a cloud to watch more closely the fortune of the man's throw.

Most Etruscan kottabos stands have been found in tombs; almost always they are crowned with a little figure, sometimes a dancer teetering on one leg while he balances the saucer on one hand high over his head, sometimes a grotesque figure who balances the saucer on his head. These grotesque figures seem to be intended for demons of the underworld. The figures are not as fine as those from candelabra, and their production seems to have begun later and continued longer, into the third century at least.

MIRRORS

It was the engraved mirrors of the Classical period that gave scholars their first clue toward deciphering the Etruscan language—the Etruscan transliteration of Greek names (see chap. ix). During the first decades of the fifth century, Etruscan engravers took to labeling the figures in their elegant tondi with their names, and as these figures are almost always characters from Greek myths, easily recognizable by costume and appearance, we come to know Herakles under the name of Herecele or Hercle and Athena as Menarva, Meneruva, Mera, etc. In the fourth century, elaborate scenes from Greek myths seem to have been popular, often set before the façade of a columned and gabled building, as though this were a theatrical performance with a temple as a stage. (One wonders about sacred drama or miracle plays in Etruria.) The artists that engraved the mirrors that show such

scenes were fond of large figures and crowded, overlapping compositions; one of the best known and most interesting mirrors shows the adoption of Herakles by Hera. She sits, elaborately dressed and jeweled, enthroned on a high-backed chair with a striped cushion; her feet, shod in soft shoes with upturned toes (calcei repandi), rest on a footstool. Herakles, bearded and wearing the lion's skin, bends forward to touch his lips to the breast she offers, the ritual sign of his adoption. Behind her to the right, a bearded god with a cloak and sceptre (Zeus, though his name is not given) holds a sheet of writing, of which the words "*Hercle Unial clan*" can be translated: "Hercules, Juno's son." A female figure wearing a cloak over her head and an elaborate necklace stands behind the central pair, and two young male figures, one of whom is Apollo since he leans on a branch of his laurel, stand to the left. Above the colonnade, a bald-headed silenus is stretched out at ease and, unconscious of the drama below, is drinking from a shallow wine cup; and at the join of mirror and handle sits a chubby winged boy with a bulla around his neck.

Mirrors with scenes involving only three or four figures are handsomer. They have no cluttered architectural background, and the figures are gracefully arranged to yield to the circular space; often these show love scenes—Venus and Adonis is especially popular. In one, the boy Dionysus leans back to kiss his mother Semele (Semla), while Apollo, again with his laurel staff, looks on and a little satyr boy sits playing the double pipes in the background. Perhaps the finest of all these mirrors of the Classical period are those with a single figure; one splendid example in the Vatican shows the seer Calchas (*Chalchas*), winged and bearded, bending forward to examine the liver of a sacrifice, which he holds in his left hand in front of a table altar.

Plate XLI shows another fourth-century mirror with a single central figure. Though his name is not given, this is presumably Orpheus, for the figure is half-nude, with long, clustering curls, and sits in a rocky landscape tuning his lyre. A tame doe with a bell around her neck is couched in front of him, her head lifted eagerly to the music; a cat romps in the foreground, and two birds perch on the rocks behind the musician—neither is much impressed—one sleeps with his

head under his wing, while the other pecks vigorously at something on his perch. The easy pose of the human figure and the liveliness of the animals are exquisitely drawn; this Etruscan engraver could hold his own in any company.

CISTAE

In the foreground of this scene, to the left of the cat, is a cylindrical box on feet, with its shallow, domed lid lying beside it and the tops of two scrolls showing at the mouth of the box; this is the musician's scrinia with his rolls of music. Boxes of the same shape (cistae) were used as toilet boxes; they are often found in tombs of the Classical and Hellenistic periods, and in them are stored the strigils, mirrors, combs, hairpins, scent bottles, rouge pots, etc., that no Etruscan lady would be found dead without. Cistae of wood inlaid with ivory were used in the Archaic period; in the fifth century, the majority were still of wood, round or oval, and covered with painted leather; the handle on the lid was a bronze figure, often of an athlete or acrobat bending backward so that the arched body made a convenient grip.

The cistae of the fourth and early third centuries are of bronze, and most were made in the Latin city of Praeneste (Palestrina), where engraved mirrors in Etruscan style were also made. The cylindrical body of the cista and frequently the domed surface of the lid are covered with engraved scenes whose artistry ranges from the perfunctory to the superb. They stand on four feet, generally in the shape of lions' paws, with a figured group in high relief above them, riveted to the walls of the box. The feet are cast in molds but carefully retouched, and the reliefs are sometimes extremely fine. A statuette or a group crowns the lid; these, apparently, are not moldmade but individual castings, like most votive bronzes.

The finest of all, the Ficoroni cista, is in the Villa Giulia Museum at Rome. The reliefs on the feet represent Eros between Herakles and Iolaus; all three appear as young men, athletic and graceful, their beards not yet grown. Only Eros' wings and Herakles' lion's skin distinguish them. The handle shows the young Dionysus between two satyrs, their arms laid across each other's shoulders; one satyr smiles;

the other scowls; both wear leopard skins knotted on the chest. Dionysus wears a necklace and bulla and a heavy cloak which leaves most of his upper torso bare; its sharp, shallow folds are like those of the cloak of the lady on Plate XXXIX*a*. On the base of this group is incised: "*Novios Plautios med Romai fecid. Dindia Macolnia fileai dedit.*" ("Novius Plautius made me at Rome. Dindia Maicolnia gave me to her daughter"). This inscription is usually taken to mean that Novius Plautius had set up a workshop at Rome, but it need not; it may quite well have been a special order. Plautius is, in any case, a Praenestine name, and the cista is a masterpiece of the Praenestine style.

The engraved scene on the body of the box shows an episode in the story of the Argonauts—Polydeuces binding King Amycus to a tree, after having defeated him in a boxing contest, and other Argonauts drawing water at the spring Amycus had defended so jealously. The whole scroll makes a unified composition whose chief focus is the group of Polydeuces and Amycus. The composition was certainly not designed for this cista; it must have been a famous wall painting, to judge from the number of copies and imitations of the central group that exist in Etruscan art. The date of the original, like that of the cista itself, must belong in the fourth century, to judge from the linked composition of the two- and three-figure groups. The original is supposed to have been Greek, Novius Plautius being credited with the few Etruscan details to be seen, such as the barrel-shaped water jar, and the bulla worn around the neck of one of the young heroes; but one figure, that of Athena, is completely Etruscan and can be matched by a number of bronze figurines of the goddess of the late Classical period. She stands quietly, the right hand on the hip, the left grasping a lance; except for the lance and her aegis, she is dressed like a fashionable Etruscan beauty in the thin dress with buttoned sleeves and the heavy cloak that the lady of Plate XXXIX*a* wears. There is a stephane in her hair and a snake bracelet on her right wrist, and she wears two necklaces and drop earrings. While this is perhaps not enough to prove that the original wall painting was Italian rather than Greek, why should it not have been? There is abundant evidence

for large-figured compositions (tomb paintings and sarcophagi) in
Etruria in the fourth century; this, to be sure, is better drawn and a
finer composition than any of them, but that merely suggests that the
original was not a tomb painting. Perhaps the original was in Rome
itself, and this is why Novius Plautius went to Rome to make the
cista; certainly this is what the evidence suggests.

STONE

As in the Archaic period, stone was used in the fifth and fourth cen-
turies only for funerary purposes, for tombs and their architectural
decorations, for grave stelae and monuments, and for statues of the
dead. The favorite tomb monument was still the guardian lion, posed
like the Chimaera of Arezzo, crouching and snarling; the finest of
these is a huge figure, now in Florence, from the tomb of the Nevzna
family at Val Vidone near Tuscania, who stands guard with his left
forepaw on a ram's head.

Bologna produced an interesting series of grave stelae in the fifth
century; these are horseshoe-shaped, the flat faces divided by horizontal
bands into three or four sunken panels carved in low relief with scenes
of the journey to the underworld, athletic contests, warriors, and
armed combats, among which are the earliest representations of the
Gauls, who first appeared in the Po Valley sometime during the late
sixth century and sacked Rome in the fourth.

The finest series of classical tomb statues comes from Chiusi, where
cremation was still the normal, though not the only, burial rite through
the fifth and fourth centuries, whereas elsewhere in Etruria inhuma-
tion was preferred. One form of ash urn, the earliest examples of
which date from the third quarter of the sixth century, is a large en-
throned figure carved in limestone with a removable head and the
torso hollowed out to hold the ashes. These figures are completely
anthropomorphic, but clearly the type descends from the Clusine
canopic jars of the seventh and early sixth centuries (Pl. XII), which
also had frequently been placed on thrones in the grave. Like them,
the stone figures are portraits or representatives of the dead and their

magical embodiment as well, made more splendid and stately than in life, enthroned in immortal calm.

The Archaic seated figures we have all happen to be bearded men; the seated Classical figures are all women. One holds a child in her arms; some scholars interpret this figure and the others as Persephone, queen of the dead, holding a soul in her arms. But this may not be so. The contemporary male figures are all shown as banqueters, each reclining on a couch, propped up on the left elbow, with a libation bowl in the left hand and the head wreathed with golden leaves. One is shown with his wife, but she sits erect in the Greek manner at the foot of the couch, her feet comfortably settled on a footstool. In the Classical period at Chiusi—and in the Archaic period, too, to judge from the banquet scenes on the Clusine cippi of the late sixth century—it was not considered proper for a wife to recline on the couch with her husband, though this had been customary at Cerveteri and Tarquinia during the Archaic period and continued, at least in Tarquinia, into the fifth century. So the enthroned ladies of the Classical period at Chiusi need not be interpreted as goddesses; they may perfectly well be respectable Clusine matrons.

In other parts of Etruria where the normal burial rite was still inhumation, it had been the custom to lay the body, wrapped in linen cloths, on a funeral couch in the tomb or on a stone bench which might be carved in imitation of a wooden couch. But occasionally, from very early times, the body was inclosed in a sarcophagus of wood or stone carved in the shape of a wooden chest. The first stone sarcophagi with relief decorations are three from Chiusi and one from Perugia; they are in the shape of wooden chests on heavy claw feet; the sides are ornamented with sunken panels carved with figures in low relief; the lids are plain gables.

Between 450 and 400 b.c., the coastal cities—Vulci, Cerveteri, and particularly Tarquinia—begin to show a taste for elaborately carved sarcophagi which were also shaped like a wooden chest with a gabled roof. This was not treated like the lid of a chest or the roof of a building, however, but as if it were a couch with a triangular head and foot; on this the effigy of the dead was shown lying supine, elaborately

dressed, and holding a shallow libation bowl, as did the banqueters of Chiusi. A handsome early example of this type from Cerveteri, in the Vatican Museum, shows a bearded man crowned with a wreath of laurel, wearing a necklace hung with five bullae and a bracelet with three more around his left upper arm. His left hand grasps a loose woolen fillet that hangs around his neck; his right holds the patera; a cloak covers the lower part of the body. On the front of the chest is a procession led by a musician carrying a great curved trumpet which frames his head as he turns to look back at those who follow —a man carrying a lituus or the Tuscan trumpet which is shaped like a lituus (see chap. ix), another with a herald's staff, a lyre player, a piper, an elderly couple, a young boy, and finally a two-horse chariot with a youthful charioteer. The relief has a very flat surface, originally covered with paint, much of which is preserved; the color of the men's flesh and one of the horses is reddish-brown; the hair of all the figures is yellow.

One of the most elaborate sarcophagi of this type was found at Vulci and is now in Boston (Pls. XLIII and XLIV). It is a double sarcophagus for husband and wife, who are shown lying together on the lid, though the inscription indicates that only the woman was buried in it: "*Ramtha Viśnai Arnthial Tetnies puia*" ("Ramtha Viśnai, wife of Arnth Tetnie"). It comes from a tomb which contained another double sarcophagus—the only other one that shows husband and wife on the marriage bed. The second sarcophagus held the bodies of Larth Tetnie, son of Arnth Tetnie and Ramtha Viśnai, and his wife Thancvil (Tanaquil) Tarnai. The carving on the son's sarcophagus is purely Greek in style, and its antiquarian details all suit a date in the middle or third quarter of the fourth century. The sides are carved with battles of Greeks and Amazons and horsemen and foot soldiers in a style that recalls the friezes of the Mausoleum at Halicarnassus—the figures widely spaced, some shown in three-quarter or back view, the shields foreshortened. The ends have groups of lions devouring a bull and griffins attacking a horse, compositions that derive from Persian art and were popular in Greece during the fourth century. Certain terracottas from Taranto look particularly like the

groups on this sarcophagus, and it may well be that the whole sar-
cophagus was carved for the Tetnie family by a Tarentine Greek.

The mother's sarcophagus looks somewhat later than the son's,
though still to be dated in the fourth century. We may conjecture
that the Greek sarcophagus was ordered for the parents but that the
father died far from Vulci and the son kept the splendid sarcophagus
for himself, commissioning a local sculptor to make one of the same
type for his mother which would also serve as a cenotaph for his
father.

On the lid (Pl. XLIV*c*) husband and wife lie embraced and over
them is spread a semicircular cloak, evidently the toga. One remembers
that Varro reports that the toga in ancient times had been used for a
blanket (Non. 14.541M) and that according to Arnobius (*Adv. Nat.*
2.67) the husband threw his toga over the marriage couch. The couple
is shown in middle age, the wife still pretty, but the contours of her
face beginning to sag and blur; the husband broad and fleshy with
a heavy, jowled face. These are not so much likenesses of the dead as
ethical types, like those created by contemporary Attic tomb sculptors
—the woman no longer young, the heavy, thick-bodied elderly man.
This Etruscan gentleman is clean-shaven, which would suggest a date
after the beginning of Alexander's reign were he Greek, but we are
not quite sure about Etruscan fashions; in the Archaic period, mature
men wore full beards, as in Greece, and they sometimes did so in the
Classical period (Pl. XLII), but perhaps not so often as in Greece.
The woman's hair is simply dressed, the soft waves parted in the
center and bound with a braid, a fashion also known in fourth-century
Athens. She wears a thin dress with buttoned sleeves (cf. Pl. XXXIX*a*),
simple disc earrings, and a spiral bracelet on the right wrist.

The front of the sarcophagus (Pl. XLIII) shows husband and wife
again; they stand in the center of the panel, their right hands clasped,
the woman's left arm across the man's shoulder. It is a scene of fare-
well, like those on many Attic grave stelae, and it has the same gentle
solemnity. The man wears a rectangular cloak like the Greek himation
and leans on a heavy staff; the woman's dress is like that of the bronze
lady in London (Pl. XXXIX*a*) or the lady on the red-figure skyphos

(Pl. XLII)—a diadem of some sort, a short necklace of large beads, a longer strand hung with pendants, a thin unbelted dress with buttoned sleeves, a long tassel hanging from the right shoulder, a voluminous cloak, soft shoes with thick soles. At each side of the central figures stand their attendants; on both corners are girl musicians, a citharist on the left, a flute player on the right. Three young men carry the husband's insignia: the first carries the curule chair; the second holds a thin wand in his lowered right hand and a second rod and a lituus in his left; the head and torso of the third are framed by a great curved trumpet. Behind the lady stands a male attendant wearing only a cloak kilted around his hips and holding an open parasol on a long staff; from one of the parasol's ribs hangs a small pear-shaped situla of a type often found in fourth-century graves. Two female attendants carry the wife's jewel case and fan, another pear-shaped flask (for perfume?), and a small loop-handled box, perhaps for cosmetics. The dress of the girl attendants is like contemporary Greek dresses, a thin garment fastened on the shoulders to make short sleeves and belted at the waist; the girl with the fan and the flute player wear the Doric peplos over this undergarment, as many fourth-century Greek figures do. The Greek dress of the servants is carefully contrasted with the Etruscan costume of the mistress; it may well be that they wear Greek clothes because they actually were Greek slaves (many funerary inscriptions of slaves and freedmen from Etruria have Greek names). But the young men look like Romans; the husband's attendants wear a short toga, the toga exigua, considerably skimpier than the toga of the bronze boy in Catania (Pl. XXXIX*b*) or that of the man on the red-figure skyphos (Pl. XLII) but the same semicircular shape. It is worth notice that the attendants wear the toga while the master wears the Greek himation; such laxity would not have been permitted at Rome.

The scenes on the ends of the sarcophagus (Pls. XLIV*a* and XLIV*b*) are not easy to square with the front scene; in one, two women sit side by side in an open two-wheeled carriage drawn by a pair of mules. They have their arms around one another and hold a parasol over their heads; a curly-haired driver sits in front of them,

and the group is met by a winged female figure who brandishes a snake in either hand, one of the Vanths, or female death spirits. Is this the journey of the lady Ramtha Viśnai to the underworld? Who, then, is the lady with her? On the other end, a bearded man wearing a toga mounts a two-horse chariot behind which stands his young attendant, carrying a staff and a lituus or Tuscan trumpet. Who is this? Not the father, who is shown as clean-shaven. Is it the son? And is he on his way to the underworld too? In that case, perhaps the second lady in the carriage is the son's wife.

The wheel of the mule cart (Pl. XLIV*a*) has the curious Etruscan form—a single spoke forming a diameter, braced with curved bars—of the carriage in the wedding procession on the late Archaic gem in Boston (Pl. XXXIII). The ten-spoked wheel of the chariot on the other end (Pl. XLIV*b*) has its parallels in Archaic Ionian art.

Like the friezes of all Classical Etruscan sarcophagi and Greek friezes of the same period, these are carved in low relief against plain backgrounds, and the figures fill the entire height of the frieze. The figures on the front of the chest, though less widely spaced than those on the sarcophagus of the son and his wife, stand without overlapping, except for the central group of husband and wife; on the ends, the composition is tighter, with figures on foot appearing behind the horses, but this is no more than we have already seen on the gem in Boston (see chap. v and Pl. XXXIII).

PAINTING

Tomb paintings of the early Classical period, the first half of the fifth century, have the same subjects as the late Archaic ones in Tarquinia—the funeral banquet, dances, funeral games. Again, most of the painted tombs are in Tarquinia, but in this period there are some at Chiusi as well, where the artists are quite as lively, but perhaps not such skilled draftsmen.

The two most beautiful banquet scenes are in the Tomb of the Triclinium and the Tomb of the Leopards at Tarquinia. There, young men and women dance to the sound of pipes and lyres in groves of young trees, while other young men and their blonde ladies recline

on banqueting couches served by nude boys. Athletes and horses decorate the walls of the Tomb of the Chariots at Tarquinia; chariot races are shown in the newly discovered Tomb of the Olympic Games at Tarquinia and in the Tomb of the Monkey and the Casuccini Tomb at Chiusi. One end of the central chamber of this last (Pl. XXXVI, *left*) is given up to three banquet couches, on each of which two young men are reclining in animated conversation—at Chiusi the ladies did not, as at Tarquinia, share the men's banquet couches. In the opposite corner, there are athletic contests going on—a jumper with weights in his hands; a Pyrrhic dancer crouching as he leaps; a piper; a dancing girl; another piper; a boxer shadow-boxing; an umpire who watches two wrestlers, one of whom is about to be thrown. The Tomb of the Monkey also has a fine scene of a pair of wrestlers and their umpire and one of a barefoot dancing girl who balances a bronze incense burner on her head as she turns to the sound of the pipes in front of a lady sitting on a high stool under an umbrella.

After the middle of the fifth century there is a gap of a hundred years in the tomb paintings, and the next series belongs to the second half of the fourth century. Not only the style but the subject matter and, above all, the mood have greatly changed. A favorite scene is still the banquet, but now it is a solemn feast in the underworld in the presence of Hades and Persephone themselves, as in the Golini Tomb at Orvieto, or surrounded by the demons of the afterlife, as in the Tomb of Orcus at Tarquinia. A second chamber in this large tomb has a series of underworld scenes. Hades and Persephone are enthroned, the triple-headed Geryon standing before them; on another wall appears the ghost of Tiresias; elsewhere, Theseus and Pirithous are glued to their seats before the door of Hades. The inspiration for these was undoubtedly Polygnotus' famous painting of the underworld, at Delphi.

Mythological scenes of a different kind also come into favor—scenes of death and mutilation—the blinding of Polyphemus in still a third chamber of the Tomb of Orcus, the slaughter of the Trojan prisoners at the tomb of Patroclus in the François Tomb at Vulci.

THE ETRUSCANS

Such grim scenes also appear occasionally on contemporary sarcophagi and become very popular on the ash urns of the Hellenistic period.

An atmosphere of gloom and foreboding would seem to have invaded Etruscan psychology during the hundred years between the Tomb of the Leopards and the Tomb of Orcus. Various explanations for this have been suggested—the loss of Etruria's land empire, the constant encroachments of Rome, the sense that they were a dying people. But this they can hardly have felt in the second half of the fourth century; not even Rome could have foreseen, then, the history of the next three hundred years. The change is much more likely to be a reflection of a change in Etruria's religious beliefs. Apparently, the life after death, which in the Archaic and early Classical periods seemed to be a light-hearted continuation of the gayest aspects of this life, was now something different, set apart, irrevocably cut off from this world. The dead journey to rejoin their ancestors, who feast eternally in the presence of the gods, but they must pass through the terrors of the underworld to reach their everlasting banquet couch. And the terrors of this passage are shown in two ways: by the demons that meet and accompany the dead on their journey (Pl. XLIV*a*) and by the violent and tragic scenes taken from Greek myths. Death itself, they seem to have felt, is violent and terrible, but beyond death you will rejoin your kinsmen, and your wife will sit on the banquet couch at your feet; you may fill your cup again and feast to the music of the pipes and the lyre. It is this promise that is shown and repeated for each member of the Velcha family in the frescos that decorate the last of the classical tombs at Tarquinia, the Tomb of the Shields, of the third century B.C.

At least some of these Classical tomb paintings are, like the engravings of the Ficoroni cista, echoes of more splendid wall paintings for public buildings or temples. The Hellenic underworld of the Tomb of Orcus can have been no more than suggested by Polygnotus' painting at Delphi, though to judge from Pausanias' description (10.28–31) it too showed a series of disconnected episodes, for the demons are Etruscan and so, apparently, are Hades' wolf cap and the snakes in Persephone's hair. The painting on one wall of the

François Tomb at Vulci, however, the slaughter of the Trojan prisoners by Achilles, is a unified composition, the central figures of which are found no less than seven times in Etruscan and Latin art. Achilles, a young and muscular figure wearing a bronze cuirass over a short-sleeved tunic, bends forward to slit the throat of a nude Trojan who sits on the ground with his back to the hero, while another, his hands bound behind his back, is led forward by a warrior in a leather cuirass. Behind Achilles stands the ghost of Patroclus, dressed in a long, flowing garment, his head and breast bound with cerecloths. In the François Tomb, a beautiful female figure with spreading wings stands between Achilles and Patroclus; her wings frame the heads and shoulders of the two heroes as she clasps her hands and bends forward a little, a look of compassion on her face. Behind the seated Trojan stands the Etruscan demon Charun with his hammer, blue-skinned, like Polygnotus' demon Eurynomos, whose skin was the color of meat flies (Paus. 10.28.7). The winged Vanth does not appear on any of the other six versions of this scene, but a somewhat different Charun is present in several. Since no such composition is ever used for this scene in Greek art, one must conclude that the original painting was in some Etruscan city and the work of an Etruscan artist. The unified composition in which a number of groups of figures converge on a central focus of interest is an invention of fifth-century Greece; its development in the fourth century is well illustrated by the Ficoroni cista; the combination of controlled violence and controlled pathos in the scene of the slaughter of the Trojan prisoners suggests that its creator was a master painter. Unfortunately, the figures in the François Tomb itself are carelessly drawn and must be doing him considerable disservice.

VASE PAINTING

In the first half of the fifth century, vase painters in Etruria were still copying the Attic black-figure style but had also developed a technique of painting in red over the black glaze to imitate Attic red-figure. Not till nearly the middle of the century were any vases produced in Etruria in the true red-figure technique, in which the

figures are outlined in black glaze on a red background, interior details added in thinned glaze, and the background around the figures then filled in with black. The first Etruscan red-figure vases are close copies of Attic vases, sometimes figure for figure; one of the earliest, a kylix inscribed with the name of the Etruscan hero Avles Vpinas (see chap. ix), evidently the offering of a descendant of his, copies the dancing satyrs on an Attic kylix done by a follower of Duris (*ca.* 470–460 B.C.) and found at Vulci.

Though red-figure vases became commoner in the second half of the fifth century, the majority of Etruscan vases in this style belong to the fourth. Falerii had a workshop whose earliest examples are so like Attic vases of *ca.* 400 B.C. that the possibility of Athenian workmen at Falerii must not be ruled out; other centers of vase manufacture grew up at Chiusi, Volterra, and Vulci; a large series of small plates decorated with women's heads, the so-called Genucilia plates, seem to have been made first at Falerii and later at Cerveteri. They must be among the latest Etruscan painted vases, since some of them have been found in tombs of the mid-third century.

An enormous skyphos in Boston, 38.5 centimeters in height (Pl. XLII), is a late fourth-century example of the Faliscan school. The scenes are drawn without relief lines or preliminary sketches; the hair and the lines of drapery are painted in thinned glaze, as are the dotted lines that indicate the muscles of the nude torso. The scene on the front of the vase shows a husband and wife over whom broods, though not unkindly, a winged death demon, probably Charun. He is hovering with wings displayed, apparently in an attempt to interrupt an impassioned speech of farewell which the man, on the left, is delivering with gestures. The man is middle-aged, bearded, with a not unhandsome, but unimpressive, face; he wears a toga like that of the bronze youth in Catania (Pl. XXXIX*b*); here it has slipped down to the right hip, and both ends are slung loosely over the left arm. He also wears high boots with horizontal wrappings about the ankles. His left hand rests on the woman's right shoulder; his right arm is stretched forward, the hand spread dramatically. Behind him is a man's cippus, an elegant Tuscan column surmounted by a pointed

egg. The woman is dressed in a thin dress and heavy cloak like the bronze lady in the British Museum (Pl. XXXIX*a*); her necklace of large round beads also has three large leaf-shaped pendants; her diadem is a high three-tiered affair, tied in back with a ribbon; her earrings are of the grape-cluster type illustrated on Plate XL*c*. She stands quietly, her hands playing with the folds of her cloak; and this pose and the imperturbable and distinctly skeptical expression on her face are in strong contrast to the histrionics of her husband. Behind her, too, is a funeral monument; this one is block- or chest-shaped, like the grave monuments used for women at Cerveteri.

It is hard to believe that this scene is not deliberately comic; the woman's pointed nose and little double chin, her raised eyebrow, and tightly closed lips look like the work of a fine caricaturist. The scene is usually interpreted as Admetus' farewell to Alcestis, and so it very well may be, particularly when one remembers that Euripedes' *Alcestis* was not a tragedy but a satyr play. Here is the supremely selfish husband making an eternal to-do about his beloved wife, whose feelings are summed up in her expression. Not a few vases of the later fourth century have funerary scenes—Charun and other demons, Hades, Persephone, the journey to the underworld—and often they are treated lightly, rather than with tragic intensity, but nowhere else so sardonically as here. Presumably, however, all of them were intended for grave furniture.

JEWELRY

Etruscan ladies of the Classical period wore a variety of jewels and apparently considered themselves underdressed without a stephane or similar ornament for the hair, earrings, and a necklace (Pls. XXXIX*a* and XLII). Ramtha Viśnai, even in bed (Pl. XLIV*c*), wears good-sized disc earrings and a snake bracelet, and on the front of the sarcophagus (Pl. XLIII) she appears to wear a diadem and two necklaces. The beautiful Velcha of the Tomb of Orcus at Tarquinia also wears two necklaces, one of small, even beads, the other of larger beads, alternate spheres and cylinders. Her stephane is a wreath of gold leaves; actual wreaths like it have been found in Etruscan fourth-

century tombs. Her earrings are conventionalized grape clusters, a pattern very fashionable in Etruria in the fourth and third centuries.

Plate XL*c* shows a pair of earrings of this type. They are large and showy, but very light, since they are entirely in repoussé except for the tiny added beading. The "Alcestis" on the Boston skyphos (Pl. XLII) wears such earrings, as well as a high stephane of three tiers, fastened behind with a narrow ribbon, surely the most unattractive of all Etruscan women's fashions. Her necklace of large, round beads has three even larger pendants.

Whether these pendants or those worn by Ramtha Viśnai (Pl. XLIII) were bullae is hard to make out. A bulla is a hollow pendant, usually lenticular, apparently designed to hold an amulet, as did the Roman bulla (Macr. 1.6.9). At Rome, a golden bulla was worn by the triumphing general because, they say, Tarquin the First gave one to his young son when, at the age of fourteen, he killed an enemy single-handed (Plin. 33.4.10; Macr. 1.6.8). A bulla of leather or precious metal was worn by freeborn boys at Rome until they assumed the toga virilis. In Etruria, one or more bullae might be worn by anyone important without regard to sex or age. They were added as pendants to necklaces and bracelets worn on the upper arm, or were strung on a cord or ribbon hung around the neck, or were slung like a baldric around a child's body. They are not uncommonly found in tombs of the Classical period.

An uncommonly beautiful example in gold, now in Baltimore (Pl. XL*a*), must come from a wealthy Etruscan lady's jewel box. It is a pear-shaped drop, the body made of two plates decorated in repoussé. Two rings are soldered to the top, and between them a ribbed cylindrical piece forms the handle of a removable stopper. Inside, there are still traces of aromatic resin, like that used as a base for more delicate scent, and this charming piece of goldwork was evidently a perfume flask that could be worn as an ornament.

The edges of the rings and the cylindrical piece, as well as the knob at the bottom, are outlined with tiny gold beads. The repoussé figures on the body are retouched with fine incised details. This combination of repoussé and beading is characteristic of Etruscan goldwork of the

Classical and Hellenistic periods (cf. Pl. XL*c*), taking the place of the earlier granulation and filigree decoration (Pl. XL*b*).

The available space on each face of the bulla is filled by the figure of a young man with outstretched wings. His knees are sharply bent and his legs drawn up to show that he is flying. His smooth, long hair is tied by a fillet, and he wears a short tunic with crinkly folds. Both young men carry implements in each hand, and their names are inscribed from right to left above their heads. One would expect these young men to be Erotes, armed with the necessities of a lady's toilet, but one is *Taitle* and the other *Vikare*. One carries a saw and an adze, the other, a double ax and a carpenter's square. They are Daedalus and Icarus, making their escape from Crete.

The composition of the figures is still Archaic; heads and legs are shown in profile while the torsos are in front view, but the bend of the arms and the modeling of the legs and feet are easy and natural. The style dates this small masterpiece some time in the first half of the fifth century, probably in its second quarter.

The Art of the Hellenistic Period
(ca. 300–30 B.C.)

T H E new world carved into kingdoms from Alexander's empire by his successors naturally produced a new art with new forms and purposes; cities like Alexandria and Antioch were founded and flourished, while old towns needed considerable refurbishing; new schools of official art were required, and acres of decorative claptrap had to be produced for a suddenly enormously expanded clientele. No wonder that Hellenistic art is full of mass production and trivial repetition or that at its best it is magnificently vigorous and stimulating; small wonder that with the many new centers of artistic activity, each with its own styles and purposes, the beautifully logical, organic development of Greek art was suddenly disrupted by freakish cross-pollinations which often make it hard to place or date Greek Hellenistic art with any accuracy or agreement.

To Italy, the centuries between Alexander's death and the battle of Actium brought a more gradual but even more overwhelming change. Rome was one town among many in the late fourth century, already formidable and enterprising, although not yet, even in her own eyes, a political world power; but when Octavian defeated Cleopatra, Rome had become mistress of the Mediterranean and the focus of history.

Art of the Hellenistic Period

THE TWO TRADITIONS

One cannot make sense of the Hellenistic art of central Italy without keeping constantly in mind the story of the rise of Rome. Central Italy had, we know, been importing and imitating Greek art since some time in the second half of the eighth century (Pl. IV*a*); but until the beginning of the third the Etruscans dominated this process. The earlier Hellenizing of Rome and Latium, or Umbria, had an Etruscan flavor, and Rome must have looked like any big southern Etruscan city through most of the fourth century. But during that century the Romans came to know Greek civilization at first hand, without benefit of Etruscan eyes. When Capua asked Rome for help against the Samnites in 343 B.C., the Romans entered territory that had once been Greek and must still have been strongly Hellenized. And we can see in the pages of Livy and the chapters of Pliny on Roman art how soon thereafter the appearance of the city of Rome began to be Hellenized in a new way.

HONORARY STATUES

First of all was a wave of new statues in the city. Rome had already borrowed from Greece—whether or not through the good offices of Etruria we do not know—the custom of erecting statues at public expense and by decree of the senate to honor distinguished citizens. The Greeks had erected such statues from early times in honor of the victors at the Olympic, and other, games; in 509 B.C., for the first time, men were so honored for a political reason, when the Athenians erected in the Agora statues of the tyrannicides Harmodius and Aristogeiton (Plin. 34.16–17). The Romans seem to have copied the idea immediately, since they set up a statue of their chosen hero, Horatius Cocles, who defended the bridge against Lars Porsenna and the armies of Etruria in 508 B.C. Here is a curious discrepancy: Harmodius and Aristogeiton had been put to death by Hippias after the assassination of Hipparchus in 514 B.C. (Thuc. 6.57.4), and therefore it was not till the Pisistratidae were expelled from Athens in 509 B.C. that the Athenians could set up the statues. Evidently, to honor the dead patriots Athens

gave them statues as if they were heroes, half-divine protectors of the state. And for some hundred years thereafter, honorary statues in Greece were only of the dead.

In Livy's story of the defense of the bridge (2.10), Horatius survived the battle; if so, the Romans either anticipated Greek practice by a century or actually set up the statue of Horatius much later than tradition records; but according to Polybius, our oldest authority for the story of the defense of the bridge, Horatius deliberately sacrificed his life to save the city (6.55). If Polybius is right, the Romans, like the Athenians, were honoring a dead hero. And, as at Athens, the only other honorary statues recorded at Rome before the Samnite Wars were commemorative, statues of the five ambassadors murdered by the people of Fidenae in 438 B.C. (Liv. 4.17; Plin. 34.11.23).

By the end of the fifth century, Greece was erecting honorary statues to living men, and during the Samnite Wars Rome began to follow suit. In 338 B.C. bronze equestrian statues of the consuls Camillus and Maenius were set up in the Forum (Liv. 8.13; Plin. 34.11.23), and a third, of the consul Marcus Tremulus, was erected in 306 B.C. in front of the Temple of Castor (Liv. 9.43; Plin. 34.11.23). Though, as Pliny says (34.10.19), the idea of an equestrian statue was originally Greek, these three bronze horsemen could never have been taken for Greeks, since they wore the toga. The equestris togata is a statue type created in Italy, though possibly not at Rome; there exists, in any case, at least one Etruscan example of the type, a handsome little votive bronze of the late fifth century, now in Detroit. One can argue, therefore, that the idea of an equestrian statue, though ultimately Greek, reached Rome by way of Etruria.

But if these figures of horsemen still looked Etruscan, the statues of Pythagoras and Alcibiades, "the wisest and bravest of the Greeks," which were set up on the horns of the Comitium some time during the Samnite Wars (Plin. 34.12.26), must have looked thoroughly Greek. And when, in 285 B.C., the Greek city of Thurii asked Rome for help against the Lucanians, the tribune of the plebs who persuaded the Romans to send help and the consul who led the army that freed Thurii were each thanked by her citizens with a portrait statue and a crown of

gold, and the Roman Senate allowed these to be set up publicly at Rome. These must have been actually of Greek manufacture, as the figures of Pythagoras and Alcibiades probably were. The face of Rome was changing.

Bronze statues of divinities had been almost unknown at Rome before the Samnite Wars. The earliest was a statue (or several statues) of Ceres made from the property of Sp. Cassius, who was put to death by his father in 484 B.C. for trying to make himself king (Liv. 2.41; Dion. H. 8.79.3; Plin. 34.9.15). This was not a cult image—those were always of terracotta—but an expiatory offering for Cassius' crime. But during the Samnite Wars it became customary for the victorious general to dedicate a bronze image of a god on the Capitoline. In 305 B.C., when three cities had been taken from the enemy, it was a heroic statue of Hercules (Liv. 9.44.16); in 293 B.C., at the close of the Third Samnite War, the consul Carvilius set up a colossal bronze Jupiter; it was made from the spoils of the battle—Samnite breastplates and helmets and greaves—and it was big enough to be seen from the sanctuary of Jupiter Latiaris on the Alban Mount (Plin. 34.18.43). This great figure must have been an echo of Phidias' colossal bronze statue of Athena Promachos, which was made from the spoils of Marathon and towered over the Acropolis of Athens.

At the foot of his Jupiter, Carvilius dedicated a bronze portrait statue of himself, made from the filings of the colossal figure (Plin. 34.18.43). Such "portraits of the donor" were also in Greek tradition; sometimes they were statues; often they were paintings; and painted portraits of triumphing generals were also dedicated to the gods at Rome. The consul M. Fulvius Flaccus, who destroyed Volsinii in 264 B.C., dedicated a temple on the Aventine to Vertumnus, the chief god of the city (Prop. 4.2.3–4), and a portrait of Fulvius in triumphal dress hung in the temple (Fest. 209M).

Votive Statues

We do not know whether such Greek practices were followed only at Rome or also in Etruria in the late fourth and early third centuries. But we do know, thanks to a votive stips found about ten years ago at the

site of the Latin colony of Carseoli (Carsòli), that Rome was no longer depending exclusively on Etruria for statue types by the middle of the third century.

This colony was founded in 298 B.C., during the Third Samnite War, in the territory of the Aequi, in one of the high mountain valleys of the Abruzzi on the road that runs from Tivoli to the Adriatic over the Apennines. The datable material from the stips is all of the third century. The pottery is the characteristic black-glazed ware of Hellenistic Italy, sometimes decorated with designs added in white or yellow paint, the so-called Gnathia fabric, which was not made after the end of the century. The coins, of which over seven hundred were found, are mostly Romano-Campanian of the first half of the third century; the latest are Roman coins of the sextantal reduction, beginning about 215 B.C., apparently early in the series, since they have no moneyer's names.

A number of votive bronze figurines were found with the coins and pottery, and their types are most illuminating. A young man in a toga, pouring a libation from a patera held in his right hand, is a direct descendant of the classical Etruscan togatus (Pl. XXXIXb), and a warrior in a leather cuirass, leaning on his spear, is a debased variant of the famous Mars of Todi of the fourth century. But these are the only two figures from the deposit whose types can be traced to Etruscan sources.

Several other types are purely Greek. A young, curly-headed Herakles, nude except for the lion's skin that hangs, napkin-like, over his outstretched left forearm, lunges forward brandishing his club. Anatomically, the modeling is a little uncertain, but there is life and vigor and a truly Hellenistic twist to the muscular young body. In Greece, figures of the striding or lunging Herakles appear in the late sixth century, but except for one decorative bronze of the early fifth century, the type was not used in central Italy before the Hellenistic period. In the last two centuries of the Roman Republic, however, it is the commonest of all votive types in the West; it is found in Italy wherever the Roman legions went, as well as in Spain and Gaul (where there are so many examples that the type is often called Gallo-Roman); even Etruria adopted it, as a fine example in Florence (Pl. XLVIIa) indicates. Here, as is common, the lion's mask is worn as a hood, with the forepaws

knotted around the hero's neck and the rest of the skin wrapped around his left arm. This was probably the arrangement on the Greek prototype, which was not the Archaic bearded Herakles but a young, beardless hero, perhaps a portrait of Alexander himself, since he is known to have liked to dress as Herakles and to have lent his features to the head of the young Herakles on the coins of Macedon, and since Mithridates VI of Pontus, who preened himself on his affinity with Alexander, had statues made of himself in this costume and attitude.

The Etruscan Hercules in Florence is uncommonly handsome; the lean, sinewy body shows a far greater interest and competence in anatomy than is customary in Etruria in the Archaic and Classical periods. The elongated proportions and long, narrow face are the taste of the mid-second century and may be compared with the spare, muscular warriors of the ash urn in Worcester (Pl. XLV).

Another Greek type, the nude, helmeted warrior leaning on his lance, also appears at Carsòli, apparently for the first time in Italy. This must be the type that Pliny means when he speaks of "[*statuas*] *nudas tenentes hastam*" which were, he says, imitations of Greek athletic figures and were called Achilleis (34.18). Greek athlete figures in this pose date from the mid-fifth century, but this particular version, the helmeted figure, is more probably an echo of Lysippus' "Alexander with the Lance."

A number of other Hellenizing figures from Carsòli must be called priestesses for lack of a better name. They are narrow-shouldered, spindle-waisted, little bronzes whose heads tend to be too big. They wear the Hellenistic chiton made fashionable by the Greek ladies of Alexandria, who used the native Egyptian linen woven in narrow lengths; the dress is fastened on each shoulder and has a long overfold reaching to the hips or below; sometimes unbelted, more often it has a belt worn rather high under the breasts. Greek figures in such dresses cannot be dated earlier than 275 B.C. Some of the Carsòli priestesses wear a heavy mantle wrapped around the lower body and the left arm, occasionally drawn over the head. Their hair is brushed loosely back from the face and caught by a ribbon at the nape of the neck, from which three wavy tresses stray along the top of the shoulders; most of

these figures wear a crescent-shaped stephane. They stand in a graceful attitude which is monotonously repeated, the weight on the right leg, right hip thrust out, torso swaying to the left, head tilted to the right.

Two fine figures from Carsòli are of particular interest, both togati: one holds a patera in the right hand and a small box in the left, the acerra of later Roman statues of sacrificants; and, like these sacrificants, his toga is pulled up over his head. This way of draping the toga I have never found in Etruria; it seems to be strictly Roman, and the Carsòli bronze is the earliest datable example of the type. The other has wrapped his toga tightly about him so that the bent right arm is held close against the body, while the hand pulls the upper edge of the toga into a shallow **V**. The left arm hangs easily at the side, under the toga. This pose is extremely common in Hellenistic statuary both in Greece and at Rome, where it continued to be popular under the empire. The finest Greek example is a marble figure from Eretria, at Athens; the only securely dated Greek example is the headless portrait of Dioscorides of Delos, a magistrate in 138 B.C. Greek examples wear the rectangular himation; so do many of the republican Roman figures. It was a favorite type for tomb statues at Rome in the first century B.C. and later; sometimes, instead of the Greek himation, the Roman figures wear the toga, as does the little votive bronze from Carsòli.

We must conclude that by the middle of the third century Rome was not only borrowing directly from Greece, as well as from Etruria, but was already adapting Etruscan and Greek types to suit her own purposes.

The priestesses of Carsòli are the forerunners of a series of bronze ladies from central Italy, the largest of which, half-life-size, was found near the sanctuary of Diana at Nemi and is now in the British Museum, together with seven smaller bronzes found with her. There are other examples from Latium and Etruria; one in Florence (Pl. XLVII*b*) of unknown provenience bears an Etruscan inscription stating that the figure was dedicated by Larce Lecni to, possibly, Juturna.

This figure is typical of the group. Like the little Carsòli priestesses, she wears the narrow Hellenistic chiton and an enveloping cloak

wound about her waist; there are soft shoes on her feet. Her hair is heavy and luxuriant; the long tresses are gathered at the nape of the neck and fall in the usual three locks along the top of the shoulders; shorter locks frame the face, rising in a fountaining pompadour over the forehead, as if Alexander's hair had furnished the model for this coiffure; and a strand curls on the cheek in front of each ear. She wears an ogival stephane with an ornament at the peak and volutes at the ends, and around her neck is a torque, a twisted bar of gold open at the throat. The proportions of the figure, like the Hercules in Plate XLVII*a,* belong to a Hellenistic canon new in Etruria; the head is narrow with a long, oval face; the neck is long; the slender body has narrow shoulders and a short waist, while the legs are exaggeratedly long. The graceful pose, with the weight on the right leg, the left knee bent, and the foot drawn to the side; the slight twist of the upper body; and the turn and lift of the head indicate a considerable knowledge of Greek Hellenistic style. Though the drapery has none of the virtuoso quality of Greece, the spread of the skirt at the feet makes a pyramidal base that supports the movement of the upper body. The face is quite unlike Etruscan classic faces, not only in shape but in the soft, sensuous modeling of the full cheeks and heavy chin; the low, triangular forehead and shadowed eyes are Etruria's acknowledgement of the style of Scopas.

No figure of this type can be securely dated by antiquarian evidence: the Gaulish torque began to be worn in Italy during the third century; the ogival stephane seems to be commoner in the second. The tendril of hair on the cheek is a Hellenistic detail but cannot be dated closely. Perhaps the best evidence for the date of this particular figure (Pl. XLVII*b*) is furnished by her narrow shoulders and long legs; these are characteristic of the second half of the second century, both in Greece and in Italy. As a series, these figures apparently date from the middle of the third through the second century, and the enormous number of wretched little reproductions of the type seems to indicate that its life continued into the first century B.C.; one of these cheap versions was found in a house in Arezzo, where it had been used as a lararial figure along with early imperial bronzes.

THE ETRUSCANS

The priestesses have a male counterpart, of which there is a fine example in Baltimore (Pl. XLVIIc). None was found in the third-century stips at Carsòli, but at least five were found with the big priestess at Nemi. Like the priestesses, the male figures were adopted in Etruria; examples have been found with Etruscan inscriptions. Two come from the ruins of a Roman house at Vetulonia, where they were apparently used as lararial figures; they are very large (30 centimeters), but clumsy, with elongated proportions and very narrow shoulders, late versions of the handsome original type.

This male figure represents a young divinity or priest who pours a libation from a shallow patera in the right hand, while the left holds the acerra. The upper part of the body is nude; the left shoulder and lower body are draped in the folds of the semicircular toga, one end of which is thrown over the left forearm. The hair is worn long, in thick, tousled locks that frame the face and cluster at the nape of the neck; and the head is crowned by a wreath of vine leaves. In the example on Plate XLVIIc, the surface of each lock is deeply grooved to give the hair texture. The face is broad, with the heavy M-shaped mouth of the Etruscan classic style, and the smooth forehead and expressionless eyes are also in the Etruscan tradition. The modeling of the youthful, not very athletic, torso and the complicated pose, in which the body swings to the left above the supporting leg while the head is turned sharply to the right and lifted, are lessons learned from Greece. One must suppose that the Greek original of the type was a youthful Dionysus, but the Romans have given him a toga, a costume that they bestowed on no divinity but Jupiter, so far as we know. But there is this possibility: imperial lararial figures of the Genius of the household and the Genius of the emperor are togate, usually capite velato, and pour libations from paterae. And the Roman Genius, like the Greek Agathos Daimon, was often identified with Dionysus or his Latin counterpart, Liber Pater. So these pretty Dionysiac figures draped in the Roman toga and holding the patera and acerra of a Roman sacrifice are probably examples of a statue type created at Rome, perhaps in the late third century, to represent the Genius of the household.

Art of the Hellenistic Period

FUNERARY STATUES: THE ETRUSCAN TRADITION

Of course, during the first phase of Rome's emancipation from Etruria, the late fourth and early third centuries, the Etruscans went on producing art for themselves in their own style and according to their own taste. The Classical tradition of funerary sculpture, illustrated here by the fourth-century sarcophagus of Ramtha Viśnai from Vulci (Pls. XLIII and XLIV), had produced a distinguished Hellenistic continuation at Tarquinia, which inspired other workshops in the third and second centuries at Volterra, Chiusi, and Perugia. The sarcophagi and ash urns of Etruria, in fact, show the logical and organic development of a style from the Classical stage, through the early Hellenistic and the baroque of the second century, to its lingering and unedifying death in the first years of the Roman empire. The last dated sarcophagus, from Viterbo, gives the year of death in the consulship of Piso and Sestius, 23 B.C.

The Classical stone sarcophagus of the late fifth and fourth centuries, shaped like a chest ornamented on all four sides with figured panels in low relief and topped by a gabled lid representing a funeral couch on which the effigy of the dead lies supine, gives way in the third century to a new form in which the relief panel is confined to the front of the chest and the figure on the lid no longer lies flat, but leans on his elbow on a banquet couch. The high point of this development is in the sarcophagi and ash urns of the mid-second century from Chiusi (Pl. XLV); the latest sarcophagi, of the late first century, still have effigies of this type, but all attempts at producing a credible human figure have long been given up; the body is extravagantly elongated, but shapeless, while the head sticks up at an impossible angle.

It was the third-century banqueter sarcophagi of Tarquinia, with their single main relief, that the workshops of Chiusi, Perugia, and Volterra imitated. Volterra's workshop seems to have been the earliest; it produced few sarcophagi, but an enormous number of ash urns, most of them carved in the local alabaster. Mythological scenes and the journey to the underworld are about evenly represented. The finest urns, of the first half of the second century, have a relief style that anticipates

that of Rome under the Antonines, a multitude of figures—tall, thin, long-legged, and narrow-shouldered—so closely grouped as to hide the background out of which they seem to burst toward the spectator. The relief is very high, and the scenes are bordered at the top and bottom by elaborate architectural moldings.

Chiusi's finest sarcophagi and ash urns belong to the second century, too, and are modeled in terracotta (Pl. XLV), though Chiusi also produced urns and sarcophagi of travertine and alabaster. They represent the high point of the Hellenistic baroque in Etruria. The scenes are almost always mythological, though the journey to the underworld does appear occasionally. The composition of the reliefs is symmetrical, spreading laterally instead of thrusting forward, and the figures are not overcrowded.

The urn illustrated on Plate XLV was found near Chiusi in 1858. Very large for an ash urn, it is an outstanding example of Etruscan virtuosity in the use of clay. The tall, lean warriors stand out in high relief from the background, which shows arches behind pillars. Each figure is in tense and violent action, and to make this clearer the feet are posed on artificial pedestals or on the bodies of their fallen victims, as if they were leaping through the thick of battle. There are six warriors, three Greeks and three barbarians; each of the three erect figures has dispatched his opponent, and now the two warriors of the outer panels, who wear Greek helmets and the Hellenistic leather cuirass, are leaping toward the magnificent barbarian in the center, who is shown in back view, almost naked, wearing the Phrygian helmet and carrying the peltate shield that the Greeks used to indicate an Oriental warrior. The main action takes place in a plane parallel to the plane of the relief, but the defeated and dying warriors at the feet of the main figures break through this plane and hang over the egg-and-dart of the lower border. The artist of this urn must have learned this combination and crossing of planes from the frieze of the great altar at Pergamum. Even the pose of the fallen figures on the urn can be found in the frieze of the altar.

The ends of this urn are also decorated with reliefs, not so high as those on the front. A stone wall is shown, hung with helmets and greaves, in which there is an arched doorway, the gate of death, for in it

stands a demon of the underworld. At one end it is Charun, winged, with a monstrous face, heavy brow ridges, and great tusks. His upper torso is nude; he wears a kilt bloused over a scale-armor apron and hunter's boots, and he has knotted the paws of a lion's skin around his neck, for all the world as if he were Hercules. But the weapon on which he leans is Charun's hammer. The figure in the other doorway is female, a Vanth, like the figure on the sarcophagus from Vulci (Pl. XLIV*a*). There are little wings in her hair and wings on her shoulders; a snake is knotted around her throat for a necklace; her upper body is nude except for a crossed baldric with a central ornament worn between the breasts. She wears a bloused skirt and boots, like her male counterpart; and there are bracelets on her upper arms and her wrists.

All these figures are tall and slender, in the fashion of the second century, but the reclining figure on the lid of the urn is not; it is one of the finest Etruscan Hellenistic portraits. An elderly man, heavy but still powerful, lies in a variation of the usual banqueter pose, leaning back, his left fist pressed against his jaw, his strong, arrogant face turned away from the world and the spectator, mouth tightly shut, eyes half-frowning, looking at eternity as if he knew he could outlast it. The thin hair is brushed in wavy strands over the massive skull; the cheeks are wrinkled; the flesh sags below the broad, stubborn chin. The head is wreathed, and there is a second wreath around the neck. His upper body is nude, and a heavy cloak covers his legs. He once held a patera in the right hand; under the left elbow are two tasseled cushions. Costume and accessories are still very like a banqueter's of the Archaic period (Pl. XXXV).

There has been a good bit of nonsense talked about Etruscan portraiture, but there was no portrait likeness of a man in Etruria before the Etruscans learned from the Greeks how to produce them. Their methods are the same, the type being created before the individual. On Greek grave stelae of the fourth century and on the top of the sarcophagus of Ramtha Viśnai (Pl. XLIV*c*) we see the beginning of this kind of portraiture—the middle-aged man and the woman no longer young. In Greece, many fourth-century portraits were idealized imaginary portraits of men no longer living as, for example, the original of

the Sophocles in the Lateran. The question was "What sort of person is this?" rather than "Who is he?" Of course, an ethical portrait of this kind may also be a startling and illuminating likeness, as one cannot help believing of the Demosthenes of Polyeuctus. And it is with such Greek portraits that this effigy of an old man from Chiusi must be compared.

FUNERARY STATUES: THE ROMAN TRADITION

Roman funerary portraiture is quite another thing. We have no Roman portraits earlier than the beginning of the first century B.C., but then and thereafter, the republican funerary portraits aim at photographic realism rather than ethical likeness; and, in all, the emphasis is on the head; the body is merely a dummy. The reason is clearly given in Polybius' description (6.53) of a Roman funeral of the mid-second century B.C.:

> After the burial . . . they place the likeness of the deceased in the most conspicuous spot in the house, surmounted by a wooden canopy or shrine. The likeness is a mask made to represent the dead with extraordinary fidelity both in shape and color. These masks they display at public sacrifices . . . and when any illustrious member of the family dies, they carry these masks to the funeral, putting them on men whom they think as like the original as possible in height and other details. And these substitutes wear the clothes suitable to the rank of the person represented. . . .

Pliny tells us that at first these masks were made of wax (35.2.6), though in his day they were artistic confections of bronze or marble. It has been suggested that an actual life mask, or death mask, was taken in plaster, and the wax model made from this, and something of the sort must account for the almost savage verism of some Roman republican portraits. Why the Romans insisted on any such absolutely objective realism is another problem; it is a tendency for which there is no evidence in Classical or Hellenistic Etruria before the first century B.C. Then, a few terracottas—a fine portrait head from Cerveteri of a man between youth and middle age and an ash urn from Volterra showing an elderly man and his even more elderly and wizened wife—show the effects of Roman verism on Etruria.

Art of the Hellenistic Period

PORTRAIT HEADS

I should like to suggest that the so-called Arringatore, the famous life-size bronze statue of a middle-aged Etruscan found at Sanguineto near Lake Trasimene, is another example of Etruscan portraiture of the first century B.C., under strong Roman influence. The figure, a man wearing a tunic and toga and high senatorial boots, is generally dated in the second half of the second century B.C., but largely because antiquarians cannot believe that a toga like his could possibly be worn as late as the first century. It reaches only to mid-calf, and the upper edge is rolled only slightly, so that the folds that cover the left arm are neither voluminous nor precarious. It is undoubtedly the toga exigua, not much fuller than those worn by the attendants on the sarcophagus from Vulci (Pl. XLIII) and rather narrower than that of the classical adorans in Catania (Pl. XXXIX*b*). The imperial toga, with its two curved borders, is much bigger and clumsier and could not be draped so simply, while almost the only illustrations of Roman republican togas that we possess are funerary statues, where the toga is wrapped around the body like the Hellenistic himation of the boy from Eretria and certainly looks wider than that worn by the Etruscan bronze. However, there is one Roman figure, a terracotta from a pedimental group found in the Via San Gregorio and now in the Capitoline Museum, that represents an elderly man wearing a toga even skimpier than this Etruscan's and draped in the same way; and that figure must be dated, by the architectural terracottas found with it, about 100 B.C.

The inscription on the hem of the Arringatore's toga is Etruscan; it gives his name, *Avle Metele* (Aulus Metellus), and his family and honors. This, too, has tended to make scholars hesitate to date the bronze too late, since Latin became the official language of all Italy at the close of the Social War. But this was not an official honorary portrait, like those "togatae effigies" set up in the Roman Forum, but an ex-voto, as the word *fleres* in the inscription indicates (see chap. ix); and there are funerary inscriptions in the Etruscan language as late as the time of Augustus. The best known is the bilingual (Etruscan and

THE ETRUSCANS

Latin) inscription on the handsome marble ash urn of P. Volumnius from the Tomb of the Velimnai at Perugia.

The head of the Arringatore has been compared to a splendid bronze bust from Herculaneum, now in Naples (Museo Nazionale, Ruesch 791), a bust dated by Vessberg in the years of the Second Triumvirate; and certainly the resemblance between the Etruscan and the Campanian bronze is far closer than any between the Arringatore and Etruscan portraits on second-century sarcophagi. In the two bronzes, the shape of the head, low-crowned, with a small, rounded cranium; the high, broad forehead wrinkled nervously in transverse furrows and contracted into vertical frown lines above the nose; the pouched eyes; and the barely parted lips are very similar, extremely so, considering how unlike the two men really look. The hair is cut and shaped in the same way, short and close, not particularly low on the nape of the neck; the locks are short and stiff and lie over one another like sickle-shaped scales, while on the forehead they are neatly undercut. Coins of Lepidus and of Mark Antony show such a haircut. A generation or so earlier, the hair was worn much shorter; the little, flat, sharp-pointed locks clung to the skull with scarcely more relief than an engraved pattern, as is shown on coins of A. Postumius Albinus or the head of the actor C. Norbanus Sorex from Pompeii. But during the second century and the first quarter of the first, the hair was worn considerably longer. We have seen the long, thin, slightly wavy locks of the old man on the ash urn in Worcester (Pl. XLV); the hair of the magnificent bronze head in the Capitoline, the so-called Brutus, is like his; the locks are smooth and long and cling to the head, but have considerably more relief than in the treatment of the Sullan period.

The bronze head of a young general in the Bibliothèque Nationale is a contemporary of the Brutus head; he has the same long, curved locks which cling to the skull and are brushed forward toward the face; though, since he is a young man, his hair is thicker and springier. In other ways, the Brutus and the young general are much alike; in each the forehead is somewhat sloping, with a definite transverse break above the heavy frontal bone; the thick eyebrows are drawn down in a straight line that shadows the eyes; the nose is long and aquiline, ex-

tremely handsome, and the curve of the nostril is emphasized by a deep groove that runs toward the corner of the mouth. The mouth is wide, with thin, well-cut lips pressed firmly together. Though the lines in the face of the Brutus are emphasized more than those of the young general, there is no attempt to reproduce the wrinkled and sagging flesh of middle age, as was done in the head of Avle Metele or even in the terracotta in Worcester (Pl. XLV). These two bronze heads are still ethical portraits in the Greek tradition and have their closest counterparts in Greece in the head of Attalus I from Pergamum in Berlin and the head called "Antiochus III" in the Louvre—two magnificent psychological portraits of the early second century.

A later stage of this long haircut and of psychological portraiture can be seen in the pretty bronze head of a young boy in Florence and another head of a young man in the Louvre. In these, the hair is long and thick, rendered in many narrow locks which form a soft cap that bells out a little at the nape of the neck and over the ears and falls in a loose, heavy fringe on the forehead. The nearest parallel to this style of hairdressing is found on the coins of 87 B.C. with the head of the legendary king Titus Tatius.

FEMALE PORTRAITS

Unfortunately, female portraits are almost never so good as portraits of men. The female effigies on Hellenistic sarcophagi and ash urns are always blank and beautiful or ageless and stately, and all are dressed in the Hellenistic finery we have seen on the bronze priestesses (Pl. XLVII*b*). Two magnificent terracotta sarcophagi from Chiusi, of the mid-second century or slightly later, show ladies of the Seianti family. Seianti Thanunia Tlesnasa, now in the British Museum, has the broad classical features and opulent body of a Wagnerian soprano. Her dress is the high-girt Hellenistic chiton, and a heavy cloak is thrown over her legs. She wears a necklace with many little pendants, disc earrings with conical drops, a broad bracelet on her right upper arm, a double serpentine bracelet on her right wrist, and the ogival stephane of many of the bronze priestesses (Pl. XLVII*b*). Over this is a veil which she draws back with her right hand in the traditional gesture of the bride; there

is a mirror in her left hand. Her kinswoman, Larthia Seianti, now in Florence, has a less fine effigy; the body is too long from waist to knees and too flat. Her costume is like Seianti Thanunia's, but she wears a flowered stephane instead of the ogival type. Both these sarcophagi are highly painted, as all terracotta sculpture was originally; Larthia Seianti's dress is white with a fine blue border; her cloak and veil are also white, but the veil has a broad red border with a narrow blue selvage. Her girdle and stephane are of gold set with red gems; necklace, earrings, and bracelets are also of gold. Her hair is light brown; her flesh, pink; and her lips, bright red.

A Roman coin was found in Larthia Seianti's sarcophagus, an as with a Janus' head and ship's prow. Its weight leaves some doubt as to whether it belonged to the sextantal or the uncial series; in either case it would date from the late third or first half of the second century. The style of the sarcophagus, however, suggests that it was designed late in the second century.

The two Seianti sarcophagi are the only Etruscan examples with a purely architectural decoration on the chest. In both cases, it is a Hellenistic Doric frieze in which the space between the columnar triglyphs is filled with a rosette or a patera. A similar frieze runs above the battle on the ash urn in Worcester (Pl. XLV), where the triglyphs are separated by paterae.

ARCHITECTURE: THE ROMAN TRADITION

These Hellenistic architectural details bring up again the problem of the transformation of the appearance of central Italian cities during the Hellenistic period. The new statuary types and new uses for sculpture have already been discussed; the architectural reshaping of central Italy was no less important.

As early as 273 B.C., the Latin colony of Cosa was given a city wall with defensive towers, like those of the Greek cities of Ionia and Magna Graecia, and with arched gateways, an innovation even in the Greek world at that period. The first important Greek arched gates were those of the city walls of Priene, built around 300 B.C. The gates of Cosa were entirely unornamented, but in less than a century the Romans were

erecting freestanding ornamental arches that served as statue bases and were the ancestors of the imperial triumphal arches. The earliest of these were erected by L. Stertinius in 196 B.C. in the Forum Boarium and the Circus Maximus (Liv. 33.27), and Scipio Africanus erected another, on the Capitoline, in 190 B.C; this was crowned with seven gilt bronze statues and two horses and had two marble fountains in front of it (Liv. 37.3).

One can scarcely overestimate the importance of the Scipios in the Hellenizing of Rome during the second century B.C. Africanus was such a Graecophile that as early as 204 B.C. an ugly rumor had come back to the Roman Senate that he had been seen in public in Sicily wearing a Greek himation and sandals (Liv. 29.19). His brother Lucius Scipio, who defeated Antiochus and brought back to Rome the booty of Asia in 188 B.C., actually dedicated a portrait statue of himself in Greek dress to Capitoline Jupiter (Cic. *Rab. Post.* 10.27; Val. Max. 3.6.2).

But many other Romans of the second century helped to reshape Rome: the first basilica, a roofed hall with a columnar façade, used as a law court and for various sorts of business and assembly, was built at Rome in the consulship of M. Porcius Cato, 184 B.C; the second, the Basilica Aemilia, was built in 179 B.C. in the censorship of M. Aemilius Lepidus, who also built the piers for Rome's first stone bridge and erected colonnades in various parts of the city, in imitation of Greek Hellenistic cities. A famous double colonnade, the Porticus Metelli, was built by the Metellus who triumphed over Macedon in 146 B.C; it enclosed a sacred precinct in which stood the temples of Jupiter Stator and Juno Regina. This Temple of Jupiter was the first marble temple in Rome; it was Greek in style, peripteral; and its architect was a Greek, Hermodorus of Salamis (Vitr. 3.2.5; Vell. Pat. 1.11.5).

One would like to know how many of these innovations were also adopted by the Etruscans and whether they were borrowed by way of Rome or independently. We know that the Etruscans had always been less rigid in their dress than the Romans; they seem to have worn the himation or the toga almost indifferently (Pi. XLIII). Their architectural practices are less clear, but the urn in Worcester is of some help

to us here (Pl. XLV). The reliefs at the ends are not as significant of Hellenistic practice as one might suppose, since the peculiar ogival shape of these arches, which had sloping sides, was used in Etruria for tomb doors as early as the seventh century B.C., though none of them was built of properly shaped voussoirs with a true keystone, as they are on the urn. But the front of the urn is a different thing. We have mentioned the Hellenistic triglyph frieze; under it are three plain, semicircular arches, but there is no evidence as to what sort of building they represent. A basilica perhaps? In front of these arches is a row of pillars with Ionic capitals. It must be pointed out here that this relief is said to be the earliest example of the Roman decorative device of adding engaged columns to the piers of an arcade, the first securely dated example of which is the Tabularium at Rome, built in 78 B.C. But this relief does *not* show an arcade with engaged columns. The unfluted pillars are intended to be seen as freestanding, as the swags that hang between the arches behind them prove. Their Ionic capitals do not support the triglyph frieze, which belongs to the arcade, but rise above and in front of it to carry the low molding that finishes the top of the chest. These pillars are part of a colonnade, which is here still separate from the arcade behind it, though they do come together, before the end of the second century, in the city gates of Perugia.

One must suppose that the architectural background of this relief is a shorthand view of some second-century forum, perhaps Chiusi's. The elegant arches with their Hellenistic triglyph frieze and the Ionic colonnade are parts of the new civic architecture of the century. In that case, it might be that the scene of combat between Greeks and barbarians in the foreground does not represent some heroic battle in the East but a gladiatorial show in the forum itself, since Italian forums were specifically designed for just this purpose (Vitr. 5.1.1–2).

TEMPLE TERRACOTTAS

During the Hellenistic period, there was a great burst of temple building in central Italy. Many, if not most, of the temple foundations discovered in Etruria are Hellenistic; and most of the older temples were thoroughly rebuilt and redecorated at that time. For the first time, stone

was used for temple walls and columns; the temple at Fiesole, built early in the third century, is the first Etruscan temple with stone walls, and the columns of the Temple of Juno at Tarquinia were given stone moldings at about the same time. The temples of the Roman colonies of the third century were also of stone, but their ground plans were still Etruscan, and the roofs of all these central Italian temples were still of wood, with decorations in terracotta.

Such roofs stayed in fashion longer than one might think. Pompey the Great's Temple of Hercules at Rome was decorated in the Tuscan style (Vitr. 3.3.5), and the latest series of terracotta revetments from temple sites, the so-called Campana plaques, were designed and produced in the age of Augustus. In fact, Pliny tells us that as late as the reign of the emperor Vespasian there were temples in the municipalities and even at Rome that still carried the old-fashioned terracotta decorations (35.46.158).

On a large temple of the Hellenistic period such as the Capitolium of Cosa, built *ca.* 150 B.C. (Fig. 4), this decoration consisted of eaves tiles, antefixes, a strigillated sima surmounted by a pierced cresting on the raking cornice, acroteria, and revetment plaques nailed to the timbers below the sima of the raking cornice, as well as to the great beams of the architrave. Except for the antefixes, these terracotta plaques were decorated with conventionalized floral designs, looped palmettes, or addorsed palmettes arranged like thunderbolts and embellished with ribbons and delicate sprays of flowers. The antefixes at first still had the splendid shell frame that was developed in the late Archaic period (Pl. XXI), but later this gave way to other forms and eventually was replaced by palmettes, too.

The pediment of the Capitolium at Cosa was like that of the traditional Tuscan temple, open and deep; the flat roof over the temple porch which formed the pediment's floor was at first covered with roof tiles like the pitched roof above (cf. Pls. XLVIIIa and b); a row of antefixes was stretched across the front, at the ends of these tiles, like spectators on a balcony, while the ends of the great wooden beams at the peak and corners of the gable, the ridgepole (columen), and rafters (mutuli) were clearly visible. A terracotta model of such a

pediment from Nemi (Pl. XLVIII*a*) is our best illustration of this type. The antefixes across the front of the gable are of a late Hellenistic type, without shells. The sima of the raking cornice and its acroteria have been broken away, leaving woefully stubby traces. The ends of the columen and mutuli are decorated with reliefs, though their subjects are hard to make out. The columen plaque shows three female figures; the central one, seated with a child on her knees, presumably represents Diana as nurse and protector of children. The scene on the left mutule seems to be a combat between a man and a beast or two men—one would like to think it represents the duel between the King of the Wood and his successor; the fragmentary scene on the right mutule may have been the same.

Though the Capitolium at Cosa originally had an open pediment like this, Rome had already introduced a new kind of pedimental decoration to central Italy in the first half of the second century. Instead of the antefixes across the front of the open gable, she put large groups of terracotta figures there, in imitation of Greek pedimental sculpture. The effect must have been singularly un-Greek, since Greek pedimental figures, whether in relief or in the round (such as those of Olympia and the Parthenon), are displayed against clearly visible backgrounds, while the Italian terracottas have heads and shoulders modeled in the round, thrust forward and designed to be seen, like the earlier antefixes, against the dark emptiness of the open pediment, although the lower parts of the bodies are modeled in high relief against terracotta plaques.

The dating of Hellenistic temple terracottas is quite as difficult and unsatisfactory as that of other Italian Hellenistic art; groups are almost always eclectic and have been affected by the art of the fourth and third centuries of mainland Greece, strongly flavored by the pervasive influence of Pergamum. But fortunately, the recent excavations at Cosa uncovered such enormous quantities of architectural terracottas that it has been possible to recreate the complete decoration of all the temples excavated there, with all their patchings and refurbishings, from the date of their construction to that of their abandonment. Apparently the terracotta ornaments of a temple needed repair every twenty or twenty-

five years, and if it was an important temple they had to be replaced entirely every fifty.

It was possible at Cosa, on grounds of fabric, to match the pedimental groups to their proper architectural frame and thus date them quite closely. The four smaller temples at Cosa were given pedimental sculpture between 170 and 160 B.C., but the great Capitolium kept the old Etruscan antefixes in its open pediment till the beginning of the first century.

Since all architectural terracottas of a given period conform to a single fashion, the dates for the Cosan terracottas can safely be used for terracotta revetments from other sites and for the pedimental figures, however eclectic their style, associated with them. The pediment sculptures of the four little temples at Cosa are as early as any in Hellenistic Italy. The nearest to them in date, which far surpass them in quality, are the superb figures from the Temple of Lo Scasato on the site of ancient Falerii, now in the Villa Giulia Museum at Rome. The head and torso of a seated youth with long, curling hair which rises over his forehead in Alexander's anastolé has the head twisted to the right and the passionate upward gaze of a late Alexander portrait. A young athlete, whose short hair frames his triangular forehead in a series of springy sickle-shaped curls, stood beside a now vanished figure whose hand still rests on his shoulder. Another male head has tousled hair and the marks of a young beard on his cheeks; a beautiful female head wears a low, triangular stephane, and the straying curl that brushes her cheek recalls the bronze priestesses (Pl. XLVII*b*). The modeling of these heads is as fine as that of any terracotta from Greece.

Another series of beautiful but fragmentary terracottas comes from Arezzo; unfortunately, no datable revetments were found with them. Plate XLVI shows the head of a young man who wears a Phrygian cap, perhaps the shepherd prince Paris. The long, narrow oval of the face; the low, triangular forehead; and the shadowed eyes recall the face of the bronze priestess in Florence (Pl. XLVII*b*); the heavy, luxuriant locks that frame the face and hang on the neck are treated like those of the Genius in Baltimore (Pl. XLVII*c*), though with considerably more freedom. The modeling of the face is sensitive; the eyes are wide but

seem half-hidden by the heavy lids and the marked projection of the eyebrows, which are sharp and thin at their inner edge, thickened and softened at the outer corner; the lower lid is soft and full and holds the eye like a calyx—an effect also attempted in the bronze priestess and the Genius. The long, narrow nose with its slightly drooping tip is like that of the priestess or the Hercules in Florence (Pls. XLVIIa and XLVIIb); the soft mouth, with its short, cleft upper lip and full lower lip, is full of sensuous charm. On stylistic grounds, I would date this head in the mid-second century.

Hellenistic pediments seem to have represented two kinds of scenes: one, mythological, usually with figures in action; the other, an assembly of divinities or a religious ceremony in the presence of the gods. The head from Arezzo (Pl. XLVI) would come from a mythological scene, if this is really Paris; and as a beautiful head of Athena, evidently by the same artist, was found with it, one may suppose that the pediment showed the Judgment of Paris on Mount Ida. A pediment from Tala-mone, now in Florence, shows the battle of the Seven against Thebes. Another group, from Civita Alba in Umbria, now in the Museo Civico, Bologna, shows the discovery of Ariadne by Dionysus.

Of the assembly pediments, the best preserved is from the Via San Gregorio at Rome. On stylistic grounds and on the strength of its terra-cotta revetments, this group is dated about 100 B.C., and its figures show a change in manner and modeling from the baroque of the second century to the stiffer classicism of the first. The central figures—a goddess seated on an altar, flanked by another goddess and a male figure in armor—are life-size. The female figures wear the narrow, high-girt Hel-lenistic chiton and mantle; the only head completely preserved, that of the standing goddess, wears a triangular stephane and has a straying curl on the cheek. The male figure, probably Mars, wears the Hellen-istic leather cuirass over a longish tunic, like the Greek warriors on the ash urn in Worcester (Pl. XLV). Other, smaller, figures stood on either side of the central group, among them an elderly man wearing tunic and toga and a victimarius in the short, kilted limus worn by attendants at a sacrifice. There were also fragments of a number of animals, pre-sumably the sacrificial victims. The first pedimental group made for

the redecoration of the Capitolium at Cosa in 100 B.C. was of this type, a religious festival in the presence of the gods. Such a subject is strikingly Roman and was, indeed, the commonest subject for pedimental groups under the empire, but its ultimate inspiration was Greek, the frieze of the Parthenon on the Acropolis at Athens.

The latest terracotta pedimental groups of the Hellenistic period come from the Roman colony of Luna (Luni). These are figures from three pediments, all of about the same date, the second quarter of the first century. Two were of the assembly type; the third showed a mythological scene, the slaughter of the Niobids. The style of the figures is a somewhat eclectic recreation of the Classic style of the fifth and fourth centuries. The figures are shorter and heavier than the figures of earlier pediments; the heads are relatively large; the shoulders, broad; the male torsos, modeled with broad, flat planes in the style of the fifth century. This revival of Classical proportions and style is a Roman taste of the first century B.C. not echoed in Etruria, whose artistic output during that century was almost entirely a debased continuation of second-century types. Perhaps the spoils of Athens that Sulla brought home in 81 B.C. had something to do with Rome's neoclassicism; the Roman sense of their own overwhelming importance no doubt had even more effect. The grandiose architecture of the Sullan period is in a truly classical style, a new style for the new masters of the world, but solid, severe, and regular. The culmination of the classicizing tendency at Rome is found in the idealized portraits of the age of Augustus, when a Roman likeness is grafted on a Polyclitan head and the verism of republican portraits is replaced by an ethical, idealized likeness that may be compared with second-century Greek portraits of princes.

PAINTING

Few of the painted tombs of Etruria belong to the Hellenistic period, still fewer are truly Hellenistic in style. The third-century Tomb of the Shields at Tarquinia, belonging to the Velcha family, is painted in the Etruscan Classic style; and the costume worn by the ladies of the family is still the dress of the Classical period (Pls. XXXIX*a*, XLII, XLIII).

THE ETRUSCANS

A later tomb at Tarquinia, the Tomb of the Typhon, gives us some idea of the quality of Etruscan Hellenistic painting. The tomb is a single huge chamber whose roof is supported by a central pillar with a molded cornice; this cornice has an egg-and-dart pattern painted above an ogee and a row of painted dentils. It seems to be supported by two figures of winged giants with blue hair and blue serpents for legs, masterly translations into paint of the great carved giants of the Pergamene frieze. The forward thrust of the powerful torso and the foreshortening of the thighs are evidence of a much more competent artist than any who worked on the tomb paintings of the late Classical period. On one of the walls of this room, a much ruined painting shows a crowd of people dressed in togas, apparently being escorted to the underworld by Charun, the Etruscan death demon, and his helpers. Here, too, the composition of many overlapping figures, close-pressed, seen at various angles, half-hidden, massed in a single, slow forward motion, is quite unlike anything in earlier Etruscan painting and anticipates the composition of the processional friezes of the Ara Pacis.

Architecture

SCHOLARS of the last century credited the Etruscans with the invention, or introduction to Italy, of advanced architectural techniques to which they themselves never laid claim, most notably the arch and vault. But we know now that during the Archaic and Classic periods the Etruscans constructed no true arch, and though some of their vaulted tombs are closed with a block fitted like a keystone, the other courses of the roof are horizontal, like those of a corbel vault. The arch, as used for civil architecture, came to Italy from Greece or the East at the beginning of the third century (see chap. vii), and all available evidence suggests that it was the Romans, rather than the Etruscans, who first saw and developed its great possibilities.

The Romans wrote of two architectural forms as characteristically Etruscan—the Tuscan temple and the Tuscan atrium. Both were adopted by the Romans and adapted to Roman use, and Vitruvius' descriptions of them reflect their survival in his lifetime, not their historical development. For knowledge of Etruscan architecture before the first century B.C., we must rely on archaeological evidence, and this is woefully spotty.

In the first place, no Etruscan city has yet been systematically excavated; and in the second, Etruscan architecture, except for tombs, was largely of wood and unbaked brick. There is indirect evidence, as we have seen, that this wooden architecture could be handsome and impos-

ing. The temples were ornamented with terracotta plaques and statues, and these survive. Their discovery in some cases has led to the careful excavation of the site where they were found; and in some fewer cases, this excavation has discovered the ground plan of the temple, since the foundations were usually of stone. But these foundations, particularly in the Archaic period, are often ephemeral and disturbed, or else have been repeatedly built over, and the result is that we know very little about the shape and arrangement of early Etruscan temples.

Consequently, for architecture before the Hellenistic period, one has only scattered temple terracottas, occasional fragmentary foundations, and the secondary evidence of tombs and cippi, paintings, mirrors, and gems. Architectural details are reproduced in all these, but often for special purposes and never with the fidelity of an architect's model.

THE ARCHAIC PERIOD

City planning. According to Servius (*Aen.* 1.422), every Etruscan city had three gates and three temples. There is no evidence for this in the Archaic period. The tufa plateaus of southern Etruria, where the first big cities were established, are broad and relatively level; and their steep cliffs were, it seems, defense enough at first against attack. Unlike Greek cities, the southern Etruscan cities seem not to have felt the need of an arx. The Piazza d'Armi at Veii may be an exception, but the site of Veii is so vast that the original city cannot have occupied it all; and the hill of the Piazza d'Armi, slightly lower than the southeastern end of the main plateau and separated from it by a saddle, may have been the site of the original settlement or, as at Rome, one of the original settlements from which the city grew. Traces of Villanovan huts have been found here, but others have been found near the Portonaccio Temple and still others at the northwest end of the plateau. There is evidence of city life at an early period—though probably not as early as the first Etruscan settlements—on the northern slopes of the town, where the foundations of houses and a street have been found. In any case, even at the height of Veii's power, much of the plateau must still have been farmed, and this must have been true of the broad plateaus of Cerveteri and Vulci as well.

Architecture

The little houses on the northern slope are in a row, facing a single street. They were dated by their original excavator in the seventh century because of the fragments of bucchero found in their ruins, but domestic bucchero continues through the sixth century or even later, and these houses are probably not extremely early. However, one may conjecture that even at the beginning of Etruscan city life on these flat plateaus the inhabited parts were laid out on a grid plan of streets which intersected more or less at right angles. This is the arrangement of the sixth-century cemetery of Crocifisso del Tufo at Orvieto; the little rectangular tombs are arranged in long, narrow blocks, back to back, facing parallel streets.

But even if the tufa cities of southern Etruria may have been laid out in a grid plan as early as the seventh century, it is most unlikely that the hill towns of the north and east could ever have had such a plan. In fact, a section of the late Hellenistic city at Vetulonia has been excavated, and its streets wind and climb like those of a modern Italian hill town.

Fortifications. The oldest defense work in Etruria is the earthwork, or agger, that separates the tip of the plateau of Poggio Buco from the rest of the site. The area defended by this is very small and is usually taken to have been the arx of the city. However, it may have been the city itself in the seventh century, since early tombs are very close to the wall and the Etruscans, like the Romans, never buried their dead inside the city limits. Arx or city, the area is defended only on one side by the agger; the other sides are steep enough in themselves to protect the city from assault. This is the only well-preserved agger in Etruria, but there were undoubtedly others. Rome was once defended by such a wall, and at the Latin town of Ardea one can still see a superb example of this type of fortification. Like the earliest tombs at Poggio Buco, the agger dates from the seventh century.

The walls of Roselle have recently been excavated and dated, by the potsherds in their fill, in the first half of the sixth century. These are the oldest stone fortifications (so far as we know) in Etruria. They are built of the local limestone, which is of a very variable consistency, sometimes massive, sometimes sandy and brittle, breaking into flattish

blocks which cannot be easily worked. Where the limestone is dense and hard, the blocks are shaped in irregular polygons and loosely fitted together without mortar, the joints snecked with smaller stones; where the sandy blocks are used, the courses are lower and more regular, but the difference in appearance is due to the material, not to a difference in date. These walls are three kilometers in circuit and pierced by five gates rather than the Servian three; and, early as they are, they were not the first defense walls of the city. An earlier wall, partly overlaid by the stone fortifications, was built of sun-dried brick, in part preserved, and rested on a foundation of small stones laid in clay; the potsherds found with it date this wall in the seventh century. Evidently Roselle, which is situated on a twin-crowned hill of gentle slopes, dared not trust to natural defenses and developed a formidable system of fortification early in her history. It may be that other northeastern Etruscan cities which are built on sloping hills rather than the tops of tufa mesas also built walls during the Archaic period; Populonia and Vetulonia both have polygonal walls of unknown date. Volterra's wall includes an Archaic cemetery in its circuit and therefore cannot have been built before the fifth century; it is usually assigned to the end, rather than the beginning, of that century.

Temples and public buildings. Nothing is known about public buildings other than temples in the Archaic period, and even the temples are not very early. The oldest temple terracottas date from the first half of the sixth century (see chap. v and Pl. XX). Since it is inconceivable that the Etruscans worshipped no divinities until some time after 600 B.C., their worship before then must have been in open-air sanctuaries as it was in Latium, for example, at the grove of Diana at Nemi or the sanctuary of Jupiter Latiaris on the Alban Mount. Indeed, we know of two such sanctuaries in southern Etruria, that of Apollo Soranus on Mount Soracte and the grove of the goddess Feronia near the town of Capena. Diana Nemorensis was eventually given a temple, but Jupiter Latiaris never had a roof over his head, and apparently Feronia's precinct never acquired a temple either.

A number of other ancient sanctuaries in central Italy were given temples in the course of the sixth century, but votive material from

these sites indicates that they had been places of worship considerably earlier. The earliest material from the votive stips at Satricum dates from the first half of the seventh century, though the remains of the first temple to the Mater Matuta are no earlier than the sixth. The oldest material from the stips of the Portonaccio Temple at Veii is of the late seventh century, but the temple itself was not built till the last years of the sixth.

In northern Etruria Archaic temple terracottas are much less common and not as early as those in southern Etruria and Latium, which suggests that the north was slower to build temples than the more Hellenized south. Very early votive bronzes, figures in the wiry geometric style of the Villanovans, prove the existence of early sanctuaries at Arezzo and Fiesole, though these are not recorded in any literary tradition. Since the earliest bronzes from these sites are pre-Etruscan in style, while later statuettes from the same place are completely Etruscan (Pl. XV), it would appear that the Etruscan immigrants made use of the sacred places of the older Villanovans, just as the Greeks used those of their predecessors in Ionia.

All that is needed in an open-air sanctuary is an altar, a water supply, and some indication of the boundaries of the precinct. The precinct did not need to be large, and those inside a city were generally quite small. Remains of these are not uncommon in Etruria; they consist of a raised platform, square or rectangular, with a masonry perimeter wall trimmed with moldings and approached by steps. There is an example dating from the end of the sixth century at Marzabotto, and another, probably of the same date, crowned with a splendid and unique hawk's-beak molding, was excavated near the ancient cemetery at Vignanello. It is a continuing type; a Hellenistic example was found at Cosa, and the Ara Pacis Augusti is an imperial descendant of these. A small limestone ex-voto from Chiusi (Pl. XLVIIIc) appears to be a model of such a precinct. This shows a narrow, rectangular enclosure on a raised platform which has sides that are decorated with moldings; it is approached by a flight of three steps at one end. The top of the platform is surrounded by a low kerb in which are drilled six small holes, one at each corner and one in the

center of each long side. These are too small to have held anything but metal rods, which were probably linked together by chains or a bronze fence around the sacred area.

The first temples built in southern Etruria and Latium, in the first half of the sixth century, must have been small, to judge from the scale of the earliest terracottas, simple head antefixes and small, figured friezes (Pl. XX). Only in one case have such terracottas been found with the foundations of their temple, on the Piazza d'Armi at Veii. This foundation, of roughly squared tufa blocks, is a rectangle 15.30 meters long and 8.07 meters wide; these proportions are longer and narrower than those of later Etruscan temples and not unlike the megaron plan of small Greek temples. The first phase of temple building in central Italy apparently depended on Greek models not only for its terracotta decorations but for its floor plans, and indeed the very idea of a temple building in a sanctuary must have come to Latium and Etruria from Greece, probably by way of Campania.

A second stage in the history of the Etruscan temple is illustrated by the Portonaccio Temple at Veii. There is some doubt as to how this building was arranged inside, but the shape of the outer rectangle of the foundations is clear, and it is completely un-Greek, being perfectly square, 18.50 meters on a side. Its terracottas date it securely in the last years of the sixth century; it was for such large temples that the showy shell antefixes of the late Archaic period (see chap. v and Pl. XXI) and the handsome revetments decorated with chains of palmettes and lotuses were devised. The Capitolium at Rome was such a temple. This is an example of the type that Vitruvius describes in his canon for the Tuscan temple, and it was a continuing type, not an antiquarian fancy. Not only was Pompey's Temple of Hercules at Rome built according to this canon in Vitruvius' lifetime, but the proportions of Hellenistic capitolia in Rome's colonies correspond closely to Vitruvius' specifications (Fig. 3), and their terracotta decorations, though no longer Archaic in style, preserve a late Archaic flavor.

"Such temples," says Vitruvius (3.3.5), "are heavy-headed, low, broad; and their gables are ornamented with statues of terracotta or

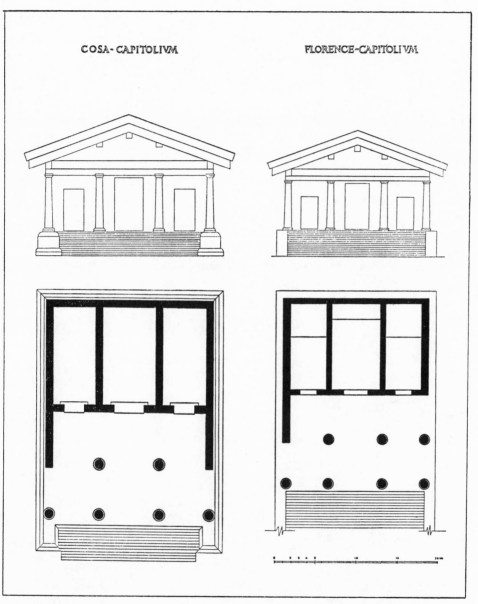

COSA-CAPITOLIVM FLORENCE-CAPITOLIVM

3. Plans and elevations of the Hellenistic Capitolia of Cosa and Florence. From F. E. Brown,
Cosa II: The Temples of the Arx, *Part I (Memoirs of the American Academy at Rome,*
Vol. 26 [Rome, 1960]), Fig. 79.

gilt bronze." In ground plan, he says (4.7.1), they should be six parts
in length to five in breadth; one-half the length is given to the cellae
(there may be three of these, as in Figure 3, or a single cella flanked
by alae); the other half forms the pronaos, a deep porch whose roof
is supported by two rows of four columns each, standing on the lines
of the outer walls and the cella partitions (Figs. 3 and 4, *center*). The
columns themselves are low, seven times the height of the lower
diameter, with bases and capitals, each one-half the lower diameter
in height; the total height of the column with capital and base is one-
third the width of the temple. Above the columns, the roof is built
of wood and has deep eaves on all sides, forming a heavy canopy
sheathed in terracotta (Fig. 4).

Vitruvius' description calls for a gable with a closed tympanum of

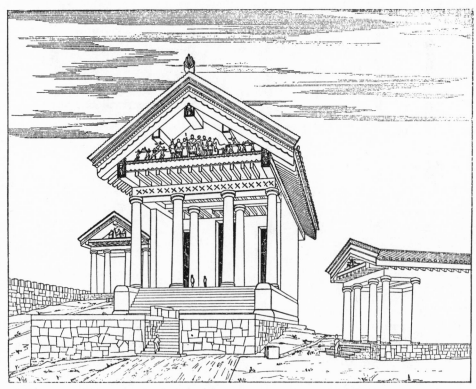

4. *Reconstruction of the three temples on the Arx of Cosa, ca. 100 B.C. From* Cosa II,
 Fig. 89.

wood or stone; but even in the late Hellenistic period, as we know from the terracotta model from Nemi (Pl. XLVIII*a*), the Tuscan temple normally still had an open pediment whose floor, flat or gently sloping, was the roof of the pronaos and was tiled like the pitched roof above (Pl. XLVIII*b*). The supports of the gable roof, the ridge-pole and rafters, were visible, unlike those in a Greek stone temple; and their ends were also ornamented with terracotta plaques. The gable roof was pitched to a slope of one in three.

One thing Vitruvius does not mention is the setting of these temples. They are always in a temenos, a sacred precinct; and they are normally placed against the back wall, fronting on a space that holds the altar. Heavy-headed, broad, deep-eaved, brilliantly polychrome, they dominated the precinct so that from the altar the worshipper looked up to the god, who glimmered in his bright paint through the shadows of the cella.

Unlike the earlier temple type, this type must have developed from native architecture. The great roof, with its deep eaves and ridgepole ornamented with sacred symbols, goes back to the Latin and Villanovan hut urns of the early Iron Age (Pl. I). The division of the broad, rectangular floor plan into two equal sections with the rear divided into three rooms fronting on a deep porch, may have been taken from an Etruscan house plan seen in three Archaic tombs at Cerveteri and several houses of the Classical period at Marzabotto.

Whether the architect who invented this type of temple was an Etruscan or a Roman has been hotly argued. The triad—Jupiter, Juno, and Minerva—was worshipped at Rome before the Etruscan period but was not worshipped in Etruria until Roman times. Triads, indeed, seem to belong to the Italic peoples of central Italy and to Greece far more than to Etruria. In fact, the only evidence for a triad of any kind in Etruria before the Roman period is at the Portonaccio Temple at Veii, where the votive stips contained a number of dedications to Minerva and one that seems to read "Aritimi and Turan." Possibly this temple was dedicated to a curious triad of ladies other-wise unknown in combination, but the weight of evidence from the stips suggests a single goddess, and the remains of the temple foun-

dations do not make it clear whether the building had, in fact, three cellae or a single cella flanked by alae, as in Vitruvius' alternative specifications.

In that case, it has been argued, the broad temple with a single cella flanked by alae open to the pronaos is the Etruscan type, while at Rome the creation of the triple-cella temple made by closing the alae was inspired by the existence of a triad of important divinities. It has also been argued that the broad Vitruvian temple was created at Rome specifically for Tarquinius Superbus' new Capitolium and that the Etruscans then imitated the new Roman type, first at Veii, later at Pyrgi, etc.

Houses. The earliest house form that we know in central Italy is illustrated by the hut urns of Latium and southern Etruria (Pl. I). Each of these represents a dwelling with a single room, round, oval, or roughly rectangular; the walls are built of wattle-and-daub; and the steeply pitched, thatched roof is supported by a ridgepole aligned with the door, which is in the center of one of the short sides, in the oval and rectangular examples. A few hut urns have a porch in front of the doorway; many also show an opening under the ridgepole over the door, a smoke hole for the hearth inside. Some few urns have a single, wide window in one of the long sides. Foundations of actual huts of this type have been found at Rome, on the Palatine, and at Veii.

The urns are Latin and Villanovan; they hardly reach the seventh century, but the house they represented is a continuing form; its descendants can still be seen in central Italy, the capanne built as summer shelters in the fields. At least one Etruscan tomb of the Orientalizing period, the Tomb of the Thatched Roof at Cerveteri, reproduces the interior of such a building; it has a rectangular room with a deeply pitched, slightly bowed roof, supported by a slender ridgepole; the side walls are so low that one can stand erect only in the middle of the room.

The little houses found at Veii, which cannot be closely dated but were built sometime in the Archaic period, are of a more complex plan and construction. They are rectangular, the foundations partly

cut in the soft tufa of the plateau and partly built of stone; and some parts of the walls remain to the height of a meter. One, the best pre-served, has a floor plan like the Greek megaron, rectangular, with a shallow anteroom and a deep back room in which is the hearth. The Regia, in the Roman Forum, which dates from the days of the Etruscan kings of Rome, is a larger megaron; and its foundations are also of stone.

An early fifth-century relief from Chiusi shows a rectangular build-ing with a gable roof and an open pediment. The undecorated faces of the rooftree (columen) and lateral rafters (mutuli) project under the eaves; at the peak of the gable is a disc-shaped acroterion, and there are big lateral acroteria in the form of crouching lions. Since actual architectural terracottas are not found in the late Archaic peri-od in Etruria in connection with buildings other than temples or tem-ple-tombs, it is likely that this building is not intended to be a house but a funerary pavilion, like those painted in the tombs of Tarquinia (Pls. XXXIV, XXXV). In any case, the gable roof with open pedi-ment is well attested in antiquity. In the painted tombs the kingpost that supports the rooftree is usually shown (Pls. XXXIV, XXXVI); the façades of late Archaic rock-cut tombs in Phrygia show gables with such brackets supporting the ridgepole; and the little, obviously wooden shrines painted on Apulian funerary vases of the fourth cen-tury often have a small post or caryatid figure in their open pedi-ments, to carry the gable.

Tombs. Archaic Etruscan tombs are arranged in cities of the dead, laid out in regular streets with rectangular blocks, as at Orvieto, or around streets and squares, as at Cerveteri. Their arrangement reflects a community with a sophisticated urban development.

Though each Etruscan city had its peculiar style of tomb and cemetery, during the Archaic period the burials were almost always inhumations in relatively small chamber tombs. Chiusi is the out-standing exception to this rule. The earliest chamber tombs seem to be trench tombs, like those of the late Villanovan period, given gable roofs, but the Orientalizing period supplied them with a tumulus, a mound of earth heaped over the chamber and provided with a cir-cular stone kerb (see chap. iii).

THE ETRUSCANS

In southern Etruria, the chamber tombs were dug out of the soft local tufa; farther north, at Vetulonia, Populonia, and Volterra, they were constructed of stone blocks and roofed with false domes. A number of tombs found in Volterra's territory have round chambers whose domes are supported by central pillars. These are the only true tholos tombs in Etruria, and the only ones whose chambers reflect the shape of the tumuli that cover them. The domed tombs of Populonia have either a square or a rectangular floor plan, and the transition to the hemispherical roof is ingeniously contrived by the use of horizontal blocks laid across the angles of the walls to form false squinches. The tumuli of these northern cities each covered a single chamber tomb, while those at Cerveteri sometimes covered as many as six. Except at Cerveteri, the tomb almost always consisted of a single rectangular room entered from one end by a dromos or a flight of steps. In some cases the room is so small that it has space only for benches along the walls of the three closed sides; these tombs can hardly be called houses of the dead; they look more like mortuary chapels.

The Archaic painted tombs at Tarquinia are examples of this one-roomed type, though the rooms are rather larger. Here, too, the tomb does not try to reproduce the look of a house but is transformed into an open banquet pavilion, supported on slender wooden columns and roofed with a colored awning (Pls. XXXIV and XXXV).

But at Cerveteri the Archaic tombs apparently do, to a certain extent, reproduce the interior of a house. Normally, the tomb has four elements—a dromos, lateral chambers opening onto it just in front of the main door, a central room, and a terminal chamber or chambers. All these elements were already present in the Regolini-Galassi Tomb (see chap. iii), though the lateral rooms were merely niches there. In the grand tombs of the seventh and sixth centuries, such as the Tomb of the Capitals (Pl. XVI*b*), the interiors are elaborately carved with architectural details, although the tombs are not organic architectural complexes that can be translated directly into houses or temples. The architecture they illustrate was of wood, heavy and

handsome, and made use of great beams and consoles to emphasize the ceiling.

This Tomb of the Capitals is one of three at Cerveteri which have ground plans that resemble Vitruvius' Tuscan temple with three cellae (Fig. 3). The broad central room of the tomb, whose heavily beamed roof is supported by an inner pair of columns, looks like nothing so much as a deep porch on which front three separate rooms, each with its own door flanked by windows. Apparently one is supposed to think away the outer wall of the central room into which the dromos opens (Pl. XVI*b, left*). The dromos and its flanking chambers are essential to the tomb but not to the house that this tomb imitates. The wide doors and windows that open onto the central chamber prove that it was thought of as a source of light, a porch, rather than a closed room.

Many other tombs at Cerveteri, some with a single terminal chamber, others with more, show this arrangement of doors and windows opening out of the back wall of the central room. Plate XVI*a*, from a ruined tomb in the Banditaccia Cemetery, gives a fine illustration of these openings. The frame is T-shaped, the jambs sloping slightly inward; the window openings are almost square; the door, a broad rectangle. In this tomb the frames are given a raised border curved in a hawk's beak at the corners of the T. The painted door in the Casuccini Tomb at Chiusi (Pl. XXXVI) is of essentially the same shape, though without the elegant hawk's beak. This form of door is Greek and corresponds to Vitruvius' description of the canonical Doric doorway.

There is another form of doorway used in the Archaic tombs at Cerveteri, at Bieda, and elsewhere in the cliff cities, in which the opening is taller and narrower, with tapering sides joined by a semicircular arch. The form is like that of the doorways on the ends of the Hellenistic ash urn in Worcester (Pl. XLV), though these represent true arches constructed of masonry with proper keystones, while those in the Archaic tombs are carved out of the soft tufa. A late seventh-century tomb at Veii, the Campana Tomb, has a doorway of this form constructed of masonry, but it is not a true arch;

the frame is of horizontal corbeled blocks closed with a keystone, like that of the false vaults of the sixth-century tombs at Orvieto. The arched shape is carefully produced by carving out the inner surfaces of the jamb and the keystone.

An arched doorway evidently meant something special to the Etruscans of the Archaic period. It is not proper to an architecture that uses wood and adobe for its materials; it belongs to stone and baked brick, and in these materials it had been used in the Near East from time immemorial, and it had been used decoratively, for doors and windows, since early in the first millennium. The architects of the Near East knew all about the construction of the true arch; the Etruscans of Italy, in the seventh and sixth centuries, evidently did not but felt it important enough to reproduce its shape as well as they could in some of their tombs. This, I think, is its explanation: the arched doorway is part of stone architecture, and to the Etruscans stone was the material for tombs and cemeteries; such an archway was, in fact, the gate to the tomb and the world of the dead, as its use on the Hellenistic urn has already suggested (see chap. vii and Pl. XLV). These Etruscan "arches," with their peculiar shape and specific use, have nothing to do with the arcades and gates that Rome introduced to central Italy during the Hellenistic period.

Another element of Etruscan funerary architecture, the flat roof of the die tombs found in the cliff cemeteries of the Fiora and Marta valleys, is also often attributed to Etruscan domestic architecture. The die tombs are, as their name indicates, cube-shaped; each has a flat roof approached by an outer staircase and the outline of a door carved on one of its façades. At first glance, they do look like square, white-washed houses with terrace roofs, of which there are so many in the warmer and drier parts of the Mediterranean.

But the roofs of the die tombs do not really look like terraces; the upper parts of the walls are decorated with heavy and elaborate moldings which roll inward like bases rather than outward like cornices; there is nothing here that would be suitable for the roof of a house. If one considers the shape of the tomb and its crowning moldings, it is an elaborate cippus, such as the one illustrated on Plate XIX or

the little square tombs of Marzabotto (Pl. XVIII*a*). What is lost from the die tomb is the crowning element. It may have been a cippus, or a stele, or there may have been earth heaped on the flat roof of the tomb, as there was on the little Archaic tombs at Orvieto, with stelae rising above them. At any rate, the exterior staircase was real, not part of an imaginary house, and like the little flight of steps that rises above the stone kerb of the great tumuli at Cerveteri, it was evidently essential to the cult of the dead.

Whatever the exact explanation of these flat-roofed tombs may be, the eclectic character of central Italy's funerary symbolism must never be forgotten. The ash urn may represent the house of the dead (Pl. I) or the dead man himself (Pls. II, XII, XIII); the sarcophagus is shaped like a storage chest, but its lid may represent the marriage couch (Pl. XLIV*c*), or the banqueting couch (Pl. XLV*a*), or the roof of a temple (Pl. XLIX*a*); and tomb architecture is evidently made up of equally disparate elements.

THE CLASSICAL PERIOD

City planning. The city of Marzabotto, on the left bank of the Reno not far from Bologna, was apparently founded in the third quarter of the sixth century B.C., but the remains of its civic architecture seem to be somewhat later than this. Its excavators uncovered a segment of a well-planned city with three broad streets running east and west that were crossed by a single wide street and a number of narrow ones running north and south; the whole made a grid plan with long, narrow blocks like those in the Archaic cemetery at Orvieto and, in fact, like those of most of the ancient towns in Italy of whose plan we know anything.

The broad streets are fifteen meters across, the central five meters apparently used for carts, the five on either side raised for sidewalks; on either side run drainage channels, and the central roadway is crossed by files of steppingstones, as at Pompeii. The narrow streets are only five meters broad, without sidewalks and with a single drain running down one side. The streets are paved with river pebbles.

Much of the city has been eaten away since antiquity by the shift-

ing of the Reno; it was built on a high bluff overlooking the river, and a further elevation to the northeast seems to have served as an arx, though rather as a sacred place than as a citadel. The remains of five constructions have been found here: one is the Archaic altar precinct mentioned above; one was a well to provide the essential water for the sacred area; the foundations of two are so fragmentary as to be unreadable; the fifth may have been a triple-cella temple. All these foundations have been heavily restored. A votive stips containing a number of small bronzes of the late sixth century confirms the impression that this was a sacred area, but there is no evidence to show what god or gods were worshipped there.

Outside the city are two small cemeteries, one to the north, the other to the east. The modest tombs are made of flat stone slabs which form a square box surmounted by a funeral monument; they have the look of cippi (Pl. XVIIIa) and are too small to be called chamber tombs or even to contain a body extended to full length.

Part of the plan of another city in the Po Valley has been recovered at Spina, the half-Greek, half-Etruscan port on the Adriatic. There, a great canal was dug to make sea traffic possible in the lagoon at the river mouth, and this was crossed at right angles by a series of little canals or ditches which formed rectangular blocks like the grid plans of Marzabotto and the cemetery at Orvieto. At Spina the houses were built on piles, as are the palaces and tenements of Venice.

Fortifications. The fifth book of Livy tells the story of Rome's siege of Veii and the eventual capture and destruction of the city (406–396 B.C.). After an initial attack, the Romans settled down to a blockade of the city, which they maintained summer and winter, a maneuver that at first distressed the Romans more than the Veientines, housed "comfortably under their own roofs, in a city protected by its magnificent walls and the natural strength of its position (5.2)." Considerable stretches of Veii's walls are preserved and include the sites of seven main gates and four posterns. In some places, it was only necessary to cut back the tufa of the natural cliff to form a vertical face; elsewhere, a massive earth rampart was faced with a wall of tufa masonry, rectangular blocks laid in regular courses with-

out mortar. Presumably this tufa wall projected above the earthwork to form a parapet. These walls, to judge by the material found with them, cannot have been built before the middle of the fifth century and were perhaps built only a short time before the city was destroyed.

The first stone fortifications of Rome, the so-called Servian wall, were built in 378 B.C. (Liv. 6.31). Like the walls of Veii, these were of rectangular blocks of tufa laid in headers and stretchers; and the curtain, as at Veii, was backed by an earth rampart. Neither at Veii nor at Rome were the walls defended by towers.

At Tarquinia the city walls are of the same type, a curtain of rectangular stone blocks laid in regular courses, backed by an earth rampart, and made without towers. Where the gates are preserved, they are set at the peak of an obtuse angle projecting inward, so that the walls on either side command the gateway and the road leading to it skirts the wall so as to force an approaching enemy to have its unprotected right side toward the wall and its defenders. The circuit of the walls at Tarquinia was about 8 kilometers, and it enclosed the whole of the plateau on which the city stands, as well as two outlying spurs which, to judge from the lack of surface finds, were not inhabited in antiquity. They were included for safety, to prevent an attacking enemy from occupying land higher than that of the city, and were probably farmed or used for pasture. The Servian wall at Rome, about 11 kilometers in length, also enclosed more territory than the city needed for dwellings and public buildings.

The walls at Tarquinia cannot be dated with any certainty by their fill. Their resemblance to the walls of Veii and the Servian wall at Rome makes it certain that they belong to the Classical period, and the fact that the mid-fourth century was a period of particular tension between Rome and Tarquinia suggests that these fortifications date from that time.

Temples. Excavations at Santa Severa, the ancient Pyrgi, have recently uncovered the foundations of a large Tuscan temple (24.05 meters by 34.40 meters) and many fragments of the splendid terracotta group that once filled its pediment (see chap. vi and Pl. XXXVII). The terracottas date this temple securely in the first half

of the fifth century, probably about 460 B.C. To judge from the foundations, it had three cellae; the central one was about twice the width of the others, which are divided, uncharacteristically, by cross walls into two small compartments of unequal size. In front of the cellae, three cross walls indicate that there were three rows of columns in the pronaos instead of the Vitruvian two, a feature of the Capitolium of Rome as well. Like the Temple of Juno Sospita at Lanuvium and the second-century Capitolium of Signia, the proportions of the temple at Pyrgi are rather longer and narrower than is normal for Tuscan temples in Etruria and seem to ally it with Latin rather than Etruscan temples.

No other surviving Tuscan temple, whether in Etruria or Latium, had a sculptured pediment before the second century B.C. But the terracottas of Pyrgi are designed to fill a triangular space and were fastened with nails to a wooden tympanum, in imitation of Greek stone temples of the Archaic and Classical periods. The form of the Pyrgi temple is, of course, not at all Greek; but its unexpected combination of an Italian ground plan and a closed Greek pediment filled with sculpture may perhaps explain the curious discrepancy between the two ancient reports about the Temple of Ceres, Liber, and Libera dedicated in 493 B.C. on the Aventine in Rome (Dion. H. 6.17, 94). Vitruvius (3.3.5) cites this temple as one example of his Tuscan canon at Rome, while Pliny (35.45.154) says that its terracottas were made by two Greek artists, Damophilos and Gorgasos, who also executed paintings for the temple. "Before this building, according to Varro," Pliny continues, "everything on temples was Tuscan. . . ." Perhaps Damophilos and Gorgasos made a "Greek" terracotta pedimental group for the Temple of Ceres instead of the normal open Tuscan pediment with its row of antefixes (Pl. XLVIII*a*) and its splendid statues on the ridgepole.

The foundations of one of the buildings on the arx at Marzabotto, though they lack the front and the right wall, look very like the foundations of the Pyrgi temple. Here, too, the central cella is much wider than the flanking cellae or alae; and they, as at Pyrgi, are divided by cross walls into two small rooms. Few architectural terra-

cottas of any kind were found at Marzabotto, but there are shell ante-fixes of the early fifth century which may well have come from this temple.

A third Tuscan temple of the Classical period has been excavated at Orvieto, near the northeastern edge of the city, between St. Patrick's Well and the Belvedere. This temple is of considerable size (16.90 meters by 21.91 meters) and was approached by a flight of steps or an earthen ramp between stone revetments. The footings for the two rows of four columns in the pronaos remain, as does a fragment of one wall of the central cella; but one cannot make out whether this was flanked by other cellae or open alae. The terracottas found here are in the Etruscan Classical style, but late, dating from the end of the fourth or even the early third century.

Apart from these foundations, our only evidence for the appearance of Classical temples in Etruria is a series of Etruscan mirrors which show an assembly of divinities or a mythological scene in front of a temple. Most of these temples, when their architectural details can be made out, have four columns across the front and an open pediment with antefixes and a columen. The capitals of these columns are usually a form of the Aeolic capital which was popular in Etruria in the Classical and especially in the Hellenistic period—a pair of thick volutes spring from the base of the echinus, spreading into a wide Y, often filled with a chevron pattern. In some mirrors, the pediment of the temple is not shown at all; instead, a figure lies along the architrave—a silenus drinking, a sleeping maenad, or the like—as if it had climbed up there to get out of the way of the main action going on below, not, as is sometimes said, to create the impression of a pedimental group. But other mirror temples do show a pediment filled in some way with sculpture, often a large head flanked by leaves and tendrils as on Apulian fourth-century vases or the fore-parts of a four-horse chariot and the torso of its driver (the Sun, to judge from a disc often engraved over his head). The head framed by flowers appears in terracotta on Hellenistic revetments, and the four-horse chariot was a favorite composition for an acroterion, but no actual pedimental terracottas of these types have been found as yet.

THE ETRUSCANS

Whether the mirrors report accurately on pedimental sculpture in the fourth century or not must be answered by future discoveries.

Houses. The foundations of a number of houses have been found at Marzabotto. They are not by any means all of one plan, but they are all city dwellings, separated from one another by party walls, without gardens but with open courtyards in which there were wells. The courts are paved with river pebbles and, though of considerable size, were not intended for wheeled vehicles, since they were surrounded on all sides by rooms or the heavy party walls between two houses. These courtyards must have served for cooking and washing and perhaps served more than a single family, since the rooms surrounding them are numerous and large; the biggest of these are about 5.10 meters (17 feet) square. The foundations of the walls are of river pebbles, and the walls themselves must have been built of sun-dried brick.

In several of these houses, the large front rooms are arranged in a row of three, fronting on the wide main street; and in at least three cases these rooms are set back behind a deep porch which, to judge from the bearing walls of its foundations, had a double row of columns supporting its roof. The resemblance to the plan of the three Archaic tombs at Cerveteri with three terminal chambers opening on a wide, columned antechamber is striking (see p. 191 and Pl. XVI*b*).

Tombs. The tombs of the early Classical period at Tarquinia (to the middle of the fifth century) are like the late Archaic tombs— a single rectangular chamber approached by a flight of steps, a pitched roof, and painted walls and ceiling. Here the effect is still that of a pavilion rather than a building of more sturdy construction. At Chiusi, the contemporary tomb combines characteristics of the tombs of Tarquinia and Cerveteri; the walls are painted with scenes from the funeral banquet and games (Pl. XXXVI), as at Tarquinia; but the ceiling is carved to represent a heavy wooden structure, perhaps in imitation of a true house roof, as at Cerveteri (Pl. XVI*b*). The ceiling of the Casuccini Tomb (Pl. XXXVI) has a very wide central beam, which is shown as resting on painted brackets at either end in the open gables; broad rafters run from this beam to the walls, and

over the rafters are laid narrower boards running lengthwise; above these, a rectangular molding and a closing slab finish deep coffers between the rafters.

This tomb has, essentially, the ground plan of the large chamber tombs of the fifth century at Chiusi. There, a dromos leads to a rectangular chamber, entering it through the center of one of the long walls, so that the gable roof lies crosswise to the entrance, as in the Casuccini Tomb; and in each of the other three walls a central door leads to a smaller chamber with benches for the dead. In the Casuccini Tomb, only one of these three chambers was finished; another was only partly cut in the soft limestone; while the third is not there at all; instead, a painted door leads to an imaginary chamber (Pl. XXXVI). The door to the main room at the end of the dromos is preserved; it is made of two slabs of travertine which still open and shut on their ancient hinge pins.

During the course of the fifth and fourth centuries, the tendency almost everywhere was to enlarge the tombs, sometimes by adding rooms and sometimes, particularly later, by greatly increasing the size of the main room. Clearly, the burial customs of the Etruscans were changing; instead of the small tomb chambers of the Archaic period, with room for only two or three burials, these later tombs are family chapels used for burials of the head of the household and his immediate family and their descendants for generations. It may be that the Archaic tombs at Cerveteri such as the Tomb of the Capitals (Pl. XVI*b*) are the first manifestations of this tendency; the early Classic tombs at Chiusi (Pl. XXXVI) are modest versions of the same thing.

At Vulci, the François Tomb is a fine example of the large Classical tomb with a multiplication of rooms; its construction dates from the fifth century, though the paintings formerly in its central room belong to the fourth. This room, like the central chamber of other tombs of the same date at Vulci, is T-shaped, entered at the center of the crossbar through an anteroom at the end of the dromos. The stem of the T projects back, and a terminal chamber opens from the center of its back wall, while three lateral chambers open from each end of the T's crossbar. In addition to these nine carefully planned

and elegantly finished rooms, there are three additional rooms, irregularly shaped, opening off the dromos, enlargements of the primitive dromos niches such as those in the Regolini-Galassi Tomb at Cerveteri. The finds in this tomb date from the mid-fifth century B.C.—an Attic red-figure amphora by the Syleus painter—to the first century B.C.—a cup with the maker's signature, P. Caisius.

The fourth-century Tomb of Orcus at Tarquinia is an example of a Classical tomb with a greatly enlarged chamber whose roof is supported by a central pillar. Actually, this was originally two separate large tombs which, in the Hellenistic period, were put together by breaking through the tufa wall between them, forming a sort of lobby, on one wall of which is painted a highly impressionistic scene of the blinding of Polyphemus.

The late Classical and Hellenistic tombs at Volterra are of the type which has a single, very large chamber and a central pillar. The tomb of the Calini Sepuś family was found untouched, with all its grave furniture. Entered by a dromos with twelve steps, this tomb has a rectangular chamber cut in travertine with a central pier supporting the roof and a continuous bench running around the three closed sides. Partly on this bench and partly on the floor between it and the pier were arranged the ash urns of the Sepuś family with their funerary offerings. The earliest urns, of the fourth century, are red-figure kraters in a local style, undoubtedly made at Volterra; the later urns are like those from Chiusi (Pl. XLV), shaped like chests, with reclining figures depicted on the lids. Altogether, there were 109 cremation burials in this tomb; the latest datable material is Arretine pottery from the time of Augustus.

THE HELLENISTIC PERIOD

City planning. One Hellenistic city in Etruria, the Latin colony of Cosa, founded by the Romans on the limestone coast of central Etruria in 273 B.C., has been surveyed and, in part, excavated. How much its plan conformed to Etruscan standards and how much to Latin we cannot tell. It stands on a rocky hill which juts into the sea, the first break in the long sweep of beaches and dunes that make

the present coastline north of Civitavecchia. The rocky islands of the Tuscan Archipelago can be seen from Cosa, and the great mass of Mount Argentario dominates it to the northwest. Rome chose this particular site for two reasons: the colony could watch the coastal waters for the fleets of Magna Graecia and Carthage, and its presence could dominate and keep in order the old Etruscan cities of the Maremma, particularly Vulci, in whose ancient territory Cosa was established.

The city is walled, 1.5 kilometers in circuit, and has three main gates and three sacred areas, more or less as Servius prescribes for an Etruscan city (*Aen.* 1.422). The city plan is a grid of long, narrow blocks, like the sixth-century cemetery at Orvieto and the fifth-century street plan of Marzabotto; the streets leading from the three gates converge around the forum which, as Vitruvius recommends for a city by the sea (1.7.1), is put near the sea gate.

Fortifications. The walls of Cosa were certainly not built according to Etruscan specifications, though their handsome polygonal masonry did have Etruscan antecedents, as for example the sixth-century walls of Roselle. The masonry at Cosa is considerably more expert than at Roselle; the joints are tight, and snecking is kept to a minimum. This improvement in technique would have come naturally in the three hundred years between the building of the walls of the two cities, but the plan of the walls at Cosa is an innovation in central Italy, for they are strengthened at places by square towers spaced at intervals of 100 Roman feet (29.6 meters), the oldest defense towers north of Magna Graecia, whose towers must have provided the pattern. The superstructure of the walls of Cosa, where it is preserved, is built of small limestone blocks and good Roman mortar. The gates were arched, of the interior court type; the outer gateway was closed by a portcullis; the inner, by doors. These fortifications, far more sophisticated than the fourth-century walls of Tarquinia and Rome, demonstrate the enormous strides in military science made by Rome during the Samnite Wars and the war with Pyrrhus.

The walls of Falerii Novi, to which the Romans moved the inhabitants of ancient Falerii after its revolt and destruction in 241 B.C.,

are also strengthened by towers—fifty towers and nine gateways in a circuit of little more than two kilometers. Since this city is in tufa country, its walls are of handsome rectangular blocks, and its arched gateways were embellished with moldings. The best preserved, the Gate of Jove, has nineteen deep, narrow voussoirs framed by a triple molding; and a head carved in high relief projects from the molding above the keystone. One of the gates of Volterra, undated and otherwise plain, is more elaborately ornamented with three battered heads on the keystone of the arch and at the spring of the arch to either side. An alabaster urn of the second century B.C., from Volterra, has a relief of the assault of the seven against Thebes; the gate on this urn is also given an arch, and a satyr's head is set into the wall beside it. This is often said to be a copy of the gate of Volterra, but the setting of head and gate is more like that of the Gate of Mars at Perugia, whose elaborate architectural frame seems a rather heavy-handed attempt at the elegance of the architecture of the Tufa period at Pompeii, of the second century B.C.

The walls of Perugia are built of rectangular blocks of beautiful whitish travertine and were towered. Their circuit is 2.9 kilometers, and there are traces of seven gates. The upper part of the most elaborate of these, the Gate of Mars, was moved by Sangallo to the façade of his new bastion in 1540. The voussoirs are framed by a molding, as are the gates at Falerii Novi. To either side a head is set, and above the arch runs a colonnade in which appear five figures—Jupiter, his sons the Dioscuri, and their horses—arranged symmetrically; and the whole panel together with the arch is framed by pilasters with Italo-Corinthian capitals. This may be the earliest combination of arch and pilaster; except for this, all the elements of the gateway appear in the second-century architecture of Pompeii—the curiously squashed Corinthian capitals, the pilasters framing a doorway, the colonnaded upper story with its ornamental grillwork. There is no need to date this gateway, as has been suggested, later than 100 B.C.

Temples and public buildings. What has been said of city planning in Etruria in the Hellenistic period may be repeated for public buildings other than temples; practically all we know about them

comes from the excavations at Cosa. The buildings around the forum there include a comitium and curia of the third century, one of the earliest building complexes erected by the colonists; a handsome colonnade was set up across one end of the forum early in the second century, and by the middle of the century a basilica had been fitted in between the comitium and the colonnade. At some time during that century, perhaps at the time the colonnade was built, the main approach to the forum was given monumental form by the construction of a triple arch whose central opening was twice the height and width of the outer arches. These embellishments—colonnade, basilica, and arch—recall the building activities of the censors at Rome during the second century B.C. (see chap. vii). We cannot be certain that every Etruscan forum of that century had similar developments, but that is not unlikely. Presumably the front of the terracotta urn from Chiusi (Pl. XLV) reproduces contemporary Etruscan architecture. Here is a colonnade of square pillars with Ionic capitals, and behind it, a façade of arches. If this scene does, as suggested in chapter vii, represent a gladiatorial combat in the forum of some Etruscan town, the town had all the elegance of Rome.

At Roselle, remains of a large Hellenistic building of uncertain type have been partly excavated, under the south entrance to the little Roman amphitheatre that crowns one of its two hills. Parts of at least two large buildings have also been found at Tarquinia, but their purpose cannot be deduced from what remains of their foundations.

Temples are common—there seems to have been an enormous amount of temple building in central Italy in the last three centuries B.C.—though apart from their terracotta decorations, not much remains of most of them. The first building of the temple at Fiesole, which was rebuilt at a higher level late in the first century B.C., has recently been excavated and is securely dated in the first years of the third century B.C. It was built on a terrace made by leveling and filling the rocky slope so that the front would rise about 2.50 meters above the original ground level, while the back would rest on the rock itself, which was, in fact, cut away here, leaving a space behind for the water from the hillside to run off.

THE ETRUSCANS

The ground plan of the temple is a rectangle, 17.20 meters by 13.45 meters, with a single central cella and two broad alae whose outer walls extend to the front of the temple and terminate in antae, between which must have stood a pair of columns. The walls were built of coursed rubble with a fill of tile and stones and are preserved in places to a height of 2.20 meters (7 feet), demonstrating triumphantly that by this period not all Etruscan temples were built with walls of sun-dried brick. Though the proportions of the plan correspond quite closely to those prescribed by Vitruvius—the width being roughly five-sixths of the length and the length of the cella almost exactly half the total length of the temple—the general effect of this building would have been very unlike that of a building made according to the Vitruvian canon. Instead of a clear division between the two parts, the rear enclosed, the front open and filled with columns, this temple had side walls that projected to the line of the façade and had only a single pair of columns between them, so that pronaos and alae together make a clear space surrounding the little cella on three sides. Such an arrangement has been found nowhere else in Etruria, but this is the only temple north of Orvieto whose foundations have been excavated and practically the only one whose foundations have even been discovered. Possibly this is the normal northern Etruscan plan, while Vitruvius' Tuscan temple is based on southern Etruscan and Latin architecture.

The ground plan of a little shrine at Bolsena does seem to have interesting resemblances to that of the Fiesole temple. The outer walls enclose a rectangle broader than it is long, 17.30 meters by 13.40 meters, but the space enclosed was not roofed, only the central cella being covered, as the roof tiles and terracotta decorations which have been found prove. There were no columns in front of the cella; in this, it is like the Archaic temple on the Piazza d'Armi at Veii, though the proportions of the Bolsena shrine are shorter and broader and, in fact, normal for the cella of a Tuscan temple. The terracotta revetments found with this shrine are Hellenistic, and a series of five beautiful antefixes in Florence once ornamented it, probably filling its open pediment; they represent groups of gods and heroes; the best

preserved shows Minerva and a headless female figure named Cilens, their names inscribed on the plinth under their feet.

It may be that such shrines as this at Bolsena, in which a single cella without columns is backed against the center of one of its precinct walls and encloses an ample open space around the front and sides of the shrine, are the ancestors of temples such as Fiesole's, with its broad, empty pronaos and alae. To make a temple of the shrine and its temenos, the Etruscan architect would have to increase the height of the precinct walls and roof the whole area, instead of just the cella. Though this suggestion cannot be taken as proved, the possibility is well worth bearing in mind.

The so-called Ara della Regina at Tarquinia is the foundation of another Hellenistic temple, raised on a handsome terrace 77.15 meters long by 35.55 meters wide. This terrace was originally bordered by a characteristic hourglass molding and approached from the east by a broad flight of steps. The temple was set on it, not squarely in the center but nearer the north wall, so that there was a broad paved space to the south. The temple itself seems to have had a single cella and alae (the foundations are incomplete and confused by rebuilding), but it was longer and narrower than was specified in the Vitruvian canon; the outer walls of the alae extended to the front of the temple, as at Fiesole, but two pairs of columns were in line with the cella walls in the pronaos. The splendid terracotta relief of two winged horses, in the Tarquinia museum, was part of the pedimental decoration of this temple.

Cosa, the Latin colony, is again our best evidence for the types of temples preferred by Hellenistic Rome. The proportions and remains of its Capitolium fit the Vitruvian canon to admiration, except that the first and last columns of the inner row in the pronaos are replaced by antae (Fig. 3). The foundations of three smaller temples have also been excavated there. Each consists of a single cella, without alae but with a deep pronaos and a façade of two or four columns, as if it were the central block of a triple-cella temple (Fig. 4). This plan is particularly popular in Latium and at Rome, where the oldest datable example is the Temple of Castor, built in 484 B.C. Temples of

this type stand on a podium, a raised platform neatly conforming to the size of the temple and approached at one end by a flight of steps. Apparently the podium, an essential feature of Roman imperial temples, was a Latin contribution rather than Etruscan; at any rate, neither the large "Vitruvian" temples of Veii, Pyrgi, Marzabotto, and Orvieto nor the early sixth-century temple in the Piazza d'Armi at Veii and the small shrine at Bolsena have podia, and the raised platforms on which the Hellenistic temples at Fiesole and Tarquinia are built are terraces which have an area considerably larger than that of the temple.

Houses. Vitruvius, in his sixth book, describes at length the town house that he considers suitable for a Roman gentleman, which should have enough land in addition to provide at least a city garden. Such houses as he describes are best known from Pompeii. The focus of this house is the cavum aedium (the hollow of the house), sometimes also called the atrium; this was a central room of spacious and lofty proportions, covered with a roof which might, but need not, have a central opening with a rectangular basin sunk in the floor under it to catch the rain from the roof. At right angles to the major axis of this hall open two other lofty rooms, the alae, extensions of the atrium rather than separate apartments, since they are open to it their whole width and height. In the center of the back wall of the atrium, a third large room, the tablinum, opens to its full width and height. By a passage one could reach the rooms in the house which faced toward the garden behind; the smaller rooms with doors, along the sides of the atrium, could be used for sleeping and storage, while the rooms to the right and left of the front door could be opened inward to the atrium or be entirely closed off from the family part of the house and thriftily rented out as shops.

In Vitruvius' mind, an atrium house needed all these component parts—atrium, alae, and tablinum—forming a cross with the atrium as the nave, the alae as transepts, and the tablinum as the chancel. The cross was filled in to a rectangle by the cubicula, the bedrooms along the sides of the atrium; the front rooms or shops on either side of the fauces, the narrow passage from front door to atrium; and

the triclinia, or dining rooms, in the corners between the alae and tablinum, facing toward the garden behind the house, which had a Greek peristyle. This is a fine, neat axial plan; and as one can see in Pompeii, it makes a most attractive house.

Varro (*L.L.* 5.161) defines and explains the term cavum aedium as "the roofed place within the house walls which is left open for the use of everyone"; evidently this was the hall in which the house-holder's clients waited around for him in the morning. It could be completely roofed, in which case it was called testudinate, from the likeness to a tortoise shell. Vitruvius also mentions the testudinate atrium; it seems to have had a pitched roof with a rooftree running the length of the house, as in the old Latin tradition of the hut urns (Pl. I). But both Varro and Vitruvius were more used to the atrium with skylight and catch basin, compluvium and impluvium; and one form of the impluviate cavum aedium was called Tuscan and, Varro says, was copied from the Etruscans by the Romans. According to Varro, the word "atrium" itself, which Vitruvius uses as a synonym for cavum aedium, was taken from the Etruscan town of Atria (Adria), from which the Romans took the model as well.

Vitruvius' Tuscan atrium has a roof supported on two heavy beams running the length of the room; these frame the long sides of the compluvium; the short sides are marked by beams hung between the main beams, and from this rectangle the roof slopes upward and out in four directions. There are no columns at the corners of the im-pluvium to support the frame of the compluvium, as there are in Vitruvius' other types of atrium. The heavy woodwork of such a ceil-ing certainly sounds like the Etruscans; their fondness for great wooden beams as decorative, as well as structural, elements has been illustrated more than once (Pls. XVI*b* and XXXVI). But if they really did invent this type of atrium, when did they do so?

The testudinate atrium with hip or gable roof and no skylight may have been invented at any age, as soon as life became complicated enough to demand different rooms for different purposes, given a strong natural bent toward axial planning. In a house of this kind, the chief function of the alae must have been to supply light to the

central room, since only they reached the outside walls of the house, where they could be provided with windows. Even so, even leaving the front door open and opening the window in the back wall of the tablinum, the cavum aedium would still be somewhat shadowy—the cave and hollow of the house.

But the impluviate atrium is something else again. It is designed for a city house whose side walls are party walls and cannot normally have windows; the compluvium admits light to the atrium, but still more significantly, as its name shows, it admits rain, which is carefully collected in a catch basin, from which it drains into a cistern under the house. It is the water supply for the household, and its storage in a cistern implies knowledge of vaulting and hydraulic cement. But this knowledge does not appear in Italy, so far as we know, before the second half of the third century B.C.

Cosa gives us, again, our evidence for the earliest use of vaulted cisterns and the oldest securely dated house with a Tuscan atrium. The limestone hill on which the city is built is without natural springs. Even wells were apparently impractical there; the excavators have found none, but there is, instead, a carefully built and maintained cistern near, or under, every public building in the town. The earliest, which must have been built when the city was first founded, is a huge open tank which caught the runoff from the slopes of the arx in the direction of the forum. The next, apparently, was a narrower rectangle which could be roofed with wood; it lay along the northeast side of the forum near the comitium, and within a few years of its original construction it was rebuilt with a vaulted roof. From then on, all the cisterns in Cosa were vaulted, and their builders had no nervous qualms about putting these under, rather than in front of, their buildings.

The impluviate house is a phenomenon of the Hellenistic period, the result of city crowding which would have made wells in courtyards injudicious, even if there had been an opportunity for them, and would also have forbidden the exterior catch basins and tanks needed to collect the rain from the eaves of a testudinate roof. In order to have clean, uncontaminated water available, the slope of the roof was

reversed, dumping the rain into the center of the house; and it was stored under the house in a vaulted cistern from which it could be drawn in buckets as needed.

The atrium house at Cosa, built about the beginning of the second century B.C., has a Tuscan atrium with a rectangular compluvium and vaulted cistern. Though it has the canonical alae of the Vitruvian atrium house, it has no tablinum, and there is no provision for a kitchen in its original form. It was evidently not a private dwelling but an Atrium Publicum, a series of offices opening onto the forum.

There is a little house of the late republican period with a Tuscan atrium at Vetulonia; apart from the Atrium Publicum at Cosa, this is so far the only atrium house known in Etruria. However, the plan of such a house is reproduced in one Hellenistic tomb, the Tomb of the Volumnii at Perugia. This tomb, variously dated but most plausibly in the second half of the second century B.C., is carved out of the yellowish sandstone of the region. A steep flight of steps leads to a small vestibule that opens onto a long, rectangular room with a high-pitched gable roof, the atrium. At the far end, an alcove, the tablinum, opens off this central room; its door measures almost its full width and is as high as the flat cornice under the gable of the atrium. To left and right, the alae are entered by high, broad doorways; and from each ala another room, in line with the tablinum, can be reached; while on either side of the atrium, between the alae and the front wall, two smaller doorways lead to the cubicula. The roofing, however, is not as satisfactorily consistent as the ground plan. The steeply pitched gable roof of the central room should make it a testudinate atrium, but each of the smaller rooms has a separate roof of its own; those of the tablinum and alae are flat and ornamented with a single elaborate coffer in the center of which is a head in high relief. Possibly these could be taken for ceilings, but the cubicula have separate gable roofs at right angles to the gable of the main room. This would be impossible in a house but is characteristic of all the multichambered tombs of Cerveteri, Vulci, and Chiusi (see above). In this respect, the Tomb of the Volumnii continues the tradition of the tomb with a central chamber and many side rooms, such as

the Casuccini Tomb at Chiusi (Pl. XXXVI) or the François Tomb at Vulci, and does not faithfully reproduce a Hellenistic house.

Where does this leave us? Varro claims that a certain kind of cavum aedium was called Tuscan by the Romans, who imitated Etruscan examples of it; Vitruvius describes a Tuscan cavium aedium, or atrium, as one whose roof and compluvium are supported by heavy beams without columns. The heavily beamed ceiling certainly corresponds to Etruscan taste, and the only actual atria so far found in Etruria are of the Tuscan type, without columns. Neither Varro nor Vitruvius suggests that the atrium house itself—a house with a central public room from which open alae, tablinum, and smaller private rooms—or the impluviate house was invented in Etruria. There is no evidence for a house with this central room and axial plan in Etruria before the Hellenistic period, though the testudinate atrium could have been designed at any time from the late Archaic period on. It looks as though Vitruvius' atrium house was not originally Etruscan, as though the impluviate house was invented somewhere in central Italy during the third century (it never appears outside Italy, not even in Sicily), and as though one form of compluvium was created by the Etruscans, in that century or the next, to suit their own taste in wooden architecture.

Tombs. The Tomb of the Volumnii, described above, is virtually the only Hellenistic example of a tomb with a central chamber from which open a number of smaller rooms. The normal Hellenistic type has a single, very large chamber whose roof is supported by a central pillar, a plan which had become popular in the fourth century.

At Cerveteri, one of the most interesting tombs of this type is the Tomb of the Reliefs. An almost square chamber is given a low, gabled ceiling with a very broad ridge beam and sloping rafters. The walls are pierced by a row of rectangular niches; at the right end of each are carved two cushions for the heads of the dead, whose bodies were laid in the niches as on funeral couches. Below the niches a bench runs around three sides of the room, deep enough to hold the bodies of the less important members of the family at right angles to the wall. Two square pillars with four-sided Aeolic capitals support the roof, rising from the bench to the rafters, not as they would have been placed in the

wooden building this pretends to be, but as genuine supports for the tufa roof of the chamber. The walls above and between the niches and the sides of the pillars are decorated with objects carved in low relief or modeled in stucco—helmets and greaves, like those on the ends of the ash urn in Worcester (Pl. XLV); shields and swords; a lady's fan, like that of Ramtha Viśnai from Vulci (Pl. XLIII); drinking cups; jugs; an ax; a butcher knife; a coil of rope; the family dog; a pet goose. The paint is still preserved on these reliefs and adds to the lively effect of the decoration.

The Tomb of the Typhon at Tarquinia, whose fine Hellenistic paintings have been mentioned above (chap. vii), is another of this type, with a huge room whose roof is supported by a central pillar and a broad bench along the walls. The latest tombs of this type, at Volterra, for example, show no interest in architectural ornament or painted decoration. The Inghirami Tomb, now reconstructed in the garden of the museum at Florence, was simply a circular room with a rough ceiling propped by a central pillar and a bench running round the walls, on which were placed the ash urns of the Atria family, for whom this tomb was made.

At Chiusi, many Hellenistic tombs were simply a single, rectangular room, reached by a long dromos in whose walls were niches to hold the ash urns of the lesser, or younger, members of the family, while the room at the end was reserved for the head of the house and his immediate family. Another type of chamber tomb at Chiusi is a single, rectangular room built of travertine blocks and roofed with a plain barrel vault. These are the earliest true vaults in Etruria and, unfortunately, cannot be dated exactly, though all their furnishings are Hellenistic and apparently of the second century rather than earlier. A similar tomb has been found near Perugia. The type was very popular in Hellenistic Greece and appears in the Greek cities of Cumae and Naples in Campania; presumably the pattern for the tombs at Chiusi and Perugia came from there.

In the cliff cities of the Marta and Fiora valleys, the archaic die tombs and their imitations, whose façades alone were carved on the face of the cliffs, continued through the Classical period and into the Hellenistic.

Occasionally, instead of being carved to resemble the façade of a flat-topped die tomb, the cliff face was made to represent a little building with a gable roof and a single central doorway, quite possibly a small house. Sometimes these gabled buildings are two-storied with a colonnaded loggia over the door, as in some second-century houses at Pompeii. At Norchia, two of the cliff tombs have the façades of Doric temples, prostyle, with two columns between antae. The architrave is plain; above it runs a triglyph frieze, with heads decorating the metopes; and above this, a row of dentils. The pediments have a closed tympanum in the Greek style and are filled with sculpture; a band of strigils follows the line of the raking cornice. These strigils imitate the terracotta gutters of a Hellenistic Etruscan temple, but otherwise the façades are those of stone temples with stone entablatures and pediments. The combination of triglyphs and dentils is not early; it appears on the frieze supported by Ionic pilasters shown on the ash urn in Worcester (Pl. XLV), of the mid-second century; and it decorates the podium of the large hall in the lower sanctuary of the Temple of Fortuna at Praeneste, also of the second century. The earliest dated example in the Greek world is the upper frieze of the colonnade of the Temple of Athena at Pergamum, which dates from the second century, too.

There is another temple-tomb in the cliff city of Sovana, the Hildebrand Tomb. Badly ruined and buried in underbrush and vines, it represents a hexastyle temple with a central cella and alae. The columns stand four deep along the sides of the temple on the line of the outer walls; they are fluted, unlike most Etruscan columns, and have Corinthian capitals; between the volutes, a head rises from a base of acanthus leaves, a beautiful type of capital which the Etruscans took from southern Italy in the second century B.C. This temple-tomb stands on a podium 3.30 meters high, with a molded base and cornice not unlike the podium of the Capitolium at Cosa. This tomb, like the temple-tombs at Norchia, gives us some idea of Hellenistic stone temple architecture in Etruria—more Greek than Etruscan in detail, but not precisely Greek, either. Clearly, by the second century, the architecture of Etruria, like that of Rome, was strongly Hellenized but vigorous

enough to adapt Hellenistic Greek details to its own forms and pur-
poses.

But with the second century, the vigor of Etruria departed. The city
gates of Perugia, the temple-tombs of Norchia and Sovana, and the ele-
gant arcades and entablature of the Worcester urn (Pl. XLV) are full
of promise. But the Social War changed all that; while Rome went
striding forward, Etruria sank back into architectural apathy, which
was the coma before the death of the Etruscan name.

Language and Literature
Music and Games

Scholars cannot yet translate the language spoken in Etruria in historic times. They can read and pronounce it, or what is left of it, because the Etruscans used a Greek alphabet, but the language itself was, as we have seen, non-Indo-European and probably connected with certain pre-Hellenic languages of the eastern Mediterranean, Cretan and Carian, for example. A related language was still used on Lemnos in the Archaic period, as the inscription on the stele from Caminia proves (see Introduction), but the language of the Lemnian inscription is as indecipherable as the Etruscan and can give no help in translating it.

THE LANGUAGE

To decipher Etruscan, a long, bilingual inscription like the Rosetta Stone, which solved the riddle of the Egyptian language, would be invaluable; but no such convenience has yet come to light. We have a few bilingual inscriptions from Etruria, epitaphs of the Hellenistic period, but they are too short to be of much use, though even they have added certain single words to our pitiful Etruscan vocabulary, for example, *lautni,* "freedman" and *etera,* "slave." We know the meaning of some other words, thanks to glosses supplied by Greek and Latin writers:

aisar, "gods" (Suet. *Aug.* 97); *capys,* "falcon" (Serv. *Aen.* 10.145); *cassis,* "helmet" (Isid. 18.14). Other words can be understood from their context; inscriptions on the sarcophagi in family tombs supply the words for "wife," *puia;* "son," *clan;* "daughter," *sech.* The Etruscan word for "actor" (mummer?), *phersu,* is painted beside the figure of a masked dancer in a tomb at Tarquinia; it seems to be related to the Latin word for "mask," *persona.* If *persona* is derived from *phersu* (and not vice versa, a distinct possibility) the English word "person" may be counted a legacy from the Etruscans.

THE ALPHABET

The earliest Etruscan inscriptions appear in the great Orientalizing tombs of the mid-seventh century (see chap. iii and Pl. XIV*b*). The alphabet, which is carved from right to left in particularly neat, clear letters on the frame of an ivory writing tablet found in the Circle of the Ivories at Marsiliana d'Albegna, now in Florence, contained the twenty-two letters of the Phoenician alphabet, in order, plus the four letters first added by the Greeks. The forms of the letters of the Marsiliana alphabet are Chalcidian, like the alphabet of Cumae, but the Etruscan alphabet includes san, which was not used at Cumae, as well as sigma, though no Greek alphabet uses both san (*ś*) and sigma (*s*). The Etruscans also used koppa (*q*) as well as kappa (*k*) and their gamma (*g*) was written like the Corinthian gamma (*c*) and pronounced like our hard *c,* as it was by the Romans, who learned their letters from Etruria. Evidently the Etruscan speech bristled with clicks and hisses, and evidently the Etruscan alphabet was, as Rhys Carpenter put it, "an artificial construction borrowing from more than one Greek source."

Four letters which appear in the seventh-century alphabets—beta (*b*), delta (*d*), omicron (*o*), and the Phoenician samech (*ks*)—were never used in inscriptions in Etruria proper, though the first three were used at Rome and are therefore still used by us; samech was used in Etruscan Campania, and omicron appears on a bilingual inscription from Pesaro in Picenum. Etruscan *o*'s were *u*'s, and their *b*'s and *d*'s, unlike the Romans', had become *v*'s and *th*'s, as in modern Greek.

By the end of the sixth century, Etruscan alphabets no longer include

THE ETRUSCAN ALPHABET

IVORY TABLET FROM MARSILIANA, MID-SEVENTH CENTURY B.C.

Etruscan Alphabet	Greek Names of Letters	Modern Equivalents
A	alpha	a
B	beta	(b)
ꓶ	gamma	c (k)
◁	delta	(d)
Ⅎ	epsilon	e
Ⅎ	digamma	v
I	zeta	z
⊟	eta	h
⊗	theta	th
I	iota	i
K	kappa	k
↲	lambda	l
M	mu	m
Ψ	nu	n
⊞	ksi (samech)	(s)
O	omicron	(o)
ꓶ	pi	p
M	san	ś
ϙ	koppa	q
ꓷ	rho	r
⌇	sigma	s
T	tau	t
↲	upsilon	u
X	ksi	s
Φ	phi	ph
Ψ	chi	ch

the unused letters, but they have added a new letter, pronounced *f*, for which they apparently borrowed a Lydian symbol, 𝟾 , though we do not know if this symbol had the same phonetic value in Lydia. The Oscans of Campania, who had also learned their letters from Etruria, by way of Capua, borrowed this figure-eight *f;* but the Romans used the digamma, which Greece and Etruria pronounced *v,* for the sound *f*. Incidentally, this Lydian symbol in the Etruscan alphabet is not evidence that the Etruscans originally came from Lydia; they had been writing inscriptions for over a hundred years before it appears, and it apparently arrived in Etruria as another refugee from the overthrow of the Eastern kingdom of Lydia by Cyrus the Great (see chap. v).

A black-glazed cup from Bomarzo, of the third century, shows an alphabet whose letters are reduced to twenty, kappa and koppa having dropped out. This alphabet continued in use as long as inscriptions were written in Etruscan.

INSCRIPTIONS

Perhaps as many as ten thousand Etruscan inscriptions have been found, most of them from Etruria itself or Campania. Few, however, repay much study; and altogether they provide us with scarcely one thousand Etruscan words. The longest text, now in Zagreb, written on the linen wrappings of an Egyptian mummy of the Ptolemaic period, contains 1185 words but with so many repetitions that its total vocabulary numbers only 530 words. Many inscriptions consist of a single word or a mere fragment of a word, and at least 80 per cent of the whole number are funerary, carved or painted on the walls of tombs, sarcophagi (Pl. XLIII), or ash urns; and these seldom contain more than proper names and designations of family relationships.

In addition to the funerary inscriptions, there is a group of religious character, of which the linen mummy wrapping is the most interesting. It was originally a true *liber linteus*, a manuscript written on a linen roll, like the lists of magistrates kept in the Temple of Juno Moneta at Rome (Liv. 4.7, 20). It seems to contain a series of liturgical formulas like those on the bronze tablets from Iguvium in Umbria, and how it came to Egypt and why it was re-used as a mummy wrapping are

pleasant subjects for speculation. Another long ritual text is inscribed on a tile found at Capua in Campania, and a stone cippus from Perugia, apparently a boundary marker, has an inscription of 46 lines and 130 words. A flat, leaf-shaped lead plaque from Magliano, in the valley of the Albegna, carries an inscription on either side, spiraling inward toward the center; this also seems to be a ritual text.

There are also many votive inscriptions, cut on bronze figurines and other ex-votos dedicated at the sanctuaries of the gods. So many of these begin "*mi fleres*. . . ." that one must suppose that *fleres* means "offering." Objects in tombs are often inscribed with the single word "*suthina*," and this suggests that *suthina* should be translated "funeral gift," or something of the sort. In both cases, the interpretation is arrived at from the context.

Actually this is the surest and most satisfactory method of attack, if a slow one, with the material we have at present. In Italy it is called the "combinatory" method and proceeds by comparing the various inscriptions of a particular type with one another. Thanks to this, not only can some hundred words be translated with reasonable assurance, but some of the elements of Etruscan grammar have been made out.

Translations from context, of course, have their limitations. *Zilath,* for example, is clearly a title and apparently that of an important magistrate. The sarcophagi of men with this title, always wealthy burials, sometimes show them wearing a toga and standing in a two-horse chariot, accompanied by lictors carrying fasces and other attendants and musicians. The lictors and the trumpeters were symbols of high office at Rome, and tradition said that they had been taken by Rome from the Etruscans. *Zilath* is therefore, reasonably enough, translated "praetor." But did every city have its *Zilath?* The word appears only in the territory of Tarquinia, but similar reliefs are carved on ash urns from Volterra, and one may wonder if the bearded man in the toga, shown mounting his biga and attended by a trumpeter, on one end of the sarcophagus from Vulci, (Pl. XLIV*b*) was not the same kind of magistrate, whether the Vulcians called him "*Zilath*" or not.

More exasperating is the case of the Tuscania dice. High-born Etrus-

Language and Literature, Music and Games

can ladies from the days of Larthia of Cerveteri (see chap. iii) were accustomed to take one or more pair of dice with them to the tomb. Etruscan dice are generally larger than those we use now but otherwise very similar, except for a pair inscribed *mach, zal, thu, huth, ci, sa*— evidently the numbers 1, 2, 3, 4, 5, 6, but which is which?

One class of Etruscan inscriptions is really satisfactory, the labels attached to the characters in mythological scenes on Etruscan mirrors of the Classical period. Generally the scenes represent recognizable Greek myths, and when the actors in these scenes are named, we can read the names. This was, indeed, the first step toward deciphering the Etruscan language: Helen and Paris appear as Elinai and Alcsentre (Alexandros); Menelaus is Menle; Apollo, Artemis, and Hercules are Aplu, Aritimi (or Artumes), and Hercle. The Etruscans, in short, used the letters of their alphabet for the same sounds that the Greeks did, though they evidently pronounced their Greek rather oddly. But often the identifiable divinities on the mirrors do not have Greek names, no matter how mispronounced: Hermes is Turms; Dionysus is Fufluns, which may be deformed Greek; but Zeus is Tinia; and Aphrodite, Turan. These are not Greek names at all, but the Etruscan names of divinities identified, at least in the Classical period, with their Greek equivalents.

The name Turan is particularly interesting linguistically; it is very likely related to the non-Greek (probably Lydian) word *turannos*, "lord, or prince." Turan, then, is the lady, the queen, the Great Goddess, and the very name Tyrsenoi may mean "the People of the Great Goddess."

Real progress has been made in the deciphering of Etruscan; excavations will undoubtedly reveal other inscriptions, and when the excavators turn their attention to the cities of Etruria rather than her cemeteries, they may at last find that informative bilingual inscription with whose help the riddle of the language will be solved. But we cannot hope ever to know Etruscan literature at first hand, and what little we know of it from references in Latin writers must leave us puzzled and dissatisfied.

THE ETRUSCANS

LITERATURE AND MYTHOLOGY

Livy (9.36) knew of a tradition that in the fourth century B.C. Roman boys had been taught to read Etruscan as they were taught to read Greek in his day, which presupposes that there was an Etruscan literature at that time, appreciably earlier, it may be noted, than there was any such thing as Roman literature; but unfortunately the only Etruscan books that really seem to have interested the Romans were the volumes of religious lore that made up the Disciplina Etrusca (see chap. x). These were divided into three main groups, the Libri Haruspicini and the Libri Fulgurales, which dealt, respectively, with divination by examination of the liver of the sacrificial animal and divination by the observation of thunder and lightning, and the Libri Rituales, which included: (*a*) the formulas for worship of the gods (the Zagreb linen roll was a fragment of one of these); (*b*) the measurement of land and the foundations of cities and temples; and (*c*) the measurement of time, which included man's allotted years on earth and the span of time allowed to the Etruscan name itself. Many of these books were translated into Latin during the late republic, some by a Tarquitius Priscus, cited as an authority by Pliny the Elder.

Varro, the great Roman antiquarian, a contemporary of Cicero, mentioned Tuscan tragedies written by one Volnius, of unknown date (*L.L.* 5.55); he also had access to Etruscan histories (Censor. 17.6) and Etruscan fables (Plin. 36.11.93). These are the only forms of literature attributed to the Etruscans, and the emphasis on the formulaic and chronological is what we might expect from a people steeped, as we know them to have been, in tradition and ritual. Every nation in the world has its fables; every nation with a written language has its histories, but the books of the Disciplina Etrusca were apparently the outstanding literary contribution of Etruria to the rest of the ancient world.

The tragedies of Volnius are a different matter. Tragedy is a highly complex literary form which came to Rome from Magna Graecia in the third century B.C. We know nothing of the Etruscan tragedies beyond Varro's statement that it was Volnius who said that the names of the three original Roman tribes—Ramnes, Titienses, and Luceres—were

Etruscan. But this suggests strongly that his tragedies were a sort of *fabulae togatae*, chronicle plays, and that some, at least, dealt with Roman subjects, the stories of the early kings of Rome and their relations with Etruria. In this case, we might conclude that they were rather late literary productions, written when Etruria was strongly under the influence of Roman culture, perhaps contemporary with the first great wave of dramatic writing at Rome, and are not earlier than the last quarter of the third century B.C. However, we have evidence that Etruria had her stories of Rome and the Etruscans at least one hundred years earlier than that: the walls of the François Tomb at Vulci, of the fourth century, are painted with a number of scenes from Greek legends—commonplaces of Etruscan funerary art—but among them is a scene showing the hero Macstrna (Mastarna) rescuing his friend Caile Vipinas (Caeles Vibenna), while Avle Vipinas (Aulus Vibenna) and his companions attack, among others, Cneve Tarchunies Rumach (Gnaeus Tarquinius, the Roman). There is no way of telling, of course, whether this scene came from an early Etruscan play; rather, it may be an episode from the Etruscans' history of Rome, which the Romans conveniently forgot.

We happen to know one other episode from the life of the Vibenna brothers, thanks to its illustration on a third-century Etruscan mirror from Bolsena and on three ash urns from Chiusi. The mirror is inscribed with the name of the protagonists: *Cacu,* a young hero, half-nude and with the flowing curls and the lyre of Apollo, sits in the middle of the scene; a boy, *Artile,* sits on the ground beside him with a book on his knees. Behind them is a great rock over which a satyr peers, while armed warriors, *Caile* and *Avle Vipinas,* creep up on either side. On the ash urns the rock is replaced by a tree under which a horse stands waiting; the scene takes place, in either case, in the wilderness, as the hunter's boots worn by the Vibenna brothers also indicate. On two of the ash urns, a middle-aged man (Artile?) sits at Cacu's feet; he has a small servant, and there are subsidiary figures in the corners, who have nothing to do with the plot.

Cacu is a seer—hence his Apollinian appearance—and his home is among rocks and trees; Artile, traveling on horseback with a single

servant on foot, seeks him out to find the answer to some question. The answer seems to fill him with melancholy; perhaps it is a prophetic warning that the Vibenna brothers are on his trail and have even now overtaken him.

There is a story in Solinus (1.8) about a certain Cacus who was sent with a Phrygian companion, Megales, as an envoy to Tarchon the Tyrrhenian by Marsyas, the Phrygian king of the Marsi in central Italy. Tarchon imprisoned Cacus, but he escaped and returned whence he had come and with the help of a great host founded a kingdom for himself on the Volturnus in Campania, but because he had dared to lay hands on territory belonging by rights to the Arcadians, he was overthrown by Hercules. Megales fled to the Sabines, who gave him refuge and learned the science of augury from him. A fine mishmash, but it has a number of suggestive points. The tradition that the satyr Marsyas fled to Italy and became king of the Marsi after his defeat in the musical contest between his pipes and the lyre of Apollo is mentioned by a number of authors (Plin. 3.12.108; Sol. 2.6; Sil. 8.503–4). The tradition that the art of divination by the flight of birds (augury) came to Italy from Phrygia is mentioned by Servius (*Aen.* 3.359), as it is implied here in the episode of the Phrygian Megales and the Sabines. If Megales was a seer, it may be that Cacus was one, too; in which case, it is possible that the scenes on the ash urns and mirror actually illustrate the story in Solinus: Cacus and Artile (Megales?) are being arrested by the Vibenna brothers, acting for the Tyrrhenian Tarchon. The Cacus of Solinus seems also to be connected with the Cacus of Virgil, who attacked the property of the Arcadians (Evander) and was suppressed by Hercules. Virgil makes his Cacus a fire-breathing demon; in Livy (1.7) he is merely a powerful robber. The original story is really unrecoverable, but it seems to have dealt with hostility between a prince of Campania (Cacus) and the Etruscans of Tarquinia (of which city Tarchon is the eponymous hero) in which the Latins of Rome were involved, probably because the land route from Etruria to Campania crossed the Tiber at that point.

Another Etruscan story referred to by Pliny in his account of the behavior of thunderbolts (2.54.140) seems to be illustrated on three

other ash urns, two from Perugia, the third from Volterra. Pliny says: "There is a tradition in the annals that thunderbolts can be constrained or summoned by certain rites and prayers. An old story in Etruria says that one was summoned when a monster which they called [an?] Olta attacked the city of Volsinii, having already devastated its fields; the thunderbolt was summoned by their king Porsina. . . ." That is to say, the king had the power to call a thunderbolt to help him by destroying the monster that was menacing his city. The urns show a monster, wolflike, or with a wolf's head, or, in one case, a young man wearing a wolf's cap, being thrust down a well by a crowd of men. The well kerb, or puteal, within whose circle the monster struggles, is like those ritual puteals built by the Romans to mark spots that had been struck by lightning. Whether Porsina of Volsinii was the same king as Porsenna of Clusium we do not know.

Other ash urns may illustrate still another Etruscan story; they show a battle scene in which a nude youth brandishing a plow beats back a crowd of armed men. The importance of the plow in Etruscan ritual (see chap. x) should be kept in mind.

The three stories illustrated on these urns—always supposing them to have been properly interpreted—are all connected closely with Etruscan religious belief and practice: Cacus, the seer who sings his prophecy; Porsina, the king who can command thunderbolts; and the youth who needs only the sacred plow for his weapon.

The most frequently cited of all Etruscan legends, one that is fundamental to Etruscan religious belief, is the story of Tages. This was a wonderful child who sprang from a furrow turned by a plowshare in the fields of Tarquinia and sang the lore of the Disciplina Etrusca to the Lucumones of the twelve cities of Etruria, as they gathered round him to record his words (Cic. *Div.* 2.23; Censor. 4.13). Thereafter, Tages fell back dead and was seen no more (Isid. 8.9.34–35). Some traditions said that he had the appearance of a child but the wisdom of an old man; others, that the child was born with all his teeth and his face was that of a mature man. In one report, he was the son of Genius and grandson of Jupiter; in one late version, it was the haruspex Tarchon of Tarquinia who wrote down the words of Tages, in a sequence

of questions and answers. The myth seems to be illustrated on a number of Etruscan gems of the fifth century on which a man is shown writing down on tablets the words of a head that rises from the ground. The scene is borrowed from Greek illustrations of the legend of the miraculous prophecies sung by the head of Orpheus after he had been killed by the Thracian women.

The Etruscans had stories about their gods, too, that are not the same as those of Greece; on an Archaic scarab from the Clusine territory, a winged goddess is shown carrying a young, beardless male figure in her arms, a group borrowed directly from Greek representations of Eos and her dead son Memnon; but the Etruscan figures are inscribed *Tinias* and *Turan;* the Great Goddess, whom the Etruscans identified with Aphrodite, is carrying the body of a god whom they, at least in the Classical period, identified with Zeus. The immortal goddess and the dying god are a characteristically Eastern pair; on Crete, Zeus himself was a dying god, a legacy from pre-Greek beliefs which this gem suggests were paralleled in Etruscan belief. Zeus was also a child-god on Crete, and it has been conjectured that this was also true of the Etruscan Tinia; if so, a terracotta group of a winged goddess carrying a child, an acroterion from Cerveteri, now in Berlin, may represent Turan and her son Tinia rather than Eos carrying Cephalus, as this group is generally identified; and the splendid terracotta group of a woman and child from Veii may represent these gods, too.

Maris (Mars) appears on a few mirrors as a child-god, or rather, a plurality of child-gods with various added names—Maris Isminthians, Maris Husrnana, Maris Thalna—fostered by Minerva, who is shown apparently bathing one of them in a pot of magic fire to preserve him from the underworld, as Demeter bathed the little prince at Eleusis. Hercle (Hercules) is also associated with children; in one scene he presents a winged child, Epeur, to Tinia, who is enthroned like the Zeus of Phidias; Turan and another goddess, Thalna, who appears to be almost the double of Turan, are enthroned on either side of the central group. In other scenes, the child is not named; once, Hercle and the child are accompanied by Menrva (Minerva) and crowned by a goddess, Munthu, in the presence of Turan. It looks almost as though this were a

family scene—Hercle and Menrva the parents of the unnamed child—
but they are probably here, as not infrequently in Greece and as Miner-
va is with the brood of little Martes, divine protectors and foster parents
rather than actual parents.

Scrappy as these indications are, they do show that the Etruscans
were no more the pedantic copyists of Greek legends and literature than
they were of the other Greek arts. They had their own myths, their own
legends, and their own histories; but we have only a few echoes of them
in Latin writings and a few scenes engraved on mirrors or modeled on
ash urns or painted on the walls of tombs.

One art they seem to have lacked—the art of poetry. We hear no ref-
erence to Etruscan epics, nor to lyric poetry, nor, except for the Volnius
mentioned by Varro, to tragedy. History and traditional stories, as we
said earlier, are perhaps more to be expected of such a people than lyric
poetry, which is essentially individual and subjective; and yet the lack
of reference to any poetry is strange because the Etruscans were famous
musicians.

Music

"Horns and trumpets," says Athenaeus (4.184), "are Etruscan inven-
tions"; and all three Greek tragic poets refer to the "Tyrrhenian sal-
pinx," the war trumpet that the Romans called the tuba and which
they, too, ascribed to the Etruscans (Verg. *Aen.* 8.526; Sil. 2.19; Stat.
Theb. 3.650). At Rome, the trumpet was used not only to sound the
calls for an army in the field (Liv. 2.64) but as one of the insignia of
honor at the triumph of a general and in the pompa circensis (Juv.
10.36–43). According to Strabo (5.C220), this honor, like the bundles
of rods and the axes of the lictors, was taken by Rome from the Etrus-
cans.

Ancient trumpets were of various shapes; on Roman imperial reliefs,
the long straight trumpet with a flaring bell and the great curved
trumpet which is bent into a perfect circle are the most popular, no
doubt because of their aesthetic possibilities. The trumpeter whose head
and shoulders are framed in the circle of his instrument is a favorite
motif, and something very like it was already part of the repertory of

THE ETRUSCANS

Etruscan reliefs in the Classical period, as the handsome trumpeter on the front of a sarcophagus from Vulci shows (Pl. XLIII). A scholium on *Iliad* 18.219 (William Dindorf [ed.], *Scholia graeca in Homeri Iliadem* [Oxford and Leipzig, 1808], VI) speaks of six kinds of trumpet; the bell of the Tyrrhenian trumpet, like the end of the Phrygian pipe, the scholiast says, is bent upward; it is very high-pitched and is called the shrill trumpet. The charioteer's attendant on the Vulci sarcophagus (Pl. XLIV*b*) carries such a trumpet; it looks like a lituus, but the curved bell is joined to the shaft by a short bar, as the crook of the lituus never is.

Etruria was also famous for its pipers. The pipes, auloi in Greek, tibia in Latin, are said to have been invented in Phrygia or Lydia; and the Greeks considered their music more plaintive and emotional than that of the lyre, though the Spartans marched to battle to the sound of the pipes and so did the Corinthians, to judge from a painted frieze on a mid-seventh-century jug, the so-called Chigi vase, found in a tomb at Formello near Veii and now in the Villa Giulia Museum at Rome. The pipe was played from the end, fingered like an oboe or clarinet, and had a reed mouthpiece; it could be played either singly or in pairs, one for each hand. The double pipes were far more popular, and the little Capuan bronze figure in Plate XXVI*a* is playing these. The turbaned men on the situla in Providence (Pl. XXX*b*) are playing the multiple Panpipes, a very different instrument which was not fingered; in Etruria proper, such Panpipes are played only by sileni.

The double pipes are played by the woman leading the wedding procession on an archaic gem in Boston (Pl. XXXIII), and a girl, one of the attendants of the man and wife portrayed on the fourth-century sarcophagus from Vulci (Pl. XLIII), holds a pair of pipes in her hand.

The Etruscans played the pipes for many occasions other than processions; Athenaeus repeats twice that the Etruscans accompanied their boxing matches with the music of the pipes and adds that they kneaded bread and flogged their slaves to this music (Ath. 4.154; 12.518), but to judge from Etruscan paintings and reliefs, the pipes were played most commonly at banquets or as an accompaniment to dancing. In such scenes the piper is often joined by a lyre player, like the two musicians

that flank the great krater on the end wall of the Tomb of the Lionesses at Tarquinia (Pl. XXXIV). The two instruments were sometimes played together in Greece, too; but in Greece the lyre was the solo instrument par excellence, and generally the performer sang to his playing. In Etruria the lyre players do not sing, and in fact you can scarcely find the representation of a singer in all Etruscan art. Even the Orpheus on the fourth-century mirror in Boston (Pl. XLI) is not singing; he is a tight-lipped virtuoso musician.

The only references to Etruscan singing are curious and specific: Tages *sang* the Disciplina Etrusca to the Lucumones of the twelve cities (Censor. 4.13), and the old man of Veii who unwillingly betrayed to the Romans the secret of the Alban Lake (Liv. 5.15) was heard *"singing* after the manner of prophets" (italics mine). Cacu, who holds the lyre of Apollo on the mirror and the ash urns where his story is illustrated, is shown in one instance to be actually singing. One gathers that in Etruria song was the prerogative of the haruspex and the seer. No wonder there was no body of lyric poetry in Etruria.

DANCING

Music was, to the majority of Etruscans, an accompaniment for action rather than words, and most of all for dancing. Livy records (7.2) that in 364 B.C., when Rome was in the grip of a pestilence, stage shows (ludi scaenici) were introduced to that city for the first time, to placate the gods. "Without singing or pantomime, performers from Etruria danced to the music of the pipes, not ungracefully, in the Tuscan mode." The beauty and life of the Tuscan dances is illustrated again and again in the painted tombs of Tarquinia. Usually the dancers were young; boys and girls danced together, often in groups of four or six in the Classical period; their leader was one of the girls, who set the rhythm with a pair of castanets and who wore over her dress a tight jacket sewn with bands of bells. One young man would play the double pipes as he danced; another might play the lyre. They danced in the open, in sight of the sea, among trees hung with garlands. The prettiest of these classical dancers are to be found in the Tomb of the Leopards and the Tomb of the Banquet Couch.

THE ETRUSCANS

There were solo dancers, too, usually women, like the elaborately dressed dancer on the end wall of the Tomb of the Lionesses, whose heavy cloak swings out behind her (Pl. XXXIV) or the girl on the wall of the Tomb of the Monkey at Chiusi, who wears a bell skirt and tight jacket crossed with bells and balances a perfume brazier on her head as she whirls barefoot to the sound of the pipes. *Pas de deux* are less common; the lively young couple in the Tomb of the Lionesses (Pl. XXXIV) has no real counterpart elsewhere, though pairs of dancers do appear among the figures for candelabra of the Classical period. Small bronze figures of dancers, indeed, are not uncommon; sometimes the chief dancer is shown with her castanets and distinctive dress; sometimes a nude boy is dancing to the castanets, or a nude boy or girl is dancing on the banquet table itself. These last presumably must represent slaves. Athenaeus (4.153; 12.517) reports that according to Timaeus the Etruscans were so extravagantly licentious that they were waited on at the table by nude slave girls, but I know no Etruscan illustration of this, and as for nude dancers, there were quite as many in Greece as in Etruria.

GAMES

The dances painted in the tombs of Tarquinia and Chiusi were part of the grave ritual—the funeral games offered to the dead. In the two great ancient descriptions of Greek and Roman funeral games, the games in honor of Patroclus (*Il.* 23) and those for Anchises (*Aen.* 5), there is no mention of dancing; this may have been a specialty of Etruria. As we know from the tomb paintings, the Etruscan games also included horse races, chariot races, boxing, and wrestling matches. Such sports were not always funerary; one is reminded that the first Tarquin introduced horse races and boxers to Rome to celebrate the Ludi Romani, and the Etruscan dancers who came to Rome in 364 B.C. performed at a religious festival. It may be presumed that the games at the Fanum Voltumnae that the king of Veii broke up (Liv. 5.1) consisted of such contests and dances. And it should be noticed that these games were performed by slaves—professionals or at least trained performers —apparently the Etruscans, like the Romans, preferred spectator sports.

Language and Literature, Music and Games

Whether other contests, like that of the two musicians on the situla in Providence (Pl. XXX*b*), were also regular parts of the Etruscan games is uncertain but not unlikely; at Delphi, for example, the games always included musical contests.

Only one part of the funeral games was strictly funerary in character, the gladiatorial contest. According to Livy (summary of Bk. 16), these were first introduced to Rome in 264 B.C., and Athenaeus (4.153) says the Romans took the custom from the Etruscans, though they may have gotten their taste for these shows from the Oscans of Campania, who had gladiatorial fights at their banquets (Liv. 9.40), as Athenaeus says the Romans themselves did (4.153). Nevertheless, at Rome during the republic, gladiatorial shows were given only at funerals. The combat to the death was a blood sacrifice to the dead, like the sacrifice of Polyxena at Achilles' tomb or the slaughter of Trojan prisoners at the tomb of Patroclus; both of these scenes appear on an Etruscan sarcophagus of the fourth century at Orvieto, and the slaughter of the Trojans is painted on one of the walls of the François Tomb at Vulci.

Even under the empire, the funerary origin of these shows was remembered by the Romans; the man who dragged the bodies from the arena was dressed like the underworld god, Dis Pater, and carried the hammer of Charun (Tert. *Apol.* 15). Tertullian's description of gladiatorial shows in which actors were dressed as gods and "danced over human blood and the dirt of capital punishment, supplying plots and subjects for the guilty" (*Apol.* 15), explains a scene painted on the right-hand wall of the Tomb of the Augurs at Tarquinia and on one of the walls of the recently discovered Tomb of the Olympic Games. A man, wearing only a breechclout made of a beast's skin, armed with a club but with his head muffled in a bag, is trying to defend himself from a savage black dog held on a long leash by a demon-masked figure whose name, Phersu, is inscribed beside him. The club suggests that the man is acting out the scene in which Hercules comes to fetch Cerberus from the underworld; his blindfold insures that the darkness of Hades is real to him. The masked actor wears a false beard, a cap with long pointed ears, and a tight jerkin of black spotted with white—evidently the costume of a demon of the underworld. There is no evidence that

the actor impersonating Hercules was expected necessarily to free himself and capture the dog; the dancing Phersu on the opposite wall of the tomb is not the same Phersu as the dog's owner—their costumes are quite different—nor is he, as he is often said to be, running for his life from the man with the club.

Whether the other dances shown on the walls of Etruscan tombs were also mimes of mythological stories remains a subject for speculation.

Religion

OUR knowledge of Etruscan religious beliefs is still lamentably incomplete and, in important matters, inadequate, and any attempt at presenting a picture of the religious life of this people must resemble a patchwork quilt rather than an illuminated manuscript. We know, for example, from Livy (5.1) that the Etruscans were dedicated to religion beyond any other people and more expert in its practices; Dionysius of Halicarnassus tells us (1.30) that the gods worshipped by the Etruscans were not the gods of the Lydians, supposed by most ancient authors to have been their ancestors; Arnobius (*Adv. Nat.* 7.26) contemptuously describes Etruria as the creator and mother of superstition. Other Greek and Roman writers of the late republic and the empire provide a certain amount of information about the official cults of a few Etruscan cities and rather more about the branch of Etruscan religion which most interested the Romans—their art of divination.

In addition to the evidence from literary sources, archaeology offers material which has the advantage of coming from all seven centuries of Etruria's cultural history and coming at first hand, rather than at second hand by way of Rome, from the last period of Etruria's independence or even later. As a commentary on the literary tradition, however, the archaeological evidence is singularly unhelpful. Except for one object of notable interest, the bronze liver found near Piacenza,

archaeology has shed almost no light whatever on the Etruscan science of divination; but, on the other hand, Etruscan burial practices, about which Roman writers seem to have been completely indifferent, have been illustrated in all their enormously complicated variety from the beginnings of Etruscan civilization in central Italy to its disappearance under the all-pervading civilization of the Roman empire. Only in the case of the official cults of the gods does archaeology materially supplement the literary sources.

THE GODS

Occasional references by Roman historians (particularly Livy) and antiquarians indicate some of the chief divinities of a number of Etruscan cities. Thus we know that Juno Regina was the great goddess of Veii, that her priesthood there was hereditary, that her image was brought to Rome from her temple there when Veii was destroyed in 394 B.C., and that to house it, Camillus, the conqueror of Veii, built a new temple on the Aventine which was dedicated in 392 B.C. (Liv. 5.31). An image of Vertumnus, or Vortumnus, whom Varro (*L.L.* 5.46) called "*deus Etruriae princeps*" ("the chief god of Etruria"), was brought to Rome from Volsinii under similar circumstances in 296 B.C.; a temple was dedicated to him, also on the Aventine, and beside the cult image was hung a portrait of M. Fulvius Flaccus, the destroyer of Volsinii, in the dress of a triumphing general. A statue of Juno Curritis, the chief deity of Falerii, was apparently brought to Rome after the destruction of Falerii in 241 B.C., and the "Minerva Capta" at Rome, whose temple was on the Caelian, was another Faliscan exile.

The accidents of war partly account for our knowledge of Etruria's gods in other ways, too; we know that Vulcan was worshipped at Perugia because it is recorded that his was the only temple to escape destruction in the Perusine War of 42 B.C. The goddess whose great sanctuary at Pyrgi (see chap. vi and Pl. XXXVII), on the coast near Cerveteri, was sacked by Dionysius of Syracuse in 384 B.C. owes her continuing fame to that expedition; the Greek authors, who are the only writers to mention the episode, call her Leucothea or Eileithyia, a goddess of the sea or a goddess of childbirth; her local name was apparent-

ly Uni (see chap. vi), a name used on Etruscan mirrors for the Greek Hera. The other divinities mentioned so far have, it must be noticed, Latin names; no Roman author preserves the Etruscan name of a divinity. It is only natural that Juno Curritis and the Minerva Capta of Falerii had Italic names, since Falerii, though it considered itself an Etruscan city, spoke an Indo-European language closely related to Latin. Feronia, in the territory of Capena, and Soranus, sometimes called Apollo Soranus, on Mount Soracte, may have also been worshipped by Indo-European-speaking "Etruscans." It would be reasonable to suppose that the Romans Latinized the names of the Etruscan gods that came to Rome; but there are references in Roman literature to other local divinities in Etruria whose names are Italic: Hostia, at Sutrium; Nortia, at Volsinii; and Voltumna, at whose shrine the league of Etruscan cities met yearly. But with the possible exception of the last, the place of whose shrine is not known, these "Italic" Etruscan divinities belong to southern Etruria, where the pre-Etruscan inhabitants were apparently always more numerous than in the north.

That the Etruscans themselves had Etruscan names for their gods we know from inscriptions of two kinds. Those on mirrors (see chap. ix) allow us to identify divinities with purely Etruscan names with their Greek and Roman counterparts: Tinia, Zeus or Jupiter; Turan, Venus; Sethlans, Vulcan; and Turms, Mercury. Other gods illustrated on these mirrors have Etruscanized Latin names: Uni, Juno; Mera or Menrva, Minerva; Maris, Mars; and Hercle, Hercules. Still others have Etruscanized Greek names: Aplu, Apollo; Aritimi or Artumes, Artemis. Fufluns, the oddest of the Etruscan names, their name for the Roman Liber Pater or the Greek Dionysus, may well be Etruscanized Greek—"Fufluns" being a gallant attempt on the part of the Etruscans to transliterate "Byblinos," "the god of Byblos," which was located on the island of Naxos, where a remarkably fine wine was grown.

The other class of inscriptions is found on ex-votos—statuettes, utensils, pots, and other objects. These, particularly in the Hellenistic period, are often inscribed with a dedication to a specific divinity, and such inscriptions, of course, prove that the god had an actual cult in Etruria and was not merely a creature of myth. Votive inscriptions from Veii,

THE ETRUSCANS

Tarquinia, Volsinii, Pyrgi, Orvieto, Chiusi, Cortona, and Arezzo give us the names of the following divinities: Tinia, Uni, Mera, Turan, Aritimi, Maris, Selvans, Cilens, Thuflthas, Culsans, Muantrns, and Klanins. The first six we have already met on mirrors; "Culsans" is inscribed on a bronze statuette of a young male divinity with a Janus head (at Cortona); there is no clue to the nature or appearance of Muantrns or Klanins. The names "Cilens" and "Thuflthas," besides being inscribed on ex-votos, appear on the liver of Piacenza (see below) in positions which make it possible to identify them, respectively, with the Di Involuti, the Shrouded Gods, the highest and most mysterious powers of the Etruscan pantheon, and the Di Consentes, the Councilors, the twelve gods associated with the Etruscan Jupiter.

There were, it would seem, three kinds of gods worshipped in Etruria. First, there were old Italic divinities whose cults were taken over by the Etruscans without appreciably changing their names—Uni, Mera, Maris, Selvans (Silvanus)—and the more specifically local gods recorded by Roman historians—Hostia, Feronia, Nortia, Voltumna. Second, there were purely Etruscan gods that sometimes became identified with Indo-European (Greek or Latin) divinities—Tinia, Turan, Sethlans, Turms, Cilens, Thuflthas, Culsans, Muantrns, Klanins. Third, there were Greek gods taken, apparently, into the Etruscan pantheon in the same way as the Italic gods—Aritimi, Aplu, Fufluns. At Cerveteri, which had a large Greek population, the Greek Hera was worshipped under her own name as late as the third century B.C.

The Liver of Piacenza and the Disciplina Etrusca

The Etruscan pantheon was by no means restricted to the names listed above. A remarkable object discovered in 1877 near Piacenza in the Po Valley has furnished the names of at least eighteen more divinities, all of whom were evidently of ritual importance to the Etruscans. This object, a bronze model of a sheep's liver, has a flat upper surface from which projects the stylized gall bladder, *lobus pyramidalis* and *processus papillaris,* and a convex lower surface divided into two almost equal lobes by a transverse ridge. On the broader lobe, close to this ridge, is inscribed the name "Usils" (we know from the ever helpful Etruscan

mirrors that this is a name for the sun god); on the smaller lobe, "Tivs." The flat upper surface of the liver is marked off into a border of sixteen divisions and twenty-four inner compartments of various shapes and sizes; in these forty divisions are inscribed the names of some thirty gods, several repeated more than once.

Sixteen was a significant number to the Etruscans: Cicero and Pliny, and Servius in his commentary on the *Aeneid* (8.427), record the fact that they divided the heavens into sixteen parts and that it was extremely important to them to observe from which of these parts lightning appeared. We know of no other people in antiquity who used this six-teen-fold division (the Romans, Cicero says rather smugly, needed only four), so when the late Roman writer Martianus Capella divides the heavens into sixteen regions and describes the gods whom Jupiter summons from each to the wedding of Mercury and Philology (1.45), it is a virtual certainty that he used an Etruscan source. Now there is a striking correspondence between the names of many of Martianus' divinities and those of the gods inscribed in the sixteen divisions of the border of the bronze liver. This not only indicates that the Etruscans looked on the liver as a microcosm of the universe but allows us to identify a number of the Etruscan divinities through the translations of their names in Martianus. The liver adds two "Italo-Etruscan" gods: Ani, who corresponds in position, as in name, to the Latin Janus; and Satres, who must be the Latin Saturnus. Hercle (Hercules), by his appearance on the liver, is proved to be an important god in Etruria, not merely the beloved Greek hero Etruscanized, as one might assume from his popularity on mirrors and gems.

The identification of Cilens with the Di Involuti and Thuflthas with the Di Consentes is suggested by their position on the liver near Tinia, whose name appears three times at the end of the broad lobe, evidently the position of greatest importance. These collectives of gods, the Di Consentes and the Di Involuti, were as mysterious to the Romans as to us; Arnobius (3.40) and Martianus (1.45) call the Di Consentes the Penates Iovis, and Varro knew that they were six male and six female gods, but their names were unknown (evidently they were not the Twelve Gods of Olympus). They were Jupiter's counselors, without

whose advice he could not hurl his second thunderbolt (see below). The Di Involuti were even more powerful and mysterious, neither their number nor their names were known, but without their permission Jupiter could not hurl his third and most terrible thunderbolt. Evidently they were the Etruscan Fates, against whom even Jupiter had no recourse.

The Romans called these Etruscan thunderbolts manubiae (Serv. *Aen.* 1.42; Fest. 129M), and the right to hurl them was reserved by nine gods. We know the names of six from references in ancient authors: Jupiter, Juno, Minerva, Vulcan, Mars, and Saturn; but Jupiter himself could wield three sorts of thunderbolt. The first, he launched on his own initiative; it was admonitory and was sent before an action had taken place but after it had been decided on. The second he sent after consultation with the Di Consentes; it was terrifying and sometimes dangerous, but of good omen. The third, sent on the advice and with the permission of the Di Involuti, was destructive and final (Sen. *Q.N.* 2.41.1–2).

From the color and sound of the thunderbolt and above all from the part of the heavens from which it came, the Etruscan priest, the haruspex, could tell which god had sent it and what it meant. He would then consult the Libri Fulgurales to find out what to do about it. The Libri Fulgurales was one section of the library of ritual books which made up the Disciplina Etrusca. It was the lore of these books that the miraculous child Tages was suposed to have sung to the Lucumones of Etruria (see chap. ix), and the haruspex referred to these books for an explanation of any portent and for instruction on what to do about it.

It was the detailed and explicit knowledge of the Etruscan haruspices that fascinated the Romans, who had no such technique for coping with portents. At Rome, only Jupiter, or his nighttime alter ego, Summanus, could hurl the thunderbolt, and when he did, he was unequivocally angry. Normally, the College of Pontifices could order the proper expiation, as they could for a mere rain of stones. Whenever the Roman state wanted to know the gods' opinion of a specific policy, the augur was consulted, but his power was limited to ascertaining whether the gods did or did not approve of a proposed action. This is the basis of the

curious story of the augur Attus Navius and the whetstone. Tarquinius Priscus, the sophisticated Etruscan with a Corinthian father, was apparently contemptuous of the simple religious machinery of Rome and challenged Attus Navius to a test of his power, asking him if he could tell whether what Tarquin had in mind to do could be done. Attus Navius, having marked out the heavens into their four regions and observed the portents (the flight of birds), replied that it could indeed be done. Tarquin, who had been thinking of dividing a whetstone with a razor, was delighted at having trapped the augur in an impossibility, but Attus Navius offered to try and succeeded in cutting the whetstone without difficulty, thus proving that the gods themselves endorsed the art of augury.

This same half-Greek king of Rome was to provide the Romans with a Greek instrument for coping with portents, the Sibylline Books, a collection of prophetic utterances in hexameter verse inscribed on scrolls. Such collections were not uncommon in antiquity; those at Rome probably came from Cumae, where Apollo had a prophetic shrine. Their contents seem to have been not unlike some of the matter of the Disciplina Etrusca; Cicero remarks on the correspondence between the responses of Etruscan haruspices and the prophecies of the Sibylline Books. These books were kept in the Capitolium at Rome and consulted, but only at the order of the Roman Senate, by a board of men especially appointed to keep the books. This guaranteed that none of the ecstatic and mediumistic quality of Apollinian prophecy could infect the religion of the Roman state.

Perhaps it was just the cold-bloodedness of this approach to the Sibylline Books that induced the Roman state, on the occasion of really serious or uncommon portents, to turn to the Etruscan haruspices or to send a mission to Delphi itself. Apollo's priestess at Delphi was a medium and clairvoyant, and her responses must have seemed fresher and more pertinent to the crisis than any Sibylline hexameters. The haruspex used books as the Romans did, but not cold-bloodedly, like the Roman priestly colleges. According to Roman tradition, during the war with Veii an unprecedented rise in the level of the Alban Lake perturbed the Romans so much that, not being able to consult the harus-

pices because of the war, they sent a mission to Delphi to find out what the portent meant and what should be done. Before this mission had had time to return, an old man of Veii was heard by the Roman and Etruscan sentries as he sang "after the manner of prophets" that Rome would never capture Veii till the water had been released from the Alban Lake. One of the Romans, learning that this man was a haruspex, managed to kidnap him and take him to headquarters, where the old man lamented that the gods must have been angry with Veii on the day when they inspired him to foretell the destruction of his own city but that what he had sung then, under divine inspiration, he could not unsay or recall; thus it was written in the book of fate, thus ran the tradition of the Disciplina Etrusca: when the Alban Lake rose and the Romans drew it off properly, the gods would give them victory over Veii. And when the mission returned from Delphi it brought the same response from the oracle.

The Etruscan haruspex was, then, a priest who could interpret signs of various sorts with the help of a body of recorded lore, but his interpretations had the added power of prophecy under divine influence. This accounts for the great importance of the haruspex at Rome in all periods. A number of times during the long, terrible war with Hannibal, haruspices were sent for from Etruria to give advice on portents (Liv. 27.37); Livy reports (35.21) that haruspices were consulted during the war with Antiochus, when an ox was heard to say "*Roma, cave tibi!*" ("Rome, be on thy guard!"). The haruspices ordered the ox to be carefully kept and fed, but it is not recorded that it spoke again. During the same war, when two oxen climbed up the stairs to the flat roof of a building, the haruspices had them burnt alive and the ashes thrown into the Tiber (Liv. 36.37). By the time of the Gracchi, it seems to have been not uncommon for noble Romans to have a personal haruspex: Herennius Siculus was the haruspex and friend of Gaius Gracchus; Postumius was the name of Sulla's haruspex; Spurinna was Caesar's— the man who said "Beware the Ides of March!" Augustus established a college of sixty haruspices, which continued at least into the third century A.D. There were haruspices at the court of Julian the Apostate, and in 408 A.D. Etruscan commanders of the lightning offered to protect

Rome against Alaric, as Porsina of Volsinii had once defended his city against the Olta, by calling down thunderbolts. The prestige of the Disciplina Etrusca far outlasted that of Delphi or any other oracular shrine.

CITIES, TEMPLES, AND SANCTUARIES

The ritual books of the Disciplina Etrusca included much more than the art of divination; in them, for example, were the prescribed rites for founding a city, for marking out the limits of its territory, and for dedicating temples and altars (Fest. 285). The boundary of the future city—and this rite the Romans took from the Etruscans so early that their tradition recorded that Rome itself had been founded in the Etruscan manner (*more etrusco*)—was marked off by a plow shod with bronze and yoked to a bull and a cow. The founder drove a deep furrow around the boundary line, while those who followed him took care that the clods turned up by the plow were thrown inward, toward the city. Wherever a gate was to stand, the plowshare was lifted and carried across the width of the gateway, to break the sacred circle of the wall and make it possible to carry in and out of the city "those things which are necessary but unclean." Between this magic furrow and the city wall itself was a space "which could not be inhabited or plowed" called the pomoerium. At Rome, only the Vestal Virgins could be buried inside the pomoerium; the cemeteries began just outside the gates and straggled down the highways that led away from town. The same kind of prohibition was in effect in Etruria, where the cemeteries are also always outside the city limits.

The Etruscan city itself was not considered a true city, Servius says, unless it had three gates, three main streets, and three main temples to the three greatest gods, Jupiter, Juno, and Minerva. As we have seen (see chap. viii), no Etruscan city has yet been found to conform to these specifications; only the Latin colony of Cosa has three main gates, three main streets, and three main sacred areas.

The limits of a city's territory were established at Rome by agrimensores; and their science, Varro says, came from Etruria. We are very fortunate in having a fragment of a Roman translation of an

THE ETRUSCANS

Etruscan book on this science of boundaries (limitatio). A nymph, Vegoia, revealed the science to one Arruns Veltumnus: "Know that the sea was divided from the land. Thereafter, when Jupiter laid claim to the land of Etruria for himself, he decreed and gave command that its territory should be measured and its fields given boundaries. . . ." (The Latin can be found in Lachmann's edition of the *Gromatici veteres* [Berlin, 1848].)

Vitruvius (1.7.1) tells us that, by rule of the Disciplina Etrusca, temples of Venus, Vulcan, and Mars had to stand outside the city walls, so that the young people and the mothers of families might not be seduced by the charms of Venus, nor the city be put in danger of fire, nor the citizens aroused to civil strife. If the Portonaccio Temple at Veii was actually dedicated to the triad of Minerva, Artemis, and Turan (Venus), as one inscription found there seems to indicate, Venus had indeed carried her sister goddesses outside the city walls, though not beyond the rim of the plateau on which the city stands. In Roman cities also, according to Vitruvius, the temples of Mars and Venus should stand outside the pomoerium, Mars in the Campus Martius, Venus at the harbor.

The foundation ceremonies for a temple are discussed only once in ancient writings, by Tacitus (*Hist.* 4.53), who describes the emperor Vespasian's refounding of the Capitolium at Rome. The rite was Etruscan, since Etruscan haruspices were consulted and prescribed the proper technique for ritually cleaning the site as well as the form that the new temple should take—"The gods did not wish its ancient form to be changed, though it might be made taller." So the Capitolium of the empire was still, in ground plan, the triple-cella Tuscan temple of Vitruvius' description (see chap. viii).

Vitruvius' Tuscan temple, as we know, was a creation of the last years of the sixth century; earlier temples were built in Etruria, but none before the first quarter of the century. Before that time, as we have seen, the Etruscans, like the Italic peoples their neighbors, worshipped their gods in open-air sanctuaries. Indeed, in some cases the old sanctuaries of the Villanovans remained sacred places to the Etruscans. Presumably it was in this way that some Italic divinities became

identified with Etruscan gods (Jupiter with Tinia, for example), while in other cases the Etruscans merely adopted the protecting deity of a particular territory—Nortia, Hostia, Feronia, etc. Possibly the very peculiar triad of the Portonaccio Temple at Veii was the result of a combination of identification and adoption—Minerva, the Italic goddess; Aritimi, the Greek; and Turan, the Etruscan—the same lady named in three languages. Of course, no Greek would have identified Athena and Artemis with Aphrodite, but perhaps an Etruscan of the Archaic period could have. The Greeks did, after all, identify the Uni of Pyrgi with Leucothea and Eileithyia, and the Romans apparently identified her with their Mater Matuta.

Though there is no independent evidence on this point, it is wildly improbable that the Etruscans, or any people, made cult images before they had begun to build temples to put them in. Ex-votos can stand out in the rain, but a cult statue becomes the presence of the divinity, and its peculiarly sacred character needs protection. At Rome, according to Varro, no image of a god was set up for one hundred and seventy years after the founding of the city; the first was the terracotta figure of Jupiter made for the Capitolium by the Etruscan sculptor Vulca of Veii. The cult image seems to have been an Etruscan innovation; before the Etruscan period the Romans had worshipped their gods without images.

Presumably, until the first decades of the sixth century, when their first temples were built, the Etruscans had done the same. Though there are many votive figures of the seventh century from Etruria, these almost invariably represent worshippers (Pl. XV), as the Villanovan ex-votos had.

One would expect the first Etruscan cult statues, like their first temples, to have dated from the early sixth century. Since they were of terracotta or wood, as they were at Rome until the spoils of Sicily and Greece brought luxury and Greek taste to the Romans (Plin. 35.46.158; cf. Cato, in Liv. 34.4), it is not surprising that none has survived. But, at least in Greece, where no cult images have survived either, votive figures were often reduced copies or imitations of cult statues, and such figures might also be expected to turn up among

the votive bronzes of the sixth century in Etruria. And so they do, but not before the third quarter of the century: Minerva in the form of Athena Promachos (Pl. XXIV*b*); Mars, a hoplite in full armor (Pl. XXV*a*); and Hercules, wearing the lion's skin like a hooded coat, a statue type borrowed directly from Cyprus (Pl. XXIV*a*). Why these three should be the first gods reproduced in Etruscan sculpture is a puzzle; the earliest Jupiter-Tinia figures date from the beginning of the fifth century, and they wear the costume and stand in the pose of the Zeus of the Pyrgi pediment (Pl. XXXVII).

THE DEAD AND THE UNDERWORLD

Neither the mirrors of the Classical period nor the Piacenza liver furnishes us with the names of the Etruscan gods of death and the underworld. For these we must refer to inscriptions on tomb paintings and sarcophagi, and even in these no gods or demons of Hades are mentioned or illustrated before the fourth century B.C. From then on, however, pictures of the creatures that peopled the life after death are common. Two painted tombs of the fourth century, the Tomb of Orcus at Tarquinia and the Golini Tomb at Orvieto, show scenes of the Etruscan underworld with Hades and Persephone (Aita and Phersiphnai) enthroned. Hades wears a cap made of a wolf's scalp, the cap of darkness, which is also worn by Perseus on one Etruscan mirror; a snake is twined about his sceptre. Persephone, in the Tomb of Orcus, is young and beautiful, but she wears snakes in her hair.

In this tomb, where the underworld scenes are evidently inspired by Polygnotus' painting at Delphi, one scene shows Theseus and his companion, Pirithous, seated on either side of a table, while behind them rises up a fearsome winged demon with a vulture's beak, ass's ears, and snake-infested hair. This monster brandishes a great, green, bearded serpent over Theseus' head; his name, *Tuchulcha,* is drawn beside him.

Tuchulcha is a purely Etruscan demon, named here for the only time. Charun appears much oftener; his name is evidently taken from the Greek Charon, the ferryman of the dead, but his appearance and personality are quite different. Often winged like Tuchulcha (Pl.

XLII), he has a hooked nose, horrid tusks, snaky hair, and is generally armed with a hammer (Pl. XLV*b*). He appears as the announcer of death and divider of families (Pl. XLII), the guide on the road to Hades, the porter at hell's gate (Pl. XLV*b*). Sinister though he may look, his gestures are sometimes gentle and compassionate (Pl. XLII). As companions and helpers, Charun has a number of winged female spirits called Vanths, generally young and fair, half-clad, wearing crossed baldrics, short skirts, and hunters' boots (Pl. XLV*c*); they flourish snakes or burning torches, and like the Valkyrie they are present at battles or at the slaughter of prisoners, or they meet or accompany the dead on the road to Hades (Pl. XLIV*a*). A sister of theirs, Culsu, guards the gate to the underworld on one sarcophagus in Palermo.

There is no trace of a cult of any of these beings in Etruria, not even of Hades and Persephone; for all we know to the contrary, they are all merely the traditional trappings of the underworld, bogeymen like the Gorgon, whom Odysseus feared to see, or like Empusa, who frightened Dionysus and his slave Xanthias on their way to Hades to fetch back Euripides. But there is one divinity of the underworld that did have a cult; she is never represented on tomb paintings or reliefs, and we do not know, though perhaps we may guess at, her name.

In 1885, the remains of an altar, fragments of architectural terra-cottas, votive figurines, and the statue of a nude goddess carved in limestone with an elaborately molded limestone base were found at Orvieto in the Etruscan cemetery called the Cannicella. The ex-votos and the architectural fragments date from the Classical and Hellenistic periods, but the statue, which is three-quarters life size and was evidently the cult image of this little sanctuary, is in the style of the third quarter of the sixth century B.C. The head is an ugly but perfectly recognizable imitation of the pretty, egg-headed Attic korai of about 530–520 B.C.; the pose is that of a koré: erect, frontal, feet together; the right arm is curved easily across the body; the left is, unfortunately, missing. But there is no such thing as a nude koré from Greece.

In the Archaic period in Greece and still more in Etruria, a nude female figure is very uncommon, although professional hetaerae ap-

pear on Attic vases, and figures of nude dancing girls are sometimes used as mirror handles in the sixth century in Greece, and there are a few nude dancing girls and tumblers among the late Archaic decorative bronzes of Etruria. But for a nude goddess one must wait till the fourth century and Praxiteles' Aphrodite of Cnidus, or turn to the East.

A nude goddess of fertility and love was worshipped in the Near East from the Stone Age till the end of paganism. The Greeks borrowed her at some early date but, remembering her Eastern origin, called her the "Lady of Cyprus," one of their commonest titles for Aphrodite. But their first representations of the goddess show her as well and as completely dressed as any other Olympian goddess. Praxiteles, in fact, was restoring the lady to her pristine Oriental appearance.

The nudity of the Etruscan cult image, considering Etruria's modesty in the Archaic period, must be of ritual importance. One is reminded of the bronze amulets in Villanovan graves, which represented a nude fertility goddess whose ultimate connections were with the East (see chap. ii). Her earliest appearance in Italy is on the amulet from the Gallinaro Cemetery at Tarquinia (Pl. V*a*); her most astonishing is as the beast-headed female from Vetulonia (Pl. VII); her prettiest, the ivory goddess who presses a cup to her breast, from Marsiliana (Pl. XI).

These figurines were all tomb furnishings; in Italy, as in the East, the fertility goddess evidently had chthonic affinities. And indeed, the sixth-century Etruscan image is the goddess of a shrine in a cemetery, and, what is more, the figure is carved in stone, a material which we know to have been, in Etruria, peculiarly devoted to the tendance of the dead (see chap. v). This shrine at Orvieto is clear evidence for the continuation, from the late Villanovan period, at least, to the Hellenistic, of the worship of an Eastern goddess, the lady of life and death.

As for her name, the nude goddess of love was called Aphrodite by the Greeks, and even in Greece Aphrodite had occasionally the aspect of a death goddess. She was worshipped at Delphi under the

name of Aphrodite Epitumbios; at Rome the goddess in whose grove wood was cut for funeral pyres was Venus Libitina. So in all probability the Etruscans called their nude goddess at Orvieto "Turan" and worshipped her there as goddess of the dead.

The style of the statue dates her in the same period as the first small bronzes representing cult images, the Minerva, Mars, and Hercules figures of the third quarter of the sixth century (Pls. XXIV and XXV*a*). One wonders whether there actually were no cult statues in Etruria before this period, even though the Etruscans had begun to build temples nearly fifty years earlier. At Rome, according to tradition, there had been temples before the Capitolium was built; it was only the cult statue that was an Etruscan innovation. However, the evidence of the excavation at Orvieto suggests that the statue and the altar were earlier than any temple structure there; possibly the archaic shrine had had no terracotta decoration, or perhaps the fact that the figure was of stone made an architectural protection seem unnecessary.

The Etruscan feeling that stone belonged to the world of death was not something brought from the East or borrowed from Greece. Either they developed it themselves in Italy, in the late seventh century, or—possibly—they learned this point of view from the Villanovans.

Stone, of course, has a purely material protective quality, quite apart from any esoteric meaning that may be read into it, and the tufa of southern Etruria lies so close to the surface of the ground that it would be hard not to dig into it if one were designing a grave of any size. The stone-lined graves of the late Villanovan cremation burials and their inhumation counterparts, the trench tombs, need not indicate anything more than a wish to provide a resting place for the dead as commodious and as secure as possible. The feeling that stone is a magical material with a life of its own is, however, not uncommon among primitive peoples, and it may well have obtained in Italy before the arrival of the Etruscans—the shield-shaped stone covers of some Villanovan graves at Vetulonia certainly suggest this. If this is

so, the Etruscans may, again, have taken over an Italic belief and practice.

Other Italic burial practices did continue to flourish after the Etruscans had become lords of central Italy; the hut urns of the early Iron Age (Pl. I) must be, in some way, the ancestors of the later house tombs of Cerveteri (Pl. XVI) and Perugia, the temple tombs of the cliff cities, and the temple sarcophagi of the Hellenistic period (Pl. XLVIII*b*).

Another pre-Etruscan practice, Villanovan rather than Latin, is the characterization of the burial urn as the dead man himself; a two-storied urn whose lid is a helmet (Pl. II) must stand for the warrior whose ashes it guards. At Chiusi, from the beginning of the Oriental-izing period, this tendency was stressed and elaborated (see chap. v and Pls. XII and XIII). During the Archaic and Classical periods there, stone figures of men and women were used as ash urns (see chap. vi), so that the effigy of the dead was at the same time its guardian, as it had been in Villanovan times. Such figures are not, of course, *likenesses* of the dead, but since they *impersonate* them they must be counted as portraits. As we have seen (see chap. vii), true portraiture in Etruria is a product of Greek Hellenism, but masks and impersonations are infinitely older. In fact, the Clusine masks of the seventh century probably give a very just impression of what Roman funerary masks looked like before the taste for exact likenesses reached central Italy.

Late in the seventh century and during the sixth, the portrait urns of Chiusi were often placed on elaborate thrones in the grave; these thrones are generally round, with high, rounded backs, though some-times the backs and the seats are rectangular. The bronze fittings for a rectangular throne were found in the seventh-century Regolini-Galassi Tomb at Cerveteri, and one of the rounded type comes from the Barberini Tomb at Palestrina; others are carved in the tufa in some sixth-century tombs at Cerveteri. The stone ash urn statues of the sixth and early fifth centuries at Chiusi are all seated, and these and a few other funerary statues are the only seated figures from Etruria, with the exception of some votive terracottas, direct copies of

Greek types. Most Etruscan votive terracotta figures and all votive bronzes represent standing or striding figures. In the Near East, seated figures represent either divinities or the heroized dead; in Greece, the seated figure became secularized in the course of time, but in Etruria not even a divinity was represented in sculpture as seated, though all kinds of figures are shown sitting in paintings and reliefs. Even so, except in the paintings of Hades and Persephone in the Golini Tomb at Orvieto and the Tomb of Orcus at Tarquinia, the piece of furniture is not a throne. The musicians on the Bolognese situla in Providence (Pl. XXX*b*) sit on chairs with scooped seats and springy backs like something modern from Milan; in Etruria proper the commonest seat for a man is the folding stool, the Etruscan equivalent of the Roman magistrate's *sella curulis* (Pl. XLIII), while a woman's is a square stool covered with a cushion.

The enthroned tomb figures from Chiusi are evidently set apart from living mortals by the very thrones they sit on; the dead are given an honor comparable to that of the divinities of the lower world, if we may use the paintings in the Golini Tomb and the Tomb of Orcus as evidence. And perhaps the Etruscans did believe that the dead became gods of the lower world; both Servius and Arnobius (2.62) record that the Etruscans believed that after having offered the blood of certain animals to certain divinities, their souls would become divine and freed from the usual laws of mortality; these souls were called "*di animales*," or spirit gods, because they had once been the souls of men.

Yet, from the usual scenes in Etruscan tombs and on cippi and sarcophagi, one does not get the impression that the dead were about to become gods, except in Claudius' sense. Archaic tomb paintings and cippi show the funeral banquet with its dancers and musicians and the funeral games (Pls. XXXIV–XXXVI), including in a few cases a kind of gladiatorial combat, the funeral game par excellence (see chap. ix).

Occasionally, even in the Archaic period, the journey to the underworld is illustrated (Pl. XIX); in the fourth century, this becomes the most popular of all subjects on sarcophagi. The dead man or

woman may be shown taking leave of his family (Pl. XLIII) or on the road, sometimes by sea, oftener by land—on foot, on horseback, by mule cart, by chariot (Pls. XLIV*a* and XLIV*b*). He may be surrounded and guided by demons of the underworld or met by them at hell's gate (Pl. XLV). And in the underworld itself, one gathers from the pictures in the Tomb of Orcus and the Tomb of the Shields at Tarquinia and the Golini Tomb at Orvieto, the dead man feasts with his wife and his kinsmen in the presence of Hades and Persephone themselves.

Evidently the common Etruscan belief, at least in the Classical period and probably already in the Archaic, was that the dead had to set out on a long and fearsome journey—something like the journey in the Lyke Wake Dirge—but its destination was tranquil and stately, if not gay. This is not the same as becoming a god in your own tomb. Apparently the Etruscans held two contradictory beliefs about the destiny of the soul after death. If one may speculate from the evidence that it was the cremating Villanovans who made the urn an image of the dead, the belief that the dead man became a god enthroned in his tomb was pre-Etruscan, while the belief in the journey and the banquet with his kinsfolk belonged to the Etruscans and reached Italy with them. But this is no more than conjecture.

Sarcophagi and ash urns of the Hellenistic period seem to be the result of a sort of conflation of the two beliefs; the image contains the remains of the dead; he does not, however, sit enthroned like a god but reclines like a banqueter. The reliefs of this period often still show the journey to the underworld, but scenes from mythology are more popular, always scenes of violence and danger—the duel of Eteocles and Polynices, the murder of Clytemnestra by Orestes, the story of Actaeon, the slaughter of the Trojan prisoners at the Tomb of Patroclus, Odysseus in the Palace of Circe, Odysseus and the sirens. These last really reproduce the "journey" theme in a metaphor. The contrast between these perilous scenes with their highly charged emotions and the stately resignation of the figure that reclines on the lid of the urn (Pl. XLV*a*) is deliberately contrived. The dead man has finished with such things; they represent the world that he has left,

and his present state can only be happier—"Fear no more the heat of the sun, nor the furious winter's rages. . . ."

The impression that the finest of these urns gives, of an eternal quiet beyond an hour of violence and fear, implies, along with a certain melancholy nobility in the Etruscan temperament, a strong sense of fatalism. And this impression is reinforced by references in late writers, particularly Censorinus. According to these, the Etruscans believed that a man had an allotted span of life, and that the end of life could be postponed for a certain time by prayers and sacrifices, but that after the age of seventy he could not and should not ask the gods for more time. In the same way, an Etruscan city had its appointed span, which could be prolonged for thirty years by prayers and sacrifices but no longer; and the Etruscan nation itself was allotted only ten saecula of existence—the length of each saeculum corresponding to the longest lifetime of any person born at the moment the saeculum commenced. When the tenth saeculum was finished, there would be an end to the Etruscan name—*finem fore nominis Etrusci.*

One can hardly believe that this idea was current in Etruria in the Archaic period, but it is quite believable when one looks at the Hellenistic funerary portraits; it is a simple fatalism that is quite un-Greek and even more un-Roman. Rome knew that her empire would endure forever; Jupiter had promised this even before the city was founded; in the first book of the *Aeneid* (282–83) he says to Venus, "For this people I have set bounds neither of place nor time; I have given them an empire that shall have no end—*imperium sine fine dedi.*"

AFTERWORD (1976)
We know a great deal more about Etruria than we did when this book was published twelve years ago. Excavations in the sanctuary at Pyrgi have uncovered a second temple, older than the Tuscan temple whose pedimental group appears on Plate XXXVII, and peripteral, in the Greek manner. The "pedimental group" itself has turned out to be a great columen plaque illustrating, not the Battle of the Gods and

THE ETRUSCANS

Giants, but two episodes in the story of the Seven against Thebes: Tydeus gnawing the head of Melanippus in the presence of a horrified Athene, and Capaneus defying Zeus. The most arresting and informative discoveries are the three inscriptions on gold plaques found between the temples, two written in Etruscan, one in Phoenician. They tell us that the Lady Astarte of the Phoenicians and the goddess Uni of Pyrgi were identified with each other, and that it was the Etruscan king of Caere who made the dedication to the Punic goddess, as a thank-offering. The inscriptions date from the end of the sixth century, not long after the Caeretans and Carthaginians, according to Herodotus, had banded together to drive the Phocaeans from Corsica (p. 75).

At Graviscae, one of the ports of Tarquinia, an archaic sanctuary of Apollo has recently been discovered, a Greek sanctuary in an Etruscan town, like that dedicated to Hera at Caere (p. 234). An inscription on a marble cippus names the god the Apollo of Aegina, and the dedicator Sostratos; it has been suggested that he was that Sostratos of Aegina with whom, Herodotus says (4.152), no seaborne merchant could compete in wealth.

Like the Corinthian Demaratus of literary tradition, Sostratos came to Tarquinii. Caere, we are told, had a treasury at Delphi; we know now that she had a Punic shrine at Pyrgi. The links between Etruria and the rest of the Mediterranean world seem closer, and the eclectic, international character of her civilization more understandable, in the light of these new discoveries.

Inland, at Poggio Civitate near Siena, a complex of buildings of the early sixth century has been uncovered, a great square courtyard colonnaded on three sides, surrounded by square and rectangular buildings whose rooftrees were decorated with astonishing seated figures in terracotta, bearded gentlemen in wide-brimmed hats and ladies wearing shoes with curled-up toes, like the boot on the bucchero rhyton, Pl. XXXIIa. Relief plaques, the most archaic yet found in Etruria, show scenes of solemn processions, horse racing, banqueting, and austere seated figures—Magistrates? Or divinities? Was the

place a sanctuary, or was it the palace of some north Etruscan kinglet?

Terracotta revetments have been taken, till now, to indicate that the building they decorated was a temple, but the new excavations at Aquarossa near Viterbo have produced painted tiles, flamboyant acroteria, and griffin-headed cover tiles that decorated the roofs of houses of the late seventh century. No certain temple foundations are known in Etruria as early as this. Perhaps, when the Etruscans began to build temples for their gods, they borrowed the most splendid ornaments from their own houses to enhance the new houses of their divinities.

The picture of Etruria is changing as I write.

Bibliography

The abbreviations used in the following bibliography are the standard abbreviations recommended by the *American Journal of Archaeology*, 62 (1958), pp. 3–8.

This is a working bibliography: I have included only such books as, in my opinion, will help the interested reader to supplement this introductory volume and will carry him somewhat deeper into the study of Etruscan archaeology. Because so much new material has been discovered and published in the last decade, I have cited, wherever possible, the latest publications on any specific subject. Where there is no adequate recent publication, the standard work is listed. A few of the classical books on Etruscan studies are included because their observations and scholarship have yet to be superseded in spite of our greater present knowledge.

Whenever possible, books and articles written in English stand at the head of their several lists.

General

George Dennis *Cities and Cemeteries of Etruria*. (3rd ed.) London, 1883.
Unsurpassed for its description of the Tuscan countryside and the ancient sites and their material remains, many of which are no longer in existence.

M. Pallottino *The Etruscans*. (Pelican Books, A 310.) Aylesbury, Eng., 1955.
A translation of the author's *Etruscologia*. (3rd ed.) Milan, 1955. A general survey of the origins, history, civilization, and language of the Etruscans. Argumentative.

K. O. Müller *Die Etrusker*. 2 vols. Stuttgart, 1877.
W. Deecke Still valuable as a reference book. It assembles the ancient literary references to the Etruscans and discusses them with knowledge and judgment.

O. W. von Vacano *Die Etrusker: Werden und geistige Welt*. Stuttgart, 1955.
Not really for the beginning student. Highly controversial, but contains excellent contemporary descriptions of Etruscan sites. Well illustrated.

Bibliography

L. Banti *Il mondo degli Etruschi.* Rome, 1960.
 An admirable reconstruction of the civilization of Etruria, using
 purely archaeological evidence. The topographical distinctions of the
 country and its styles are particularly well explained. An extremely
 valuable book.

J. Heurgon *La Vie quotidienne chez les Étrusques.* Paris, 1961.
 The author makes excellent use of a combination of literary refer-
 ences, epigraphical material, and archaeological evidence in his
 presentation of the Etruscans.
 Studi Etruschi, published since 1927 by the Istituto di Studi Etruschi
 e Italici, contain valuable articles on Etruscan history, linguistics,
 archaeology, and ecology.
 Tyrrhenika: Saggi di studi etruschi. Milan, 1957.
 A collection of lectures given by various scholars in 1955–56 for the
 Istituto Lombardo di Scienze e Lettere.
 Historia: Zeitschrift für alte Geschichte, 6 (1957), pp. 1–132.
 A series of articles by scholars of different nationalities on various
 phases of Etruscan studies.

History of Art

PICTURE BOOKS

G. Q. Giglioli *L'Arte etrusca.* Milan, 1935.
 Still the largest and most comprehensive corpus of illustrations of
 Etruscan material.

M. Pallottino *Art of the Etruscans.* London and Zurich, 1955.
W. Dräyer Brief, sensible text; superb photographs of many of the Etruscan
M. Hurlimann works of art exhibited in Zurich in 1955.

C. M. Lerici *Nuove testimonianze dell'arte e della civiltà etrusca.* Milan, 1960.
 Descriptions and illustrations of the most recent finds at Cerveteri,
 Vulci, Tarquinia, etc.

ART HISTORY

P. J. Riis *An Introduction to Etruscan Art.* Copenhagen, 1953.
 A collection of lectures on different aspects of Etruscan art, of unequal
 value.

T. Dohrn *Grundzüge etruskischer Kunst.* Baden Baden, 1958.

THE ETRUSCANS

Sites

ETRURIA PROPER

Arezzo
L. Pernier. "Arezzo: Ricerche per la scoperta delle antiche mura urbane laterizie nei terreni di Fonte Pozzola e Catona," *NSc*, 1920, pp. 167–215.

C. Lazzeri. "Arezzo etrusca: Le origini della città e la stipe votiva alla Fonte Veneziana," *StEtr*, 1 (1927), pp. 113–27.

G. Maetzke. "Arezzo," *Enciclopedia dell'arte antica, classica e orientale.* Rome, 1958——.

Bieda
H. Koch, E. von Mercklin, and C. Weickert. "Bieda," *RM*, 30 (1915), pp. 161–303.

Bolsena
R. Bloch. "Volsinies étrusque et romaine," *MélRome*, 1950, pp. 53–123.

Cerveteri
R. Mengarelli. "Caere e le recenti scoperte," *StEtr*, 1 (1927), pp. 145–47.

B. Pace *et al.* "Caere: Scavi di Raniero Mengarelli," *MonAnt*, 42 (1955).

Chiusi
R. Bianchi Bandinelli. "Clusium: Ricerche archeologiche e topografiche su Chiusi e il suo territorio in età etrusca," *MonAnt*, 30 (1925), cols. 209–552.

K. A. Neugebauer. "Aus dem Reiche des Königs Porsenna," *Die Antike*, 18 (1942), pp. 18–56.

Clusium Vetus
D. Anziani." Cosa et Orbetello dans l'antiquité," *MélRome*, 30 (1910), pp. 373–95.

L. Pareti. "Clusini veteres e Clusini novi," *StEtr*, 5 (1931), pp. 147–61.

Cortona
A. Neppi Modona. *Cortona etrusca e romana.* Florence, 1926.

Cosa
F. E. Brown. "Cosa I: History and Topography," *MAAR*, 20 (1951), pp. 7–113.

Falerii
L. A. Holland. *The Faliscans in Prehistoric Times.* Rome, 1925.

P. Villari *et al.* "Degli scavi di antichità nel territorio falisco," *MonAnt*, 4 (1894), cols. 5–588.

Fiesole
G. Caputo and G. Maetzke. "Presentazione del rilievo di Fiesole antica," *StEtr*, 27 (1959), pp. 41–63.

Luni
L. Banti. *Luni.* Florence, 1937.

Marsiliana d'Albegna
A. Minto. *Marsiliana d'Albegna.* Florence, 1921.

Orvieto
P. Perali. *Orvieto etrusca.* Rome, 1928.

S. Puglisi. *Studi e ricerche su Orvieto etrusca.* Catania, 1934.

Bibliography

Perugia L. Banti. "Contributo alla storia ed alla topografia del territorio perugino," *StEtr*, 10 (1936), pp. 97–127.

Populonia A. Minto. *Populonia: La necropoli arcaica*. Florence, 1922.
The same, reports in *NSc* from 1923 to 1926 and in *MonAnt*, 34 (1929).
A. de Agostino. "Nuovi contributi all'archeologia di Populonia," *StEtr*, 24 (1955), pp. 255–68.

Pyrgi M. Pallottino. "Scavi nel santuario etrusco di Pyrgi," in *ArchCl*, 9 (1957); 10 (1958); 11 (1959); 13 (1961).
G. Colonna, G. Foti, and A. Ciasca. "Santa Severa: Scavi e ricerche nel sito dell'antica Pyrgi, 1957–1958," *NSc*, 1959, pp. 143–263.

Roselle R. Naumann and F. Hiller. "Rusellae: Berichte über die Untersuchungen der Jahre 1957–1958," *RM*, 66 (1959), pp. 1–30, Pls. 1–16.
C. Laviosa. "Rusellae: Relazione preliminare della I campagna," *StEtr*, 27 (1959); "Seconda relazione," *StEtr*, 28 (1960); and "Terza campagna," *StEtr*, 29 (1961).

Saturnia A. Minto. "Saturnia etrusca e romana," *MonAnt*, 30 (1925).

San Giovenale A. Boethius *et al*. *Etruscan Culture, Lands, and Peoples: Archaeological Research and Studies Conducted in San Giovenale and Its Environs by Members of the Swedish Institute in Rome*. Malmo, 1962.
Beautifully illustrated.

San Giuliano A. Gargana. "La necropoli rupestre di S. Giuliano," *MonAnt*, 33 (1931).

Sovana R. Bianchi Bandinelli. *Sovana*. Florence, 1929.

Tarquinia M. Pallottino. "Tarquinia," *MonAnt*, 36 (1937).
P. Romanelli, "Tarquinia: Scavi e ricerche nell'area della città," *NSc*, 1948, pp. 193–270.

Tolfa and S. Bastianelli. "Il territorio tolfetano nell'antichità," *StEtr*, 16 (1942),
 Allumiere pp. 229–60.

Veii M. Pallottino. "Scavo di un'area sacra a Veio," *Le Arti*, 1 (1938–39), and "Le recenti scoperte nel santuario dell'Apollo a Veio," *Le Arti*, 2 (1939–40).
M. Santangelo. "Santuario 'di Apollo,' scavo fra il 1944 e il 1949," *BdA*, 37 (1952).
J. Ward Perkins. "Veii: The Historical Topography of the Ancient City," *BSR*, 33 (1961).

Vetulonia I. Falchi. *Vetulonia e la sua necropoli antichissima*. Florence, 1891.

Volterra L. Consortini. *Volterra nell'antichità*. Volterra, 1940.
E. Fiumi, "Gli scavi della necropoli di Portone degli anni 1873–74," *StEtr*, 25 (1957), pp. 367–68, and "Materiali volterrani nel Museo Archeologico di Firenze," *StEtr*, 25 (1957), pp. 463–87.

THE ETRUSCANS

Vulci

S. Gsell. *Fouilles dans la nécropole de Vulci.* Paris, 1891.

F. Messerschmidt and A. von Gerkan. "Nekropolen von Vulci," *JdI*, Ergänzungsheft, 12 (1930).

CAMPANIA

An excellent, but brief, chapter on Etruscan Campania is included in P. J. Riis. *An Introduction to Etruscan Art.* Copenhagen, 1953.

Capua

J. Heurgon. *Recherches sur l'histoire, la religion et la civilisation de Capoue préromaine. (Bibliothèque des Écoles françaises d'Athènes et de Rome,* Vol. 154.) Paris, 1942.

LATIUM

Rome

I. Ryberg. *An Archaeological Survey of Rome from the Seventh to the Second Century B.C.* Philadelphia, 1940.

E. Gjerstad. "Discussions concerning Early Rome," *Opuscula Romana,* Part 3. (*Skifter utgivna as svenska Institutet i Rom,* Series 4, 21.) Lund, 1961.

Highly controversial.

THE PO VALLEY

"Spina e l'Etruria padana," *StEtr,* Supplement, 25 (1959).

R. Scarani and G. A. Mansuelli. *L'Emilia prima dei Romani.* Milan, 1961.

Adria

G. B. Pellegrini and G. Fogolari. "Iscrizioni etrusche e venetiche di Adria," *StEtr,* 26 (1953), pp. 103–54.

Bologna

A. Grenier. *Bologne villanovienne et étrusque. (Bibliothèque des Écoles françaises d'Athènes et de Rome,* Vol. 106.) Paris, 1912.

Marzabotto

E. Brizio. "Relazione sugli scavi eseguiti a Marzabotto presso Bologna," *MonAnt,* 1 (1891), cols. 249–422.

Spina

S. Aurigemma. *Il R. Museo di Spina.* (2d ed.) Bologna, 1936.

P. E. Arias and N. Alfieri. *Il Museo Archeologico di Ferrara.* Ferrara, 1955.

Mostra dell'Etruria Padana e della città di Spina. 2 vols. Bologna, 1960.

Introduction, Chapters I–III

ORIGIN OF THE ETRUSCANS

H. Hencken

"Archaeological Evidence for the Origin of the Etruscans," in *Ciba Foundation Symposium on Medical Biology and Etruscan Origins.* 1958. Pp. 29–47.

Sensible and illuminating, from the point of view of a prehistorian.

Bibliography

F. Schachermeyr *Etruskische Frühgeschichte*. Berlin, 1929.

P. Ducati *Le Problème étrusque*. (*Études d'archéologie et d'histoire*.) Paris, 1938.
These both follow the Herodotean tradition, with embellishments.

M. Pallottino *L'Origine degli Etruschi*. Rome, 1947.
The Etruscans. (Pelican Books, A 310.) Aylesbury, Eng., 1955. Part I.
These give the arguments of the followers of Dionysius of Halicarnassus.

F. Altheim *Der Ursprung der Etrusker*. Baden Baden, 1950.

G. Säflund "Über den Ursprung der Etrusker," *Historia*, 6 (1957), pp. 10–22.

THE IRON AGE IN CENTRAL ITALY

D. Randall-MacIver *Villanovans and Early Etruscans*. Oxford, 1924.
The Iron Age in Italy. Oxford, 1927.
His dates are no longer acceptable, but the descriptions and illustrations of material are excellent.

W. R. Bryan *Italic Hut Urns and Hut Urn Cemeteries*. (*PAAR*, Vol. 4.) 1925.

O. Montelius *La Civilisation en Italie depuis l'introduction des métaux*. Stockholm, 1910.
His dating is no longer acceptable, but these volumes provide an invaluable corpus of early material arranged by site.

F. von Duhn *Italische Gräberkunde*. Heidelberg, 1924. I.

F. von Duhn
F. Messerschmidt *Italische Gräberkunde*. Heidelberg, 1939. II.
For reference only.

H. Müller-Karpe "Vom Anfang Roms," *RM*, Ergänzunsheft, 5 (1959).

THE GREEKS IN CENTRAL ITALY

A. Blakeway "Prolegomena to the Study of Greek Commerce with Italy, Sicily and France in the Eighth and Seventh Centuries B.C.," *BSA*, 33 (1932–33), pp. 170–208.
"Demaratus: A Study in Some Aspects of the Earliest Hellenization of Latium and Etruria," *JRS*, 25 (1935), pp. 129–49, Pls. 20–22.

H. Hencken "Syracuse, Etruria, and the North: Some Comparisons," *AJA*, 62 (1958), pp. 259–72, Pls. 56–71.

THE ART OF THE GEOMETRIC AND ORIENTALIZING PERIODS

G. M. A. Richter "The Technique of Bucchero Ware," *StEtr*, 10 (1936), pp. 61–65.

G. M. A. Hanfmann "The Origins of Etruscan Sculpture," *La Critica d'Arte*, 10 (1937), pp. 158–66, Pls. 120–24.

H. Hencken "Horse Tripods of Etruria," *AJA*, 61 (1957), pp. 1–4.

THE ETRUSCANS

E. H. Richardson — "The Recurrent Geometric in the Sculpture of Central Italy and Its Bearing on the Origins of the Etruscans," *MAAR*, 27 (1962).

P. Ducati — "Osservazioni su di un tripode vetuloniese e su monumenti affini," *StEtr*, 5 (1931), pp. 85–103.

F. Messerschmidt — "Die 'Kandelaber' von Vetulonia," *StEtr*, 5 (1931), pp. 71–84.

G. M. A. Hanfmann — *Altetruskische Plastik I: Die Menschliche Gestalt in der Rundplastik bis zum Ausgang der orientalisierenden Kunst.* Würzburg, 1936.

Å. Åkerström — *Der geometrische Stil in Italien. (Skrifter utgivna av svenska Institutet i Rom,* Vol. 9.) Lund and Leipzig, 1943.

M. G. Marunti — "Lebeti etruschi," *StEtr*, 27 (1959), pp. 65–77.

TOMBS AND TOMB GROUPS

C. Densmore Curtis — "The Bernardini Tomb," *MAAR*, 3 (1919), pp. 9–90, Pls. 1–71.
"The Barberini Tomb," *MAAR*, 5 (1925), pp. 9–52, Pls. 1–43.

E. Hall Dohan — *Italic Tomb Groups in the University Museum.* Philadelphia, 1942.
An outstanding contribution to the study of early Italy.

G. Matteucig — *Poggio Buco: The Necropolis of Statonia.* Berkeley and Los Angeles, 1951.

L. Pareti — *La Tomba Regolini-Galassi del Museo Gregoriano etrusco e la civiltà dell'Italia centrale nel secolo 7 A.C.* Vatican City, 1947.

Chapter IV

R. A. L. Fell — *Etruria and Rome.* Cambridge, 1924.

O. W. von Vacano — *Die Etrusker in der Welt der Antike.* Hamburg, 1957.
The introduction to L. R. Taylor's *Local Cults in Etruria* is an excellent, brief historical sketch of Etruria and her neighbors.

Chapters V–VII

SCULPTURE

P. J. Riis — *Tyrrhenika: An Archaeological Study of the Etruscan Sculptors of the Archaic and Classic Periods.* Copenhagen, 1941.
The first attempt to recognize local, regional styles in Etruscan sculpture.

E. H. Richardson — "The Etruscan Origins of Early Roman Sculpture," *MAAR*, 21 (1953), pp. 77–144.

W. Llewellyn Brown — *The Etruscan Lion.* Oxford, 1960.
Though it deals specifically with the lion in Etruscan art, the book manages to be a remarkably illuminating study of the history of Etruscan sculpture as a whole.

258

Bibliography

R. Herbig	*Die jüngeretruskische Steinsarcophage.* Berlin, 1952.
G. Thimme	"Chiusine Aschenkiste und Sarcophage der hellenistischen Zeit," *StEtr*, 23 (1954–55), pp. 25–147.
G. M. A. Hanf-mann	*Etruskische Plastik.* Stuttgart, 1956.
A. Hus	*Recherches sur la statuaire de pierre étrusque archaïque. (Bibliothèque des Écoles françaises d'Athènes et de Rome,* Vol. 198.) Paris, 1961.

RELIEFS

G. M. A. Hanf-mann	"Etruscan Reliefs of the Hellenistic Period," *JHS*, 65 (1945), pp. 45–57, Pls. 8–10.
G. Körte	*I rilievi delle urne etrusche.* 3 vols. Berlin, 1916. An invaluable corpus.
F. Magi	"Stele e cippi fiesolani," *StEtr*, 6 (1932), pp. 11–85, Pls. 1–12.
A. Minto	"Le stele arcaiche volterrane," in *Scritti in Onore di Bartolomeo Nogara.* Vatican City, 1937. Pp. 305–15. Pls. 42, 43.
E. Paribeni	"I rilievi chiusini arcaici," *StEtr*, 12 (1938), pp. 57–139, Pls. 6–37.

PAINTING

F. Poulsen	*Etruscan Tomb Paintings: Their Subjects and Their Significance.* Oxford, 1922.
Prentiss Duell	"The Tomba del Triclinio at Tarquinia," *MAAR*, 6 (1927), pp. 7–68, Pls. 1–12C.
M. Pallottino	*Etruscan Painting.* Geneva, 1952.
F. Messerschmidt	"Probleme der etruskischen Malerei des Hellenismus," *JdI*, 45 (1930), pp. 62–90.
L. Banti	"Problemi della pittura arcaica etrusca: La Tomba dei Tori a Tarquinia," *StEtr*, 24 (1955–56), pp. 143–81.
M. Moretti	"Lastre dipinte inedite da Cere," *ArchCl*, 9 (1957), pp. 18–25.
F. Weege	*Etruskische Malerei.* Halle, 1921. This and the following have excellent photographs.
H. Leisinger	*Malerei der Etrusker.* Stuttgart, n.d.

VASE PAINTING

J. D. Beazley	*Etruscan Vase Painting.* Oxford, 1947.
M. del Chiaro	*The Genucilia Group: A Class of Etruscan Red-figured Plates.* Berkeley and Los Angeles, 1957.

THE ETRUSCANS

P. Ducati *Pontische Vasen. (Bilder griechischer Vasen*, ed. J. D. Beazley and Paul Jacobsthal, Vol. 5.) Berlin, 1932.

T. Dohrn *Die schwarzfigurigen etruskischen Vasen aus der zweiten Hälfte des sechsten Jahrhunderts.* Cologne, 1937.

MINOR ARTS

Bronzes G. M. A. Hanfmann. "Studies in Etruscan Bronze Reliefs: The Gigantomachy," *ArtB*, 19 (1937), pp. 463–84.

M. Guarducci. "I bronzi di Vulci," *StEtr*, 10 (1936), pp. 15–53, Pls. 3–15.

K. A. Neugebauer. "Archaische vulcenter Bronzen," *JdI*, 58 (1943), pp. 206–78.

L. Banti. "Bronzi arcaici etruschi: I tripodi Loeb," *Tyrrhenika: Saggi di studi etruschi.* Milan, 1957.

Mirrors J. D. Beazley. "The World of the Etruscan Mirror," *JHS*, 69 (1949), pp. 1–17.

E. Gerhard, A. Klügemann, and G. Körte. *Etruskische Spiegel.* 5 vols. Berlin, 1840–97.
Still the essential corpus.

G. A. Mansuelli. "Gli specchi figurati etruschi," *StEtr*, 19 (1946), pp. 9–137, Pls. 1–5.

R. Herbig. "Die Kranzspiegelgruppe," *StEtr*, 24 (1955–56), pp. 183–205.

Utensils K. A. Neugebauer "Archaisch etruskische Weihrauchständer," *Berl-Mus*, 45 (1924), pp. 28–35.

M. V. Giuliani Pomes. "Chronologia delle situle rinvenute in Etruria," *StEtr*, 23 (1954) pp. 149–94, and *StEtr*, 25 (1959), pp. 39–84.

T. Dohrn. "Zwei etruskische Kandelaber," *RM*, 66 (1959), pp. 45–64.

S. Haynes and H. Menzel. "Etruskische Bronzekopfgefässe," *Jahrbuch des römischgermanischen Zentralmuseums*, 6 (1959), pp. 110–27.

Ivories Y. Huls. *Ivoires d'Étrurie. (Études de philologie, d'archéologie et d'histoire anciennes, l'Institut Historique Belge de Rome*, Vol. 4.) Rome, 1957.

Jewelry A. Furtwängler. *Die antiken Gemmen.* 3 vols. Leipzig and Berlin, 1900.

G. M. A. Hanfmann and E. Feisal. "Inschriftliche Denkmäler des Museum of Fine Arts in Boston: Etruskische Gemmen," *StEtr*, 10 (1936), pp. 399–405.

G. Becatti. *Oreficerie antiche.* Rome, 1955. Pls. 45–74, 77–79, 91–94, 108–12, and relevant text.

Coins S. L. Cesano. *Tipi monetali etruschi.* Rome, 1926.

Bibliography

Chapter VIII

There is as yet no adequate book on Etruscan architecture.

J. Durm	*Die Baustile II: Die Baukunst der Etrusker*. Stuttgart, 1905. Ingenious and still valuable as a reference.
L. Polacco	*Tuscanicae dispositiones*. Padua, 1952. Must be used with great caution.

CITY PLANNING

P. J. Riis	"The Etruscan City Gates of Perugia," *ActaA*, 1934, pp. 65–98.
F. Castagnoli	*Ippodamo di Mileto e l'urbanistica a pianta ortogonale*. Rome, 1956. This includes plans and discussions of Capua and Marzabotto and a chapter on Etruscan and Italic city planning.

HOUSES

A. Kirsopp Lake	"The Origin of the Roman House," *AJA*, 41 (1937), pp. 598–601.
G. M. A. Hanfmann	"Etruscan Doors and Windows," *JASAH*, 2 (1942).
A. Gargana	"La casa etrusca," *Historia*, 8 (1934), pp. 204–36.

TEMPLES

A. Kirsopp Lake	"Archaeological Evidence for the Tuscan Temple," *MAAR*, 12 (1934), pp. 89–149.
F. E. Brown	"Architecture," *Cosa II: The Temples of the Arx*. (*MAAR*, Vol. 26.) Rome, 1960. Pp. 9–147.
G. E. Rizzo	"Di un tempietto fittile di Nemi e di altri monumenti inediti relativi al tempio italico-etrusco," *BullComm*, 38 (1910), pp. 281–321, Pls. 12–13 and *BullComm*, 39 (1911), pp. 23–61.
G. Bendinelli	"Il tempio etrusco sopra alcuni specchi graffiti," *BullComm*, 46 (1918), pp. 229–45.
A. M. Colini	"Indagini sui frontoni dei templi di Roma," *BullComm*, 51 (1924), pp. 299–347, Pls. 1–2.
L. Pernier	"Il tempio etrusco-italico di Orvieto," *Dedalo*, 6 (1925), pp. 137–64.
E. Stefani	"Civita Castellana: Tempio di Giunone Curite," *NSc*, 1947, pp. 69–74.
G. Maetzke	"Il nuovo tempio tuscanico di Fiesole," *StEtr*, 24 (1955), pp. 227–53. An extremely valuable recent publication.
M. Pallottino	"Scavi nel santuario di Pyrgi," *ArchCl*, 10 (1958), pp. 315–22, Pls. 105–11, and *ArchCl*, 11 (1959), pp. 251–52, Pl. 87.

THE ETRUSCANS

ARCHITECTURAL TERRACOTTAS

A. Andrén *Architectural Terracottas from Etrusco-Italic Temples.* 2 vols. Lund and Leipzig, 1939.
The dating of the Hellenistic groups has been in part superseded by the following.

L. Richardson, Jr. "The Architectural Terracottas," *Cosa II: The Temples of the Arx.* (*MAAR*, Vol. 26.) Rome, 1960. Pp. 151–300.

E. H. Richardson "The Terracotta Sculpture," *Cosa II: The Temples of the Arx.* (*MAAR*, Vol. 26.) Rome, 1960. Pp. 303–80.

E. Stefani "Veio: Basi di statue fittili scopperte del santuario 'Dell'Apollo,' " *NSc*, 1946, pp. 36–59.

M. Pallottino *La scuola di Vulca.* Rome, 1945.
"Il grande acroterio femminile di Veio," *ArchCl*, 2 (1950), pp. 122–79.

A. Minto "Problemi sulla decorazione coroplastica nell'architettura del tempio etrusco," *StEtr*, 22 (1952), pp. 9–48.

M. Zuffa "I frontoni e il fregio di Civitalba nel Museo Civico di Bologna," in *Studi in onore di Aristide Calderini e Roberto Paribeni*, III. Milan, 1956. Pp. 267–88.

O. W. von Vacano "Ödipus zwischen den Viergespannen," *RM*, 68 (1961), pp. 9–63, Pls. 4–11.

TOMBS

Å. Åkerström *Studien über die etruskischen Gräber.* Uppsala, 1934.
Still the best and most comprehensive work on this subject.

A. Minto "Edicole funerarie etrusche," *StEtr*, 8 (1934), pp. 105–18, Pl. 28.

A. Minto "Pseudocupole e pseudovolte nella architettura etrusca delle origini," *Palladio*, 3 (1939), pp. 1–20.

The following is by no means a complete list of publications of single tombs; it is intended to be a selection of good examples, well described. In addition, the bibliography for chapters i–iii includes a number of early tombs, and the volumes cited under Cerveteri and Vulci include descriptions and plans of later tombs and tomb groups.

G. Rosi "Sepulchal Architecture as Illustrated by the Rock Façades of Central Etruria," *JRS*, 15 (1925), pp. 1–59, Pls. 1–11, and *JRS* 17 (1927), pp. 59–95.

L. Pernier "Tumulo con tomba monumentale al Sodo presso Cortona," *MonAnt*, 30 (1925), pp. 88–127.
An Archaic chamber tomb.

Bibliography

R. Bianchi Bandi-
nelli
"La tomba dei Calini Sepuś presso Monteriggione," *StEtr*, 2 (1928),
pp. 133–76, Pls. 27–37.
A family tomb, used from the fourth to the first centuries B.C.

D. Levi
"La tomba della Pellegrina, Chiusi," *NSc*, 1931, pp. 475–505.
A Hellenistic tomb.

A. von Gerkan
F. Messerschmidt
"Das Grab der Volumnier bei Perugia," *RM*, 57 (1942), pp. 122–235.
A Hellenistic chamber tomb.

R. Pincelli
"Il tumulo vetuloniese della Pietrera," *StEtr*, 17 (1943), pp. 47–113,
Pls. 6–11.
A tholos tomb of the late seventh century.

G. Caputo
"Nuova tomba etrusca a Quinto Fiorentino," *StEtr*, 27 (1959), pp.
269–70.
Another tholos tomb.

Chapter IX

LANGUAGE

The best account in English of the problems of the Etruscan language and the history of its
decipherment—so far as this has progressed—appears as Part III of M. Pallottino's *The
Etruscans*. In addition to a chapter on the nature of the problem and one on the methods
used to cope with it, there are brief discussions of the alphabet, recognizable grammatical
forms, translations of a number of texts, and a partial lexicon of Etruscan words with their
probable meanings. The best account in English of the alphabet used by the Etruscans is
Rhys Carpenter's "The Alphabet in Italy," *AJA*, 49 (1945), pp. 452–53.

INSCRIPTIONS

Corpus inscriptionum Italicarum (*CII*) 3 vols. Turin, 1867——.

Corpus inscriptionum Etruscarum (*CIE*) Leipzig, 1898——.

N. Buffa
Nuova raccolta di iscrizioni etrusche. Florence, 1935.
This includes all known inscriptions not in *CII* and *CIE* up to 1935.

M. Pallottino
Testimonia linguae Etruscae. Florence, 1954.
A convenient little collection of the most useful inscriptions, arranged
by site.

STUDIES OF THE LANGUAGE

G. Buonamici
Epigrafia etrusca. Florence, 1932.

M. Pallottino
Elementi di lingua etrusca. Florence, 1936.

A. della Seta
"Iscrizioni tirreniche di Lemno," in *Scritti in onore di Bartolomeo
Nogara.* Rome, 1937.

THE ETRUSCANS

THE COMBINATORY METHOD

R. Lambrechts *Essai sur les magistratures des républiques étrusques. (Études de philologie, d'archéologie, et d'histoire anciennes, l'Institut Historique Belge de Rome,* Vol. 7.) Brussels, 1959.
Interesting and provocative.

Chapter X

GENERAL

C. Clemen *Fontes historiae religionum primitivarium.* Bonn, 1936. Pp. 27–57.

A. Grenier *Les Religions étrusques et romaines.* Coll. "Mana" 3. Paris, 1948.
A very brief essay on the known facts of Etruscan religion.

DIVINITIES

R. Herbig *Götter und Dämonen der Etrusker.* Heidelberg, 1948.
A short study of Etruscan gods and demons.

F. de Ruyt *Charun: Démon étrusque de la mort.* Brussels, 1934.

R. Enking "Lasa," *RM,* 57 (1942), pp. 1–15.
"Culsu und Vanth," *RM,* 58 (1943), pp. 48–67.
"Minerva Mater," *JdI,* 59–60 (1944–45), pp. 111–24.

S. Ferri "La 'Juno Regina' di Veii," *StEtr,* 24 (1955), pp. 107–13.

CULTS

L. R. Taylor *Local Cults in Etruria. (PAAR,* Vol. 2.) 1923.
Though not up to date, this is still an essential work of reference.

Q. F. Maule *Votive Religion at Caere: Prolegomena.* Berkeley and Los Angeles,
H. R. W. Smith 1959.

L. Banti "Il culto del cosidetto 'tempio di Apollo' a Veii e il problema delle triadi etrusco-italiche," *StEtr,* 17 (1943), pp. 187–224.
A highly important publication.

DISCIPLINA ETRUSCA

C. O. Thulin *Die etruskische Disciplin.* 3 vols. Göteborg, 1906–9.
"Die Götter des Martianus Capella und der Bronzeleber von Piancenza," *Religionsgeschichtliche Versuche und Vorarbeiten,* 3 (1907).
Nothing has superseded these volumes, which not only quote the original texts of all pertinent ancient references but organize the material into a comprehensible whole.

J. Heurgon "The Date of Vegoia's Prophecy," *JRS,* 49 (1959), pp. 41–45.

Index of Subjects

[Roman numerals refer to plate numbers]

Aborigines, 3, 25
Aequi, 158
Agrimensores, 239
Alphabet, 8, 48–49, 214–17
Apenninic peoples, 5, 6, 7, 17, 31, 32, 33, 35
Architecture, 91, 115–16, 170–72, 179–213
 arcade, 172, 192, 213
 arch, 164, 170–71, 172, 179, 191–92, 201, 202, 203
 capitals: Acolic, 197, 210; Doric, 116; figured, 212; Ionic, 172, 203; Italo-Corinthian, 202
 columns: engaged, 172, 202; Tuscan, 186
 corbeled dome (false dome), 50, 92, 190
 corbeled vault, 51, 192
 dentils, 212
 keystone, 172, 191, 192, 202
 king post, 116, 123
 polygonal masonry, 182, 201, 240
 ridgepole (rooftree), 101–2, 116, 127, 173, 186, 188, 189, 210
 triglyph frieze, 170, 172, 212
 vault, 179, 208, 209, 211
Architecture, constructions:
 city plans, 180, 189, 193–94, 200–201
 fortifications, 30, 181, 194, 201; agger, 181; gates, 170, 172, 180, 182, 192, 194–95, 201, 202, 239; towers, 170, 195, 201–2; walls, 68, 170, 181–82, 194–95, 201–2
 forums, 172, 201, 203, 208, 209
 houses, 123, 180–81, 187, 188, 189, 190, 194, 198, 206–10, 212; alae, 206–7; atrium (cavum aedium), 179, 206, 209; atrium, testudinate, 207, 208, 209; atrium, Tuscan, 207, 209, 210; compluvium, 207, 208, 209; cubicula, 206, 209; fauces, 206; impluvium, 207, 208, 210; peristyle, 207;

tablinum, 206–7, 208, 209, 210; triclinium, 207
 megaron, 184, 189
 pavilion, 116, 190, 198
 public buildings: basilica, 171, 172, 203; bridge, 171; colonnades, 171, 172, 202, 203, 212; comitium and curia, 203, 208
 streets, 180–81, 189, 193, 239
 temples: heroön, 189; terrace, 203, 205–6
 temples, Tuscan, 173, 179, 184–88, 191, 194, 195–98, 204, 240; acroteria, 123, 127, 173, 174, 189, 197, 224; alae, 186, 188, 197, 204, 205, 212; antefixes, XX*a*, XXI, 74, 98–100, 101, 126–27, 128, 130, 173, 184, 187, 196, 197, 204; Campana plaques, 173; columen (rooftree), 173–74, 197; doors, 191, 192, 199, 202; frieze, XX*b*, 99–100, 184; mutuli (rafters), 173, 174, 186, 210; pediment, 34, 89, 128; pediment, open, XLVIII*a*, 128, 173, 187, 189, 197; podium, 206, 212; pronaos, 186, 187, 188, 196 204, 205; relief plaques (columen, mutuli), 127, 131, 174, 187; revetment plaques, 100, 127, 173, 184, 197; roofing, XLVIII*b*; sculpture, pedimental, XXXVII, XLVI, 128–30, 133, 167, 174–76, 195–96, 242; sculpture, roof, 101–2, 127, 196, 224; terracottas, 89, 90, 98–99, 126–31, 172–77, 180, 182, 184, 196, 203, 243
Architecture, materials:
 brick, baked, 192
 brick, sun-dried, 179, 182, 192, 204
 cement, 208
 mortar, 201
 stone, XV*a*, XV*b*, XVIII*a*, XXXVI, XLVIII*b*, XLVIII*c*, 91, 141, 179, 189, 212

Architecture, materials—*Continued*
 wattle-and-daub, 188
 wood, 96, 179, 186, 190–91, 192, 198, 207, 210, 211
Arx, 180–81, 194, 196, 208
Augury, 222, 236–37
Aurini, 25
Ax, 67, 153, 211, 225

Braid, Syrian, 40, 57, 60, 61, 94
Bronze, general, 70, 74, 108
 armor and weapons, 30, 53; helmets, Etruscan, XXXI, 77, 111; helmets, Villanovan, III, 34, 35, 36, 39, 41, 47; shields, 36, 38, 53; swords, 32, 35, 36, 37, 53
 ornaments: fibula, 27, 32, 35, 37, 47; girdle, 36, 37; pendant, V*a*, 39
 statuary; *see* Sculpture, bronze
 techniques: casting, 38, 55, 104; hammering, 34; repoussé, 34, 37, 110–11
 vessels and utensils, 110, 136; ash urn, 36, 38, 111; brazier, 114; candelabrum, 89, 112, 114, 136, 228; cauldron, 53, 54–55, 68; cista, 139–40, 148; incense burner, 112–13, 147, 228; kottabos stand, 136; krater, 117; lampstand, 109, 136; mirror, XXIX, XLI, 112, 121, 137–39, 197, 219, 221, 227, 233, 234, 235, 242; pilgrim flask, 37, 38; pot stand, V*b*, 41; situla, XXX, 68, 111–12, 226, 229, 247; tripod, XXVIII, 35, 39, 89, 108, 112–13
Bulla, XL*a*, 35, 122, 138, 140, 143, 152–53

Carians, 45
Carthaginians, 75, 77
Celts, 78
Chariot, 30, 53, 108, 110–11, 119
Cimmerians, 8, 44–45
Cippus, XIX, 71, 98, 116, 142, 150–51, 192 194, 218, 247
Coins, 158, 168, 169, 170
Copper, 12, 13, 29
Costume:
 Attic helmet, 108, 128
 chiton, 124, 159, 160, 169, 176
 dress, man's, 62, 93, 104–6, 110, 111–12, 113, 117, 120, 123–24, 134, 140, 143, 144–45, 150, 160, 162, 164–65, 167, 171, 229
 dress, woman's, 52, 59, 61, 93, 100, 107, 109, 117, 120, 123–24, 133–34, 140, 144–45, 151–52, 159–61, 169–70, 176, 177, 227, 228
 himation, 144–45, 160, 171

leather cuirass, 108, 134–35, 158, 164, 176
 loincloth (perizoma), 62, 93, 105
 peplos, 105, 128, 145
 plaid material, 59–60
 pointed cap, 102–3, 107, 108, 123–24
 toga, XXV*b*, XXXIX*b*, XLII, XLIII, 67, 102, 106, 117, 123, 129, 132, 134, 144–45, 150, 156, 158, 160, 162, 167, 176, 178, 218
Cremation, 30, 33, 36, 40, 49, 50, 51, 59, 141, 200, 245
 ash urns, XIII, XLV, 30, 51, 53, 59, 67, 97, 102, 141, 159, 163–66, 191, 193, 200, 202, 203, 212–13, 217, 218, 221, 223, 227, 248
 biconical urns (two-storied urns), II, 33, 38, 40, 246
 canopic jars, XII, 58, 141
 hut urns, I, 34, 35, 36, 187, 188, 207, 246
Curule chair (sella curulis), 66–67, 145, 247

Dancing, XXIV, 97, 107, 113, 115, 117, 118, 120, 146, 147, 226–28, 244, 247
Dice, 2, 52, 218–19
Disciplina Etrusca, 220, 223, 227, 234–39
 Libri Fulgurales, 220, 236
 Libri Haruspicini, 220
 Libri Rituales, 220, 239
Drama, 137, 220–21, 225, 227

Faïence, 43, 46, 47, 54, 122
Faliscans, 22, 49, 79
Fasces, 67, 218
Fertility goddess, 57, 58, 244

Games, 63, 67, 75, 228–30; *see also* Subjects
Gauls, 24, 71, 73, 78–79, 80, 81, 82, 84, 125
Gems, XXXIII, 122–23, 189, 224, 235
Glass, 43, 122
Gold mines, 29
Goldwork, 46, 47, 52, 93, 151–53
 objects: bulla, XL*a*, 152–53; earrings, XL*b*, XL*c*, 152; fibula, 52; pectoral, 38, 47, 52
 techniques: beading, XL*a*, XL*c*, 152; filigree, XL*b*, 52, 122; granulation, 52; repoussé, XL*a*, 38, 46, 52, 152–53

Haruspex, 64, 223, 227, 236, 237–38, 240
Hathor locks, 47, 52, 56
Hittites, 7, 47

Inhumation, 30, 31, 33, 36, 38, 40, 50, 51, 141–42, 189, 245

Index

Inscriptions, XIV*b*, 8, 23, 48–51, 53, 66, 122, 135, 136, 137–38, 140, 143, 153, 160, 167, 217–19, 242
Ionians, 45, 103
Iron, 12, 20, 29

Latin League, 69, 76
Latins, 24, 49, 66, 69, 71, 222, 246
Lead, 12
Leagues of twelve cities, 64, 71–73, 74, 76, 80, 223, 227
Lictors, 67, 218, 225
Ligurians, 84
Lituus, 143, 145, 146, 226
Liver of Piacenza, 73, 231, 234–35, 242
Lucumones, 15, 66, 223, 227, 236
Lydians, 2–7, 52

Marble, 73, 90, 91, 171
Marsi, 222
Monteleone chariot, 108, 110–11, 119
Museums; *see under* specific location in Index of Places
Musical instruments:
 bells, 70, 227–28
 castanets, 97, 227, 228
 lyre (cithara), 117, 146, 221, 226–27
 Panpipes, 112, 226
 pipes (auloi), 97, 107, 117, 146–47, 226–28
 trumpets, 143, 145, 146, 218, 225

Oscans, 217, 229

Painting, XXXIV, XXXV, XXXVI, 97, 114–22, 140–41, 146–49, 177–78, 196, 242
Pelasgians, 2–7, 25
Peoples of the Sea, 5–6
Phocaeans, 75, 77, 103
Phoenician bowls, 53–54
Pinakes (painted plaques), 97, 118
Piracy, 16, 17, 27, 75, 77, 112, 125
Plow, 223, 239
Pomoerium, 239–40
Pottery, fabrics:
 Arretine, 27, 86, 200
 black-figure: Attic, 97, 103, 111, 119, 120, 124, 149; Caeretan, 119–20; Chalcidian, 119; Etruscan, XXXII*b*, 121; Ionian, 119, 120; Laconian, 119, 120; "Pontic," 120–21
 black glaze, 158, 217
 bucchero, XIV*a*, XIV*b*, XXXII*a*, 48–49, 53, 54, 58, 59, 69, 90, 104, 119, 121–22, 181

Corinthian, 28, 29, 96, 103, 119, 120
 Gnathia, 158
 impasto, IV*b*, XII, 33, 36, 47–48, 53, 58, 95
 Italo-geometric, IV*a*, 38, 66
 Protocorinthian, 29, 46, 47, 53, 65, 226
 Red-figure: Apulian, 189, 197; Attic, 149–50, 200; Etruscan, XLII, 137, 149–50, 200; Faliscan, 144, 150–51
 white-ground, Attic, 115
Pottery, shapes:
 amphora, XXXII*b*, 119, 121, 200
 aryballos, 28
 askos, 32, 35
 beaked jug, IV*b,* 47, 95
 cauldron, 47, 53
 chalice, 121
 hydria, 119
 kantharos, 38
 krater, 38, 124, 200
 kyathos, XIV*b*, 48, 61, 119
 kylix, 119, 137, 150
 lecythos, 115
 oenochoë, XIV*a*, 38, 46, 48, 58, 65, 66, 121
 rhyton, XXXII*a*, 122
 skyphos, XLII, 38, 46, 53, 65, 144, 150–51
Punic Wars, 83

Rutulians, 64–65

Sabines, 31, 66, 222
Samnite Wars, 24, 81, 82, 156, 201
Samnites, 31, 78, 81, 82, 91, 125, 155
Sanctuaries, open-air, XLVIII*c*, 182, 183, 194, 240
Sarcophagi, XLIII, XLIV, 67, 97, 123, 137, 142, 143–44, 163–64, 169–70, 193, 217, 218, 226, 229, 242, 246, 247, 248
Scarab, 35, 43, 224
Sculpture, general:
 Apollo of Veii, 101–2
 "Arringatore," 167–68
 "Brutus," 168
 caryatids, 53, 58, 59, 90, 189
 Chimaera of Arezzo, 135–36, 141
 cult statues, 68, 89, 241, 243–45
 Daedalic figures, 91, 93–95, 97, 103
 hand-on-hip, XXV*b*, 39, 106, 123
 Hittite pose, XV*a*, XV*b*, XV*c*, 61, 62, 94, 107
 Mars of Todi, 134–35, 158
 portraits, 34, 59, 90, 141, 156–57, 164–67, 177, 246

Sculpture, materials and types:
 bronze reliefs, 108, 110–12, 226
 bronze statuary, 89, 103–13, 132–36; decorative, V*a*, V*b*, VI, VII, VIII, IX*b*, XXVI*a*, XXVIII, 72, 89, 226; funerary, 90, 93; honorary, 90, 155–56; votive, XV, XXIV, XXV, XXVI*b*, XXVII, XXXIX, XLVII, 26, 60–62, 89–90, 92, 93, 103–9, 132–36, 157–62, 183, 194, 218, 234, 241–42, 243, 247
 ivory, IX*a*, XI, 46, 54, 56–57, 58, 244
 ivory reliefs, X, 47, 51, 56–57, 60
 stone, XVII, 91–98, 141–46, 163
 stone reliefs, XVIII, XIX, XLIII–XLIV, 92, 95–98
 terracotta, 89, 98–103, 143; funerary, XII, XIII, XLV, 58, 90, 102, 164–66, 169–70; votive, XXII, XXIII, XXXVIII, XLVIII*a*, 90, 101–3, 104, 131–32, 173–74, 187, 246–47; *see also* Architecture
 wood, 241
Sculpture, subjects:
 athletes, 107, 175
 banqueters, XLV*a*, 102, 142, 164, 193, 248
 bearded man, 131, 142, 143
 boxers, 107, 111
 centaur, 94–95
 dancers, 107, 113, 228, 244
 discoboli, 107
 divinities, XXIV*a*, XXIV*b*, XXV*a*, XLVII*a*, XLVII*c*, 93, 104–5, 113, 132, 139, 157, 158, 162, 175, 234, 242, 247
 ephebe, XXXVIII, 131, 132
 giant, XXXVII, 128–30
 harpy, 127
 horse, 53, 95
 horseman, 39, 107, 156
 Janiform figures, 55, 234
 koré, 100, 128, 243
 kouros, 73, 93, 94, 101, 104, 105, 106
 kriophoros, 107
 lion, 95, 141
 lion, winged, XVII, 95
 maenad, 100, 107, 127, 130
 musician, XXVI*a*, 107, 111
 nude female figure, V*a*, V*b*, VII, XI, 39, 40, 41, 57, 228, 243–44
 old man, 131
 priestess, XLVII*b*, 159–61, 175
 satyr, 100, 107, 112, 126–27, 130, 139–40
 seated figures, 58, 60, 131, 132, 141–42, 246–47
 sileni, 74, 113, 226

 siren, VIII, 54–55, 57, 58, 60, 94
 sphinx, IX*a*, IX*b*, 46, 55–56, 57, 58, 59, 95
 togata, equestris, 156
 togatus, XXV*b*, XXXIX*b*, 106, 133, 134, 158, 160, 167
 warrior, VI, XV*a*, XXV*a*, XXVII*a*, 41, 62, 99, 105, 108, 131, 133, 134–35, 158, 159
 woman, XV*b*, XV*c*, XXVI*b*, XXVII*b*, XXXIX*a*, 60–62, 92–94, 101, 102, 107, 108, 109, 133
Sibylline Books, 237
Sicilian expedition, 3
Silver vessels, 38, 52
Social War, 85, 167
Stele, 73, 78, 114, 141, 193; Lemnian, 8, 49, 214
Subjects:
 animals: apes, 41, 47; bull, XXVIII, 113, 143; dolphin, XXXIV, XXXV, 15, 116; ducks, 15, 52, 96, 116; goat, 96, 111; horse, 39, 47, 99, 115, 143; lion, XIV*a*, XIV*b*, XXVIII, 46, 48, 52, 53, 54, 55, 56, 58, 96, 113, 115, 120, 123, 135, 143, 189; panther, 96, 116, 120; stag, X, 56–57, 96, 99
 armed combats, XLV, 127, 141, 164, 172
 assemblies of divinities, 176–77, 204
 banquet in the underworld, 136–37, 147, 248
 carriage, XLIV*a*, 123–24, 145
 centaur, XVIII*b*, 96, 120
 chariot, X, XLIV, 52, 56, 98, 99, 143, 218
 funeral: mourners, 97, 118; prothesis, 97
 funeral banquet, XXXIV, XXXV, XXXVI, 97, 116–17, 146–47, 198, 247; dancers, XXXIV, 97, 115, 117, 118, 120, 146–47, 226–28, 247; musicians, XXXIV, 97, 117, 147, 226–27, 247
 funeral games, 97, 111, 116, 117–18, 141, 146–47, 198, 228–30, 247; boxing, 118, 147, 228; chariot races, 67, 97, 118, 120, 147, 228; foot race, 97, 118; gladiatorial combat, 118, 172, 203, 229–30; horse race, 67, 75, 97, 118, 147, 228; spectators, 97, 121; wrestling, 67, 118, 147, 228
 Gauls, 78, 141
 gorgonea, 100
 griffin, 53, 55, 59, 96, 99, 120, 143
 horseman, 39, 96, 98, 99, 115, 143
 husband and wife, XLIII, XLIV, 144, 150, 166, 226
 journey to the underworld, XIX, XLIV, 97–98, 141, 146, 151, 164, 178, 247–48
 marriage couch, XLIV, 143–44, 193
 Mistress of animals, 46, 52

Index

mythological scenes, 219; Achilles and the slaughter of the Trojan prisoners, 147, 149, 229, 248; Achilles and Thetis, 110; Achilles and Troilus, 96, 116; Actaeon, 248; Admetus and Alcestis, XLII, 151; blinding of Polyphemus, 147, 200; Daedalus and Icarus, XL*a*, 153; Dionysus and Ariadne, 176; Eos and Cephalus, 112, 127, 224; Eos and Memnon, 224; Eteocles and Polynices, 248; Europa and the bull, 119; Greeks and Amazons, 143; Herakles and Hera, 138; Herakles and Iolaus, 139; Hercules and Busiris, 120; Hercules and Cerberus, 229; Hermes and the cattle of Apollo, 120; Judgment of Paris, 120, 175–76; Odysseus and Circe, 248; Odysseus and the sirens, 248; Orestes and Clytemnestra, 248; Orpheus and the Thracian women, 224; Peleus and Thetis, 124; Polydeuces and Amycus, 140; sacrifice of Polyxena, 229; Seven against Thebes, 176, 202; slaughter of the Niobids, 177; Theseus and Pirithous, 147, 242; Venus and Adonis, 138

processions, XXXIII, 123, 143, 226

siren, XXXII*b*, 121

sphinx, X, 47, 52, 96, 120

Temenos, 187, 205

Temples; *see under* specific location in Index of Places

Throne, 53, 141, 246–47

Thunderbolts, 220, 222–23, 236, 239

Tin, 12, 29

Tombs:

chamber, XVI*a*, XVI*b*, XXXVI, 35, 36, 40, 46, 50, 71, 92, 96, 115, 178, 189–91, 194, 198, 209–11, 246

circle, 41, 49, 50

cliff, 25, 35, 211

corridor, 50

die, 35, 192, 211

painted, XXXIV, XXXV, XXXVI, 15, 114, 146–49, 190, 198, 217, 226–28, 247

temple, 35, 189, 212, 213, 246

trench, 33, 36, 40, 50, 92, 96, 189, 245

well, 33, 36, 50, 92

See also under specific location in Index of Places

Travertine, 26, 91, 199, 202

Trojans, 64–65

Tufa, 12, 13, 19, 23, 25, 27, 35, 50, 91, 95, 180–81, 189, 190, 191, 194, 200, 202, 245, 246

Tumuli, 40, 50–51, 92, 95, 189, 190, 193

Tyrsenoi (Tyrrheni, Tyrrhenians), 1–9, 10, 219, 222, 225–26

Umbrians, 2, 3, 5, 23, 31, 79

Urnfields, 7, 8, 24, 30–34, 72

Veneti, 71–72

Villanovans, 4–9, 16, 17, 24, 25, 26, 28–42, 43, 45, 46, 47, 49, 50, 52, 53, 54, 55, 56, 57, 72, 90, 108, 180, 183, 188, 189, 240, 241, 244, 245, 246, 248

Volscians, 79, 81

Wine, 13, 23, 38, 73

Writing, 48, 54

Index of Proper Names

Aeneas, 24, 64–65
Agathocles, 78
Aita (Hades), 242; *see also* Hades
Alcibiades, 77
Alcsentre; *see* Alexandros
Alexander, 144, 154, 159, 161, 175
Alexandros (Alcsentre), 219
Ani (Janus), 235
Antiochus, 238
Aphrodite, 7, 120, 131, 219, 224, 241, 244
Aphrodite Epitumbios, 245
Aplu (Apollo), 219, 233, 234; *see also* Apollo
Apollo, 101–2, 106, 129, 138, 219, 222, 227, 233, 237; *see also* Aplu
Apollo Soranus, 182, 233
Aritimi (Artumes), 47, 187, 219, 233, 234, 241
Artemis, 46, 131, 219, 233, 240, 241
Artile, 221–22
Artumes; *see* Aritimi
Ascanius, 65
Athena, 105, 120, 127, 137, 140, 176, 241
Athena Promachos, 104, 128–30, 242
Augustus (Octavian), 3, 26, 86, 154, 167, 177, 200, 238
Aulestes, 72

Bocchoris (Bokhenranf), 44, 46
Brutus, 76

Cacu (Cacus), 221–22, 227
Caecina, Aulus, 85
Caesar, Julius, 86, 238
Calchas, 138
Calini Sepuś (family), 200
Camertes, 81
Camillus, 78, 156, 232
Catiline, 85–86

Ceres, 118, 157
Charun, 149, 150, 165, 178, 229, 242–43
Cilens, 205, 234, 235
Cilnii (family), 82, 86
Circe, 1, 71
Croesus, 103
Culsans, 234
Culsu, 243
Cypselus, 65
Cyrus, 217

Damophilos, 118, 196
Demaratus, 29, 65–66, 89, 118
Di animales, 247
Di Consentes, 234, 235, 236
Di Involuti, 234–36
Diana, 68, 160, 182
Dindia Macolnia, 140
Dionysius of Syracuse, 17, 77, 232
Dionysus, 112, 113, 122, 137, 138, 139–40, 162, 219, 233
Diopus, 89
Dioscuri, 202
Dis Pater, 73, 229

Ecphantus, 118
Eileithyia, 127, 232, 241
Eros, 139
Esarhaddon, 44
Eucheir, 89
Eugrammon, 89

Fabius, Caeso, 81
Fabius, Quintus, 24, 81–82
Feronia, 182, 233, 234, 241
Fufluns, 219, 233, 234

Index

Genius, 162, 175, 223
Geryon, 147
Gorgasos, 118, 196
Gracchus, Gaius, 238
Gracchus, Tiberius, 84
Gyges, 44, 45

Hades, 147, 148 151, 242, 243, 247, 248
Halesus, 4
Hannibal, 19, 26, 83–84, 238
Harpagus, 75
Helen (Elinai), 219
Hephaistus, 110
Hera, 120, 233, 234
Herakles; see Hercules
Hercle (Herecele), 137, 219, 224–25, 233, 235
Hercules (Herakles), 68, 73, 89, 96, 101, 104,
 105, 113, 120, 127, 133, 137, 157, 158–59, 161,
 176, 219, 222, 233, 242, 245
Herecele; see Hercle
Herennius Siculus, 238
Hermes, 101, 106, 120, 219, 233
Hermodorus of Salamis, 171
Hieron of Syracuse, 77, 111, 125
Horatius Cocles, 90, 155–56
Hostia, 233, 234, 241

Janus; see Ani
Juno, 68, 173, 187, 233, 236, 239
Juno Curritis, 232–33
Juno Regina, 171, 232
Juno Sospita, 196
Jupiter, 68, 127, 129, 132, 157, 162, 187, 202, 223,
 233, 234, 235, 236, 239, 240, 241, 242, 249
Jupiter Latiaris, 157, 182
Jupiter Optimus Maximus, 67, 132
Jupiter Stator, 171

Klanins, 234

Larthia, 51–52, 219
Latinos, 1–2, 64
Leucothea, 77, 127–28, 232, 241
Lucumo, 65–66

Macstrna; see Mastarna
Maris, 224–25, 233, 234
Marius, 85
Mars, 68, 79, 104, 106, 176, 233, 236, 240, 241,
 245

Marsyas, 222
Mastarna (Macstrna), 69, 221
Mater Matuta, 183, 241
Megales, 222
Menarva; see Mera
Menelaus (Menle), 219
Mera (Menarva, Meneruva), 137, 224–25, 233,
 234
Mercury, 233, 235
Mezentius, 64–65
Minerva, 68, 104–5, 131, 187, 205, 224, 233, 236,
 239, 240, 241, 242, 245
Minerva Capta, 232–33
Muantrns, 234
Munthu, 224

Neptune, 4
Nevzna (family), 141
Nortia, 233, 234, 241
Novius Plautius, 140–41

Ocnus, 72
Octavian; see Augustus
Odysseus (Ulysses), 1, 16, 71, 243
Olta, 223, 239
Orpheus, 138, 224, 227

Paris, 120, 175–76, 219
Persephone, 41, 142, 147, 148, 151, 242, 243, 247,
 248
Persius Flaccus, Aulus, 86
Phersiphnai, 242; see also Persephone
Phersu, 215, 229–30
Pluto, 41
Polyclitus, 132, 134, 177
Polygnotus, 147, 242
Porsena of Clusium, Lars, 24, 70–71, 73, 90, 155,
 223
Porsina of Volsinii, 223, 239
Postumius, 238
Psammetichos (Psamtik), 44
Pyrrhus, 201

Sargon II, 8, 44
Satres, 235
Saturnus, 235, 236
Scipio Africanus, 18, 20, 26, 83–84, 171
Scopas, 161
Seianti (family), 169–70
Selvans (Silvanus), 234
Semele, 138

THE ETRUSCANS

Semo Sancus, 69
Servius Tullius, 69
Sethlans, 233
Silvanus; *see* Selvans
Spurinna, 238
Sulla, 85, 87, 238
Summanus, 236

Tages, 223, 227, 236
Tanaquil, 65
Tarchon, 222, 223
Tarchunies Rumach, Cneve, 69, 221
Tarquinius Priscus, Lucius, 65–66, 68, 69, 71, 76, 78, 89, 118, 228, 237
Tarquinius Superbus, Lucius, 66, 68, 69, 76, 188
Tarquitius Priscus, 220
Tetnie (family), 143–46
Thalna, 224
Thuflthas, 234, 235
Tiglath-Pilesar, 44
Tinia, 127, 219, 224, 233, 234, 235, 241, 242
Tiresias, 73, 147
Tivs, 235
Tolumnius of Veii, Lars, 79
Tuchulcha, 242
Turan, 7, 127, 131, 187, 219, 224, 233, 234, 240, 241, 245

Turms, 219, 233
Turnus, 64

Ulysses; *see* Odysseus
Uni, 128, 233, 234, 241
Usils, 234

Vanth, 146, 149, 165, 243
Vegoia, 240
Velcha (family), 148, 177
Velimnai (Volumnii) (family), 168, 209–10
Venus, 7, 233, 240, 249
Venus Libitina, 245
Vertumnus (Vortumnus), 157, 232
Vesta, 34
Vibenna, Aules (Avle Vipinas, Avile Vipiiennas, Avles Vpinas), 69, 150, 221
Vibenna, Caeles (Caile Vipinas), 69, 221
Viśnai, Ramtha, 143–46, 151, 163, 165
Volnius, 220, 225
Voltumna, 233, 234
Volumnii; *see* Velimnai
Vortumnus; *see* Vertumnus
Vulca of Veii, 68, 89, 241
Vulcan, 86, 232, 233, 236, 240

Zeus, 77, 128, 132–33, 138, 224, 233, 242

Index of Places

[Roman numerals refer to plate numbers]

Abruzzi, 31, 158
Acquapendente, 12, 19
Adria (Atria, Hatria), 72, 78, 207
Aemilian Way, 73
Agylla, 4; see also Caere
Alalia, 75, 77
Alban Hills, 30, 32, 34, 71
Alban Lake, 29, 227, 237–38
Alban Mount, 157, 182
Albegna River, 10, 16, 25, 26, 84, 218
Allumiere, 29
Alsium, 4
Amiata, Mount, 13
Anatolia, 33, 40, 44, 47, 51, 55
Apennines, 10, 13, 20, 27, 30, 31, 71–73, 78, 83, 84, 158
Appian Way, 70
Apuan Alps, 11
Apulia, 28, 30, 189, 197
Ardea, 118, 181
Arezzo; see Arretium
Arezzo, Museo Archeologico: XVa, 61–62; XVc, 60–61; XLVIIIb, 187
Argentario, Mount, 12, 14, 16, 201
Ariminum; see Rimini
Arno River, 10, 11, 14, 84; see also Val d'Arno
Arretium (Arezzo), 19, 23, 24, 26, 60, 64, 66, 81, 82, 83, 84, 85, 86, 92, 93, 135, 141, 161, 175, 183, 234
Assyria, 44–45, 47, 57, 91
Athens, Acropolis, 113–14, 157, 177
Atria; see Adria
Aurelian Way, 18

Baltimore, Walters Art Gallery: IXa, 46, 52, 56; X, 47, 56–57; XLa, 152–53; XLVIIc, 162, 175
Berlin, Antiquarium, 133; XXIVb, 104–5

Berlin, Pergamon-Museum, 169
Berlin, Staatliche Museen: XXa, 98–99, 184
Bieda (anc. Blera), 25, 35, 191
Bisenzio (anc. Visentium), 25, 35, 38
Bologna (Bononia), 31, 71–72, 73, 78, 84, 111, 114, 141, 193, 247; see also Felsina
Bologna, Museo Civico, 176
Bolsena, 19, 23, 204–5, 206, 221; see also Volsinii
Bolsena, Lake, 10, 12, 19, 23, 25
Bomarzo, 217
Bononia; see Bologna
Boston Museum of Fine Arts: XXXIIa, 122; XXXIII, 123–24, 226; XLI, 138–39, 227; XLII, 150–51; XLIII, 143–46, 226; XLIV, 123, 143–46
Bracciano, Lake, 10, 12, 18, 19
Bruna River, 14
Brussels, Musée du Cinquantenaire: XIVa, 48, 52

Caere (Cerveteri), 4, 6, 11, 16, 17, 18, 23, 27, 29, 32, 35, 37, 38, 46, 47, 50, 56, 58, 60, 64, 66, 70, 75, 77, 80, 81, 82, 91, 98–99, 100, 102–3, 108, 118, 119, 126, 127, 131, 142, 150, 151, 166, 180, 187, 189, 190, 191, 193, 198, 209, 219, 224, 232, 234, 246
Caere, cemeteries:
 Banditaccia, XVIa, 191
 Sorbo, 56
Caere, tombs:
 Capitals, XVIb, 190–91, 199
 Regolini-Galassi, 49, 51–54, 56, 58, 59, 71, 92, 119, 190, 200, 246
 Reliefs, 210–11
 Thatched Roof, 188
Calabria, 28

Camers, 108

Campania, 1, 29, 37, 71, 73–74, 75, 76, 77, 78, 81, 98–99, 107, 119, 124, 125, 184, 211, 215, 217, 218, 222, 229

Campiglia Marittima, 12

Capalbio, 11

Capena, 80, 182, 233

Capodimonte, 25

Capua (Etrusc. Volturnus), 74, 98–99, 100, 103, 107, 125, 155, 217, 218, 226

Caria, 214

Carsòli (anc. Carseoli), 158–60, 162

Carthage, 43, 69, 76, 78, 84, 85, 201

Cassian Way, 12, 18, 19

Castel d'Asso, 25

Catania, Castello Ursino: XXXIX*b*, 134, 150, 167

Catena Metallifera (the ore-bearing chain), 11, 14, 16, 17, 19, 25, 27, 29

Cava de' Tirreni, 74

Cecina River, 16, 20; *see also* Val di Cecina

Cerveteri; *see* Caere

Chiana; *see* Val di Chiana

Chiusi; *see* Clusium

Chiusi, Museo Civico: XIX, 97–98, 247; XLVIII*c*, 183–84

Ciminian Forest, 24, 26, 81–82

Ciminian Mountains, 18, 24

Civita Alba, 176

Città Castellana; *see* Falerii Veteres

Civitavecchia, 10, 13, 14, 201

Claudian Way, 18

Cleveland Museum of Art, 133

Clusium (Chiusi), 19, 23, 24, 26, 35, 38, 49, 53, 58–60, 66, 67, 70–71, 76, 80, 83, 85, 96–98, 100, 103, 108, 114, 116, 122, 141–43, 146–47, 150, 163–64, 169–70, 172, 183, 189, 198, 200, 203, 209, 211, 221, 224, 234, 246, 247

Clusium, tombs:
 Casuccini, XXXVI, 147, 191, 198–99, 210
 Monkey, 147, 228

Clusium Vetus (Clusium-by-the-Sea), 24, 71

Colline Metallifere (the ore-bearing hills), 20

Copenhagen, Ny Carlsberg Glyptotek: XX*b*, 99, 184; XXIII, 102–3

Corsica, 75, 76, 77, 103

Cortona, 3, 19, 23, 26, 82, 83, 93, 234

Cortona, Palazzo Pretorio, 234

Cosa, 12, 14, 15, 16, 24, 131, 170, 173–75, 183, 200–201, 203, 205, 208, 209, 212, 239

Creston, 2

Crete, 34, 115, 214, 224

Cumae, 1, 28, 29, 37, 45, 49, 74, 77, 111, 119, 125, 211, 215, 237

Cyprus, 33, 43, 68, 100, 105, 133, 136, 242, 244

Delphi, 27, 44, 72, 75, 147, 229, 237–38, 239, 242, 244

Detroit Institute of Arts, 156

Dodona, 114

Egypt, 35, 43, 44, 45, 46, 54, 56, 57, 88, 91, 116, 217

Elba (anc. Ilva), 12, 20, 77

Elea (Velia), 75

Emilia, 30

Faesulae (Fiesole), 19, 23, 24, 51, 83, 85, 86, 173, 183, 203–4, 205, 206

Falerii Novi (Santa Maria dei Falleri), 20, 201–2

Falerii Veteres (Città Castellana, Faleria), 4, 20, 23, 24, 25, 64, 80, 81, 82, 83, 100, 126, 127, 130, 150, 201, 232–33

Falerii Veteres, Lo Scasato Temple, 175

Faliscan region, 38, 99

Falterona, Lake, 133

Fanum Voltumnae, 63–64, 67, 80, 228

Felsina (Bologna), 71–72, 73, 78, 84; *see also* Bologna

Fermo, 31

Fidenae, 79, 156

Fiesole; *see* Faesulae

Fiesole, Museo Civico: XXIV*a*, 105, 133

Fiora River, 10, 11, 12, 16, 23, 25, 192, 211

Flaminian Way, 18, 20

Florence (anc. Florentia), 15, 18, 19, 72, 85, 104, 106

Florence, Museo Archeologico, 92, 137, 170, 204–5, 211, 215; V*a*, 39, 42, 54; V*b*, 40, 54; VI, 41, 54, 62; VII, 41–42, 54, 56; XI, 57–58; XIV*b*, 48–49; XV*b*, 61–62, 94; XVIII*b*, 96–97; XLVI, 175–76; XLVII*a*, 158–59, 176; XLVII*b*, 160–61, 169, 175, 176

Follonica, 20

Formello, 226

Gabii, 69

Gavorrano, 12

Gordium, 8, 44, 51, 55

Graviscae, 84

Grosseto, 14, 16

Hatria; *see* Adria

Herculaneum, 74, 168

Index

Ionia, 75, 99, 103, 124, 183
Ischia, 29, 37

La Spezia, 10, 14
Lanuvium, 100, 118, 126, 196
Latium (Lazio), 10, 18, 29, 30, 32, 34, 35, 47, 49,
 64, 74, 76, 77, 98, 100, 124, 126, 131, 155,
 160, 182, 183, 184, 188, 196, 205
Le Saline, 20
Leghorn (Livorno), 14
Lemnos, 3, 8, 33, 214
Liguria, 18
Lipari Islands, 30
Locri, 74, 114
London, British Museum, 93, 160, 169; XXII,
 101; XXV*b*, 106; XXIX, 112; XXXI, 75;
 XXXIX*a*, 133, 151
Lucania, 74, 75
Lucca (anc. Luca), 17, 84
Luni (anc. Luna), 10, 18, 84, 131, 177
Lydia, 44–45, 67, 99, 103, 217, 219, 226

Mantua, 73, 78
Marcina, 74
Maremma, 15, 116, 201
Marsiliana d'Albegna, 16, 18, 23, 25, 40, 49, 58,
 244
Marsiliana d'Albegna, tombs:
 Fibula, XI, 57
 Ivories, 215–16
Marta River, 12, 25, 192, 211
Marzabotto, 72, 78, 130, 183, 187, 196–97, 198,
 201, 206
Marzabotto, tombs, XVIII*a*, 73, 98, 193–94
Massa Marittima, 12, 20, 133
Melpum, 78
Milan, 71, 247
Modena, 73
Montecristo, 12
Montefiascone, 19
Munich Antiquarium, 108, 120

Naples, 1, 27, 74, 77, 211
Naples, Museo Nazionale, 168; XXVI*a*, 107–8
Narce, 20, 25
Nemi, 160, 162, 174, 182, 187
Nepi (anc. Nepete), 20, 81
New Haven, Yale University Art Gallery: IV*b*,
 47–48, 95; XXXII*b*, 121
New York, Metropolitan Museum of Art, 108,
 110; XVII, 95; XXI, 100; XXVIII, 113–14;
 XL*c*, 152

Nicaea, 75
Nimrud, 57, 60, 61
Nola, 74
Norchia, 25, 35, 212, 213

Olmo Bello, 25
Olympia, 77, 111, 114, 126, 130, 174
Ombrone River, 14
Orbetello, 10, 14, 15, 24
Orvieto, 10, 13, 19, 23, 24, 25, 99, 100, 189, 192,
 193–94, 201, 204, 206, 234, 245
Orvieto, cemeteries:
 Cannicella, 243
 Crocifisso del Tufo, 181
Orvieto, Golini Tomb, 136, 147, 242, 247, 248
Orvieto, Palazzo dell'Opera del Duomo, 229
Orvieto, temples, 130–31
 Belvedere, 131, 197

Paestum (anc. Poseidonia), 74, 75, 116
Paglia River, 12, 19
Palestrina; *see* Praeneste
Paris, Bibliothèque Nationale, 168–69; XXVI*b*,
 107; XXVII*b*, 109
Paris, Louvre, 102, 169; XXV*a*, 105–6; XL*b*,
 122
Parma, 73
Pavia, 71
Pergamum, 51, 164, 174, 178, 212
Persia, 67, 103
Perugia; *see* Perusia
Perugia, Musei Civici, 108
Perusia (Perugia), 10, 23, 26, 66, 72, 82, 83, 86,
 100, 108, 142, 163, 172, 202, 211, 213, 218,
 222, 232, 246
Perusia, Volumnii (Velimnai) Tomb, 168, 209–
 10
Philadelphia, University Museum: XIII, 59–60
Phoenicia, 35, 43, 44, 45, 48, 54, 56–57, 215
Phrygia, 44, 189, 222, 226
Piacenza (anc. Placentia), 73, 231, 234
Picenum, 30, 31, 74, 215
Piombino, 14
Pisa, 4, 11, 14, 17, 18, 84
Pithecusa, 29, 37
Pitigliano, 13, 23, 25
Placentia; *see* Piacenza
Po River, 30, 72
Po Valley, 31, 71–72, 75, 76, 78, 84, 107, 111, 124,
 125, 141, 194, 234
Poggibonsi, 19
Poggio Buco, 23, 99, 181

THE ETRUSCANS

Pomarance, 20
Pompeii, 74, 91, 136, 168, 193, 202, 206, 207, 212
Populonia, 12, 16, 18, 20, 23, 51, 83, 182, 190
Praeneste (Palestrina), 59, 71, 100, 139, 212
Praeneste, tombs:
 Barberini, 49, 246
 Bernardini, VIII, IX*b*, 49, 54, 57, 58
Princeton University Art Museum: XXVII*a*,
 108-9
Providence, Rhode Island School of Design,
 Museum of Art: XXX, 68, 111-12, 229, 247
Pyrgi (Santa Severa), 17, 77, 232-33, 234, 241,
 242
Pyrgi, temples, XXXVII, 126, 127-28, 129-30,
 133, 188

Quinto Fiorentino, 50

Radicofani, 13, 19
Reggio Emilia, 73
Reno River, 72, 193-94
Rhodes, 39, 100, 114
Rimini (anc. Ariminum), 18
Rome, 13, 17, 18, 24, 27, 29, 32, 34, 43, 44, 65-71,
 76, 79-87, 89, 99, 114, 118, 124, 125, 126, 132,
 134, 140-41, 152, 154-57, 160, 171, 172, 176,
 180, 181, 187, 188, 189, 195, 201, 203, 221,
 222, 227, 228-29, 236-37, 239, 241, 245
Rome, Capitoline Museum, 167, 168
Rome, Museo Preistorico: VIII, 54-55, 57; IX*b*,
 55-56, 58, 59
Rome, temples:
 Capitoline Jupiter, 68, 89, 184, 188, 196, 240,
 241, 245
 Castor, 205
 Ceres, 118, 196
 Hercules, 173, 184
 Juno Moneta, 217
 Juno Regina, 171, 232
 Jupiter Stator, 171
 Minerva Capta, 232
 Vertumnus, 157, 232
 Vesta, 34
Rome, Vatican, Museo Etrusco Gregoriano, 51,
 113, 143
Rome, Villa Giulia Museum, 102, 127, 139-40,
 175, 226; XXXVII, 128-30; XXXVIII, 132;
 XLVIII*a*, 128, 187
Roselle; *see* Rusellae
Rusellae (Roselle), 14, 15, 16, 18, 23, 66, 82, 83,
 181-82, 201, 203

Sabatinian Mountains, 18
Saena; *see* Siena
Salerno, 74
Salpinum, 23, 80
San Giovenale, 25, 35
San Giuliano, 25
Santa Maria dei Falleri; *see* Falerii Novi
Santa Severa; *see* Pyrgi
Sardinia, 75
Sardis, 51, 66
Satricum, 100, 126, 127, 131, 183
Saturnia, 4, 25, 82
Segni (anc. Signia), 126, 127, 131, 196
Signia; *see* Segni
Siena (anc. Saena), 12, 18, 19
Siena, Museo Archeologico Senese: XII, 58-59
Soracte, Mount, 13, 20, 182, 233
Sovana, 12, 25, 213
Sovana, Hildebrand Tomb, 212
Spina, 72, 78, 113, 114, 194
Statonia, 23
Sutri (anc. Sutrium), 19, 24, 81-82, 233
Syracuse, 17, 28, 77, 78
Syria, 44, 46, 54, 56, 57, 60, 61, 91

Talamone; *see* Telamon
Taranto (anc. Tarentum), 17, 28, 30, 143
Tarquinia, Museo Archeologico, 205; I, 34, 187,
 188, 248; II, 33-34, 59; III, 34; IV*a*, 38
Tarquinii (Tarquinia, Corneto), 4, 11, 16, 17,
 18, 23, 24, 28, 29, 34, 35, 36, 37, 38, 39, 40,
 47, 50, 52, 65, 66, 67, 70, 76, 80-81, 82, 83,
 84, 86, 94, 95-96, 97, 99, 103, 115, 123, 137,
 142, 146, 151, 189, 190, 195, 198, 201, 203,
 215, 222, 223, 234, 244
Tarquinii, temple, 173, 205, 206
Tarquinii, tombs:
 Augurs, 118, 229
 Banquet Couch (Triclinium), 121, 146, 227
 Baron, 118
 Bocchoris, 29, 45-48, 49, 52, 53, 54
 Bulls, 116
 Chariots, 147
 Hunting and Fishing, 15
 Leopards, 146, 148, 227
 Lionesses, XXXIV-XXXV, 115-17, 227-28
 Olympic Games, 147, 229
 Orcus, 147, 148, 200, 242, 247, 248
 Shields, 148, 177, 248
 Typhon, 178, 211
 Warrior's Grave, 38, 47, 52, 53
Telamon (Talamone), 12, 16, 24, 85, 176

Index

Thurii, 156

Tiber River, 10, 11, 12, 13, 14, 20, 25, 79, 108, 222, 238

Ticinus River, 71

Todi (anc. Tuder), 20, 134–35, 158

Tolfa, 29

Tolfa Mountains, 13, 29, 30

Trasimene, Lake, 10, 13, 23, 83, 167

Treia River, 25

Troy, 32

Tuder; see Todi

Tursa (Tyrsa), 7

Tuscan Archipelago, 12, 201

Tuscania, 99, 141, 218

Tusculum, 71

Tyrrhenian Sea, 10, 14, 16, 25, 32, 75, 125

Umbria, 10, 20, 30, 74, 100, 108–9, 124, 135, 155, 176, 217

Urartu (Kingdom of Van), 44, 55, 56

Vadimo, Lake, 82

Val d'Arno, 13, 19

Val di Cecina, 12

Val di Chiana, 13, 70

Valerio, Mount, 12

Van; see Urartu

Veii, 4, 18, 23, 27, 38, 63–64, 66, 67, 69, 70, 76, 78, 79–80, 98–99, 100, 101–2, 104, 106, 125, 132, 180, 188, 194–95, 206, 224, 226, 227, 228, 232, 233, 237–38

Veii, Campana Tomb, 115, 191

Veii, temples:
 Piazza d'Armi, 184, 204, 206
 Portonaccio, 101–2, 127, 131, 180, 183, 184, 187–88, 240, 241

Velia; see Elea

Velletri (anc. Velitrae), 100

Verrucchio, 31

Vesuvius, Mount, 73–74

Vetralla, 19

Vetulonia, 12, 14, 16, 18, 23, 35, 39, 40, 41, 43, 47, 49, 50, 54, 57, 61, 62, 66, 67, 92, 95, 162, 181, 182, 190, 209, 244, 245

Vetulonia, tombs:
 Acquastrini, VI, 41
 Cauldrons, 55
 Costiaccia Bambagini, VII, 41, 56
 General (Duce), XIV*b*, 49, 62
 Pelliccie, V*b*, 40
 Pietrera, 50, 92–93, 96

Vico, Lake, 10, 12, 18, 19, 24, 81

Vignanello, 99, 183

Visentium; see Bisenzio

Viterbo, 19, 163

Volaterrae (Volterra), 11, 12, 16, 18, 19–20, 23, 66, 67, 82, 83, 85, 86, 150, 163, 166, 182, 190, 200, 202, 211, 218

Volaterrae, Inghirami Tomb, 211, 223

Volsinii (Bolsena), 19, 23, 80, 82, 83, 89, 157, 223, 232, 233, 234

Volterra; see Volaterrae

Volturnus; see Capua

Volturnus River, 74, 222

Vulci, 11, 12, 14, 15, 16, 18, 23, 67, 82, 91, 94, 95, 96, 112–14, 122, 123, 124, 135, 142–44, 150, 163, 165, 167, 180, 201, 209, 218, 226

Vulci, tombs:
 Cucumella, 50, 68
 Cucumelletta, 50
 François, 147, 149, 199, 210, 221, 229
 Isis, 93–94

Worcester Art Museum: XLV, 159, 164–66, 191, 212–13

Index of Ancient Authors and Sources

"Acta Triumphorum Capitolina," 82
Appian, 86
Arnobius, 144, 231, 235, 247
Asconius, 134
Athenaeus, 103, 109, 114, 225, 226, 228, 229
Augustine, 68

Cato, 18, 64, 74, 171, 241
Censorinus, 63, 220, 223, 227, 249
Cicero, 14, 85, 86, 171, 220, 223, 235, 237
Cornelius Nepos; see Nepos, Cornelius
Critias, 109, 114

Dio Cassius, 83, 86
Diodorus Siculus, 17, 75, 77, 78
Dionysius of Halicarnassus, 3, 4, 5, 6, 7, 25, 29,
 65, 66, 67, 68, 69, 77, 157, 196, 231

Eusebius, 28

Festus, 157, 236, 239

Hellanicus of Lesbos, 3, 5
Herodotus, 2, 3, 4, 5, 6, 7, 44, 45, 52, 63, 65, 75
Hesiod, 1, 6
Homer, 16, 110, 228, 243

Isidore of Seville, 215, 223

Justinus, 4
Juvenal, 225

Livy, 17, 18, 19, 23, 24, 26, 63, 64, 65, 66, 68, 69,
 70, 71, 72, 74, 76, 78, 79, 80, 81, 82, 83, 84,
 86, 108, 155, 156, 157, 171, 194, 195, 217, 220,
 222, 225, 227, 228, 229, 231, 238, 241

Macrobius, 65, 152
Martianus Capella, 235

Nepos, Cornelius, 78, 118
Nonius Marcellus, 144

Ovid, 4, 34, 65

Pausanias, 90, 148, 149
Pliny, 3, 4, 5, 7, 23, 24, 25, 29, 65, 68, 73, 78, 88–
 89, 90, 118, 134, 152, 155, 156, 157, 159, 166,
 173, 196, 220, 222, 235, 241
Plutarch, 84, 85
Polybius, 24, 69, 71, 73, 78, 82, 156, 166
Propertius, 157

Sallust, 86
Scholia on Iliad, 226
Scriptores Historiae Augustae, 132–33
Seneca, 23, 236
Servius, 4, 18, 20, 66, 72, 180, 215, 222, 235, 236,
 239, 247
Silius Italicus, 222, 225
Solinus, 4, 222
Statius, 225
Strabo, 4, 5, 14, 17, 73–74, 78, 225
Suetonius, 63, 86, 215

Tacitus, 240
Tertullian, 229
Thucydides, 2, 6, 8, 28, 77–78, 155
Timaeus, 43, 228

Valerius Maximus, 171
Varro, 23, 43, 63, 68, 70, 144, 196, 207, 210, 220,
 225, 232, 235, 239, 241
Velleius Paterculus, 74, 171
Virgil, 24, 65, 71, 222, 225, 228, 249
Vitruvius, 23, 171, 172, 173, 179, 184, 191, 196,
 201, 204, 205, 206, 210, 240

Notes on the Plates

I. Tarquinia, Museo Archeologico. Hut urn #1 Monterozzi Cemetery, Tarquinia. Archaic I, ninth–eighth centuries. Photograph by Felbermeyer.

II. Tarquinia, Museo Archeologico. Ash urn and terracotta helmet. Grave 39, Poggio dell'Impiccato, Tarquinia. Archaic I, ninth–eighth centuries. Photograph by Felbermeyer.

III. Tarquinia, Museo Archeologico. Bronze Villanovan helmet. Tomb of February 22, 1882, Monterozzi Cemetery, Tarquinia. Photograph by Felbermeyer.

IV*a*. Tarquinia, Museo Archeologico 2422. Italo-Geometric painted jug with trefoil lip. Ht. 0.30 m. *Corpus vasorum antiquorum, Italy* fasc. 25, *Museo Nazionale Tarquiniense* fasc. 1; IV, C, 1. Pl. 1, 1. Photograph by Felbermeyer.

IV*b*. New Haven, Connecticut, Yale University Art Gallery 1913-217. Long-necked impasto jug with relief ornament. Ht. 0.35 m. Archaic III. Paul V. C. Baur, *Catalogue of the Rebecca Darlington Stoddard Collection of Greek and Italian Vases in Yale University* (New Haven, 1922), p. 135, No. 217, Fig. 51. Photograph Courtesy of the Yale University Art Gallery.

V*a*. Florence, Museo Archeologico. Bronze pendant in the form of a nude female figure. Ht. 0.058 m. Trench tomb 9, Poggio Gallinaro, Tarquinia. Archaic II. L. Pernier, *Notizie degli scavi* (1907), p. 341, Fig. 70. Photograph by Felbermeyer.

V*b*. Florence, Museo Archeologico 6830. Bronze figure of a nude woman carrying a two-storied jar on her head. Ht. 0.078 m. Second Circle of the Pelliccie, Vetulonia. Archaic III. I. Falchi, *Vetulonia e la sua necropoli antichissima* (Florence, 1891), p. 174, Pl. 15, 5. O. Montelius, *La Civilisation primitive en Italie depuis l'introduction des métaux* (Stockholm, 1910), p. 890, Pl. 196, 22. F. Messerschmidt, "Die 'Kandelaber' von Vetulonia," *Studi Etruschi,* 5 (1931), p. 71, Pl. 5, 1. Photograph by Felbermeyer.

VI. Florence, Museo Archeologico. Bronze head of a warrior. Ht. 0.041 m. Circle of the Acquastrini, Vetulonia. Archaic III. Falchi, p. 186, Pl. 17. M. Pallottino, "Gli scavi di Karmir-Blur in Armenia e il problema delle connessioni tra l'Urartu, la Grecia e l'Etruria," *Archeologia Classica,* 7 (1955), pp. 114–15, Pl. 45. Photograph by Felbermeyer.

VII. Florence, Museo Archeologico 8380. Bronze beast-headed figures. Ht. of male figure 0.11 m., of female, 0.10 m. Circle of the Costiaccia Bambagini, Vetulonia. Archaic III. Falchi, p. 194, Pl. 17. Photograph by Felbermeyer.

VIII. Rome, Museo Preistorico. Bronze siren's head from the rim of a cauldron. Ht. 0.071 m. Bernardini Tomb, Palestrina. C. Densmore Curtis, "The Bernardini Tomb," *Memoirs of the American Academy in Rome*, 3 (1919), pp. 72–75, No. 75, Pl. 52, 2; Pl. 54, 1. Photograph by Felbermeyer.

IX*a*. Baltimore, Maryland, Walters Art Gallery 71.489. Ivory sphinx from the lid of a pyxis. Ht. 0.045 m. Sorbo Cemetery, Cerveteri. Mid-seventh century. W. Llewellyn Brown, *The Etruscan Lion* (Oxford, 1960), p. 32, Pl. 14*b*. L. Banti, *Il mondo degli Etruschi* (Rome, 1960), p. 299, Pl. 27. Photograph courtesy of the Walters Art Gallery, Baltimore.

IX*b*. Rome, Museo Preistorico. Wingless sphinx from a bronze fitting. Bernardini Tomb, Palestrina. *Ca.* 650 B.C. Curtis, p. 84, No. 91, Pl. 66, 1. Photograph by Felbermeyer.

X. Baltimore, Walters Art Gallery 71.489. Ivory pyxis. Mid-seventh century. See notes under Plate IX*a*. Photograph courtesy of the Walters Art Gallery, Baltimore.

XI. Florence, Museo Archeologico. Ivory figurine of a nude goddess. Ht. 0.095 m. Circle of the Fibula, Marsiliana d'Albegna. Mid-seventh century. A. Minto, *Marsiliana d'Albegna* (Florence, 1921), pp. 86, 216, Pl. 16, 2. G. Q. Giglioli, *L'Arte etrusca* (Milan, 1935), Pl. 30, 3. Photograph by Felbermeyer.

XII. Siena, Museo Archeologico Senese. Impasto head from a canopic jar. Ht. 0.17 m. Castelluccio la Foce, Chiusi. Third quarter of the seventh century. Photograph by Felbermeyer.

XIII. Philadelphia, Pennsylvania, University Museum MS 1399. Terracotta canopic jar with standing effigy, mourners, and griffins' heads. Territory of Chiusi. *Ca.* 650–625 B.C. Photograph courtesy of the University Museum, Philadelphia.

XIV*a*. Brussels, Musée du Cinquantenaire A. 777. Bucchero oenochoë with spout in the form of a lion's head, incised lions on body. Second half of the seventh century. Giglioli, Pl. 41, 5. Brown, pp. 37–38, Pl. 18. Photograph courtesy of the Musées Royaux, Brussels.

XIV*b*. Florence, Museo Archeologico. Bucchero kyathos, winged lions in relief on the interior of the cup, an Etruscan inscription incised on the foot. Ht. 0.245 m. Tomb of the General, Vetulonia. Mid-seventh century. Falchi, Pl. 9, Figs. 13–14. Montelius, Pl. 186, 10. G. Buonamici, *Epigrafia etrusca* (Florence, 1932), Fig. 78. Giglioli, Pl. 39, 3. Photograph courtesy of the Soprintendenza alle Antichità dell'Etruria, Florence.

XV*a*. Arezzo, Museo Archeologico 11495. Bronze figure of an Etruscan warrior. Ht. 0.107 m. Late seventh century. G. Micali, *Storia degli antichi popoli italiani* (Milan, 1836), Pl. 37, 8. G. M. A. Hanfmann, *Altetruskische Plastik I: Die menschliche Gestalt in der Rundplastik bis zum Ausgang der orientalizierenden Kunst* (Würzburg, 1936), p. 88, No. 7. Photograph by Felbermeyer.

XV*b*. Florence, Museo Archeologico 225. Bronze figure of a woman in a cloak. Ht. 0.095 m. Second half of the seventh century. F. Magi, "Di due bronzetti arcaici di offerenti del R. Museo Archeologico di Firenze," *Studi Etruschi*, 12 (1938), pp. 267–70, Pl. 48, 1–2. Photograph by Felbermeyer.

XV*c*. Arezzo, Museo Archeologico 11501. Bronze figure of a girl of the Regolini-Galassi period. Ht. 0.081 m. Micali, Pl. 37, 3. Photograph by Felbermeyer.

XVI*a*. Cerveteri, Banditaccia cemetery. Rear wall of the central chamber of a rock-cut tomb; door and windows opening to the inner chamber. Archaic period. Photograph by Felbermeyer.

Notes on the Plates

XVI*b*. Cerveteri, Banditaccia cemetery. Interior of the main chamber of the Tomb of the Capitals. Early Archaic. G. Ricci. "Caere: Scavi di Raniero Mengarelli," *Monumenti Antichi*, 42 (1955), pp. 450–55, No. 56, Figs. 100–103. Photograph by Felbermeyer.

XVII. New York, Metropolitan Museum of Art 60.11.1. Rogers Fund, 1960. Stone figure of a winged lion, a tomb guardian. Ht. 0.955 m. Early sixth century. *Bulletin of the Metropolitan Museum of Art*, New Series, 19 (October, 1960), p. 45. Photograph courtesy of the Metropolitan Museum of Art.

XVIII*a*. Marzabotto. Etruscan grave with columnar grave marker. Archaic period. Photograph by author.

XVIII*b*. Florence, Museo Archeologico. Carved stone architectural element from an early chamber tomb, Tarquinia. Late seventh century. Giglioli, Pl. 71, 2. Photograph courtesy of the Soprintendenza alle Antichità dell'Etruria, Florence.

XIX. Chiusi, Museo Civico P. 921. Limestone cippus. Late sixth century. D. Levi, *Il museo civico di Chiusi* (Rome, 1935), p. 25, Fig. 7. E. Paribeni, "I rilievi chiusini arcaici," *Studi Etruschi*, 12 (1938), No. 71, Pl. 34. Photograph by Felbermeyer.

XX*a*. Berlin, Staatliche Museen, Antiken Sammlung. Terracotta head antefix from Cerveteri. Early sixth century. A. Andrén, *Architectural Terracottas from Etrusco-Italic Temples* (Lund, 1940), I, p. 20, No. 1:4; II, Pl. 6, No. 13. Photograph courtesy of the Staatliche Museen, Berlin.

XX*b*. Copenhagen, Ny Carlsberg Glyptotek H. 174. Terracotta frieze of warriors and chariots from Cerveteri. Early sixth century. Fr. Poulsen, *Das Helbig Museum der Ny Carlsberg Glyptotek* (Copenhagen, 1927), p. 82; *Bildertafeln des etruskischen Museums, Helbig Museum der Ny Carlsberg Glyptotek* (Copenhagen, 1928), Pl. 62. Andrén, I, pp. 15–17, No. 1:1. Photograph courtesy of the Ny Carlsberg Glyptotek, Copenhagen.

XXI. Boston Museum of Fine Arts 31.912. Terracotta antefix, satyr's head once surrounded by a strigillated shell. Late sixth century. A. Andrén, "Terracottas of Unknown Provenance," *Architectural Terracottas from Etrusco-Italic Temples*, II, Pl. 154, Fig. 520. Photograph courtesy of the Boston Museum of Fine Arts.

XXII. London, British Museum D 217. Terracotta head of a youth, broken from a votive statue. Ht. 0.153 m. Late sixth century. H. B. Walters, *Catalogue of the Terracottas in the Department of Greek and Roman Antiquities, British Museum* (London, 1903), p. 342, D 217. Photograph courtesy of the British Museum.

XXIII. Copenhagen, Ny Carlsberg Glyptotek H. 169. Terracotta head of a girl wearing a cap, from a votive statue from Cerveteri. Ht. 0.24 m. Late sixth century. Poulsen, *Helbig Museum*, p. 81, and *Bildertafeln*, Pl. 60. P. J. Riis, "Etruscan Statuary Terracottas, Archaic and Classical, in the Ny Carlsberg Glyptotek," *From the Collection of the Ny Carlsberg Glyptotek*, 3 (1942), pp. 11–12, Figs. 9–10.

XXIV*a*. Fiesole, Museo Civico 484. Bronze Hercules found at Sant'Apollinare near Fiesole, 1898. Ht. 0.164 m. Third quarter of the sixth century. E. Galli, *Fiesole, gli scavi, il museo civico* (Milan, n.d.), p. 114, Fig. 100. Giglioli, Pl. 124, 1 (full face). Photograph by author.

XXIV*b.* Berlin, Antiquarium 7095. Bronze Minerva found near Florence. Ht. 0.104 m. Third quarter of the sixth century. V. Müller, "Gewandschemata der archaichen Kunst," *Mitteilungen des Deutschen Archäologischen Instituts, Athenische Abteilung,* 46 (1921), p. 49, Pl. 4, 2. Giglioli, Pl. 122, 1. P. J. Riis, *Tyrrhenika* (Copenhagen, 1941), p. 138. Photograph courtesy of the Berlin Antiquarium.

XXV*a.* Paris, Musée du Louvre 125. Bronze warrior or Mars from central Italy. Ht. 0.285 m. Third quarter of the sixth century. A. de Ridder, *Les Bronzes antiques du Louvre* (Paris, 1913), Pl. *14. Encyclopédie photographique de l'art.* (Ed. TEL, Paris, 1938), III, Pl. 99, D. Photograph courtesy of the Louvre Museum.

XXV*b.* London, British Museum 509. Bronze togatus from Pizzirimonte, near Prato. Ht. 0.17 m. Last quarter of the sixth century. H. B. Walters, *Catalogue of the Bronzes, Greek, Roman and Etruscan, in the British Museum* (London, 1899), p. 70, No. 509. W. Lamb, *Greek and Roman Bronzes* (London, 1929), p. 109, Pl. 40*b.* Photograph courtesy of the British Museum.

XXVI*a.* Naples, Museo Nazionale S.N. Bronze figure of a nude boy playing the double pipes. Third quarter of the sixth century. Photograph courtesy of the Soprintendenza alle Antichità della Campania, Museo Nazionale di Napoli.

XXVI*b.* Paris, Bibliothèque Nationale 211. Bronze figure of a woman wearing a pointed cap. Ht. 0.132 m. Second half of the sixth century. E. Babelon and J.-A. Blanchet, *Catalogue des bronzes antiques de la Bibliothèque Nationale* (Paris, 1895), p. 94, No. 211. Photograph courtesy of the Bibliothèque Nationale.

XXVII*a.* Princeton, New Jersey, University Art Museum 41-27. Umbrian bronze warrior. Ht. 0.213 m. Fifth century b.c. D. Levi, "An Archaic Etruscan Statuette," *Record of the Museum of Historic Art, Princeton University,* 1 (1942), pp. 9–13. Photograph courtesy of the Art Museum, Princeton University.

XXVII*b.* Paris, Bibliothèque Nationale 212. Umbrian bronze woman. Ht. 0.162 m. Mid-fifth century. Babelon and Blanchet, p. 95, No. 212. Photograph courtesy of the Bibliothèque Nationale.

XXVIII. New York, Metropolitan Museum of Art 60.11.11. Fletcher Fund 1960. Bronze group of a lion and a bull, from a tripod. End of the sixth or beginning of the fifth century. D. von Bothmer, "Newly Acquired Bronzes—Greek, Etruscan, and Roman," *Bulletin of the Metropolitan Museum of Art,* New Series, 19 (January, 1961), p. 149, Figs. 19–21. Photograph courtesy of the Metropolitan Museum of Art.

XXIX. London, British Museum 545. Bronze mirror, boy running over the sea. Diam. 0.153 m. Late Archaic. E. Gerhard, A. Klügeman, and G. Körte, *Etruskische Spiegel* (Berlin, 1840–97), IV, Pl. 289, 2. Walters, *Bronzes,* p. 76, No. 545. J. D. Beazley, "The World of the Etruscan Mirror," *Journal of Hellenic Studies,* 69 (1942), p. 2, Pl. 1*a.* Photograph courtesy of the British Museum.

XXX. Providence, Rhode Island, Museum of Art, Rhode Island School of Design 32.245. Bronze situla. Ht. 0.277 m. Late sixth century. G. M. A. Hanfmann, "The Etruscans and Their Art," *Bulletin of the Museum of Art, Rhode Island School of Design,* 28 (1940), Figs. 2–7. Photographs courtesy of the Rhode Island School of Design.

XXXI. London, British Museum 250. Bronze Etruscan helmet found at Olympia in 1817. Dedicated by Hieron of Syracuse after his victory over the Etruscans at Cumae in 474 b.c. Ht. 0.204 m. Walters, *Bronzes,* p. 27, No. 250. The inscription reads:

Notes on the Plates

ΘIAPON O ΔEINOMENEOΣ

KAI TOI ΣURAKOΣIOI

TOI ΔI TURAN ATTO KUMAΣ

Hieron son of Deinomeneus
and the Syracusans
to Zeus (for victory) over the Tyrrhenians at Cumae
Photograph courtesy of the British Museum. (The words are not separated in the original.)

XXXIIa. Boston Museum of Fine Arts 80.580 (306). Bucchero rhyton. Ht. 0.185 m. Late sixth century. A. Fairbanks, *Catalogue of the Greek and Etruscan Vases, Museum of Fine Arts, Boston* (Cambridge, 1928), I, p. 218, No. 648, Pl. 88. Photograph courtesy of the Boston Museum of Fine Arts.

XXXIIb. New Haven, Yale University Art Gallery 1913-233. Etruscan black-figure amphora. Ht. 0.23 m. End of the sixth or beginning of the fifth century. Baur, *Catalogue,* p. 143, No. 233, Fig. 55. Photograph courtesy of the Yale University Art Gallery.

XXXIIIa. London, British Museum, Blacas 467. Gem, sardonyx scaraboid, 13 × 10 mm. Death of Capaneus. G. M. A. Richter, *The Engraved Gems of the Greeks, Etruscans and Romans. Part One: Engraved Gems of the Greeks and the Etruscans* (London 1968), p. 205, No. 835.

XXXIIIb. London, British Museum 65.7-12.97. Gem, carnelian scarab, 16 × 13 mm. Perseus and Medusa. Richter, *loc. cit.,* p. 209, No. 854. Photographs by Felbermeyer.

XXXIV. Tarquinia, Monterozzi Cemetery. Tomb of the Lionesses, end wall. *Ca.* 520 B.C. M. Pallottino, *The Great Centuries of Etruscan Painting* (Geneva, 1952), pp. 43–48. Photograph by Felbermeyer.

XXXV. Tarquinia, Monterozzi Cemetery. Tomb of the Lionesses, detail of side wall. Photograph by Felbermeyer.

XXXVI. Chiusi. Tomb of the Hill (Cassuccini), interior. Early fifth century. R. Bianchi Bandinelli, "Clusium," *Monumenti Antichi,* 30 (1925), p. 268 No. 80, Fig. 10. Photograph by Felbermeyer.

XXXVII. Rome, Museo di Villa Giulia. Terracotta group from the center of the pediment of the Tuscan temple at Pyrgi. *Ca.* 460 B.C. M. Pallottino, "Scavi nel santuario etrusco di Pyrgi," *Archeologia Classica,* 9 (1957), pp. 218–22, Pls. 95–100; 10 (1958), pp. 319–22, Pls. 108–10; 11 (1959), pp. 251–52, Pl. 90. Photograph by Felbermeyer.

XXXVIII. Rome, Museo di Villa Giulia. Head of an ephebus; votive terracotta statue from Veii. End of the fifth or beginning of the fourth century. Banti, p. 333, Pl. 77. Photograph by Felbermeyer.

XXXIXa. London, British Museum 613. Bronze figure of a woman. Ht. 0.14 m. Late fifth century. Walters, *Bronzes,* p. 91, No. 613, Pl. 14. Lamb, p. 173, Pl. 66b. Giglioli, Pl. 223, 2. Photograph courtesy of the British Museum.

XXXIXb. Catania, Castello Ursino. Bronze figure of a young man wearing a toga. Ht. 0.185 m. Early fourth century. G. Libertini, *Il Castello Ursino e le raccolte artistiche comunali di Catania* (Catania, 1937), p. 90, No. 3728, Pl. VIII. E. H. Richardson, "The Etruscan Origins of Early Roman Sculpture," *Memoirs of the American Academy at Rome,* 21 (1953), p. 114, Figs. 29–32. Photograph by author.

THE ETRUSCANS

XL*a*. Baltimore, Walters Art Gallery 57.371. Gold pendant with relief of Daedalus flying, said to be from Comacchio (Spina). Ht. 0.04 m. Mid-fifth century. G. M. A. Hanfmann, "Daidalos in Etruria," *American Journal of Archaeology*, 39 (1935), pp. 189–94. E. Fiesel, "The Inscription on the Etruscan Bulla," *American Journal of Archaeology*, 39 (1935), pp. 195–97. Photograph courtesy of the Walters Art Gallery, Baltimore.

XL*b*. Paris, Musée du Louvre. Gold earring ornamented with filigree work. Late sixth century. A. de Ridder, *Catalogue sommaire des bijoux antiques, Musée Nationale du Louvre* (Paris, 1924), p. 23, No. 263 (C 75), Pl. VII. Photograph by M. Chuzeville.

XL*c*. New York, Metropolitan Museum of Art 18.103.1–2. Purchase, funds from various donors, 1918. Pair of gold earrings. Fourth or third century. G. M. A. Richter, *Handbook of the Etruscan Collection, Metropolitan Museum of Art* (New York, 1940), p. 54, Fig. 172. Photograph courtesy of the Metropolitan Museum of Art.

XLI. Boston Museum of Fine Arts 13.207. From the collection of E. P. Warren. Bronze mirror, Orpheus playing the lyre. Diam. 0.146 m. Fourth century. Gerhard, Klügeman, and Körte, V, Pl. 160. Photograph courtesy of the Museum of Fine Arts, Boston.

XLII. Boston Museum of Fine Arts 97.372. Etruscan red-figure skyphos, husband and wife in the presence of Charun. Ht. 0.385 m. Fourth century. J. D. Beazley, *Etruscan Vase Painting* (Oxford, 1947), pp. 166–67, Pl. 37. Photograph courtesy of the Museum of Fine Arts, Boston.

XLIII. Boston Museum of Fine Arts A 1281. Peperino sarcophagus from Vulci. Long frieze, man and wife with attendants. Fourth century. R. Herbig, *Die jüngeretruskischen Steinsarcophage* (Berlin, 1952), pp. 13–14, No. 5, Pl. 40. G. M. A. Hanfmann, "Etruscan Reliefs of the Hellenistic Period," *Journal of Hellenic Studies*, 65 (1945), p. 47, Pl. 8. Banti, p. 340, Pls. 102, 103. *Corpus inscriptionum Etruscarum* (Leipzig, 1898—), II, 1. 2., p. 175, No. 5312. Photograph courtesy of the Museum of Fine Arts, Boston.

XLIV. Boston Museum of Fine Arts A 1281. Peperino sarcophagus from Vulci, top and ends. Photographs courtesy of the Museum of Fine Arts, Boston.

XLV. Worcester, Massachusetts, Art Museum 1926.19. Terracotta ash urn from Chiusi. Mid-second century. G. M. A. Hanfmann, "An Etruscan Terracotta Urn," *Worcester Art Museum Annual*, 5 (1946), pp. 15–31. Photographs courtesy of the Worcester Art Museum.

XLVI. Florence, Museo Archeologico. Head of a youth wearing a Phrygian cap, a terracotta pedimental sculpture from Arezzo. Ht. 0.20 m. Second century. L. Pernier, *Notizie degli scavi* (Rome, 1920), p. 206, No. 6, Pl. 3. Giglioli, Pl. 378, 1–2. Andrén, I, p. 268, No. 1: 1; II, Pl. 89, Fig. 318. Photograph courtesy of the Soprintendenza alle Antichità dell'Etruria, Florence.

XLVII*a*. Florence, Museo Archeologico 146. Bronze statuette of a striding Hercules. Ht. 0.266 m. Second century. Photograph by author.

XLVII*b*. Florence, Museo Archeologico 554. Bronze statuette of a priestess. Second century. *Corpus inscriptionum Etruscarum*, I, No. 301. M. Buffa, "L'Offerta di Larcio Licinio," *Studi Etruschi*, 7 (1935), pp. 451–56, Pl. 25. Photograph courtesy of the Soprintendenza alle Antichità dell'Etruria, Florence.

Notes on the Plates

XLVIIc. Baltimore, Walters Art Gallery 54.1088. Bronze statuette of a togate Genius. Ht. 0.32 m. Second century. D. K. Hill, *Catalogue of Classical Bronze Sculpture in the Walters Art Gallery* (Baltimore, 1949), p. 63, No. 127, Pl. 30. Photograph courtesy of the Walters Art Gallery, Baltimore.

XLVIIIa. Rome, Museo di Villa Giulia. Terracotta model of the pediment of an Etruscan temple from Nemi. Late Hellenistic. G. E. Rizzo, "Di un tempietto fittile di Nemi e di altri monumenti inediti relativi al tempio italico-etrusco," *Bulletino Communale,* 38 (1910), pp. 281–321, Pls. 12, 13. Photograph by Felbermeyer.

XLVIIIb. Arezzo, Museo Civico. Lid of a funerary urn in the form of a gable roof with ante-fixes. Hellenistic. Andrén, I. xxviii, No. 25, Fig. 2. Photograph courtesy of the Soprintendenza alle Antichità dell'Etruria, Florence.

XLVIIIc. Chiusi, Museo Civico 2619. Limestone model of a temenos (sacred enclosure). Levi, *Il museo civico di Chiusi,* p. 23. Photograph by Felbermeyer.

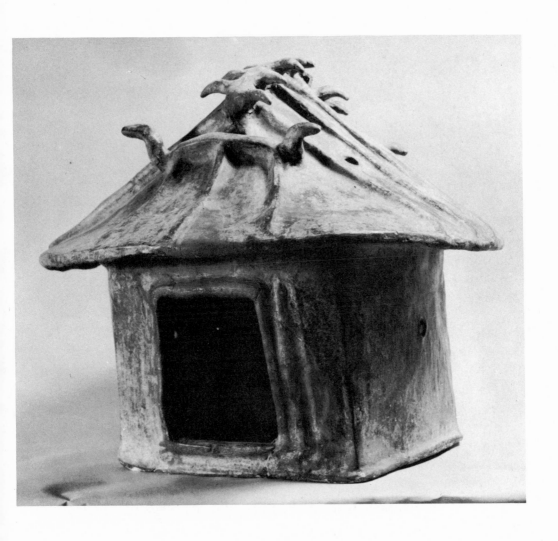

I. Hut urn. Tarquinia.

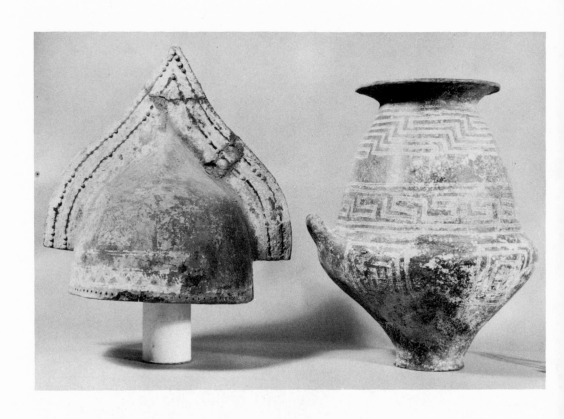

II. Biconical ossuary and helmet. Tarquinia.

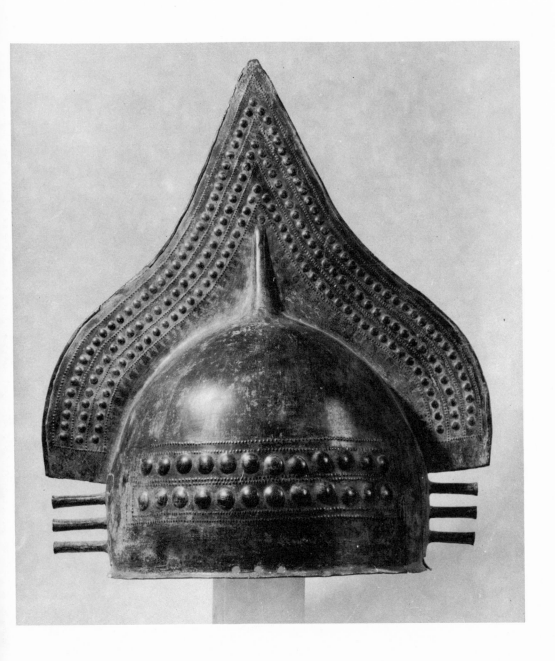

III. Bronze Villanovan helmet. Tarquinia.

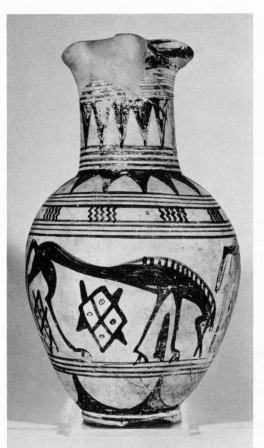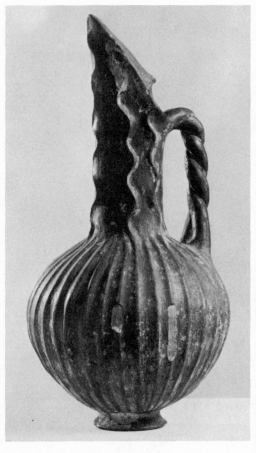

IVa. Italo-Geometric jug. Tarquinia.

b. Impasto jug. Yale University Art Gallery.

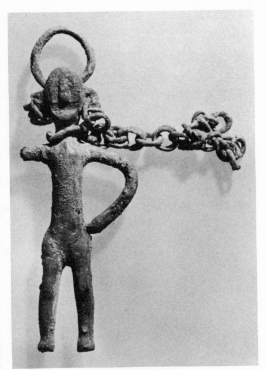 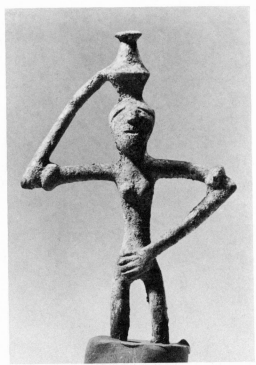

Va. Bronze figure of a nude woman from Tarquinia. In Florence.

b. Bronze woman with pot from Vetulonia. In Florence.

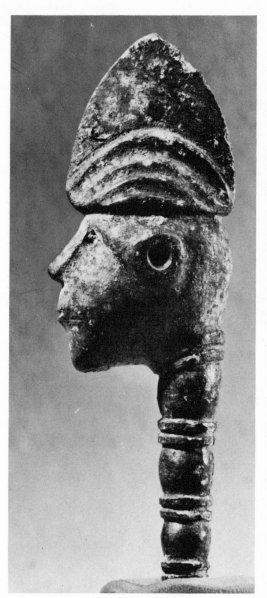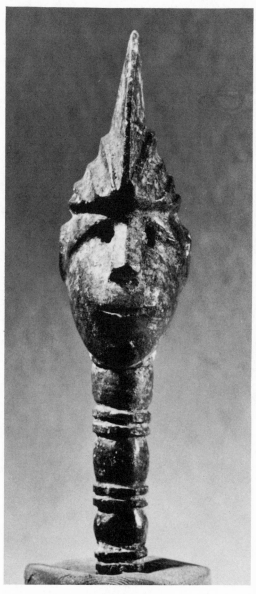

VI. Warrior's head from Vetulonia. In Florence.

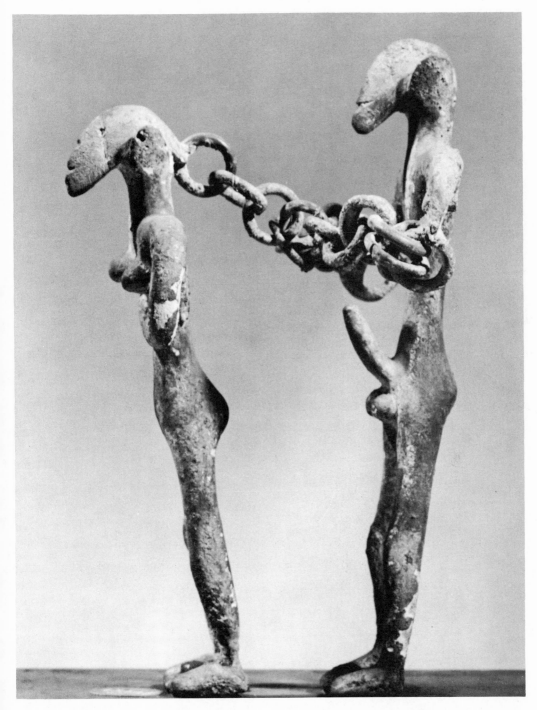

VII. Beast-headed man and woman from Vetulonia. In Florence.

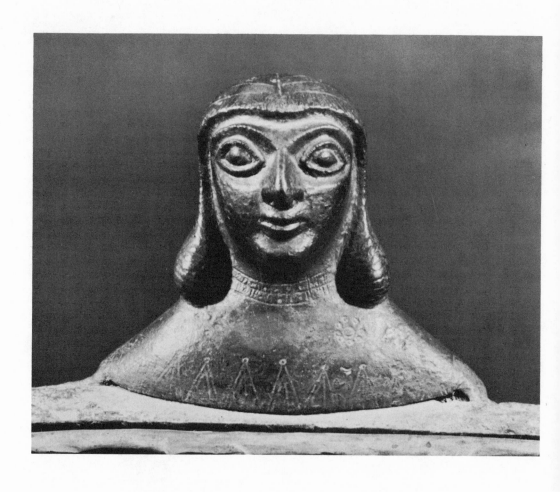

VIII. Siren from the Bernardini Tomb, Palestrina. In Rome.

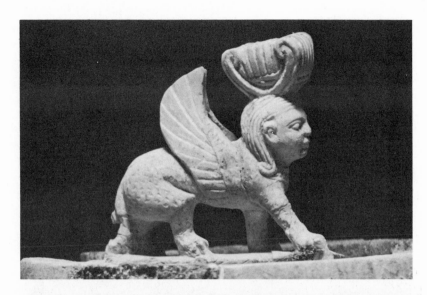

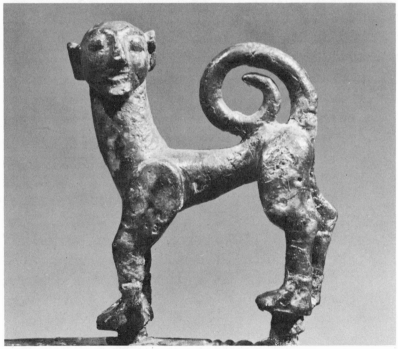

IXa. *Ivory sphinx. Baltimore, Walters Art Gallery.*

b. *Bronze sphinx from the Bernardini Tomb, Palestrina. In Rome.*

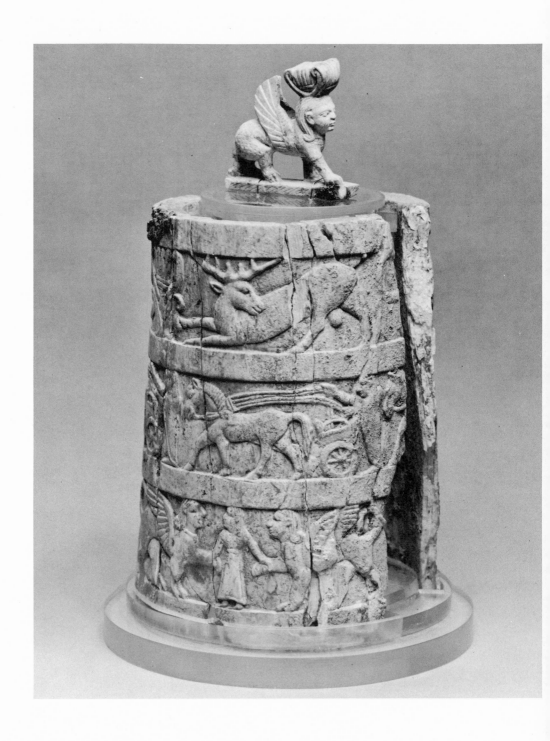

X. Ivory pyxis from Cerveteri. Baltimore, Walters Art Gallery.

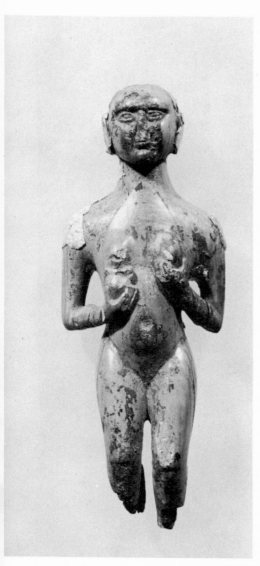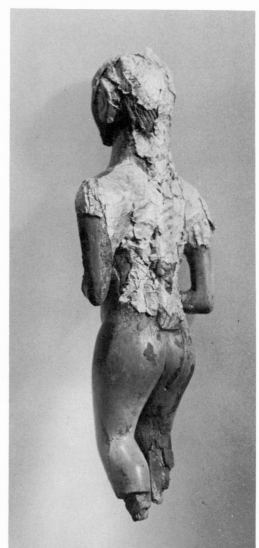

XI. Ivory figurine of a nude woman from Marsiliana. Florence, Museo Archeologico.

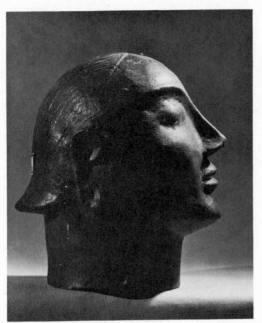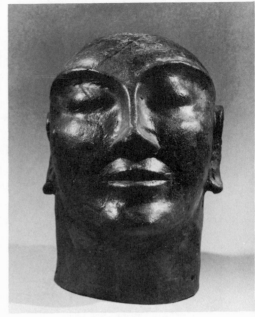

XII. Head from a canopic jar from Castelluccio la Foce, Chiusi. In Siena.

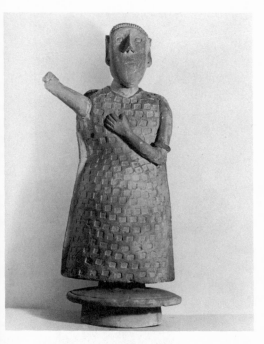

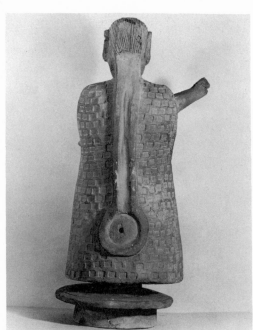

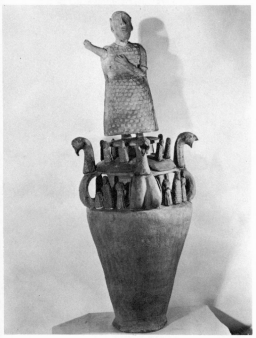

XIII. *Figured ash urn from Chiusi. Philadelphia, University Museum.*

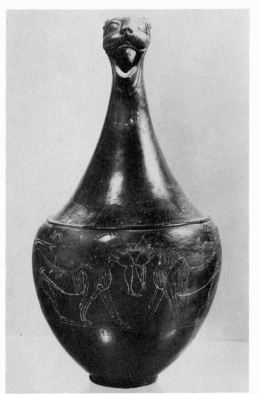 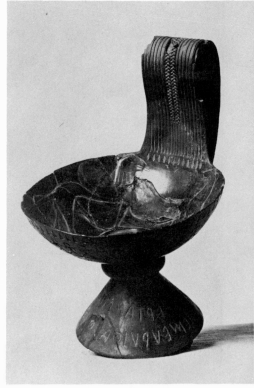

XIVa. Bucchero oenochoë with lion's head. Brussels, Musée du Cinquantenaire.

b. Bucchero kyathos with Etruscan inscription from Vetulonia. Florence, Museo Archeologico.

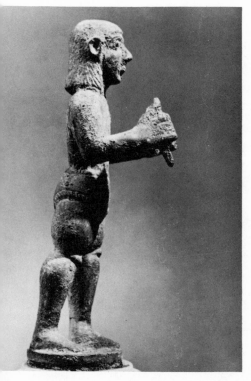

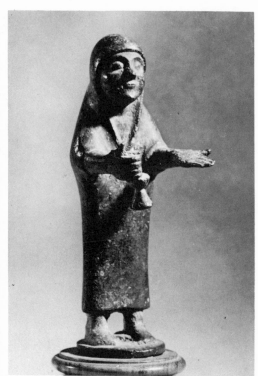

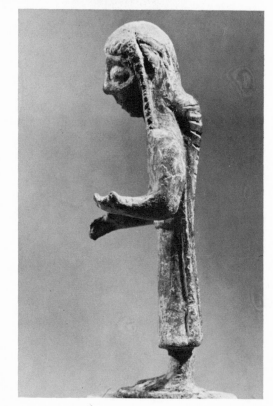

Va. *Bronze warrior. Arezzo 11495.*

b. *Bronze woman in cloak. Florence 225.*

c. *Bronze girl. Arezzo 11501.*

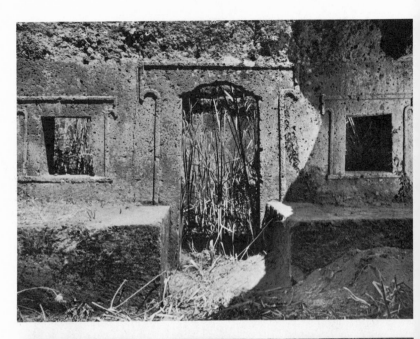

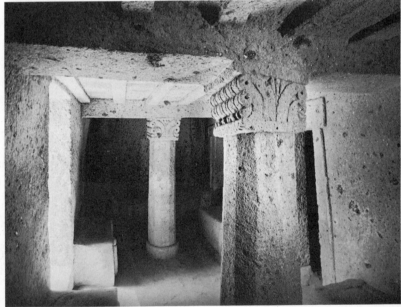

XVIa. Tomb chamber, door, and windows. Cerveteri.

b. Tomb of the Capitals, central chamber. Cerveteri.

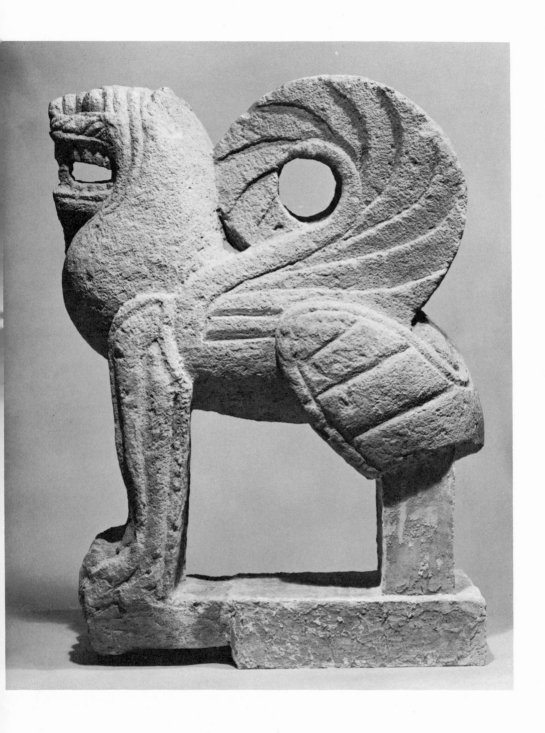

XVII. Winged stone lion. New York, Metropolitan Museum of Art.

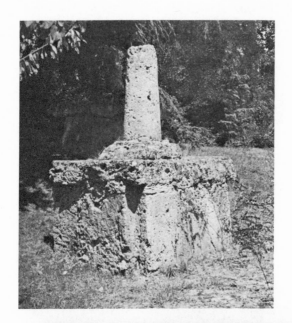

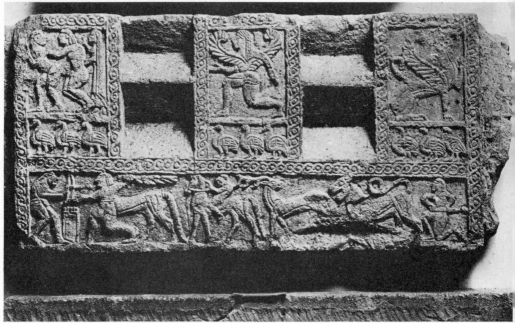

XVIIIa. *Grave with columnar marker. Marzabotto.*

 b. Stone slab from an early chamber tomb at Tarquinia. Florence, Museo Archeo-
 logico.

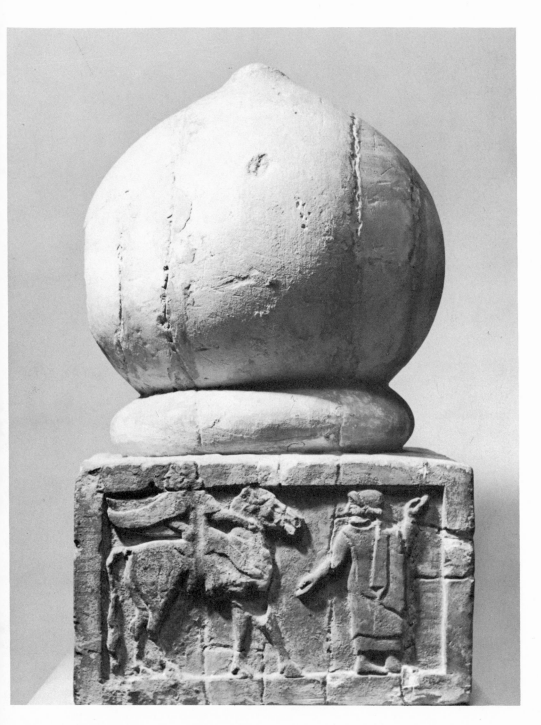

XIX. Stone cippus. Chiusi.

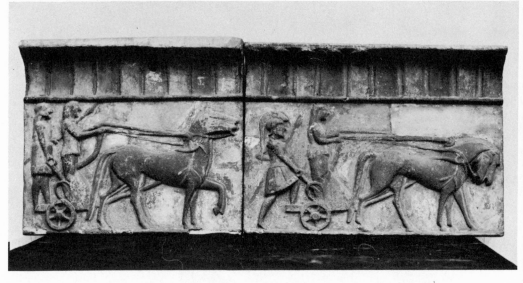

XXa. Antefix from Cerveteri. Berlin, Staatliche Museen.

b. Frieze from Cerveteri. Copenhagen, Ny Carlsberg Glyptotek.

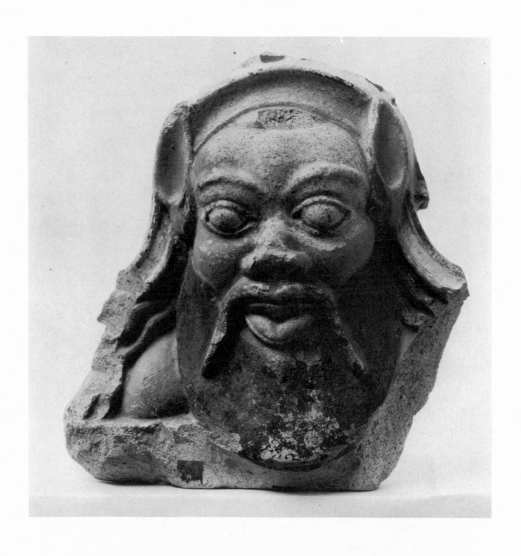

XXI. Shell antefix, satyr's head. Boston Museum of Fine Arts.

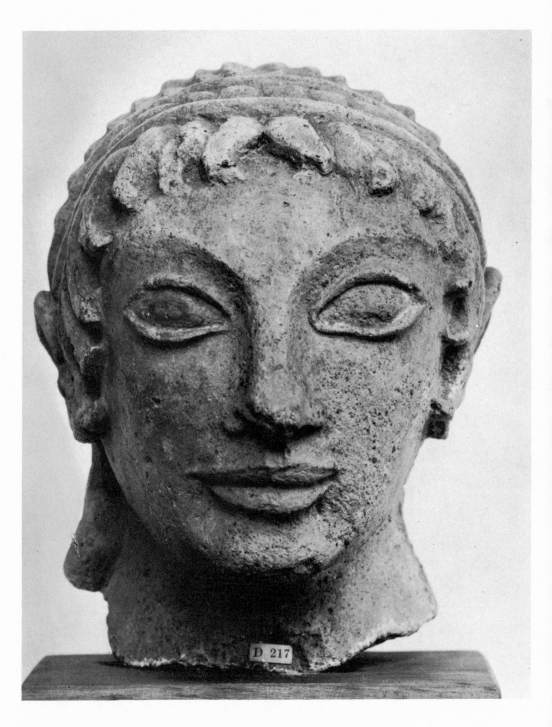

XXII. Head of a kouros from a votive statue. London, British Museum.

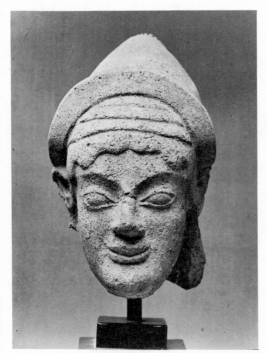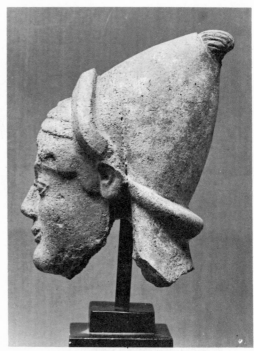

XXIII. Head of a girl from Cerveteri. Copenhagen, Ny Carlsberg Glyptotek.

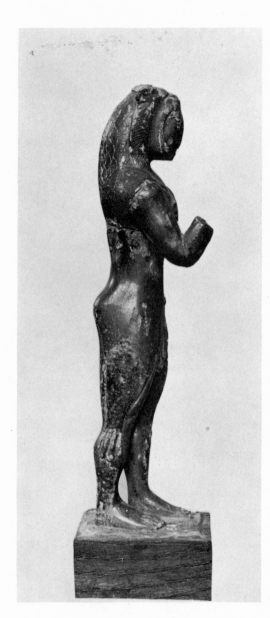

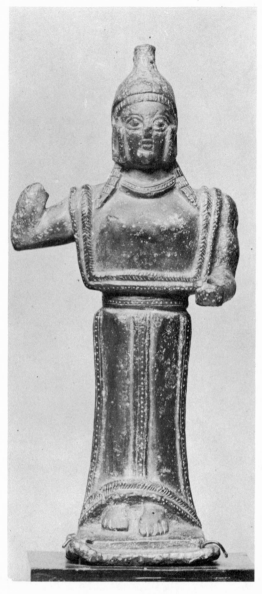

XXIVa. Hercules. Fiesole 484.

b. Minerva found near Florence. Berlin Antiquarium.

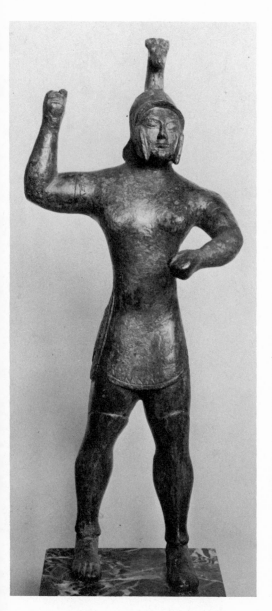
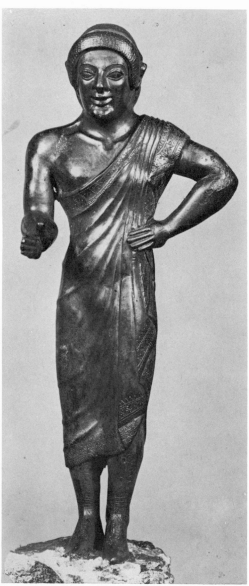

XXVa. Warrior, or Mars, from central Italy. Paris, Louvre 125.

b. Togatus from Pizzirimonte near Prato. London, British Museum 509.

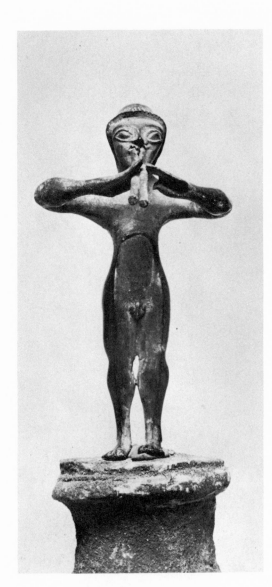
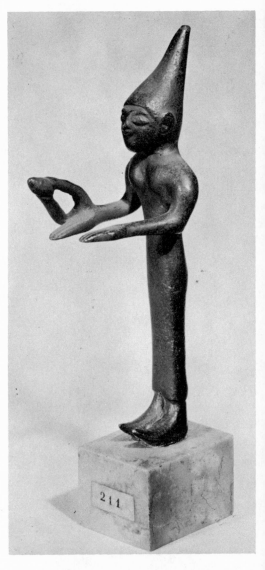

XXVIa. Nude boy playing the double pipes. Naples Museum.

b. Woman in pointed cap. Paris, Bibliothèque Nationale 211.

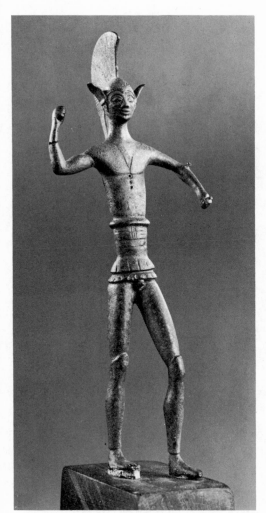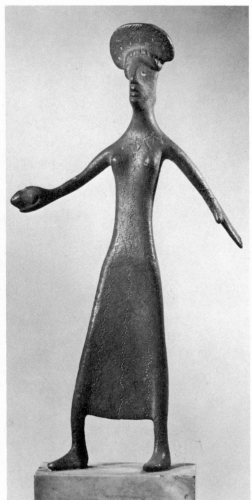

XXVIIa. Umbrian Warrior. Princeton University Art Museum 41–27.

b. Umbrian woman. Paris, Bibliothèque Nationale 212.

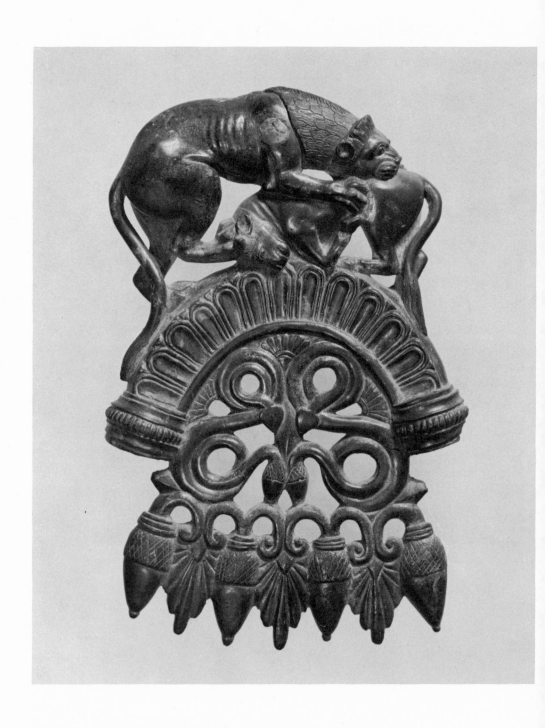

XXVIII. Bronze group of lion and bull from a tripod. New York, Metropolitan Museum of Art.

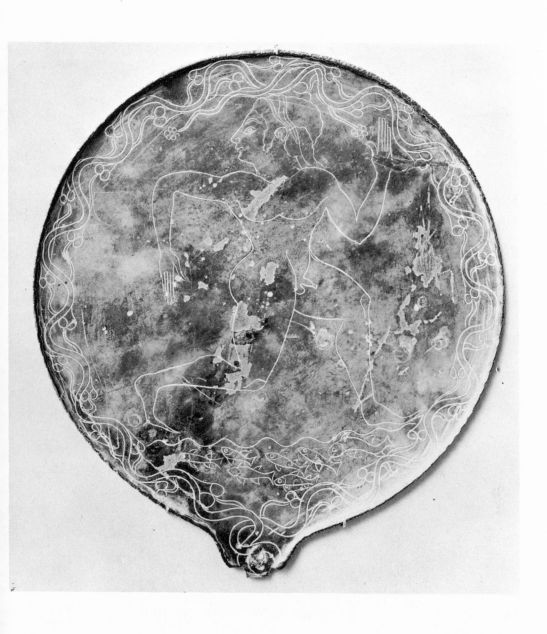

XXIX. Bronze mirror with incised picture. London, British Museum 545.

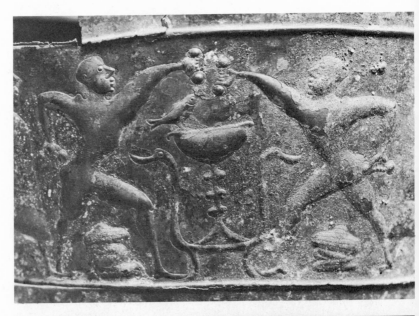

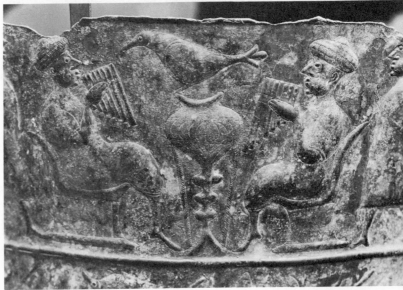

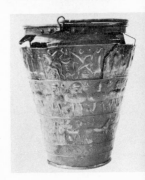

XXX. Situla. Providence, Rhode Island School of Design,

Museum of Art.

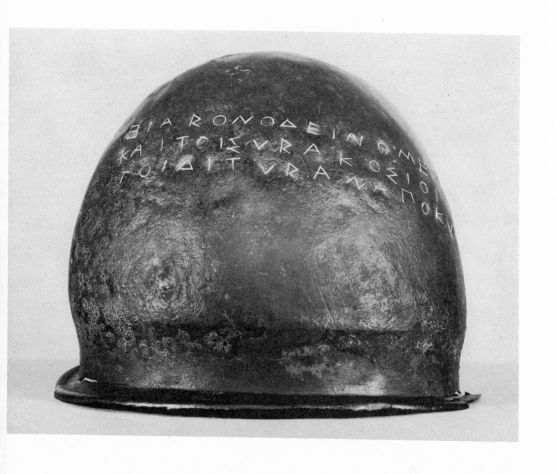

XXXI. Helmet found at Olympia. London, British Museum 250.

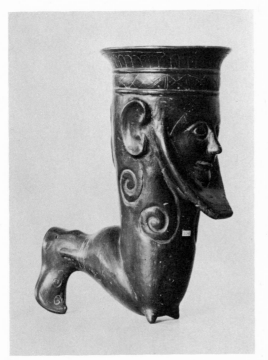 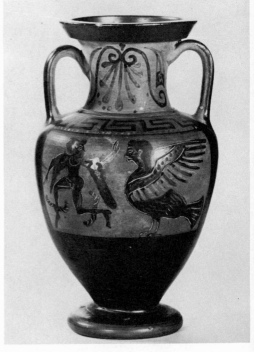

XXXIIa. Bucchero rhyton. Boston Museum of Fine Arts.

b. Etruscan black-figure amphora. Yale University Art Gallery.

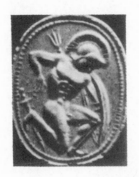

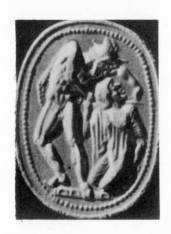

XXXIIIa. Gem. Death of Capaneus. London, British Museum.

b. Gem. Perseus and Medusa. London, British Museum.

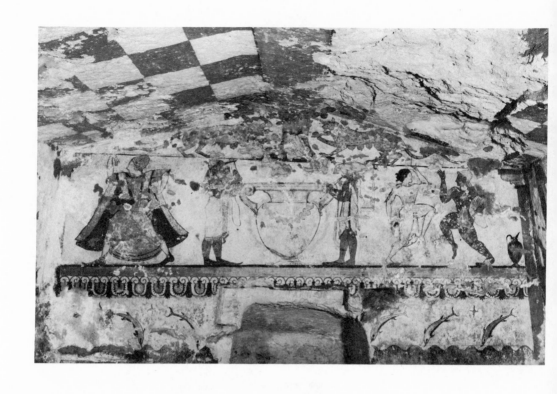

XXXIV. Tomb of the Lionesses, end wall. Tarquinia.

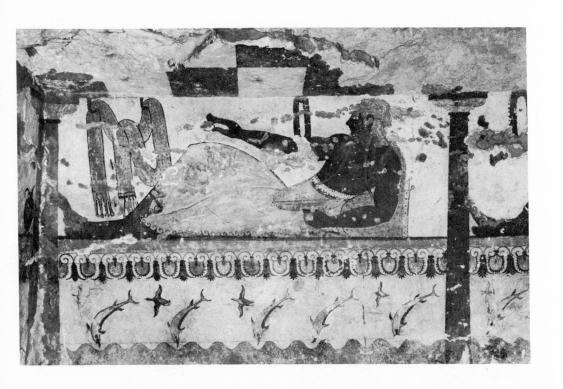

XXXV. Tomb of the Lionesses, detail of side wall. Tarquinia.

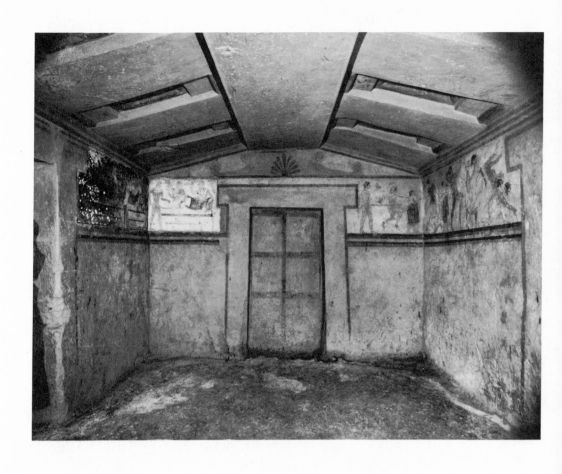

XXXVI. Cassuccini Tomb, interior. Chiusi.

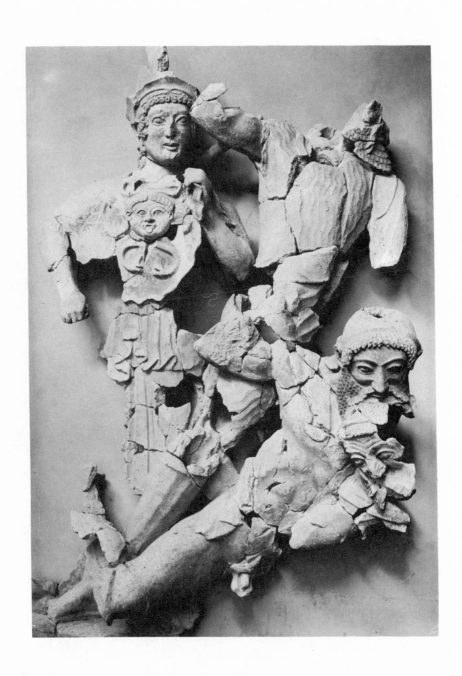

XXXVII. Pediment group from Pyrgi. Rome, Villa Giulia.

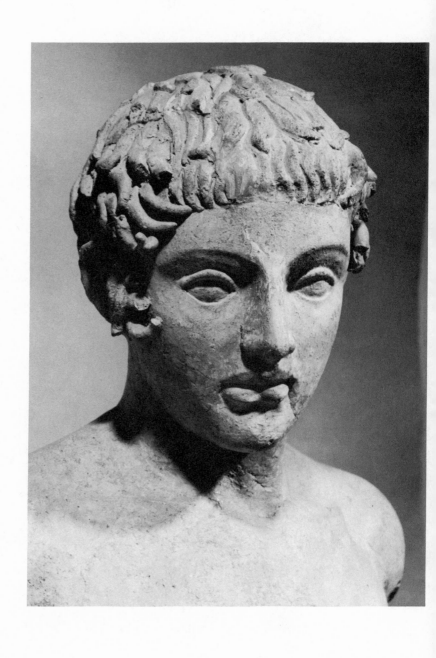

XXXVIII. Head of a terracotta youth from Veii. Rome, Villa Giulia.

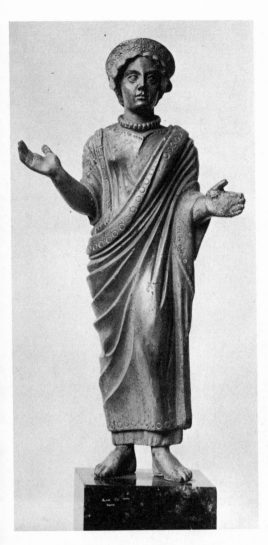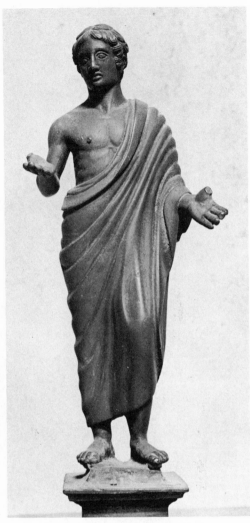

XXXIXa. Bronze figure of a woman. London, British Museum 613.

b. Bronze figure of a youth wearing a toga. Catania, Castello Ursino.

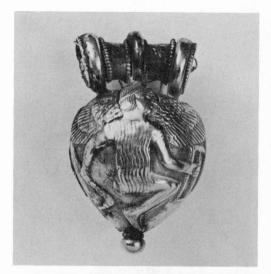

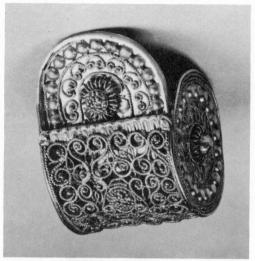

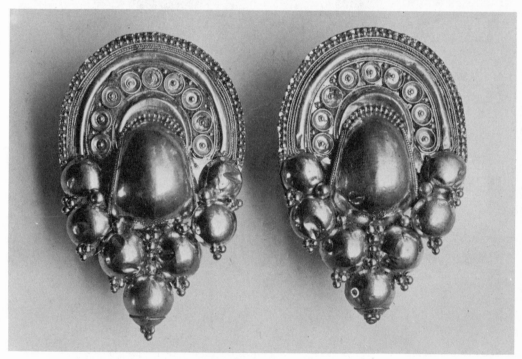

XLa. *Gold bulla, relief of Daedalus flying. Baltimore, Walters Art Gallery.*

b. *Gold earring with filigree decoration. Paris, Louvre.*

c. *Pair of gold earrings. New York, Metropolitan Museum of Art.*

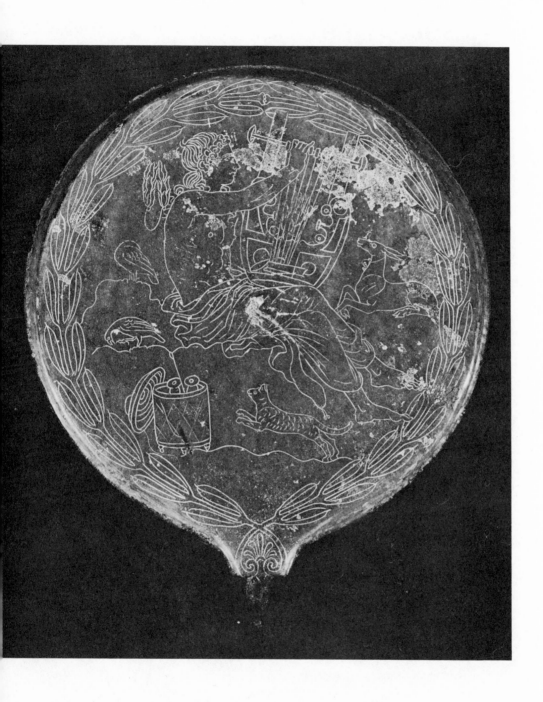

XLI. Bronze mirror, Orpheus. Boston Museum of Fine Arts.

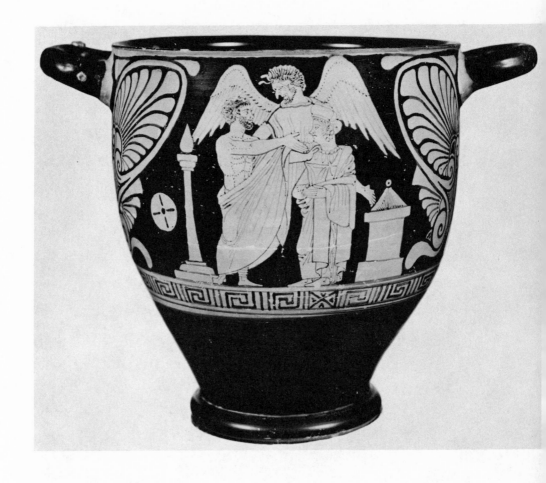

XLII. Etruscan red-figure skyphos. Boston Museum of Fine Arts.

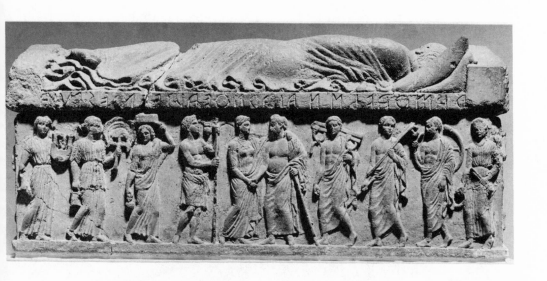

XLIII. Sarcophagus from Vulci, front. Boston Museum of Fine Arts.

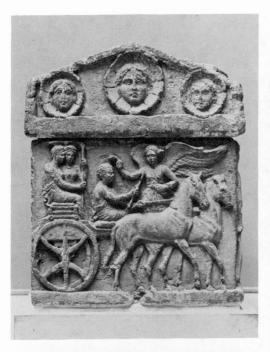

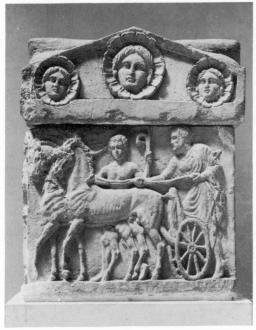

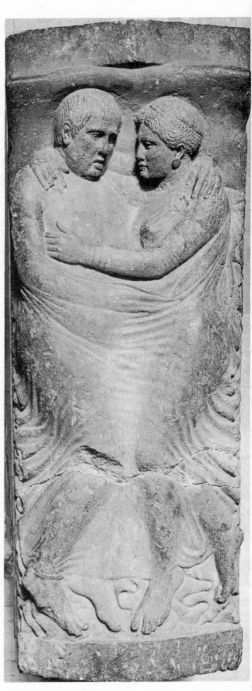

XLIV. *Sarcophagus from Vulci, top and ends. Boston Museum of Fine Arts.*

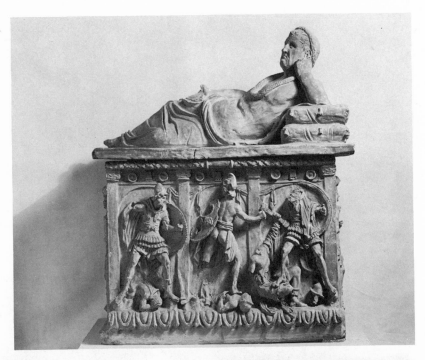

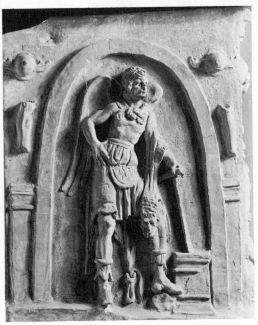

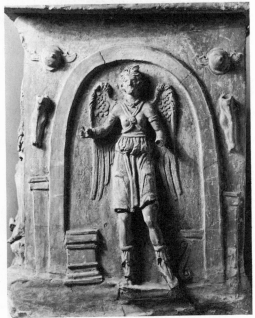

XLV. Ash urn from Chiusi. Worcester Art Museum.

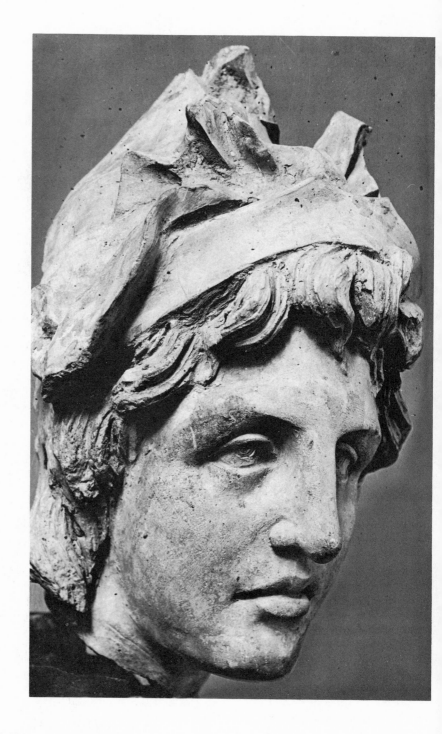

XLVI. *Terracotta head of a youth wearing a Phrygian cap, from Arezzo. In Florence.*

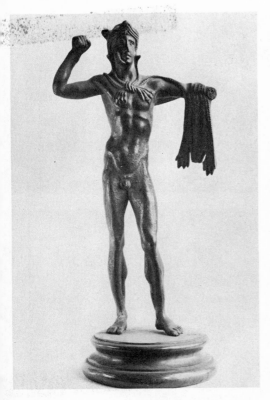

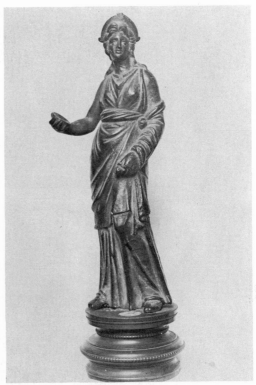

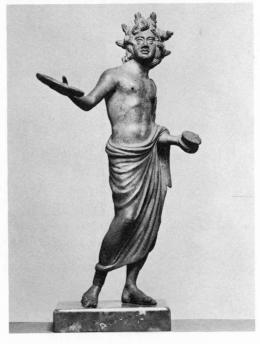

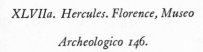

XLVIIa. *Hercules. Florence, Museo*

 Archeologico 146.

 b. Priestess. Florence, Museo

 Archeologico 554.

 c. Genius. Baltimore, Walters

 Art Gallery.

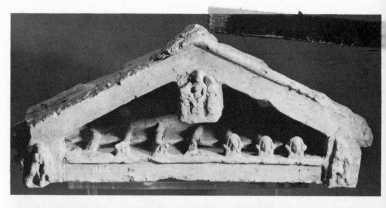

XLVIIIa. *Model of a temple pediment from Nemi. Rome, Villa Giulia.*

b. *Lid of an ash urn in the shape of a gabled roof. In Arezzo.*

c. *Stone base, model of a temenos. Chiusi, Museo Civico.*